Extraordinary Partnerships

HOW THE ARTS AND HUMANITIES ARE TRANSFORMING AMERICA

Edited by
Christine Henseler

**LEVER
PRESS**

DOI: https://doi.org/10.3998/mpub.11649046
Print ISBN: 978-1-64315-009-3
Open access ISBN: 978-1-64315-010-9

Library of Congress Control Number: 2019954609

Published in the United States of America by Lever Press, in partnership with Amherst College Press and Michigan Publishing

To the next generation of artists and humanists.
To my daughter, Leah.

The arts and humanities define who we are as a people.
That is their power—to remind us of what we each have to offer,
and what we all have in common.
To help us understand our history and imagine our future.
To give us hope in the moments of struggle
and to bring us together when nothing else will.

—Michelle Obama

Contents

Member Institution Acknowledgments

Lever Press is a joint venture. This work was made possible by the generous support of Lever Press member libraries from the following institutions:

Adrian College
Agnes Scott College
Allegheny College
Amherst College
Bard College
Berea College
Bowdoin College
Carleton College
Claremont Graduate
 University
Claremont McKenna College
Clark Atlanta University
Coe College
College of Saint Benedict /
 Saint John's University
The College of Wooster

Denison University
DePauw University
Earlham College
Furman University
Grinnell College
Hamilton College
Harvey Mudd College
Haverford College
Hollins University
Keck Graduate Institute
Kenyon College
Knox College
Lafayette College Library
Lake Forest College
Macalester College
Middlebury College

Morehouse College

Oberlin College

Pitzer College

Pomona College

Rollins College

Santa Clara University

Scripps College

Sewanee: The University of the South

Skidmore College

Smith College

Spelman College

St. Lawrence University

St. Olaf College

Susquehanna University

Swarthmore College

Trinity University

Union College

University of Puget Sound

Ursinus College

Vassar College

Washington and Lee University

Whitman College

Willamette University

Williams College

HUMANITIES RISING

How the World Is . . . and Might Be

Christine Henseler

The arts and humanities are entering a renaissance. Few would agree. The present picture looks grim. Enrollments are falling. Budgets are dropping. Public support is failing. At the dawn of 2020, the arts and humanities are going through a rough patch, with expansive repercussions.[1]

But the future can't be captured by the state of the present. In transformational times, it is the glimpses we see on the horizon that come into focus when we begin to walk toward them. This book provides a small step toward a shared belief in the need for a humanistic turn, a leap and a jump—steeped in hope—toward a future that holistically applies artistic and humanistic principles to the making of a more inclusive, equitable, caring, and kind—yet no less productive and innovative—world community.

The small step this volume takes is not unique, nor is it exclusive. But it is urgent. And it is everywhere. It is inspired by a long

history of creative doers going as far back as the Renaissance. Frans Johannson called these periods "Medici effects": moments in time that produce explosive breakthrough ideas that are both valuable to society and realized (14–15). During these creative junctures, individuals from different fields associated ideas in previously unimaginable ways. They challenged assumptions, questioned systems, and integrated bits from seemingly disparate fields. They do so again today. And their effects feel like the delightful unwrappings of desperately needed aha moments.

Today, Medici effects are all around us. To recognize them, we have to expand how we see, where we look, and what we subsequently do. What this book does is explicitly embrace and expose the very human complexities and constructive possibilities that unfold when we genuinely engage with our own and each other's strengths and vulnerabilities, when we build from what I like to call the constructive tensions that arise when people from different walks of life come together. By extension, the personal tones enthusiastically adopted by the authors in this volume reflect a need, a hunger, really, to reconnect to one another on deeply human levels.

The voices you hear in this volume are of people telling their stories of social and cultural transformation, in their own registers and through their own perspectives.[2] And, if you listen closely, you will hear them crying out, desperately calling to look beyond ourselves, to reach out to one another through our own unique voices, because we need to urgently address the social crises that are bubbling beneath our current state of affairs. We need individuals and organizations who advance a holistic and humanistic approach to our systemic challenges, from the ground up. These individuals are particularly well placed to save humanity, one community at a time.

THE RISE AND RENAISSANCE OF THE ARTS AND HUMANITIES

Contrary to public sentiment, I believe that we are entering a renaissance sparked by the bold and brave work of visionary artists and humanists, across all professions and disciplines. I was driven to pull this book together because I hope to widen and deepen contemporary conversations about the transformative role of culture and the arts and humanities within and beyond the walls of our academic institutions.

Within our institutional walls, we are clearly feeling the effects of a now almost decade-old economic crisis that has shifted public interest toward majors with direct financial and practical outcomes. The data compiled by the American Academy of Arts & Sciences' Humanities Indicators project provide impactful statistical evidence of declines that we are painfully feeling on our individual campuses and across a wide range of cultural organizations. By extension, the pressures on our administrative offices are leading to budget cuts that are directly impacting departments and programs, faculty and staff lines, courses, and initiatives. In response, those of us in the arts and humanities are having to defend and advocate more directly for their value. Examples of this day-to-day hard work can be found across the nation, in our K–12 schools and institutions of higher learning, in our communities and our cultural foundations, and, yes, even in our business organizations.

The goal of this book is not to undermine or deny the existence of our current crisis in the arts and humanities, nor is it to suggest that these efforts are not having their intended effects. On the contrary, our struggles give me hope. My hope is that this volume will add to the vision, stamina, and hard work of the many talented and dedicated individuals who are driving these conversations forward. My hope is to feed into these efforts by not consciously repeating our now well-worn worries about the

perceived value of the arts and humanities but by redirecting our national conversations into more fruitful waters. I wish to further encourage our shared action toward a national turn that takes control of the transitional times in which we live by claiming this worrisome historical parenthesis—this moment of deep change—as our own.

It is not a coincidence that the crisis in the arts and humanities coincides with our environmental crisis, our political crisis, our human rights crisis, our immigration crisis, our need for deep-seated systemic changes across a host of institutions. Why? Because human beings have been loosening their grip on basic human decency, respect, and dignity for years. We are currently witnessing a broad-based tectonic shift during a complex historical period that is marked by both deep despair and emerging hope. This is a time of disturbing polarization and change. This is a time during which the arts and humanities will have—I have no doubt in my mind—a definitive contribution to make in our individual lives and communities, to humanity.

I assert that tomorrow's artists and humanists must not only take a seat at the table but must chair the conversations concerning the future of higher education, the burgeoning new landscape of America's future, and the fundamental nature of humanness.

Indeed, we should look to the future with hope. On the whole, Millennials and Generation Z are more focused on social justice and social good than conspicuous consumption compared to previous generations. These rising demographics will cause the tidal waves that will transform our economies, our politics, our societies—our everyday lives. The world may look grim today, but tomorrow's landscape springs with hope and opportunity if we continue to nourish the minds of future generations as artists and humanists across all fields and professions, in all schools and programs, at all levels, in our communities and in our everyday lives.

DIVIDED WE DO NOT STAND

At the moment, the United States is a country deeply divided—divided by regionalism, divided by socioeconomic status, divided by sociocultural tensions, by religion, by ideology. Although this may sound idealistic, I believe the arts and humanities have the capacity to reach and positively impact individuals from all walks of life, no matter their nationality, beliefs, race, gender. It is my position that we must look to the arts and humanities as a panacea and as connective tissue. This connective fabric enables all of us, if we choose, to enter into collaboration and partnership. These partnerships can support innovation and promote civility, peaceability, cooperation, and productive and positive dialogues.

This volume highlights the work of everyday artists and humanists whose transdisciplinary, collaborative processes reimagine communities and renegotiate our divisive national narratives. They are not famous. Their work is not broadcast on television nor marketed widely. But, they are visionary artists and humanists who are transforming the boundaries of their sociocultural contexts. To understand the work of these visionary transdisciplinarians, we must raise our eyes above the walls of the academy so that we can engage more expansively with the complex, radical shifts being driven by some of our most thoughtful and creative thinkers.

The chapters in this book propose the need to make space, to let go of our habits of mind, and to expand the ways in which we engage with one another. For as long as we discuss the role and value of the arts and humanities in our own linguistic registers, among ourselves and through communication channels geared toward the like-minded only, our ability to affect the world outside our walls will remain limited and stunted. In this volume, Amar C. Bakshi emphasizes this point when he says that, "talking to people unlike ourselves is always important, but particularly so today. There are powerful forces driving us deeper into our own communities, including widening income inequality, a consolidating

mass media, and dwindling public spaces." That's why the essays in this project are written from more personal perspectives. When we begin to tell personal stories, we can more readily come together from different places, potentially connect on human levels more directly—politics aside—and in turn see one another more clearly.

Whether we are working in higher education or community organizations, whether we are parents or students, black, brown, or white, republicans or democrats, the need to include all people in the creation and understanding of what we in the arts and humanities do and how we think, is becoming a social imperative. Expanding the reach of our work does not only open our minds to others but allows us to understand our own place in this complex and fast-changing net world.

The need for communication and listening are becoming urgent. We desperately need to marry access and production of knowledge with the diversity and inclusivity efforts on our campuses, in our communities and workplaces. We must answer the question posed by scholars M. Gibbons and H. Nowotny—"Where is the place of people in our knowledge?" (75)—by opening ourselves up to new and unusual spaces, new and unusual conversations. Toward this goal, the chapters in this book function to sew together human social fabrics of often-marginalized, excluded, or largely invisible voices, not only to be seen and heard but, more importantly, to be integrated as highly valued contributors to a reimagined design of contemporary society.

Indeed, this volume proposes making space for the personally transformative experiences that intersect and expose how it is that our thinking and acting are influencing the communities in which we live. Some would call these individuals "activists," but I consciously do not use this term. The artists and humanists whose works are included use their beliefs and skills to strengthen relationships within the communities in which they live and work in ways that are often subtle, under the radar. They are the "ordinary" in the extraordinary that marks this title. And, it's time we publicly

elevate the individuals who are affecting change in our everyday lives. They are our unsung heroes.

It is in the chapters of this volume that the impact of the arts and humanities are not separated from everyday life and culture but understood to live and breathe inside and across multiple communities; they open spaces toward inclusive dialogues that challenge assumptions and creatively move and connect us through sometimes unusual places, including shipping containers, marketplaces, gardens, public squares, video games, or circus tents. Who can or cannot speak or feel visible and valuable and which visions are left out when those voices are lost are driving threads throughout this book. For this reason, readers will hear the voices of the undocumented, the circus "freaks," the inmates, the abused and violated, the indigenous, the voices of Latinx students, and the women who have all been—yes, I am referring to the movie— *hidden figures* for far too long.

TURNING THE TIDE

I see the future of the arts and humanities moving more fluidly across our educational environments, our communities, our businesses, our foundations, and our personal lives. The voices presented in this volume suggest the need to see ourselves as part of a more mobile and seamless environment where each of us wear various hats—as we do every day—as educators, community members, entrepreneurs, freelancers, activists, parents, students, children, and more.

As such, this project falls in line with the thinking of David Theo Goldberg and Helen Small who passionately advocate for a more agile, pluralistic, inclusive, and nonisolating approach to the discussion of the arts and humanities. Furthermore, I wish to acknowledge the work of Eleonora Belfiore and Anna Upchurch who elucidate on the usefulness and the value of artists and humanists who have influenced humanistic thought. They believe, as I do,

that to address the complexity of contemporary society, we need to try to untangle "live ethical, practical, and scholarly challenges" (4). It is my hope that this book will inspire undergraduate and graduate students, faculty members, community members, and business professionals to reaffirm their own process of "untanglement" and add to the conversations that this volume hopes to energize.

I find this verb—to untangle—highly enticing, though not as a way to engage in critical unravelings that may lead us again to separations and disparate parts, units, or threads but as productive states of reinvolvement within one another's evolving work and life experiences. I see the process as delightfully playful and dance-like, as intellectual enmeshing and creative bewilderment that resonate within because it is born from a deeply human place of care and genuine engagement and curiosity for and with one another. For this same reason, I prefer to use the word partnership over collaboration in the title of this project.

Partnerships foreground less the working conditions of two or more people than the human conditions that bring us together. Partnerships are built on mutual respect, on honest engagement, on patience and care—on acceptance. They are not trendy; they are not one-sided; they are generous and hopeful. They juggle with those live, electrically charged wires that shock us into returning to common sense and sensibility, wonder and excitement. They fill us with wonder and awe. They help us dismantle oppressive structures that prevent self-actualization and communal actualization. They remind us of the evermore important need for dialogue to lower the walls between polarized groups. They reassert the importance of the arts and humanities as vehicles of nonviolent conflict resolution and to reimagine how we live, work, and, yes, even die.

Partnerships demonstrate that any small or large social transformation must first and foremost come from a very human, individual place. Some may call this process of first looking within as "soft," perhaps "anti-intellectual," or "unscholarly." I call it "about

time." It is high time we stop talking in abstraction or jargon. Deeply impactful and humanistic transformation will only occur if we return to foundational values and beliefs and we find a common language to connect to one another on more equal ground. To accomplish this, we must bring theory and practice together in dynamic, diverse, and perhaps unusual spaces. We must shift where we look, how we speak, and who we speak with. And, we must create committees and projects not limited to individuals with impressive professional titles.

The use of the verb to transform in the title of this project underscores the importance of capturing and supporting projects, big and small, that are adapting to our changing times. Transformations point to the importance of locating ourselves across professional and personal communities and disciplines, reaching beyond in order to expand our understanding of each other and the world around us. It starts with us. This concept is literally embodied in contributing author Amar C. Bakshi's Portals project, which consists of gold-painted containers with immersive media technology that allow anyone to connect face-to-face with individuals from communities across the globe and, in the process, as Bakshi remarks, break down the stereotypes we carry of one another. Subsequently, our enemies become friends, the dehumanized real. Similarly, professor of French and Francophone studies, Charles Batson, discusses the playfully transformative effects on the disabled and underrepresented youth of Cirque du Monde's social circus. These entertainers expose the lived connections between everyday life and the larger state of affairs in the United States; one, says Kim Cook, Creative Initiatives Director at Burning Man, in which we can draw connections between the marginalization of art and culture and the marginalization of migrant communities and underrepresented populations.

The prefix trans- in transforming also relates to the deeply transdisciplinary nature of this project, which, I would like to stress, is meant to underscore the foundational importance of each

discipline in and of itself, not in exclusion of each part, even as it transgresses its own boundaries. As such, I believe that the future of the arts and humanities lies in both strengthening its core and in expanding our reach into unexplored areas, not as a sideshow but as full partners. But because the term has mostly been driven by the sciences and technology—in part because of a transdisciplinary emphasis on real-world problem solutions and collaboration that has considered marginal the contributions of the arts and humanities—it is high time for the arts and humanities to take an equal seat at the table. As such, the individuals and groups presented in this volume all provide very real, very "on the ground" and socially impactful examples of the arts and humanities.

Although transdisciplinary programs and efforts in and of themselves are not new, and in fact they are often quoted as valuable approaches in the resolution of our society's "big problems," it is worth pausing to think about their impact on those smaller but nagging and festering issues that are so integrated into our social fabric that we barely notice them at all. In this book, the voices of artists and writers, educators, community members, and professionals from all backgrounds enter into dialogue to showcase how even the smallest of transformations, whether in the way we approach a task or we view the world around us, can lead to perceptual shifts when we work in partnership with one another. These are extraordinary partnerships in which deep scholarly knowledge is put into practice, not only to envision "how the world actually is, but how it might be" (Gottstein).[3]

Artists and humanists across America, and beyond, are creating partnerships, developing new methodologies, launching projects, and starting initiatives that effect positive and lasting change. These futurists are transforming their communities, their businesses, their environments, and building more inclusive, holistic, and humanistic futures. This book offers case studies and personal and professional pathways meant to inspire, question, challenge,

and act to redirect and reimagine our society's future, one community at a time.

The need for a cultural shift is one that is becoming increasingly apparent in our day and age. And to think of transforming our social fabric and broken political and economic systems without the arts and humanities is, quite honestly, unimaginable. Perhaps even deadly. That's why I believe, as all of the contributors in this volume express through their life and work experiences, that the tide is turning. The arts and humanities are rising. And they are coming back stronger than ever.

THE ESSAY CONTRIBUTIONS

Creating Space, Context, and Moment

The authors in the first section of this book propose ways of seeing a greater range of possibility for ourselves and others.[4] They identify how the arts and humanities can serve to build shared contexts and allow us to write, create, and play ourselves into existence. These partnerships make space for the identification and expression of diverse cultural identities within open and honest participatory environments. They emphasize the transformative effects of the arts and humanities toward the building of connective human tissue, the expansion of our social fabrics, and the inclusion of our historically underrepresented populations. They ask how it is that we can create context and quite literally make space and allow for moments that can transform society through more holistic and inclusive practices.

The volume begins with the work of former *Washington Post* reporter Amar C. Bakshi's installation art called "Portals." Bakshi placed a shipping container in the back of his yard, painted it gold on the outside, put grey rugs on the inside, and with immersive media technology, he gave everyday folks the opportunity to come face-to-face with strangers, even political enemies from across

the globe, through deeply transformative interactions. The idea of expanding how we see and who we can be when we make space to interact with others presents us with powerful transformative potential that can be applied to different realms. And the Portal project quite literally challenges how we think about the boxes we inhabit and create—be they our homes, our public squares, our classrooms, or our institutions and organizations.

The creation of space, context, and moment through the power of storytelling are at the center of Kim Cook's essay "When Art Lives as Culture." For Cook, our diverse traditions and everyday culture as lived through food, music, singing, and movement; in our homes; in our public squares; at births and funerals are vitally important means of self-expression and building shared communities. When Cook connects her own life story about the role and place of multicultural dance and movement to her multiple professional roles as president and CEO for the Arts Council New Orleans, creative director and founder of Light Up NOLA Arts (LUNA) Fête, and Director of Burning Man's Creative Initiatives, she provides concrete lived examples of the ways in which participatory and community-engaged art plays a role in advancing community goals.

But Cook warns us that although we may recognize the value of culture in our everyday lives, when policies are not in place to preserve local residents' abilities to own property and live in the community, they are at risk for great losses. This is the challenge of the creative economies and creative placemaking efforts, where cultural assets are recognized and protected, she says. To safeguard those efforts, Cook suggests that what is required is a consideration of our own roles in the creation of context: it is important to be curious, to ask questions about your surroundings, to inquire as to what already exists, and to work authentically with others.

According to Christina Lanzl, quality of life and caring about community are at the core of a contemporary movement, which is increasingly becoming a grassroots-driven approach to embrace the places we inhabit. Successful placemaking, the arts

and culture--in short, ways for people to engage in public--are at the center of thriving, functioning neighborhoods. As director of the Urban Culture Institute in Boston, Lanzl asks: How can we create successful public places that provide all with powerful incentives for active participation? Which tools can we employ to ensure diversity and inclusivity? What kind of hands-on processes can be utilized? Are there universal platforms for discourse? Which creative activities and solutions produce improved, shared environments?

To answer these questions, her essay quotes from six principles of the *Placemaking Manifesto* to offer examples that encourage active and inclusive neighborhoods, to find ways to bridge the past, the present, and the future. Her experience in the field of urban culture design demonstrates that placemaking practice is overcoming the limitations of individual disciplines that have traditionally designed and activated public spaces, such as architecture, urban design, landscape architecture, the arts, and community or social programs. By sharing specific strategies and case studies, she suggests that "everybody—people of all backgrounds, ages, and abilities—can participate in creating successful public places," and confidently embrace their "common humanity and heritage."

Professor of French and Francophone studies, Charles Batson continues to discuss the positive transformation that can come from another public realm; namely, the playful one of the social circus in Quebec and around the world. What is lost and what is gained, he asks, when funding is cut for programs that make space for underserved and underrepresented populations who are traditionally excluded or forgotten by society? Batson proposes that these circus spaces can develop new bonds within a society that has often excluded our marginalized populations. But it is not only that these spaces enrich lives but that an increased emphasis on the creative expansion of our social fabric will no doubt lead us to expand the way we think and act and, by extension, turn the ideas,

systems, and structures that are currently defining us upside down and inside out.

What happens when academics shift from being moved by their observations to actively engaging in making space for deeply impactful moments that transform the way we think about a problem? Rebecca Volino Robinson, Claudia Lampman, Brittany Freitas-Murrell, Jennifer Burkhart, and Amanda Zold start their essay with a powerful quote by Czech writer Václav Havel: "Art can present truths in ways that sneak around our unconscious prejudices. It is a way to speak the unspeakable."

Their experiences performing an off-Broadway show called *Stalking the Bogeyman* leads to the understanding that a partnership between theater and dance and psychology can address problems that are big, such as the problem of child abuse in Alaska, by starting small and talking about the unspeakable, one story at a time. Their work transformed the way they thought about and addressed the problem of child sexual abuse in their community, and, by extension, their state, through an integrative and interdisciplinary process that had a deep impact on all participants. When members of the worlds of theater and dance, psychology and art partnered with community organizations, such as Standing Together Against Rape and the Alaska Children's Trust, in their own words, they were able to "turn up the volume" and transform the way people thought about the problem of child abuse in the state of Alaska.

Perhaps one of the most unusual partnerships in this volume is the one that was boldly advanced by the Cook Inlet Tribal Council (CITC), a tribal nonprofit organization in Anchorage, Alaska, with E-Line Media, an entertainment and educational video game publisher with development studios in Seattle, Washington, and Tempe, Arizona. Their story of how they produced a video game known as Never Alone is a fascinating example of how far-reaching and deeply transformative an unexpected partnership can be. Not

only did this game garner critical, national acclaim, but more importantly, it introduced players around the world to the Alaskan Native language, culture, history, stories, and values. The game began to redirect the negative stereotypes that were affecting large segments of their youth. Their work also beautifully exemplifies how purpose and profitability can be moved forward through effective partnerships between technology and the arts and humanities.

The work of the Cook Inlet Tribal Council intersects with a question that is at the heart of the next essay as well; namely, How do we rewrite history to pave the way for the next generation? And, What is the role of technology in this path forward? Professor of art history, Amy Hamlin, shares her experience, best practices, and outcomes of the initiative known as an "Art+Feminism Wikipedia Edit-a-thon" that mobilizes others to write female artists into the largest encyclopedia in the world. Hamlin asks one of the most important questions of the day; namely, Who is telling the stories of today and how do we tell them differently? Her journey through this grassroots initiative provides powerful insights into the reasons why "there are more Wikipedia entries on porn stars than there are on children's books." In essence, Hamlin's adventures in this edit-a-thon helped shift public narratives and challenged her own assumptions about her role in the creation and transformation of knowledge inside and outside of the classroom.

The art of consciousness-raising by writing invisible or marginalized groups of people into being is something Ella Maria Diaz, professor of English and Latinx studies, experienced personally when she joined a Deferred Action for Childhood Arrivals (DACA) student in a college protest movement. In her essay, Diaz shares her experiences and understanding of the use of Chicanx poster art as an example of how the arts are not simply a recreational hobby but they "are life." She finds that poster art addresses many of the values and ideals upon which the humanities are premised: societal inclusion and enfranchisement; cultural visibility and

representation; and, ultimately, what it means to be a human being despite the categories of nationality, citizenship, and other statuses that push us further away from a common humanity.

In keeping with the impact of art, the next essay by Betsy Andersen, director of the online museum Museo Eduardo Carrillo, and Julia Chiapella, journalist and leader of a young writer's program for grades four through twelve, discuss an initiative called the Hablamos Juntos project. The program transforms how students of color, especially those from Latinx cultures, experience themselves as reflected in and engaging with contemporary Latinx art. Responding to this art with their writing, and having that writing published alongside the artwork of contemporary artists, allows for a shift in perception: student writing is valued equally with the artwork of adults, promoting a sense of accomplishment and self-respect. The Hablamos Juntos project demonstrates an important element about the power of storytelling that repeatedly appears in this volume; namely, its ability to support the development of personal agency and new viewer perception.

The first segment of this volume ends with an essay by Margaret Graham who, in 2016, joined a partnership between a selective liberal arts college and a maximum-security prison as an instructor for a college preparation course for prisoners. "Humanizing American Prisons" highlights both the challenges and the benefits of bringing—in this case, poetry—to a group that has been systematically dehumanized, often for the majority of their lifetimes. Graham explores the role of colleges, and a humanities education in particular, in the transformation of a systemic problem that underlines our social values. How this experience transformed the inmates, and herself, is a journey worth reading and remembering.

EXPANDING PARTNERSHIPS AND SHIFTING PARADIGMS

The second section of the book moves us beyond traditional walls. Contributors affirm that we cannot use old structures to

solve unprecedented problems. For this reason, they highlight the role of the arts and humanities as fundamental wireframes to broaden professional boundaries and reenvision the fields of business, technology, science, sociology, engineering, and health care. The authors suggest that these fields are standing before a much-needed currency change, one in which the systems by which they operate must be more inclusive and empowering of diverse communities, spaces, topics, and methodologies.

Susan M. Frost, CEO of a marketing and communications firm, gets us started by suggesting that in order to dismantle traditional structures we must move beyond our disciplinary divides. But, instead of linking disciplines, she evocatively suggests that we *think though* the humanities. Frost gives it a name: a "humanities biosphere." This biosphere, she argues, "infuses other disciplines with an empathetic understanding of mutual impact: one discipline affects and informs another." This approach opens windows into interrelated structures, a way to examine the interdependence of disciplines—economic change, the rise of consumerism, modern marketing principles, shifts in family values, city development, and changes in law—all seriously impacting one another.

Bailey Reutzel takes us on the road in a 2008 Ford Escape to collect the thoughts of everyday individuals in small towns and cities across the United States. Her goal is to find out how money shapes their lives. After twenty-six thousand miles and a successful blog called *Moneytripping*, Reutzel discovers that there is a disconnect between what our marketers consider to be the hottest topics in the United States—science, technology, and Silicon Valley—and what individuals *actually* care about: "to be listened to." What Reutzel finds is that people mostly want to philosophize, to speak, to tell their stories. As such, she finds that "good" technology is that which connects and serves humanity and allows people—especially those who have been unable—to understand a broader humanity.

Speaking of broadening, Chantal Bilodeau, a playwright, translator, and research artist whose work focuses on the intersection

of science, policy, culture, and climate change, examines how, in recent years, many artists have taken on climate change as their subject of exploration, often partnering with scientists, social justice organizations, and communities to broaden their impact. As the founder of the blog and international network *Artists and Climate Change*, she shares a yearslong project meant to move her audience to action, and she discusses the nature and impact of a collaboration with nonart partners. By helping align our beliefs and values with our changing reality, Bilodeau explains that the emotional power of art can "reach our most vulnerable places and move us in ways no scientific argument ever could. At times, they shake us to our core and provide experiences so visceral that they exist beyond language." In this essay, Bilodeau takes us on her powerful artistic exploration of climate change, a journey that led her toward several unexpected partnerships.

There is another way that influential action can take place: through the physicality we feel in our bodies. Jane Hawley and Jodi Enos-Berlage, professors of visual and performing arts and biology at Luther College, began a multiyear partnership that gave birth to *Body of Water*—a project and performance that describes "how collaboration instilled trust between [their] disciplines, how [their] vulnerability sustained [their] commitment, and, finally, how *Body of Water* impacted both audience and performers alike, creating connection points for new communities." Their partnership grew to involve local landowners, water stakeholders and leaders, college students, K–12 students, and audiences through programs such as the Iowa Water Conference and National Water Dance. Their daily interactions with water—talking, thinking, learning, witnessing, and becoming water—demonstrate that one's physical participation in the act of storytelling can address larger problems, one community at a time.

An architect, a biologist, a psychologist, and a photographer arrived to teach a program in Quibdó, Colombia—this is the beginning of a highly effective program called PreTexts: Higher-Order

Literacy, Innovation, and Citizenship. In her essay, Doris Sommer, professor of Romance Languages and Literatures and African and African American studies and founder of the nongovernmental organization (NGO) known as Cultural Agents, with Antonio Capete, postdoctoral researcher at the Harvard-Smithsonian Center for Astrophysics, explain the emotional journey to their finding that practical, almost always technical, responses to unfavorable environmental, economic, and political challenges have not led to favorable solutions. To effect sustainable structural changes, then, they suggest a shift in the paradigms through which we think and, by extension, the applications of our learning to different communities and disciplines.

Rebecca Kamen is one of those people who literally embodies the transformative shifts in paradigm when joining art and science in both scholarly and applied contexts. As a sculptor, artist, and professor emerita, Kamen's essay presents concrete examples from her work about the collective power of joining disciplines as diverse as cosmology, history, philosophy, chemistry, astrophysics, neuroscience, art, dance, music, and poetry. Her art projects capture and reimagine scientific theories in an effort to, in her own words, "expand our boundaries exponentially." Kamen's crossdisciplinary artworks foster collaborative learning experiences, serve as catalysts for change, and make "the invisible visible."

The need to make "the invisible visible" is what Luke Keller, professor of Physics and Astronomy, and Madeline Holzer, educator in residence at the Academy of American Poets, share through three case studies from middle school and college classrooms. They demonstrate the effects of teaching students to communicate scientific observations through the lens of poetry and visual art. They describe an approach to teaching and learning art and science that begins with exploring what artists and scientists *do* rather than what art and science *are*, to begin with action and participation in order to see, firsthand, how art and science works. Their overall goal is to prepare students for life as citizens with

a deep appreciation of both art and science—as integrated and essential ways of learning and communicating—who are informed and confident lifelong learners as well as consumers and creators of information.

Speaking of creators of information, Ari Epstein, Elise Chambers, Emily Davidson, Jessica Fujimori, Anisha Gururaj, Emily Moberg, and Brandon Wang broaden students' understanding of the power of storytelling and audiences' understanding of the role and impact of the sciences. By opening students' ears, Epstein et al. share how radio production can serve as a path toward a deeper understanding of the human context in which scientific and technical problem-solving is done. In doing so, students interview people who are directly affected by the issues they have been studying, and they learn and record the human stories of those people. They then weave together these stories, along with their own perspectives, to create a deeply humanistic view of issues that they had previously studied largely through a technical or scientific lens.

Gemma Mangione is one of those individuals who works at the intersection of two unlikely bedfellows: as an academic and museum evaluation consultant she partners art and sociology. In her essay, Mangione explains the impact and need to bring together aesthetic value and beauty with data and numbers, because cultural organizations are having to adjust to the pressures of the marketplace and impact-based measures of social value. Like it or not, she says, those of us in the arts and humanities have to accept that it is essential to persuade others *why* art is being created. That's why Mangione collaborates with diverse groups of professionals interested in moving these two worlds closer together, and conceiving of sociology as a tool for promoting a "philosophy of practice" rather than an abstruse set of skills.

It is only fitting that a Millennial, a former student who took a class with me on the transformative impact of my own generation, Generation X, should project this volume into the future. Julia Hotz graduated with a philosophy and political science degree from

Union College and now works at Solutions Journalism in New York City. In her chapter for this volume, she uses her writing talents to point to what she describes as the "much-needed reevaluation and reinvigoration of a partnership that is absolutely essential to the building of a holistic future that embraces our human potential: that between the everyday purpose of work and the study of the humanities." Through two millennial case studies and a short philosophical history of the meaning of work, she examines the psychological effect of today's automated workspaces, including loneliness and disconnection, and how this trend presents society with the desperate need to create more fulfilling jobs that facilitate collaboration and tangible (preferably social) impact. She appropriately ends the volume by calling for an attitude shift, one that will leave the readers of this volume wanting to raise their own voices and partner across diverse communities.

My hope is that this humble yet impactful compilation of experiences across many disciplines and communities will contribute to continuing dialogue and building new partnerships, and will expand our positive understanding of the role of the arts and humanities in our society. Because, when I look on the horizon, I see the arts and humanities rising. They are rising in ways that bring meaningful and purposeful change to our society through many delightful *aha* moments. And, from the look of our current state of affairs, we are in desperate need of new partnerships that can contribute to the building of a more holistic and humanistic future. The power is in our hands. We have the ability to affect large-scale cultural change in our education system, in our political system, in our communities, and in our daily lives. What are we waiting for?

NOTES

1. I would like to thank Yasmine Van Wilt for her editorial suggestions at the inception of this project and for codeveloping the "Extraordinary

Partnerships" interview series published in the *Huffington Post*. See more at https://www.christinehenseler.com/interview-series.html.

2. Valuable resources on this subject may be found at "Art for Social Change," Resources, International Centre of Art for Social Change, accessed January, 21, 2019, https://www.icasc.ca/resources.

3. See quote by Jenny Gottstein at "How Extraordinary Partnerships with the Arts and Humanities Are Transforming America," Extraordinary Partnerships, Christine Henseler, accessed March 21, 2019, http://www.christinehenseler.com/extraordinary-partnershipsi.html.

4. The following chapter overviews include segments from author abstract summaries.

WORKS CITED

Belfiore, Eleonora, and Anna Upchurch. *Humanities in the Twenty-First Century: Beyond Utility and Markets*. New York: Palgrave Macmillan, 2013.

Gibbons, M., and H. Nowotny. "The Potential of Transdisciplinarity." In *Transdisciplinarity: Joint Problem Solving among Science, Technology and Society*, edited by J. Thompson Klein, W. Grossenbacher-Mansuy, et al. Basel, Switzerland: Birkhüawe Basel, 2001.

Johannson, Frans. *The Medici Effect: Breakthrough Insights at the Intersection of Ideas, Concepts, and Cultures*. Boston: Harvard Business Publishing, 2004.

Small, Helen. *The Value of the Humanities*. Oxford: Oxford University Press, 2013.

Goldberg, David Theo. *The Afterlife of the Humanities*. Irvine: University of California Humanities Research Institute, 2014.

TOWARD A COMMON HUMANITY

Creating Space, Context, and Moment

LESSONS FROM THE LAUNCH OF PORTALS

Amar C. Bakshi

In 1947, my grandmother, Nani, fled Lahore, Pakistan, during partition. She left at night for India by train, with fires burning outside her window. Seven years later, at age twenty-one, Nani married my grandfather. My grandfather was a mapmaker who spent the next thirty years charting the new India–Pakistan border in exquisite detail. My grandparents gave birth to my mother. She grew up traveling with them along the India side of that border, through mountain hill stations and desert sands, before eventually earning a degree, migrating to America, and giving birth to me.

In 2007, sixty years after my grandmother fled Lahore, I became the first member of my family to return. I was reporting for the *Washington Post* on how people around the world perceive the United States. My grandmother read my pieces with great interest, but none of them fully satisfied her. She wanted to know what her old neighborhood looked like, what life was like for her childhood

friends who were Muslim and did not leave sixty years before. Nani did not have a particular friend in Lahore—just a curiosity for the place.

I told Nani to be patient, that within all the invention of tech giants she would soon be able to connect seamlessly with whomever she wanted whenever she wanted. Together, we imagined a future where she could touch down as a hologram on the streets of Lahore and interact with passersby.

Nani passed away in 2009, but I never stopped waiting for that vision to become reality.

<p style="text-align:center">*</p>

By 2013, living in New Haven, Connecticut, attending law school, and preparing for a life of policy papers and punditry, I started wondering what life was like on those Lahore streets myself. I thought back on my days as a reporter and missed those days acutely. In particular, I missed the long bus and train rides I would take on the road where my laptop would die. I had no smartphone, and there wasn't enough light to read a book, so, to pass the time, I would strike up a conversation with the stranger riding next to me—someone far different from myself. I missed talking to the young man in Pakistan heading to madrassa, keen on becoming a computer scientist, or the aging matriarch preparing for her final days. These conversations in the evening light were deinstrumentalized, purposeless interactions.

In my life in the United States—at law school, networking, dating, and socializing—I rarely encountered people I didn't already know, and when I did, it was always to get a date or land a job. On the bus or train at home, I watched a TV show, listened to a podcast, or scanned the news on my phone. I had not had a conversation with a stranger for no particular purpose in many years, and I had almost forgotten the feeling of exiting my world, losing myself in the vastness of a shared human experience, and listening attentively to the stories of another.

Without realizing it, in an attempt to fill this longing, I began to tilt away from law and policy and toward art—one of the few domains in life where the ends of a creation are not predetermined. This tilt became a full turn and brought me to Portals.

Portals began as a daydream. We've all read stories about people walking through a mirror, fireplace, cabinet, pond, tollbooth, tree hole, rabbit hole, and emerging in another world, a different time, another space.

More prosaically, I wondered: What if you could enter a door at the back of your local coffee shop and engage live with Lahore, Pakistan? What if you could share your morning coffee with people sipping their evening tea across the world, as if in the same room?

I started turning this idea over in my mind incessantly, talking about it to anyone who would listen. I got mixed reactions. The negative one was always the same: "We already have this; it's called Skype!" But then there was the reaction that made the whole initiative possible: a subset of people who were deeply invigorated by the idea and jumped into action.

One of the first people to do so was John Farrace, an architect by training. Together, we discussed how to manifest this idea in the world. Would we connect coffee shops, other preexisting spaces, or create new ones? I considered tents, inflatables, and sheds before choosing a standard intermodal shipping container. These containers are relatively affordable, omnipresent, easily securable, and uniform. They are also symbolically rich. The numbers affixed to each old container chart its movements across time through ports around the world.

With that decision made, I did what my parents had long dreaded. In August 2014, I broke the lawn fence in their backyard and dropped an old six-meter-long container on the grass. They weren't thrilled, but it was the neighbors who were absolutely livid. They complained to the local police, first claiming I was living in the container, which I was not, and then insisting that it was an eyesore regardless. On the latter point, I agreed.

To dull their rage and spark their imagination, I tried painting the Portal different colors: First white, but that was too much like a white cube gallery, which felt art-world exclusive, then black, which proved too scary, like a black site. I tried stripping the paint to buff and shine the underlying metal, but this was terrible for the environment, unhealthy, and costly. Silver looked too precious and light gold too much like money. Then I tried a dark gold that felt right. It connoted more of the sacred than the commercial. And, it had a reflective sheen to it in which passersby could see themselves, albeit imperfectly.

Inside the Portal, I wanted people to feel safe and protected, so I covered the whole interior, walls, and ceiling, too, in gray carpet. At the far end of the container, I installed a small camera in a drywall door, working with my uncle, who is, conveniently, an optical scientist, to address perspective distortion. The rest of the technology was hidden behind the wall, save for a projector, speakers, and microphone.

When you enter the gold container, you come into a gray space and, on the far wall, see an optically corrected projection of the interior of an identical Portal abroad, so you feel as though you are in one container stretching through the internet.

As a final touch, to signal what this gold box was, I put a stencil on the front of it that read, "A Portal to Iran or Pakistan." This was too much for the neighbors, one of whom called the FBI to report a possible "terrorist cell"! The FBI investigated the container, and me, and ultimately determined that the gold box was not a terrorist cell—just a shipping container with internet access. The Portal was cleared.

The structure was ready. Now we needed to commit to the paired locations. Since my grandmother had passed away, I didn't feel an urgent need to connect to Lahore and had been thinking Tehran would be a symbolically powerful first site. Michelle Moghtader, my earliest partner, worked with me to make this happen.

Michelle is Iranian American. At the time we connected in 2014,

she was a journalist reporting in and out of Tehran for a US news outlet. Her reporting was always on nuclear negotiations and oil. In Tehran, she saw their press covering the United States in similarly narrow ways. Michelle knew there was so much more to both the United States and Iran. She wanted her friends in both countries to see that too—to see beyond what the press was giving them. When I told Michelle, who I knew from my days in journalism, about my idea for Portals, she jumped the highest.

Over the course of 2014, Michelle went to Tehran multiple times to identify a partner for our launch. She faced logistical challenges around power and internet speeds, concerns about government hostility, and outright opposition to forging such connections in both countries. But she persevered until she found the perfect partner: Sohrab Kashani, the artist and curator behind the Sazmanab Center for Contemporary Art.

Sohrab's work was about grounding technology in physical spaces to create unexpected encounters across distance. For example, after being denied a visa to the United States, Sohrab hired a stranger to walk around the streets of New York City wearing a live microphone and web camera, acting as his human avatar. Sohrab saw through the stranger's eyes and spoke through the stranger's mouth. "Hello, this is Sohrab from Tehran," the human avatar would say for Sohrab. It reminded me of my promise to Nani. Sohrab had created his own hologram abroad!

*

Sohrab got Portals right away. He built an identical interior Portal space in Tehran, which we linked to an experimental arts space in the Lower East Side of New York City. It was launch time.

For two weeks that December, we invited people to enter each Portal, one-on-one, for eight-minute conversations with a stranger in the other location. We asked them to discuss the following prompt with their partner abroad: What would make today a good day for you?

The first few days were quiet, so after we put one man in for a session in New York City and no one else showed up on our end, we forgot about him altogether. Two hours later, he startled us all by popping out of the Portal! He had spent all that time with a stranger in Tehran, came out, and wrote a long essay in gold pen, in our gold book, about his experience.

His conversation began with a discussion of getting to work: how minimal traffic would make his day a good one. A march protesting the death of an African American man named Eric Garner at the hands of the police had snarled Manhattan streets. Meanwhile, in Tehran, the pollution was so terrible that it was virtually impossible to walk outside. The city was at a standstill. The personal and mundane—trying to get to work—instantly tied in the political. And the political instantly implicated the personal. The men talked about sexuality, marriage equality, and ailing parents.

We were stunned. As days went on and we got busier, we found nearly everyone wanted more time in the Portal, in both Tehran and New York City. So, we increased the base time to ten minutes, then fifteen, and then twenty. We still had to pull people out. Even more surprisingly, participants came out from the Portal in both locations deeply moved—some weeping, others exuberant, and everything in between.

Many of the people who experienced the Portal started coming back with particular ideas for what they wanted to do in it next. So, we started letting people take ownership of the space and were blown away by what they did. An Iranian American dancer who had never visited his family in Tehran was able to perform his art live, as if, as he said, they were "breathing the same air." Female dancers in Tehran, who were banned by law from performing in their own country, performed live for audiences in the United States. School groups in New York City came in to learn from substitute teachers in Tehran, and vice versa. A jazz musician in the United States created a new musical piece with a classical Persian

musician in Tehran. Over two weeks, the crowds grew, some celebrities showed up, we attracted press, and then the Portals exhibit was over.

<p style="text-align:center">*</p>

Michelle and I regrouped. What had just happened? We expected the Portals experience to be neat, unexpected—maybe cool. But we were surprised to find it had such an emotional effect.

Looking back on it now, I think Portals hit a nerve for several reasons: First, the initial conversations were one-on-one. Participants could not hide behind the most talkative member of a group. Each side was responsible for making the most out of their time together. Second, the conversations were private, diminishing the pressure to perform. Cell phones don't work in the Portal because the structure blocks signal and nothing is live-tweeted. Participants are unlikely to see their counterpart abroad again, so whatever they say is probably not going to make its way back to friends at home. Third, the conversations felt relatively natural. Instead of talking to a disembodied head on a computer screen, participants spoke to a full, standing person—fidgeting and swaying—and made direct eye contact, unencumbered by goggles or headphones. Fourth, the encounters felt rare. Because we connected Tehran and New York City, we tapped into an evocative distance. The pairing forced people to think of the connection as special in itself, a bit like receiving a pen pal letter in the past after a one-month wait. Fifth, and most importantly, the Portal encounter was contextualized in the world of art, which meant that it did not carry with it the assumption of having a single, particular purpose. It could bring joy, irritation, pleasure, disgust, insight, or boredom. No particular reaction was expected. The experience simply engaged a basic human curiosity about the lives of others.

This purposelessness also opened up the space so participants could create their own unique uses for it, like the dances, classes, and dialogues. As art, Portals opened a space for the public.

*

Just a couple weeks after the New York City–Tehran Portal closed, we got an email from Herat, Afghanistan. A computer science professor named Omid Habibi had heard about Portals on BBC Persian and wanted one at his university. He picked out a shipping container, brought it to his campus, carpeted it, painted it, and installed our tech. A couple weeks later, he hosted an opening event for the city with government officials and tribal leaders in attendance. Herat was our first permanent Portal in the world and has been running since March 2015.

Now, as of fall 2019, we have fifty permanent Portals around the globe, staffed by more than eighty people. Portals exist across geographies and institutions; they are in Afghanistan, Australia, Brazil, Germany, Honduras, Kazakhstan, Jordan, India, Iraq, Iran, Kenya, Mexico, Myanmar, the Netherlands, Nigeria, Pakistan, Palestine, Qatar, Rwanda, South Korea, Spain, Sweden, the United States, and Yemen. And they exist across cultural centers, museums, universities, detention facilities, art galleries, public parks, tech hubs, and refugee camps.

Every Portal connects to every other one, with global programming built by local Portal curators. Each Portal, with its curators, drives its own programming, making requests of one another. For example, Portals host weekly violin lessons between Kigali and Colorado Springs, Colorado, dialogues between gang leaders and tribal leaders on in El Progreso and Herat, hackathons between innovators in Baltimore, Maryland, and Gaza City, and thousands of other similar dialogues, classes, performances, and events. Since launch, more than four hundred thousand people have had intimate one-on-one conversations through Portals, and hundreds of thousands more have participated in classes, group dialogues, and other events.

*

One of the more ambitious projects we've initiated through Portals has been with professors Tracey Meares of Yale Law School and Vesla Weaver of Johns Hopkins University. Tracey had visited a Portal between New Haven, Connecticut, and Havana, Cuba, and thought that similar conversations within the United States could prove powerful. She was interested, in particular, in understanding how people in highly incarcerated communities felt about police.

As part of a multiyear research project, Tracey and Vesla helped us deploy Portals across the United States in Baltimore, Chicago, Los Angeles, Milwaukee, and Newark. Adults were invited to enter a Portal and engage with a stranger in another city about a single prompt: What do you think of the police? The conversations were recorded, transcribed, and anonymized so the researchers could analyze the dialogues to explore how communities construct their narratives of criminal justice. The researchers recognized that dialogue is the root of the formation of public opinion. A survey tells you what people feel. Dialogues open up the stories of how they came to feel that way. Over the past two years, nearly a thousand people have engaged in these dialogues, and the researchers have a forthcoming coming book on their groundbreaking insights.

But the researchers also began to see that Portals were much more than a way to collect a different kind of data. They started to see them reshape communities and forge new political spheres. As the project unfolded, their interest gravitated toward Portals as community intervention. They found that Portals provided marginalized communities a "mechanism for connection" that treats them "as singular in their authority to understand their position, not supplicants" and helps such communities "form a collective." They highlight examples, such as one from the Amani Community of Milwaukee, which is the most incarcerated in America.

Through their connections with Kigali, Rwanda, Milwaukee organizers learned of the Gacaca courts, informal venues for transitional justice adapted after the Rwandan genocide. They began to

imagine and implement new means of community healing that transcend coercive and adversarial practices in the U.S. These strategies engendered a gang truce and stopped store owners from selling tobacco and liquor to those underage — both without the use of police.[1]

The person best positioned to describe the effect of Portals on him and his life is Lewis Lee, the Portal curator in Milwaukee. As he says: "I am viewed as something other than just, Lewis Lee, three-time felon. My story, experiences, and insights are inspiring people around the world. I didn't think I could teach. I used to be ashamed of what I thought, how I spoke, how I walked, and what I wore. The Portal strips that away, or, rather flips it. People view—value you—as yourself."[2]

<center>*</center>

Seeing examples such as this happen around the world, we have begun viewing Portals as a new global public infrastructure devoted to providing connections between people who would otherwise never meet. Just as librarians and teachers inspire and guide minds in the pursuit of knowledge, Portals curators guide their communities to engage human diversity itself. At a time when the benefits of global interconnection and human diversity accrue to those who can afford to fly around the world or be part of multinational institutions, it is critical that people who rarely if ever leave their zip code can take advantage of this connected world as well.

Talking to people unlike ourselves is always important but particularly so today. There are powerful forces driving us deeper into our own communities, forces that include widening income inequality, a consolidating mass media, and dwindling public spaces. And dialogues across distance and without predetermined ends are important for a number of reasons: First, they "create room" and puncture hardened stereotypes of the other. The puncture might not yield harmony or understanding. It may exacerbate

disagreements. But at least it adds the complexity of a human face. Second, these conversations help us better understand ourselves. It breaks us out of habituated ways of thinking and enables us to see a greater range of possibility. And third, these types of dialogue create the values and narratives of our broader community. When people speak to one another without hope of gain or fear of judgment, but to convey their own truth, authentically, and to listen to someone else do the same, they create their own, unique meaning together, laying the groundwork for our shared societies.

Our long-term vision is to create a network of Portals permanently placed around the world, staffed by human beings, serving as this new civic infrastructure—a human library for our era.

<p style="text-align:center">*</p>

Across all these sites, over thousands of connected hours, so many stories have blossomed, but one is particularly moving for me. An elderly woman in the United States, who fled Cuba as a child, reengaged with the country for the first time through the Portal. She was ill and feeling down. To cheer her up, her friend surprised her by bringing her to the Portal. The woman entered and spoke to someone in Cuba. It was the first time she communicated with anyone in the country since fleeing decades before. And the stranger she talked to turned out to be a young man who grew up on the very same street that this woman did all those years before. The woman came out of the Portal dancing and laughing but also with a tinge of the bittersweet. She reignited a connection toward the end of her life after all those decades had passed. Then, more than ever, I thought of Nani.

Art opens space for us to probe essential character—that of others and our own. It helps reveal. In my case, working on Portals made me look again at the importance of my grandmother in my life. I now realize the gold color I settled on for the Portal is the same color of the small statues Nani kept on her dresser. And the gray carpet that reminds me of safety is the same color and

texture as the walls of the movie hall where Nani brought me as a child. And the idea of focusing on another human being, worthy of appreciation just by virtue of existing, reminds me of being seen by her.

NOTES

1. The above quotes derive from their grant/funding proposal, in process, titled "Portals: How Connectivity Can Build Community among America's Dispossessed," June 2018.
2. This grant proposal has not been funded yet. You can see more on the Portals policing project at http://www.portalspolicingproject.com.

WORKS CITED

Portals Policing Project. "A Policed People's Account of the State." www.portalspolicingproject.com.
Shared Studies. "Home." (Webpage). www.sharedstudios.com.

CHAPTER TWO

WHEN ART LIVES AS CULTURE

Kim Cook

ALIVE IN MOVEMENT

When I was a little girl, I danced. Starting in the tiny guest room at my grandparents' house, with my uncle, who also allowed me to jump on the bed. I learned the freddie, the monkey, and the jerk to the sounds of The Supremes. This was a particular moment in time, as my mother had just left my father, and perhaps this effort to dance was my uncle's way of bringing light and lift into my little-girl heart. I felt a natural rhythm and desire to dance in my body.

Soon I would have another opportunity to learn dance through a connection to my next-door neighbor. Her name was Nyambura Nduati, and she was a Kikuyu from Kenya and a dancer. Nyambura, who I called Auntie Nyambura, held regular Saturday night parties attended by Kikuyu from one hundred miles around that lasted long into the night. Nyambura would lead off the dancing and I would be in her footsteps, learning the movement, the fling of the head, the down-low crouch of the legs, the uplifted torso, and the

rhythmic pulse of the hands. Her high-pitched laugh, the sight of her African cloth-wrapped head moving side to side, and her exuberant energy lifted me into the music and the dance. These parties were sometimes in honor of a particular occasion, and at those times, there would be a goat in the backyard for a day or two that was then slaughtered and became part of the feast (the slaughter took place in the garage—I never witnessed it). A few days of cooking, pots bubbling, and dishes flowing from the kitchen added to the energy and connectivity of the experience as people joined together to make the festivities come to life.

Also at that time, another woman was living next door, named Donna Sebti. She was a student of Jamila Salimpour who was the first woman to open a belly dance supper club in San Francisco. I began to attend Jamila's classes, and at eleven years of age, I was learning to move my body along with the women in that studio. While it was a bit overwhelming for me with my little-girl self to be among all these full-bodied women, the movement of those classes still lives on in my body. The instinct to respond to music in movement then connected with a year that I spent living in Santiago, Chile, where late-night parties always included everyone participating in the making of music; you played guitar, you sang, you shook the maracas, you clapped; there was a role for everyone in creating the sweet sonic environment. The parties went late into the evening, included all ages, and when the children were ready to crash, the adults threw mattresses on the floor to catch us.

At this time, I was also in the first wave of school kids who were bussed to different neighborhoods in an effort to desegregate schools. I had a teacher named Jim Widess who instituted a Friday afternoon dance party in the classroom as a strategy to bring the kids from different neighborhoods together. We danced to the sounds of The Jackson Five, The Temptations, and The 5th Dimension as I learned the funky chicken, the four corners, and other popular dances of the time. The dancing was a harmonizer—and lots of fun.

These experiences mingled with my family's farming background, where Mexican American mariachi, tamales at Christmas, and the sound of Spanish being spoken were all natural parts of my environment.

In my late teens, I followed my love of dance deeply into the realm of Cuban rumba, the practice of Santeria, and the Bata drums, and many experiences that included dance, live drumming, and coming together with black beans, rice, fresh bread, and fruit—all part of ritual and creation within community. This was living culture that was integrated with food, love, dance, music, and connection to each other.

During this time, I experienced physical movement as something that happened in the home, in community centers, in backyards, in the streets, and at celebrations like weddings and birthdays. This was not "dance" in the way I once imagined studying it; it was culture. When the music played, the body moved; when the cook was in the kitchen, the music reverberated through the house; rhythm was sound and movement; it was alive in the body. It was black beans and rice or barbecued goat; it was sewing rumba skirts with women while we took turns holding a newborn baby, rehearsing in parking lots for the first Carnaval San Francisco Festival and Grand Parade in 1978, or slipping in the side door to hear live music and learn the latest dance. I could clap clave and dance rumba to the drums in the parks; I could dance with any partner on any floor in a late-night salsa club like Bimbo's 365 Club in San Francisco. I could enter into a range of spaces and connect through dance, and I had the chance to sit at the feet of my elders, learning and living in a collective sense that was rich and warm.

In all these years, I did not think I was a dancer. Because I had not trained in the classical sense, it seemed to me that I did not learn to dance. This was long before we had language about participatory art, transnational or interdisciplinary forms, or diasporic art. It wasn't until I was thirty that I went to college to train as a professional artist. As I began the study of choreography, of vocal

pedagogy and music theory, of mise-en-scène for stage, I slowly realized that this distancing of the world that I knew from the officially recognized world of art was a reflection of a more general marginalization of a large body of people. We miss out on the gifts of migrant communities, and overlook the contributions and practices of peoples in migration, in diaspora. With that marginalization comes a lost opportunity to celebrate and share in the art that lives inside of community. This art that I knew inside my body and lived memory was connected to the home, to the people, to the food, to the living of life and art in coherence with culture.

LIVING THE CULTURE

If we look at the presentation of Western European art, we find a composed set of rules and guidelines with regard to its structure and its relationship to the audience. For the most part, Western art is still guided by a convention of contrast between "the artist" and "the audience," and they do not relate in terms of a continuum—there is a division. Engagement practice is also a more cerebral process that takes place within the known paradigm of Western aesthetics. This lack of a connection is quite different from experiencing art as a practice that is wide open to a full range of expression and runs a spectrum from amateur to professional.

As an example of this difference in approaches, we can look at the presentation of hip-hop dance in a standard performance venue. In working with Lorenzo "Rennie" Harris on tour, I saw these kinds of missing connections between this hip-hop artist and the ways in which theater presenters approached the work. There are several examples for how these distinctions play out. One example is that it is a standard practice among theater presenters that the program be decided prior to the night of performance (for promotional purposes). This does not allow room for the artist to perform the dances that feel right for the moment, the mood, the occasion. If working without an advance program was

possible, there would be space for what is inherently improvised as the "spirit" moves through the company for that evening.

Also foreign to the presenting community is the provision of food as a cultural experience. While the company can travel with a "tech rider" that requests certain amenities backstage, it was the local audiences who were connected to the hip-hop cultural grapevine who would cook food in local homes and family-owned restaurants and truly *feed* the dancers. Additionally, we often found that the presenting organizers would be very nervous that no one was coming; they wanted to discount and give away tickets early, believing that the shows would be poorly attended and would not understand that hip-hop audiences were more likely to arrive and purchase at the door, which also frequently meant that the theaters were not adequately prepared for long lines at the box office the night of show: the neat, conforming, arrive on time, leave on time. This artist and audience paradigm was not typical of hip-hop participants.

One missed opportunity is when audiences are used to watching a performance sedately, followed by applause, and are not well prepared for the call and response endemic to art forms stemming from the African diaspora. In locations where the audiences were unfamiliar with this way of experiencing performance, it was often difficult for the dancers to feel the energy they needed to have the show rise to the level it might achieve when the house was "rocking."

Refreshing an approach to the relationship between those who attend and those who perform—one that has blurry lines and intense energy—offers a possibility for a community experience wherein all who are there bring something to the table musically—in dance, in food, and in energy—where all can catch the spirit and feel moved.

Why is this important? Why does it matter whether or not people sit quietly and enjoy performance or have the freedom to jump up and engage with the show or touch the space as their own?

There is something inherently valuable about self-expression and something quite limiting about our codes of behavior in public. When we are passive and not moving—in our bodies, consuming, eating, watching television—we've lost independence and freedom of spirit, something vitally ourselves. Connecting to art as culture is living it fully—food, dance, music, playing an instrument, singing a song—on your feet, in the public square, hands clapping, feet stomping; this is not only personal expression—it becomes a uniting force in communities and is vitally important.

While I've used hip-hop to illustrate my point, it takes but a moment of reflection to see the parallels in flamenco, circus, mariachi, and many other forms stemming from world culture and street performance.

LIVING IT NOW: SOME CONSIDERATIONS FOR CULTURAL POLICY

So where are we today? What kinds of practices mimic this living cultural experience? Certainly, we still have deeply rooted traditional cultures around the world and in many neighborhoods across the United States. And, in fact, there are new explorations in the philanthropy field over the last ten to twelve years that are encouraging with regard to funding strategies and an acknowledgment of the role that participatory- and community-engaged art play in advancing community goals.[1] In order to think about this a bit further, here are some cases of how varying approaches to the work can be demonstrated.

Philadelphia and "Public Art"

The 2012 Commotion festival (*commotion* references the idea of community in motion) in Philadelphia provides a new way of thinking about public art. The Commotion festival was the first time that Philadelphia Redevelopment Authority Percent for

Art funds were used for temporary, performance-based art (as opposed to visual art installations or murals). This allowed for the emergence of impermanence in terms of memory and the lasting impact of relationship-building by connecting art, food, and cultural-engagement activities. High levels of participation within the community took place over an extended period and culminated in the two-week Commotion festival. Food was incorporated, ranging from pizza at a gathering to serving tea and a meal at Shiloh Baptist Church. Photos of community members' faces, artifacts, memories, and participation were all derived from within the local resident population, and artists worked side by side to develop the ultimate work.[2] Led by artist John Philips, the funds came from construction related to a PECO (formerly the Philadelphia Electric Company) energy plant.

New Orleans and Creative "Placekeeping"

The Mardi Gras Indian tradition in New Orleans is a deeply rooted, multigenerational, creative cultural practice. The Mardi Gras Indian community continues with a high degree of community interaction that includes beading, parading, and celebration. This significant urban indigenous community is on the frontlines of cultural preservation efforts to document, retrieve, and establish their cultural legacy. However, there is also a community at risk here with an influx of post-Katrina New Orleans residents who are simultaneously appreciating the local culture while driving up housing costs and displacing, or replacing (in the case of Katrina-damaged homes), original residents.[3] Carol Bebelle, at the Ashe Cultural Center, promotes community, culture, and commerce as a battle cry for a multipronged approach for advancement within the Central City neighborhood of New Orleans. With the creation of housing, a community center, and a local theater, alongside a range of local business development, Bebelle works to stem the tide of displacement. While not exclusively focused on the Mardi Gras

Indians, Bebelle's efforts exemplify the practice of community-centered agency and opportunity for local inhabitants, including Mardi Gras Indians.

We have to beware of contradictions in value, where the culture creates value but the policies are not in place to preserve culture. This is the unfortunate effect of investors seeing an opportunity to promote neighborhood improvement through the arts as an economic driver rather than as a way to benefit local residents. This can then lead to diminished ability on the part of original inhabitants to remain in place. Here, it is worth paying attention to the thinking and writing of Roberto Bedoya, the current cultural affairs manager for the city of Oakland and longtime public intellectual in the arts, who admonishes us to consider "creative place-keeping" as a critical component of cultural planning.[4] In so doing, Bedoya points to the potential disruption of culture that occurs when overeager economic developers, and even artists, focus more attention on the influx of the new than they do on the contributions of the indigenous and traditional inhabitants of a place. This is of particular concern in New Orleans but also a pronounced challenge in many artist communities across the country.

Ansan, Korea, and Public Mourning

It is vital to observe and acknowledge the increasing role of community mourning as a way for us to come together. Tragic incidents such as the South Korean sinking of a ferry in Ansan have resulted in community gatherings, artist works, and protests. The parents of the Ansan ferry tragedy shaved their heads and marched in protest of the silencing of their grief and the hidden information about how the accident and failed rescue occurred (France-Presse).[5] There is now an annual walk through the streets of Ansan, with black umbrellas, that continues to point to this moment of loss and grief. While we would not typically consider this form of ritual mourning, protest, and art creation a part of contemporary

art—and, in fact, to do so may even appear to reduce it—it is a part of culture. People respond and come together through loss, and we consistently share food, know certain pieces of music as solace, and build altars of flowers and other symbolic items. Indeed, I would suggest that we are potentially more susceptible to this kind of cultural connection in current times than capable of creating public celebrations of culture.

Black Rock City and Immersive Art Practice

Burning Man is a completely immersive art-and-culture experience that is growing as a global movement that is a participatory, cocreated, and interactive experience. It's valuable to contemplate Burning Man not as an event, but rather as a city. Black Rock City, which is built each year by seven thousand volunteers, contains greater than nine hundred "theme camps," each a collection of people who are offering their vision for gifting the larger citizenry—more than three hundred artworks, annually, alongside four hundred mutant vehicles—while providing an opportunity for all who are there to freely express themselves and share with others.

This city, when it emerges in the Nevada desert each year in August through September, holds a population of seventy thousand. This space creates a context within which a particular kind of culture can thrive. It is a culture that came to be expressed through the lens of "10 Principles," some of which include "Radical Self Expression," "Participation," and "Gifting" ("The 10 Principles"). Through these guiding doctrines, Black Rock City and the Burning Man Project provide an extraordinary opportunity to experiment and explore on an annual basis and, through a worldwide network, what activated, engaged, and empowered creative citizens can do together. This includes more than eighty-five international participatory events, a growing network of Burners Without Borders working on community-resilience projects in disaster-relief areas, and the creation of interactive public art installations.

Making It Personal and Bringing It Home

While not everyone will make their own sojourn to the desert of Nevada to experience Black Rock City, or may not engage in shifting the economic practices of New Orleans, it is worth thinking of our own homes, the places where we live in terms of sharing and giving to each other. What if we were to recognize that each business owner, each individual within a city, is bringing the gifts they have to the rest of us? What if we saw them as providers of sustenance and nurture and value, as humans, and we were thus a little kinder, a little gentler, when we interacted? What if we were to look at the physical environment and recognize it as a social construction? We could see that our surroundings are something that was decided upon; the buildings did not arise by themselves and the sidewalks were decisions made by someone. We could install mosaics in the sidewalks, plant gardens in our neighborhoods, cocreate a place of beauty that reflects how we esteem ourselves and each other. That would indeed be "participatory art."

LIVING IT FORWARD: CULTURE AS PRACTICE

If we are to undertake a contemporary approach to art that is lived as culture, what are the critical elements? Fundamentally, what is required is a consideration of context. It is important to be curious, to ask questions about your surroundings, to inquire as to what already exists, and to work authentically with others. Often what emerges is readily apparent, natural for the place, will have a sort of familiarity or quality of feeling that is a fit with what has come before.

Certainly there is the possibility of respectful exploration and participation in traditional and indigenous cultures. In those instances, a posture of learning, or understanding that you are a guest of the culture and making space for leadership to come from within the community, is mandatory.

There is also the possibility of partnering in new ways, with cross-sector and interdisciplinary approaches such that an effort to address youth trauma is integrated with a community revitalization strategy and artists are collaborators. As one example, Mural Arts Philadelphia has evolved recently to incorporate "Restorative Justice" techniques into their already robust mural programs.[6]

As Amar Bakshi from this volume stated in his re:Publica speech from 2015: "Talking to people unlike ourselves is always important, but particularly so today. There are powerful forces driving us deeper into our own communities including widening income inequality, a consolidating mass media, and dwindling public spaces. Cultural practice is a connector rather than a divider and has an important place in addressing the challenges of today."

Ultimately, each person is creative. We, at a minimum, must improvise our way through life, crafting the narrative that is our own story. We stumble, we get back up, we relate our journey to those who listen to us, we encounter each other, and we form a personal identity. We prepare food, we engage in community rituals of passage, we attire ourselves in some way. At every moment, we are giving voice, or making a mark, or moving through the physical environment. This is, in fact, creation. How we choose to make that intentional, to share with others, and to find our own unique forms of expression has meaning. In the end, living culture as a practice expands and enlightens our own humanity, giving us touchpoints and shared experiences that bring us together and advance the possibility of a positive common future.

NOTES

1. Mirabel Alvarez, "There's Nothing Informal About It: Participatory Arts within the Cultural Ecology of Silicon Valley," Issue Lab, January 1, 2005, http://www.issuelab.org/resource/there_s_nothing_informal_about_it_participatory_arts_within_the_cultural_ecology_of_silicon_valley; F. Javier Torres, John McGuirk, Edwin Torres, Carlton Turner, Consuella Brown, "Advancing

Equity in Arts and Cultural Grantmaking Perspectives from Five Funders,"
Grantmakers in the Arts, http://www.giarts.org/article/advancing-equi-
ty-arts-and-cultural-grantmaking; Holly Sidford, "Fusing Arts, Culture, and
Social Change: High Impact Strategies for Philanthropy," A Philanthropy at
Its Best Report, National Committee for Responsive Philanthropy, http://
www.giarts.org/sites/default/files/Fusing-Arts-Culture-Social-Change.pdf.

2. For more information on this subject, please see "Percent Art Projects," Phil-
adelphia Development Authority, https://www.philadelphiaredevelopmen-
tauthority.org/percent-art-projects/commotion; Andrea Kirsh, "Commotion
Festival June 16–30—The Redevelopment Authority's Risk-Taking Temporary
Public Art Project," June 27, 2012, http://www.theartblog.org/2012/06/com-
motion-festival-june-16-30-the-redevelopment-authoritys-risk-taking-tem-
porary-public-art-project/.

3. For more information on this subject, please see Nola.com, "Creole Wild West
Mardi Gras Indian Chief Howard Miller," YouTube, August 27, 2015, https://
www.youtube.com/watch?v=e9yTCsHmVGk; Cosette Richard, "Super
Sunday—Mardi Gras Indians on the Bayou at Orleans Ave.," YouTube, April
9, 2016, https://www.youtube.com/watch?v=rjL3kQFwzLA.

4. Robert Bedoya, "Spatial Justice: Rasquachification, Race and the City,"
CreativeTimeReports, September 15, 2014, http://creativetimereports.
org/2014/09/15/spatial-justice-rasquachification-race-and-the-city/.

5. For more information about the way artists commemorated this tragedy, see
"Artists Commemorate Victims of Sewol Tragedy," *Korea Herald*, April 14,
2016 http://www01.koreaherald.com/view.php?ud=20160414000945.

6. "The Guild," Mural Arts Philadelphia, https://www.muralarts.org/program/
restorative-justice/the-guild/.

WORKS CITED

Agence France-Presse. "Grieving Parents of Korean Ferry Victims Start Long
March." Rappler. April 4, 2015.

"Artists Commemorate Victims of Sewol Tragedy." *Korea Herald*, April 14, 2016.
http://www01.koreaherald.com/view.php?ud=20160414000945.

Bakshi, Amar. "re:Publica Speech: Lessons from the Launch of Portals." Shared
Studios. May 11, 2016. https://www.sharedstudios.com/dispatches/2016/5/26/
republica-speech-lessons-from-the-launch-of-portals.

Bedoya, Roberto. "Spatial Justice: Rasquachification, Race and the City." Creative-
TimeReports. September 15, 2014. http://creativetimereports.org/2014/09/15/
spatial-justice-rasquachification-race-and-the-city/.

Burning Man Project. "The 10 Principles of Burning Man." The Culture Philosophical Center. https://burningman.org/culture/philosophical-center/10-principles/.

"The Guild." Mural Arts Philadelphia. https://www.muralarts.org/program/restorative-justice/the-guild/.

Javier Torres, F., John McGuirk, Edwin Torres, Carlton Turner, and Consuella Brown. "Advancing Equity in Arts and Cultural Grantmaking Perspectives from Five Funders." Grantmakers in the Arts. http://www.giarts.org/article/advancing-equity-arts-and-cultural-grantmaking.

Kirsh, Andrea. "Commotion Festival June 16–30—The Redevelopment Authority's Risk-Taking Temporary Public Art Project." The Art Blog. June 27, 2012. http://www.theartblog.org/2012/06/commotion-festival-june-16-30-the-redevelopment-authoritys-risk-taking-temporary-public-art-project/.

Mirabel Alvarez, Mirabel. "There's Nothing Informal About It: Participatory Arts within the Cultural Ecology of Silicon Valley." Issue Lab, January 1, 2005. http://www.issuelab.org/resource/there_s_nothing_informal_about_it_participatory_arts_within_the_cultural_ecology_of_silicon_valley.

Nola.com. "Creole Wild West Mardi Gras Indian Chief Howard Miller." YouTube, August 27, 2015. https://www.youtube.com/watch?v=e9yTCsHmVGk.

"Percent Art Projects," Philadelphia Development Authority. https://www.philadelphiaredevelopmentauthority.org/percent-art-projects/commotion.

Richard, Cosette. "Super Sunday—Mardi Gras Indians on the Bayou at Orleans Ave." YouTube, April 9, 2016. https://www.youtube.com/watch?v=rjL3kQFwzLA.

Sidford, Holly. "Fusing Arts, Culture, and Social Change: High Impact Strategies for Philanthropy." A Philanthropy at Its Best Report, National Committee for Responsive Philanthropy. http://www.giarts.org/sites/default/files/Fusing-Arts-Culture-Social-Change.pdf.

CHAPTER THREE

TOWARD A NEW PARADIGM

Public Art and Placemaking in the Twenty-First Century

Christina Lanzl

Quality of life and caring about community are at the core of a contemporary movement that is increasingly becoming a grassroots-driven approach to consciously embrace the places we inhabit. In short, successful placemaking involving the arts and culture is at the center of thriving, functioning neighborhoods and provides a way for people to engage in public life. Having worked extensively for over two decades on place-based public art and cultural projects in interaction with highly diverse urban grassroots communities--both in terms of ethnic backgrounds and know-how--I have learned many lessons. With a broad background as an art historian, visual artist, and cultural manager, combined with a keen interest in our built environment, my professional interaction with the architecture and design community came naturally. Working with both groups—residents in communities and design professionals—I have come to realize that a solid theoretical

framework, the application of best practices, flexibility, and good people skills are vital.

As a resident public art manager who has been involved with the planning of the emerging Fort Point neighborhood and its arts community, I realized that the local chapter of the American Institute of Architects, the Boston Society of Architects (BSA), offered an excellent platform for cross-disciplinary dialogue. Common Boston, an annual architecture and design festival of the BSA, became my first collaborative endeavor together with cochairing architects Justin Crane and Alyson Fletcher. While working with the many partners of the program, I realized that I was the only arts professional among architects. A more conscious discourse between the arts and architecture was in order, I felt, as has been tradition for the cultural avant-garde. To fill a perceived void of cross-disciplinary interaction, I initiated the Placemaking Network of the BSA in 2007.

Looking for a broader dialogue, the explicit vision for the new Placemaking Network[1] sought to "investigate ways to enrich the public realm through dialogue among urban planning, landscape design, architecture, and public art/design professionals."[2] The initial newsletter announcement started with this premise: "The topics of placemaking and quality of life have entered architecture and planning conversations as they have entered creative arts conversations."[3] Rather than simply functioning as a standing committee, the Placemaking Network had a mission to build a network of like-minded people who would introduce placemaking principles to their work and communities. By now, the network has grown to include engaged citizens and professionals of many backgrounds and disciplines. Since the beginning, concepts and case studies have been shared at monthly seminars where invited speakers present topics that are then discussed in a moderated roundtable format. The foundation of our work is that placemaking offers interdisciplinary dialogue on a successful public realm that engages communities and enriches lives. Initially, the spark

of successful public places that are actively used or programmed by communities was ignited by proactive urbanists, whose publications honed in on placemaking tenets.[4]

After ten years of experience and conversations, the *Placemaking Manifesto* took form. I invited cochair Robert Tullis and architectural historian Anne-Catrin Schultz to cowrite a one-page policy that lists the core placemaking principles in six points.[5] Using the equation symbol to summarize each value, the document reads like a poem. Our draft was reviewed and confirmed by our network's interdisciplinary ad hoc working group.[6] Succinctly, we concluded that placemaking is about sense of place.[7] Everybody--people of all backgrounds, ages, and abilities--can participate in creating successful public places. Everyone can serve the agenda of excellence in design, healthy communities, and thriving neighborhoods. We see our built environment as a common good that comes alive through an understanding of how humans instinctively relate to space, through the design leadership that leverages it, and the activity programming that capitalizes on it. Over the years, my ongoing work in the field of public art and with the Placemaking Network has been a cross-fertilizer on how to best mark place, history, and time through integrative, community-based public art and culture that furthers identity and local storytelling as well as learning.

On the following pages, the six principles of the *Placemaking Manifesto* are quoted and subsequently sketched in brief applications from my own practice and research to highlight examples of extraordinary partnerships. Bringing theory into practice, a series of questions and concerns are addressed: How can we create successful public places that provide all with powerful incentives for active participation? Which tools can we employ to ensure diversity and inclusivity? What kind of hands-on processes can be utilized? Are there universal platforms for discourse? Which creative activities and solutions produce improved, shared environments?

What I am hoping to share are strategies worth imitating to

encourage inclusive neighborhoods as well as ways to bridge the past, the present, and the future. Of course, different aspects of the shared case studies may contain several placemaking principles that overlap and intertwine. The reader is invited to join the discourse of discovery, to cross-reference elements contained, and to add new layers.

In order to be successful, extraordinary partnerships--not just in the arts and humanities but in all disciplines--are only possible when solid processes are employed. The complex administrative processes involved essentially require a collaborative nature within some framework of a populace. A planning team's commitment to additional efforts toward reaching the necessary consensus on any aspect of a project should indeed lead to a memorable, successful outcome following the phases of design, fabrication, installation, and continuing care, as applicable placemaking done well can withstand the trappings of vandalism or damage. Indeed, the ideal outcome is a high-quality public realm embraced by *placemakers* who confidently embrace *their* = *our* common humanity and heritage.

1. PLACEMAKING = QUALITY OF LIFE

Placemaking transforms space into place. Our public realm is a common good that comes alive through an understanding of how humans instinctively relate to place, design leadership that leverages it, and active programs for and by communities as a civic benefit for everyone. Placemaking activates our built and lived environment. We acknowledge and actively work towards improving hard as well as soft quality of life factors.

Improving quality of life, outlined as the first of six principles in the *Placemaking Manifesto*, is a strategy that focuses on public places as a common good actively shaped and used by *all*. On Meetinghouse Hill in Boston, residents united in the Friends of Coppens Square

Figure 1. Coppens Square Park and its fountain, dormant for more than forty years. Courtesy of Christina Lanzl.

initiative to demand that water flow again in a fountain, located at the center of the park, that has been dormant for more than forty years due to lack of maintenance and disinvestment (see figure 1). Key data for successful funding of the project were provided thanks to a simultaneous study project of Massachusetts Institute of Technology's Department for Urban Studies and Planning. One of the findings was that Coppens Square is centered in a neighborhood with Boston's lowest ratio of public parks per capita.[8]

The central feature of Dorchester's Coppens Square Park is its fountain, in disrepair for several decades, contributing to overall underuse. The redesigned park reinforces and restores the central role of a functioning water feature within the entire site. The fountain's original concept is to focus on the celebration and importance of the public water supply to the city of Boston. Further, an open assembly of neighborhood residents, public servants, and

elected officials collectively decided on a broadened theme that also celebrates the diversity of the neighborhood to achieve a more publicly embraced and actively used park.[9] This grassroots effort by engaged local citizens seeking to make their public park desirable beyond ornamental greenspace has the goal to create a gathering place that brings people together, where quiet reflection and neighborly conversation will be framed by larger context and meaning.

2. PLACEMAKING = A SENSE OF PLACE

Placemaking engages the five senses. It is about developing and continuing identity, distinctive, specific and memorable character in our public spaces. It's about fostering a sense of place: our body-mind's positive kinesthetic, emotional and cognitive experience of and relationship to our public surroundings. It's achieved by putting the importance of our shared, exterior spaces between buildings above that of our private, interior spaces within them. We recognize that storytelling gives meaning to our lives and is therefore an important narrative device of human civilization.

Our five senses--the faculties of sight, smell, hearing, taste, and touch--connect us to place. Sense of place is connecting positive experiences and emotions—the warmth of community and home--to our surroundings. Storytelling links personal biographies to our individual places. As an example, Berlin's Spreepark developed a distinctive identity after an amusement park was abandoned and fell into a decade-long fairy-tale sleep (see figure 2). Efforts to restructure the 70.5-acre site along an idyllic stretch of the river Spree were unsuccessful due to complex circumstances. We felt compelled to return this sizable greenspace in the east of the city to public use. An international collaborative team comprised of Berlin and United States creatives initiated Kulturpark in 2012. The project consisted of a joint effort to provide a platform for

Figure 2. Urban Culture Institute performative art tour in Berlin's Spreepark. Courtesy of Frank Sperling.

communication about the land that engaged administrators, planners, landscape architects, art professionals, artists, and residents.

The Urban Culture Institute organized an international think tank to develop a vision for the future of Spreepark, which ran parallel to a series of temporary public art projects and performances surrounding the property. Key to the project was to uncover the story of the park, to share and celebrate this dormant landscape. An executive summary of findings was issued and distributed to participants and decision makers. Since then, all hurdles, including a multimillion-dollar debt and a long-term lease have been cleared, and a new steward took over the property in a public-private partnership.

Working toward realizing Europe's first art and culture park, the newly appointed public art curator set up a series of performative art tours as part of a summer-long program featuring five artists and teams who interpreted the park's special features in various formats. Participants were invited to discover imaginary worlds,

to taste plants, to share memories, to ask questions of ownership and property, or to become part of musical stagings.

As one of the invited presenters, the Urban Culture Institute utilized the site as a backdrop for musical dialogue celebrating the interplay of nature, culture, and performance. Our team was comprised of two storytellers and two musicians. Musicians Paul Brody (trumpet) and Robyn Schulkowsky (percussion) reflected the sounds and the spirit of Spreepark with their improvisations by turning the remains of former fairground rides into resonance rooms or instruments. Each tour was accompanied by a storyteller who complemented the musical improvisations with scenic, interactive stories inspired by the exceptional Spreepark scenery. Point of departure were feature films shot in Spreepark, like the documentary *Achterbahn* or the 2011 action film *Hanna*. The performers resurrected the park's magic in the course of their interpretations. The audience was invited to actively participate on an acoustic level or by contributing specific memories related to the past, present, and future of Spreepark. Thus, different layers of time and musical composition were woven together with scenic improvisation.

Spreepark is a particularly good example of the important role grassroots efforts can play in overcoming seemingly insurmountable problems, entangling city, state, corporate, private, and public interests and fates. The soaring swell of publications, films, and digital resources are indicative of the park's growing fame since the amusement park closed its doors in 2002.

3. PLACEMAKING = CARING ABOUT THE COMMUNITY

Placemaking is about the benefits that accrue to us, our neighbors, our community, and even our culture when we engage with each other in a high-quality and healthy public realm. Including public participation in its design and use helps create community identification. Active programming, public events, and public art are powerful tools that help foster community pride.

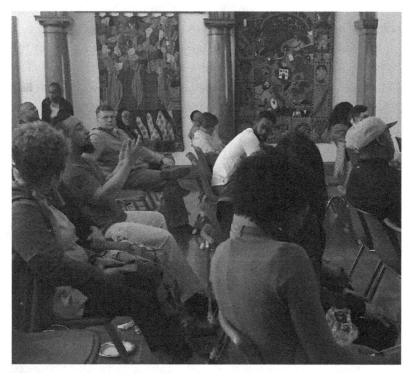
Figure 3. Codman Square neighborhood residents discuss their park at the
Great Hall. Courtesy of Christina Lanzl.

Boston's Codman Square Park is located at the geographic center of
a predominantly African American neighborhood. Second Church,
directly adjacent to the greenspace, is one of the neighborhood's
distinct architectural landmarks dating back to 1804. The entire
Codman Square area lacks open space, a welcoming atmosphere,
and safety due to unfavorable activities. Therefore, the local com-
munity association, the Codman Square Neighborhood Council
(CSNC), took on a key role in the redesign of the park in 2018 and
2019 (see figure 3). As the main voice of the local residents, CSNC
helped to establish Friends of the Codman Square Park, which is
made up of residents, community organizations, merchants, and

other groups that care for the park. Codman Square has a long tradition as a major civic center in Dorchester.

Codman Square Park was established as a public park in the 1980s by turning the terminus of a city street into parkland. The old street currently serves as a pedestrian path lined by benches, next to a small lawn and plantings. A comprehensive new plan was needed to accommodate changing-use patterns, such as an active farmers' market and annual holiday lighting ceremonies. The effort was launched by caring members of the neighborhood. Under the leadership of CSNC president Cynthia Loesch-Johnson, publicly minded residents closely worked with the city's parks department and actively participated as members of the integral landscape and public art design committee. Locally based artist Destiny Palmer joined forces with Kyle Zick Landscape Architecture after both won the respective selection processes following an intense review. The resulting transformational redesigned park proposal is responsive to ongoing programs and furthers the neighborhood's identity through a seamless integration of landscape design and public art.

Thanks to the community's advocacy efforts, the proposed design by Kyle Zick and artist Destiny Palmer combines the park with the adjacent Second Church and its land to "expand the park so it can fulfill more needs and to create a fantastic setting for the church building, which has been both the most prominent physical landmark and the spiritual heart of Codman Square. The Codman Square Park renovations will blur the boundary between the park space and the church, allowing the park to grow in size, accommodate more programming and improve the overall aesthetics. The proposed park design is intended to evoke the purpose of the church and reflect the idea of communal gathering."[10]

Actively partaking in a series of public presentations and discussions with the objective to obtain feedback on the redesign, the community ensured a meaningful design. The outcome is a more distinctive and responsive greenspace that will be animated by several creative placemaking features. Firstly, the *I Am Codman*

Square monumental sculpture is envisioned to create a "wow" effect, showcasing the culture of the square while offering an iconic photo opportunity. Secondly, cultural and neighborhood-relevant paving patterns for Codman Square invite interactive play with wayfinding markers that welcome and engage visitors to the park on the main walkway. A timeline history of embedded bronze inlays celebrates significant neighborhood milestones and events. Our deeply rooted dialogue with the neighborhood and all partners has resulted in our common intent: to celebrate the culturally and ethnically diverse community and to link it with the trajectory of the area's historic evolution.

4. PLACEMAKING = COLLABORATION AND COMMUNICATION

Placemaking integrates the individualized focus of disciplines such as architecture, urban design, landscape architecture, public art, and community cultural programming; and supersedes their boundaries by focusing on collaboration, communication and place instead of isolated projects, bringing together individuals of all backgrounds, interests and talents.

Civil rights have a strong history in the Moreland Street Historic District of Boston. This fact combined with the objective to improve community identity inspired the Roxbury Path Forward Neighborhood Association to introduce the idea of installing a civil rights tribute in Gertrude Howes Park, anticipated as new impulse, catalyst, and celebration of positive and lasting change related to racial equality and harmony (see figure 4). A dozen neighborhood organizations united in the effort to plan the project in partnership with the city following an Edward Ingersoll Browne Fund grant award in 2016. The collaborative nature of placemaking was ensured by an open and transparent process that brought the neighborhood together for all elements of the discussion and

Figure 4. Gertrude Howes Park during the Civil Rights Tribute community site walk with finalist artists. Courtesy of Christina Lanzl.

decision-making, from developing ideas to selecting an artist and deciding on a design.

Gertrude Howes Park is located within a highly diverse neighborhood, where residents are working toward ways to get to know each other and appreciate cultural distinctions. That's why local leaders focused on two main premises: (1) How do we preserve our African American heritage and (2) How can we make our neighborhood more inclusive for all and a more just, fair, and better place? To implement these plans, we wanted to "walk our talk," to live the content of our aspirations ourselves as part of the planning process. Toward this goal, a twenty-member community art selection committee chaired by Lorraine Wheeler stewarded the Civil Rights Tribute process.

Initially envisioned as an iconic individual sculpture, the outcome of the design competition embraced a different idea.

Artists—Douglas Kornfeld in partnership with Destiny Palmer—presented the concept of a gathering place for activities related to the commemoration of countrywide efforts to overcome racism in the United States. Participatory interaction, communication, and consensus of diverging opinions, backgrounds, and stakeholders indeed are driving the outcome.

5. PLACEMAKING = ACTIVE PARTICIPATION

Placemaking embraces inclusivity by offering a universal platform for discourse. Everyone is a maker of place. Everyone can serve the agenda of excellence in design, supportive environments, healthy communities, and thriving neighborhoods. In a high-quality public realm, we shed our individual bubbles and participate in a life of greater civic engagement.

Matthew Mazzotta, an environmental-activist artist, deeply cares about the active participation of people and neighborhoods in his projects. As curator for TEMPOart in Portland, Maine, I recruited him to develop artistic inquiry into ecology and the environment in a framework of research and innovation. His process is particularly intriguing because a central aspect of his planning phase is to offer opportunity for dialogue with the local community. Mazzotta has one goal only: listening. To do so, a pop-up *Outdoor Living Room* intervention has become his trademark (see figure 5). Outreach is conducted by the local partner organization to promote the event. Flyers are posted and local newspapers often assist in getting the word out.[11]

The intent is to create new local cultural settings through multidimensional collaborative experiences in an interdisciplinary design process. These temporary performative interventions bring together local residents interested in discussing status quo, dreams, and issues in their community. This way, the artist knows he also reaches folks who would not attend a community meeting

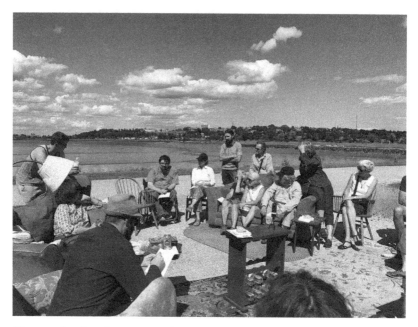

Figure 5. Outdoor Living Room listening and storytelling session with Matthew Mazzotta (bottom left) in Portland, Maine. Courtesy of Matthew Mazzotta and Cory Vinyard.

at a more formal location. Through conversation, the participants are thereby able to develop a vision and goals and a work plan that allows everyone to work together on a physical outcome by real-locating already-existing, local resources.

Typically, the outcomes result in new places for residents that bring them together. To date, their surprising designs have been small-scale design-build projects with a strong kinetic component. Mazzotta's outstanding contribution to urban development is the creation of new, permanent cultural venues and gathering spots for communities without such places. Both the process and the result transform the community and the built environment. The implementation of these kinetic works integrates art with technology in a sustainable approach. Reused and repurposed materials and a dedication to uniting local talent with specialized,

applicable resources the artist brings to the table have produced award-winning community structures in both urban and rural places. Mazzotta's continued legacy of all his projects is that they are interactive and participatory in nature, thus warranting active involvement in perpetuity.

6. PLACEMAKING = TRADITION AND INNOVATION

Placemaking combines an awareness of tradition with an embracing of new and emerging technologies. It respects time-tested rules of form and space, but also employs the research, development and innovation along with contemporary digital and social media tools to further community building.

When researching exemplary new media projects for my place-making seminar at the Wentworth Institute of Technology, the work of Urbanscreen emerged as a leader. In 2009, their stunning *555 KUBIK—Dreaming Building* was commissioned by Kunsthalle Hamburg as temporary projection mapping onto their building's facade.[13] Projection mapping is a most promising new technology with potential for the development of novel applications for building facades. With software-based technology, Urbanscreen literally maps projected light on the surface of any 3-D form as a layer that integrates the existing architecture into the visual narrative. Urbanscreen's virtual building skin has led to innovation in architectural design of permanent construction as well. The Kunsthalle project became the stepping stone and precedent for a new type of animated stepped facade of the recently completed Klubhaus St. Pauli in Hamburg's entertainment district, activated within the structure designed by akyol kamps: bbp architekten (see figure 6).

The *Placemaking Manifesto*'s criteria of tradition and innovation are synergized in these new-media projects. First, as temporary activation for a special event in the form of cutting-edge technology and then again by integrating media mesh and RGB

Figure 6. Klubhaus St. Pauli, Hamburg, Germany. Media-mesh facade and RGB panels by Urbanscreen completed in 2015 in partnership with akyol kamps: bbp architekten.[12] Courtesy of Urbanscreen.

technologies in an architectural context. On the Klubhaus facade, balconies as well as tectonic layering of the RGB panels break up the building massing and add character to the streetscape. The video animation of the facade works in the context of the city's party mile and particularly caters to young audiences. The location deserves consideration because the bustling visual stimulation through video content would disrupt any quieter urban context through image and impulse overload.

Hamburg's city administration plays an important role in regulating that the maximum advertising content displayed on facades is not to exceed one-third, with one-third being artistic and the final third establishing an artistic relationship with the building. These enlightened municipal zoning laws offer a good framework for ensuring that creative standards outweigh commercial interests.

CONCLUSION

To transform civic spaces into meaningful, dynamic places means to embrace an inclusive, collaborative approach that leverages the skills and creative thinking of multiple disciplines and perspectives. A humanist outlook additionally increases awareness in society and among academic institutions while furthering qualities like "wisdom, empathy, tolerance of ambiguity, and visual-spatial skills."[14] A lack thereof provokes "negative qualities, like physical fatigue, emotional exhaustion, and cognitive weariness."[15] As an integral part of the arts, culture, and humanities, placemaking can drive the agenda toward a more equitable, just, and humane society.

By definition, public art benefits communities. Done well, it instills a sense of place, creates local identity and places of celebration, cultural significance, and memory. In this context, public art is understood as an important *element* in the creation of comfortable and memorable places that are beloved centers of community. Embedding public art in the broader context of placemaking establishes a more comprehensive vision that considers public art holistically within its built context. Successful *placemaking* in the arts and culture are at the center of healthy, functioning neighborhoods. The key concept is to enhance the quality of life and caring about community. This allows active neighborhoods to thrive as a grassroots-driven movement that consciously embraces local places and works to improve them.

Experience shows that honest creative placemaking practice will overcome the limitations of design disciplines that have traditionally siloed professionals in the design of public spaces, often neglecting the intended activation or developing theory without a framework or the local will for implementation. Applied creative placemaking methodology and practice underline that this approach invites the inclusion of various perspectives and offers positive outcomes, particularly as a place is turned over to the user.

Placemaking activates our lived environment, offers cultural grounding, and offers a sense of place. Makers of all disciplines come together to think, plan, create, and celebrate together. The type of storytelling embraced by this method is key to sharing community and place. Stories introduce ways to deal with difficult pasts, bridge differences, and celebrate our common humanity. This way, we build our shared environment––infrastructure, architecture, open space, landscapes, parks, and public art––for active uses without the danger they might be or become overbearing or stale.

Contemporary culture and society seek to uplift our public environment by establishing mutually embraced, beloved public *living rooms* that serve the entire community. These new places are fresh starts that will develop their own history and narrative over time and will add layers of meaning. The task of the community to be a good steward of its new cultural assets will never cease. Otherwise, neglect and decay may lead to adverse repute down the road, once again. Thus, timelessness will maintain permanence or a renewed effort of redefinition will become necessary in the continuous change brought on by history itself.

NOTES

1. See "Placemaking Network," Boston Society of Architects, accessed October 23, 2019, https://www.architects.org/knowledge-communities/placemaking-network.
2. "Placemaking Network Forming Now," *BSA Newsletter*, June 7, 2007.
3. "Placemaking Network," *BSA Newsletter*.
4. Rooted in the community arts movement, urban planning research and theory developed by Jan Gehl, Suzanne Lacy, and William "Holly" Whyte, since the 1970s, believe that successful public places are shaped by the ideal convergence of infrastructure, architecture, public space, and their meaningful activation, leading to and encouraging interaction through participation. See Gehl, *Cities for People* and *Life Between*; Lacy, *Mapping*; Whyte, *The Social Life*.
5. See "Placemaking Manifesto Issued November 2017," Urban Culture Institute,

accessed October 23, 2019, https://www.urbancultureinstitute.org/blog/placemaking-manifesto-issued-november-2017.

6. See "Placemaking Manifesto: Writer's Workshop Notes," Urban Culture Institute, accessed October 23, 2019, https://www.urbancultureinstitute.org/uploads/1/1/4/6/11465358/171023_pacemaking_manifesto_notes.pdf.

7. Kenneth Frampton, regarded as a leading historian of architectural modernism and professor of architecture at the Graduate School of Architecture, Planning and Preservation at Columbia University, first introduced "sense of place" in his theory of critical regionalism.

8. A neighborhood analysis by the Massachusetts Institute of Technology documents the severe lack of greenspace in the area. At 2.5 acres per one thousand residents, the district has not only the lowest ratio in Boston, it also offers 50 percent or less public parks in Boston overall. The restoration of Coppens Square Park and its fountain therefore epitomize significant benefits to the immediate neighborhood and to the entire city of Boston. See "Connecting Bowdoin Geneva: A Plan for Community and Commerce" (Cambridge, MA: MIT Department of Urban Studies and Planning, 2017), 39, accessed October 23, 2019, https://www.urbancultureinstitute.org/uploads/1/1/4/6/11465358/bowdoin_geneva_mit_plan_1706_web.pdf.

9. The redesign plan illustrates the new vision for the park. See "Design Summary for the Redesign of Coppens Square, Dorchester, Boston MA" (Cambridge, MA: CBA Landscape Architects, LLC, 2018), accessed August 28, 2018, https://www.urbancultureinstitute.org/uploads/1/1/4/6/11465358/coppens_sq_cba_prp.pdf.

10. Destiny Palmer, "Welcome to Codman Square Park," KZLA, 2019. accessed October 23, 2019, https://www.urbancultureinstitute.org/uploads/1/1/4/6/11465358/codman_sq_park_redesign_1901.pdf.

11. Note the article by Keyes, "Want a Say."

12. See "Klubhaus St. Pauli: Media Façade Hamburg 2016," Urbanscreen, accessed August 28, 2018, http://www.urbanscreen.com/klubhaus-st-pauli.

13. See "555 Kubik: How It Would Be If a House Was Dreaming," Urbanscreen, accessed August 28, 2018, http://www.urbanscreen.com/555-kubik.

14. Lesser, "Study Finds."

15. Lesser, "Study Finds." Five universities participated in the study, which confirmed that greater exposure to the arts and humanities improved the participating students' resilience and well-being, published in the *Journal of Internal Medicine* (see Lesser). While the study was limited to medical students, the results have ramifications for all educational institutions. Case in point is the Harvard Business School's new Harvard Business Review Emotional

Intelligence Collection of four paperbacks, titled *Empathy, Mindfulness, Happiness,* and *Resilience*. Spirituality and humanism are core values that stabilize a human being's mental health.

WORKS CITED

"Connecting Bowdoin Geneva: A Plan for Community and Commerce." Cambridge, MA: MIT Department of Urban Studies and Planning, 2017. https://www.urbancultureinstitute.org/uploads/1/1/4/6/11465358/bowdoin_geneva_mit_plan_1706_web.pdf.

"Design Summary for the Redesign of Coppens Square, Dorchester, Boston MA." Cambridge, MA: CBA Landscape Architects, LLC, 2018. https://www.urbancultureinstitute.org/uploads/1/1/4/6/11465358/coppens_sq_cba_prp.pdf.

Destiny Palmer, "Welcome to Codman Square Park," KZLA, 2019. accessed October 23, 2019, https://www.urbancultureinstitute.org/uploads/1/1/4/6/11465358/codman_sq_park_redesign_1901.pdf.

Fleming, Ronald. *The Art of Placemaking: Interpreting Community through Public Art and Urban Design*. London: Merrell, 2007.

Florida, Richard. *The New Urban Crisis: How Our Cities Are Increasing Inequality, Deepening Segregation, and Failing the Middle Class—and What We Can Do About It*. New York: Basic Books, 2017.

Florida, Richard. *The Rise of the Creative Class*. New York: Basic Books, 2002.

Gehl, Jan. *Cities for People*. Washington, DC: Island Press, 2010.

Gehl, Jan. *Life Between Buildings*. New York: Van Nostrand Reinhold, 1987.

Keyes, Bob. "Want a Say in Back Cove Public Art Piece? Tell Its Creator." *Portland Press Herald*, June 20, 2017. https://www.pressherald.com/2017/06/20/visiting-artist-seeks-input-on-back-cove-public-art/.

Lacy, Suzanne, ed. *Mapping the Terrain: New Genre Public Art, 1994*. Winnipeg: Bay Press, 1994.

Lanzl, Christina; Anne-Catrin Schultz, and Robert Tullis. *Placemaking Manifesto*. Boston, MA: Placemaking Network, 2017. https://www.urbanculture-institute.org/uploads/1/1/4/6/11465358/placemaking_manifesto.pdf.

Lesser, Casey. "Study Finds Med Students Who Make Time for Art Have More Empathy." Artsy, January 30, 2018. https://www.artsy.net/article/artsy-editorial-med-students-time-art-empathy.

Lydon, Mike, ed. *Tactical Urbanism 2*. Miami and New York: Street Plans, 2018. https://issuu.com/streetplanscollaborative/docs/tactical_urbanism_vol_2_final?mode=window&backgroundColor=%23222222.

Placemaking Network, Boston Society of Architects. https://www.architects.org/knowledge-communities/placemaking-network.

Projects. Boston and Berlin, Germany: Urban Culture Institute. https://www.urbancultureinstitute.org/projects.html.

Urbanscreen. "All Projects." (Webpage.) 2018. https://www.urbanscreen.com/category/work/all-projects/.

Welcome to Codman Square Park, 2019. Boston: KZLA and Destiny Palmer. https://www.urbancultureinstitute.org/uploads/1/1/4/6/11465358/codman_sq_park_redesign_1901.pdf.

Whyte, William. *The Social Life of Small Urban Spaces*. New York: Project for Public Spaces, 1980.

CHAPTER FOUR

CIRCUS AS TRANSFORMATION

Musings on the Circus Arts as Agent and Medium for Change

Charles Batson

December 14, 2015: the famed Chamäleon Theatre in Berlin, with a history linked to cutting-edge German performance since the early-twentieth century; the hall's wood panels, dimly lit bar, and small cabaret tables viscerally recall scenes of limit-exploding variety shows of Berlin's interwar period. The Chamäleon is now devoted to new circus, that art form distinguishing itself from its more traditional version, with emphasis on dramaturgy and blended forms of dance and theater, melded with highly developed technical skills; as such, the hall has featured celebrated avant-garde *nouveau cirque* companies such as Québec's Les 7 doigts de la main and Australia's Circa. That night, it was hosting the gala performance of Circus Sonnenstich, a company founded eighteen years earlier to teach circus arts to disabled youths, particularly those with Down syndrome. Over an hour of acro dance, diabolo, beatbox, Hula-Hoop, juggling, balancing numbers, and ensemble work. Skill. Art. Transformation.

It was I who was transformed. I am a habitual practitioner of what Eve Kosofsky Sedgwick has called "reparative reading," in which a reader/viewer might seek how a text or production could, through meanings offered in vocabularies of affect, give affirmation, or what she calls "sustenance" (150), even to readers/viewers not explicitly affirmed by the culture of that text or production. So, say, a queer reader might thrill to science fiction texts, whose presentations of emotional and material difference overpower, in a reparative reading, the striking lack of nonheterosexual relationships in their pages. One might similarly imagine a queer circusgoer taking meaning in the very noncommonplace of the spectacle, even as gender roles and gendered expressions in those performances often repeat heterosexist codes from beyond the stage.[1] (I am, by the way, such a science fiction reader and circus-goer.) That night, I didn't have to have my reparative-reading lenses so closely perched to my eyes; I didn't have to actively seek sustenance for an otherness that might otherwise not be sustained. Here, there was precious little to have to repair.

That evening, I was not new to circus. I was, in fact, on my way back to the States from a circus studies conference in Stockholm; my coedited volume on Quebec's circus scenes was soon forthcoming (Leroux and Batson), and I was in the throes of co-organizing a conference in Montreal based around the theme of "Circus and Its Others." But I was reminded that night of the power of a circus that was so evidently *not* in the thralls of traditionally fit, abled bodies and related normative energies—circus that pointed to the possibility of breaking down categories and practices that required reparative reading in the first place. I wept. For days.

TRANSFORMATIONS: SOCIAL CIRCUS AND CIRQUE DU MONDE

Circus Sonnenstich figures in the constellation of what is known as "social circus," a series of practices, institutions, and engagements

grounded in the notion that positive transformation can come to traditionally underserved and underrepresented populations as they learn the complex physical, artistic, and mental skills associated with circus. Sonnenstich also literally figures on the map of some hundreds of social circus institutions across six continents as constructed by a team from the Cirque du Monde, arguably the best-known and best-financed actor in the field through its role in the social mission undertaken by the globe-straddling Cirque du Soleil.[2]

Now over thirty years after its 1984 founding in Québec, Cirque du Soleil, as I write these lines, has eighteen shows actively touring on five continents or staged in permanent fixtures, from Las Vegas to Florida's Lake Buena Vista and Mexico's Riviera Maya. It is not only the largest performing arts company in Vegas—that town of performing arts—it is, by some accounts, the largest performing arts company in the world (En Piste), with at least a billion-dollar revenue stream prior to its recent sale to an international group of investors. With presale public commitments of 1 percent of its budget going to social and cultural programming, Cirque du Soleil has been able to fund a large number of projects throughout the world. With such presence, we may easily understand why researcher Olga Sorzano suggests that the term "social circus" itself, at least for many participants in the global north, finds itself "generally attributed to a program initiated by Cirque du Monde" (117), or why a recent paper published in the *International Social Science Journal* would call it a "stakeholder" (Rivard et al., 181) in this movement.

What is that model and what are the stakes? Created in 1995 though the joining of forces between Cirque du Soleil and the NGO Jeunesse du Monde, Cirque du Monde, in its own words, "targets at-risk youth between the ages of 8 and 25. They usually come from low-income backgrounds, and many even live on the street" (CdM). Cirque du Monde calls its work a type of intervention in the lives of these youngsters: as they use circus arts to learn skills

and "change habits" (Lafortune, 16), these youth acquire what the organization calls certain "benefits": "teamwork and a combination of strengths and talents—and these are elements that can help young people develop a sense of belonging. They allow for freedom and creativity while demanding perseverance and discipline. The workshops offer young people a space to open up, express themselves and to create, while respecting their marginality, new bonds with a society that has often excluded them" (CdM).

Typically, Cirque du Monde works with a local partner, already established in the area with connections to networks of people and resources, with awareness of the particularities of local needs, offering financial, organizational, and material support, including donations of circus equipment. As examples of the range of this social circus work, they note that "in South Africa, it is used to motivate kids born with HIV to follow their treatments. In Mongolia, workshops were held in juvenile prisons. In Quebec, social circus was used as a truancy prevention tool and, in Australia, with women survivors of sexual violence." Not only are the proclaimed advantages large, but the stakes for participants are high.

Even though the movement is quite young, research is beginning to point to its success—perhaps precisely because the workshops do not explicitly stress insertion into a labor market where jobs can be, as researcher Jennifer Beth Siegel points out, "both hard to come by and alienating" (59).[3] Indeed, Cirque du Monde's leaders have explicitly stated that "the objective is not rehabilitation." And their participants' differences? "We hope above all that their marginality can enrich the social fabric. These young people first need to learn a language that will help them be a part of society. . . . All we ask of society is to come and listen, and look at these young people in a different light" (Lafortune, 16).

As Siegel notes, it is these workshops' connections with circus's history of celebration of difference and otherness that research shows to be "effective in integrating urban youth into the workforce because of its links with marginality and nomadism." In

Siegel's work with Cirque Hors Piste, another Montréal-based social circus group that partners with several local organizations that provide, among other things, safe spaces for sex workers and harm-reduction services to drug users, she has found that "many participants as well as instructors expressed disdain for the imperative to 'go to school' and 'get a job' as a measure of the program's worth, particularly at a time where going to school is no guarantor of getting a job." How does this approach work then? "What is stressed is personal and collective learning and a pursuit of one's goals . . . allow[ing] for the creation of one's own system of values and the forging of signs and meanings that orient the individual toward an alternative future, drawing on play, dreams, and collectivity" (59).

Play as transformation. As at least one play-filled artist from Circus Sonnenstich declared: "On stage I feel reborn!" (Bartlick). Reports from Sonnenstich suggest that their weekly workshops, which give rise to the shows at the Chamäleon and abroad, including in the Center for New Circus in Helsinki, lead the participants to "gain confidence and independence." Furthermore, the Down syndrome acrobats, in turn, "offer circus workshops for, among others, volunteers who work in disabled institutions abroad" (Bartlick). Meanwhile, back in Montréal, Siegel's research shows that some participants go on to college or, even, to create other social-circus-focused NGOs. Ever-expanding circles of circus work and ever-expanding possibilities of more transformation exist in this social-circus model, where there is an emphasis on, in Cirque du Monde's words, not only "respect [and] safety" but also "enjoyment" ("Imagination for People"). "Play, dreams, and collectivity" indeed. Can we add other words to this emphasis on something that is not mere *curriculum vitae* building and utilitarian skill collection? At least one reviewer of the Sonnenstich gala did: "Freude die geteilt wird" ["Joy that is shared"] (Geburtstags-Gala). Joy—yes, that (at least for me, and of the tear-provoking kind).

As I mentioned above, this movement is quite young (again,

Cirque du Monde was founded only in 1995); scholarship looking at it is younger still. We do well, I believe, to ask questions, particularly as celebrations of marginality follow in a history of circus wherein the "freaks," the marginals, have not (only) been celebrated but have been exploited *in* their difference and *as* outsiders even while being proclaimed—sometimes literally—the stars at the center of the enterprise. To return to the joy that I—a white, cisgendered, able-bodied, fully employed male—experienced in Berlin: Might there be moments when we have a sign that Cirque du Monde's ultimate goals are met, when societies themselves, including its nonmarginal populations, experience a transformation in contact with the performers who themselves are changed and changing? Moments when societies do actually "come and listen and look at these young people in a different light" and where hierarchies and exploitations are behind us? I want those tears to be at least one of those signs; I saw, when I could finally break my attention from the stage, that they were not the only ones shed in the Chamäleon Theatre that night.

We must continue our work to find other signs. Siegel seems to point to the possibility that they exist. She asks rightly, however, if these social circus models repeat patterns of hierarchy and potential exclusion in, say, calling a twenty-five-year-old a "youth" or in not fully collapsing leader-follower methods of training. She returns, though, to what reads as optimism in what "community-engaged circus collectives" can do for "breaking with habits of alienation and instead seeding futures that the joy of collective creation may initiate": it gives, even for the broader community, the model of a "together" (65), a model where an insider/outsider distinction is exploded. Indeed, what do I have in front of me as I write these lines in July 2017, in an apartment in a small street in Gay Village in Montreal? The announcement of the upcoming performance of Cirque Hors Piste in this neighborhood during Montréal Complètement Cirque, the ongoing citywide circus festival, promising "cirque et mixité sociale au coeur du village" (Cirque

Hors Piste): Circus as social diversity, at a community's heart. Perhaps Siegel is right to be optimistic.[4]

BRIDGES ACROSS DIVIDES: LANGUAGE AND PRACTICE

We should therefore continue to dig to find signs and possibilities of yet more transformations. I coconvene a group of scholars and practitioners, in fact, who are doing just that. Formed in 2014 under the aegis of the Montreal Working Group on Circus Research, after a series of performances and conversations that suggested to several of us that there seemed to be some perennial outsiders, even in contemporary circus circles, the Circus and Its Others project wishes to explore the presence—or absence—of persons and practices that are labeled "different" in performance, practice, and research. With, I readily admit, a goal that recognition of these labels will lead to yet more inclusion and, even, yet more joy. Among the elements we are examining: the notion that positive change brought about by these social circus institutions and practices may find itself constantly threatened by other impulses, considering that these institutions and practices are dependent on funding and other support, a fact underscored by the news that Cirque du Soleil, after its sale to a group of private investors, might not continue its commitment of 1 percent of global revenue to cultural and social programming. We thus wonder, for example, in what ways social circus, as powerful as it may be, remain in the shadow of the professional circus world and its related funding and training structures. Where might bridges across this division be forming—or be already formed?

In a 2018 issue of *Performance Matters*, some of my colleagues take up these questions. Olga Sorzano, for example, looks at the difference in language that is used in the global north (with, you'll remember, the primary example of Cirque du Monde) and language used in the global south, in particular Latin America. Cirque du Monde, for example, has as an explicit statement that their

"primary goal is not to learn the circus arts, but rather to assist with participants' personal and social development" (Sorzano 117), suggesting an emphasis more on the *social* than on the *circus*. Sorzano's research suggests, however, that, at least in major portions of Latin America, social circus "does not differentiate itself from the professional scene; rather, it is conceived and promoted as a professional option" (116). She argues that the so-called professional/social divide is actually one of language or discourse or narrative that gives us a primary vocabulary that filters how we both see and talk about this circus. As such, it ends up upholding more traditional representations of "'targeted' groups" (118) who then find themselves, yet still, at a remove from being fully seen as actors, agents, and subjects in their choices and world: they remain (to be talked about as) social cases and not (necessarily) circus artists. David Fancy, from his circus work with a group of "intellectually disabled (ID) survivors of extensive institutional abuse at the hands of the Ontario Government at the Huronia Regional Centre in Orillia, Ontario" (152), says we may have a way beyond this particular language: let's go ahead and talk in ways that transcend these defining, and hierarchical, categories of "social" versus "professional" circus. [5] Oh, why not, say, just use *circus*? As a sixty-seven-year-old Huronia survivor, one of the participants in the project he's involved with, said, "Circus is a place for me, for us all to be free. People do wonderful things there. We do wonderful things. We are circus" (153).

Such vocabulary might help us, for example, more fully recognize those Latin American circus artists in Solzano's studies who, no matter how professional they may become, keep getting talked about, in the language of the global north, as "social" circus participants. Solzano points to the salvatory example of the school Circo Para Todos (I cannot help but note that the Spanish-language name of the group already uses category-transcendent vocabulary), founded in Cali, Colombia, in 1995 with the goal of teaching the circus arts as a profession to disadvantaged children and youth.

She writes: "Graduates of Circo Para Todos now perform all over the globe in the professional and performance worlds" (125). They further have won signal honors, with medals from Paris's Festival Mondial du Cirque de Demain, China's Wuhan International Acrobatics Art Festival, Cuba's International Circus Festival Circuba, and Russia's Circus Master Awards.

SAINT LOUIS AND CIRCUS HARMONY

Such bridges across categories may already be taking place in the global north as well. I'm thinking in particular of St. Louis's Circus Harmony and the work done there under the guidance of its director Jessica Hentoff. She founded the St. Louis Arches Youth Circus Troupe in 1989 with a mission of instilling "the same joy of accomplishment she felt the first time she ventured into a circus arts class as a student at SUNY Purchase." She reports discovering what "would prove to be a greater joy than individual achievement: the power of the circus arts to create social change." As she watched "the difference it made in them as individuals and in how they were perceived by their community and their families" (Iverson), she herself created the entity Circus Harmony, in the face of lack of funding from a previous benefactor, to guarantee continued access to circus education. Circus Harmony is now such a recognized figure in circus training and education that they were invited to participate in the July 2017 Circus Arts celebrations in the Smithsonian Folklife Festival, alongside such noted figures as Big Apple Circus, Fédération Mondiale du Cirque, and the Wallenda Family Troupe. They have produced such artists as Reggie Moore who, at six foot five and three hundred pounds, may not have initially appeared headed for the presence he cast across the country before a fatal car accident at the age of twenty-one.

They have also produced the artists Melvin Diggs and Sidney Iking Bateman, two cast members of the internationally touring show *Cuisine & Confessions*, created in 2014 by the world-renowned

Montréal-based company Les 7 doigts de la main (The 7 Fingers, as they are known in English). Following a frequent choice of the company, which explicitly prioritizes an aesthetics of intimacy and authenticity, the show involves, through recorded or live voice, the telling of certain key memories from individual cast members' pasts. [6] During the duo number Diggs and Bateman built around an image of the "two of them helping each other through doorways" (Hentoff), symbolized by the ever-increasing numbers of superimposed square hoops, Diggs's voice rings out, telling his (hi)story: "It got to a point where it was like, y'know, I'll die young. I don't care. You're just waiting. I feel like being in St. Louis, you're constantly waiting just sitting there waiting to see when am I gonna get shot? When am I going to go to jail?" With circus, his story ends perhaps differently from some: "These things are normal, and I was just next in line to be like my brother or my uncle – and I got out of that" (Hentoff).

Bateman's story is also one of challenge—and success. Even with talent at circus skills, having been introduced to Hentoff at the age of eleven, "he would quit every so often and start running around with gangs. . . . But when his uncle was shot right in his living room, a few feet from Sidney's bedroom, he no longer felt safe in his own house." Hentoff took him into her own home for a while, shuttling him to school and training. Bateman reports that "that moment led me to go back to circus and take stock of my future" (Campbell). A part of that circus-inflected future has now arrived, of course, and it has come with international fame and, even, a 2017 return to his home training ground of St. Louis's schools as a circus coach. Bridges across divides, indeed.

PARIS, DAKAR: LOSING AND GAINING WORDS

As a part of an official series of collaborations in 2013 between the cities of Paris and Dakar, artists from the France-based Cirque Electrique joined artists from the Senegalese SenCirk' to mount a show

Figure 1. "Melvin Flying at Laumeiern." Courtesy of photographer Jessica Hentoff.

Figure 2. "Iking Flying over a car." Courtesy of photographer Jessica Hentoff.

in Paris. In this context of expanded or transcended categories, it is perhaps appropriate to note that the Cirque Electrique's performance space, officially labeled to be on the Place du Marquis-du-Vercors in Paris's 20th arrondissement, lies *beyond* the Boulevard Périphérique, which, in the French cultural imagination, marks the perimeter of the city. In the geography of that particular site, the performance space seems to somehow, (im)possibly, sit *above* the Périphérique, as if to underscore the boundary-exploding work that has happened there. As I come to talk about these artists and this collaboration at the close of this chapter on circus as transformation, I find myself at a particular, and revealing, loss for words. In the language laid out by Sorzano according to typical language of the global north in regards to the particular background and training of the artists, one might call the Parisian company a "professional" one and the company from Dakar a "social" one. What happens, however, when four artists from each company come together, in collaboration, to mount a show (with standard ticket prices paid), and in which all eight artists have pride of place on stage with, say, tumbling runs and pyramids literally mixing bodies and styles?[7] The "social" and the "professional" differentiating labels seemed to me, that night in December 2013 when I saw their show, to have no real purchase or sticking power. They were artists. Doing circus. They were circus artists.

I would be remiss, however, if I didn't point to the explicitly social nature of the Senegalese troupe: their declared mission is to "bring corporeal and artistic education based around the circus arts to underprivileged children and youth" ("Paris-Dakar"). But look further and you'll see that they may already be using language that David Fancy has called for, one in which, by transcending certain labels, we also leave other terms and narratives and discourses behind. For what do they say that they *really* offer? An "artistic resolution to political problems" (Sencirk'). Gone is language concerning autonomy, independence, discipline, or integration, which, if we follow Fancy, already bespeaks certain value-laden hierarchies.

This company is about art. Creating it. Doing it. And it is art that provides the *trans*—the crossing, the beyondness, the change—of their transformative work.

JOY

I'd like to return to that other powerful word that has appeared and reappeared in these pages from the Sonnenstich to St. Louis and now to the Senegalese: in the language of at least one reviewer in Paris, this circus, this art, is a "vecteur de joie," a vehicle, a carrier, of joy—joy-giving, joy-provoking, joy-demanding, not (only) for the performer-participants but for the spectators, who are, in this language, also called to become active participants in the joy-making enterprise. For this reviewer, "le cirque est d'intérêt general" (Hahn): circus is in and of public interest. Here, at the close of these musings on circus as transformation, we may really find ourselves leaving behind certain hierarchy-inscribing vocabularies that normally require those reparative-reading lenses I'm so used to wearing. We may find ourselves in a world, a practice, an art—joined, shared, communal, collective—that offers transformation to us all. And, to follow the implication of that Parisian reviewer, it is one that the public needs.

Circus. For all of us.

I'm ready to cry some more.

NOTES

1. I explore these thoughts further in the authored "Feeling, Doing, Acting" essay.

2. See map of Cirque du Soleil: http://apps.cirquedusoleil.com/social-circus-map/.

3. Siegel's use of the word "alienating" is not an accident in this circumstance, as she goes on to refer to Rivard's productive examination of the nexus of the modern labor market and (social) circus work in terms borrowed from Hannah Arendt's influential critiques of modernity and its various alienations,

and in which circus labor has a uniquely "non-invasive, emancipatory form" (Rivard 2007). See Siegel, "Social Circus," 59.

4. Optimism for the presence of diverse arts and practices at the heart of a community may not be limited to the events and institutions mentioned in the body of this paper and may continue with the emergence of other institutions such as the Cent Quatre in Paris, where, with government funding, in a building designed for up to five thousand people at any one time, one can witness—simultaneously, and sometimes in the same space—such varied activities as yoga classes, hip-hop performances, circus training, and digital media workshops. See http://www.104.fr.

5. He proposes specifically a discourse based on the influential notion of "body without organs," as developed by Deleuze and Gattari, which would transcend "parameters of normative corporeality . . . not reduceable or recuperative to a discourse of autonomy, self-governance, and separation part and parcel of traditional bourgeois subjectivity" (152).

6. For more on The 7 Fingers, see Batson 2016.

7. Segments of that show can be seen at "I'm a man - Cirque electrique (1)," YouTube, December 28, 2013, https://www.youtube.com/watch?v=lHA-8JYGugL8, "I'm a man - Cirque electrique (2)," YouTube, December 28, 2013, https://www.youtube.com/watch?v=qFkwcRwiHm4, and "I'm a man - Cirque electrique (3)," YouTube, December 28, 2013, https://www.youtube.com/watch?v=4kS_oiRTmRc.

WORKS CITED

Bartlick, Silke. "Disabled Performers Celebrate 15 Years of Circus Sonnenstich." Deutsche Welle, May 14, 2012. http://www.dw.com/en/disabled-performers-celebrate-15-years-of-circus-sonnenstich/a-15948182.

Batson, Charles. "Les 7 doigts de la main and Their Cirque: Origins, Resistances, Intimacies." In *Cirque Global: Quebec's Expanding Circus Boundaries*, edited by Louis Patrick Leroux and Charles R. Batson, 99–121. Montreal and Kingston: McGill-Queens University Press, 2016.

Batson, Charles R., and Denis M. Provencher. "Feeling, Doing, Acting, Seeing, Being Queer in Québec: Michel Marc Bouchard, Rodrigue Jean, and the Queer Québec Colloquium." *Québec Studies* 60 (2015): 3–22.

Campbell, Kim. "Finding Peace with Circus in Tough Times." *Spectacle* 4, no. 1, http://spectaclemagazine.com/?page_id=6068.

Cirque du Monde. "Social Circus Map." November 2, 2019. http://apps.cirquedusoleil.com/social-circus-map/.

Cirque du Monde. "About." https://www.cirquedusoleil.com/en/about/global-citizenship/social-circus/cirque-du-monde.aspx.

Cirque Hors Piste. "Evénement de cirque social." June 27, 2017. https://www.cirquehorspiste.com/blog/2017/6/27/hors-piste-2017.

Fancy, David. "Affirmative Freakery, Freaky Methodologies: Circus and Its *Bodies without Organs* in Disability Circus." *Performance Matters* 4, nos. 1–2 (2018): 151–63.

Hahn, Thomas. "Cirque électrique / Sencirk." Danser Canal Historique. https://dansercanalhistorique.fr/?q=article/cirque-electrique-sencirk.

Hentoff, Jessica. "North St. Louis Youth Turn Street Lessons into Circus Art." *St. Louis American*, December 4, 2014. Iverson, Johnathan Lee. "The Wonder Working Power of the Circus Arts." Huffington Post, January 7, 2015. http://www.huffingtonpost.com/johnathan-lee-iverson/the-wonder-working-power-er-_b_6430978.html.

"Imagination for People: Cirque du monde, a social circus." November 2, 2019. http://imaginationforpeople.org/en/project/cirque-du-monde-a-social-circus/. Nov 2, 2019.

Jean-Arsenault, Emmanuelle, and Darvida Conseil, Inc. "Circus Arts in Quebec and in Canada: Shedding Light on a Paradox." En Piste, November 2007. http://enpiste.qc.ca/files/publications/state_of_affairs_shedding_light_on_a_paradox.pdf.

KissKissBankBank. "Le Paris-Dakar d'un trampoline." KissKissBankBank and Co. https://www.kisskissbankbank.com/le-paris-dakar-d-un-trampoline.

Lafortune, Michel, and Annie Bouchard. *Community Worker's Guide: When Circus Lessons Become Life Lessons.* Montréal: Cirque du Soleil, 2010.

Leroux, Louis Patrick, and Charles R. Batson, eds. *Cirque Global: Quebec's Expanding Circus Boundaries.* Montreal and Kingston: McGill-Queen's University Press, 2016.

Rivard, Jacinthe. *Le movement paradigmatique autour du phénomène des jeunes qui vivent des difficultés: l'exemple du programme Cirque du Monde.* PhD diss., Université de Montréal, 2007.

Rivard, Jacinthe, Guy Bourgeault, and Céline Mercier. "*Cirque du Monde* in Mexico City: Breathing New Life into Action for Young People in Difficult Situations." *International Social Science Journal* 61, no. 199 (March 2010): 181–94.

Sedgwick, Eve Kosofsky. *Touching Feeling: Affect, Pedagogy, Performativity.* Durham, NC: Duke University Press, 2003.

Sencirk'. "Un crédo." (Homepage) Jimbo. https://sencirk.jimdo.com.

Siegel, Jennifer Beth. "Social Circus: The Cultural Politics of Embodying 'Social Transformation.'" *TDR: The Drama Review* 60, no. 4 (Winter 2016): 50–67.

Sorzano, Olga Lucía. "Is Social Circus 'The Other' of Professional Circus?" *Performance Matters* 4, nos. 1–2 (2018): 116–33.

Zentrum für bewegte Kunst e.V. "Geburtstags-Gala im Chamäleon theater." http://www.zbk-berlin.de/circus-sonnenstich/programme-und-vorstellungen/18-jahre-circus-sonnenstich.

CHAPTER FIVE

SPEAKING THE UNSPEAKABLE

Integrating Science, Art, and Practice to Address Child Sexual Abuse

Rebecca Volino Robinson, Claudia Lampman, Brittany Freitas-Murrell, Jennifer Burkhart, and Amanda Zold

> *Art can present truths in ways that sneak around our unconscious prejudices.*
> *It is a way to speak the unspeakable.*
>
> <div align="right">—Václav Havel, " Personal Truth as Political Theatre" (qtd. by Edward Einhorn)</div>

Stalking the Bogeyman (*STB*) is a play adapted by Markus Potter and David Holthouse, based on an original, true story by Alaskan writer and journalist David Holthouse.[1] Originally written as an article for the *Denver Westword* and then featured on *This American Life*, *STB* unfolds around a young boy's rape and his grappling with its effects as an adult. *STB* brings to light topics around sexual assault, like revenge, shame, trust, and justice.

The play's world premiere took place in Asheville, North Carolina, in 2013, and it enjoyed a successful off-Broadway run in the

fall of 2014. The University of Alaska Anchorage's Departments of Theatre and Dance, Psychology, and Art partnered with community organizations such as Standing Together Against Rape, Alaska Children's Trust, and the Alaska Native Tribal Health Consortium to create the *Stalking the Bogeyman* project.

With the play's production at its core, it was cooperative community partnerships, multi-faceted research and scholarship, and direct departmental collaborations that made the *STB* project extraordinary. By *turning up the volume* on the conversation about child sexual abuse in Alaska, the *STB* project sought to *transform* the way we think about and address the problem of child sexual abuse in our state.

This is our story.

PART 1: INSPIRATION

Rebecca: It was the fall of 2014. I was busy prepping lectures and writing about my most recent research findings when my colleague appeared at the door. She was excited. After a brief conversation, I was left with a manuscript—not the typical dense manuscript filled with statistics and carefully crafted inferences about how we might apply the findings to something in the real world, but a theater manuscript. It began:

> This time last year I started plotting to kill a man. This time last year I had a gun, and a silencer, and a plan. I had staked out the man's tract home in the Denver suburbs. I had followed him to and from his job in a high tech office park. I was confident I would get away with murder, because there was nothing in recent history to connect me to him. Homicide investigators look for motive, and mine was buried 25 years in the past (*Stalking the Bogeyman*).

I was busy. It was the end of the day. My son was waiting for me to pick him up. But I could not leave the script. I sat there in my dimly

lit office reading for forty-five minutes, breathing occasionally, wiping tears. As a psychologist, I am a keeper of stories—stories long kept silent. Secrets. The words on the manuscript represented 101 stories shared in my office, silenced by society, held closely by the keepers. But this story, this story shattered the silence. It spoke the unspeakable, and we were going to bring it to life on our campus.

Claudia: I was the excited colleague. True, I am often excited at work. But this was different. That morning, two colleagues from the Department of Theatre and Dance knocked on my door. Unusual. They said they had a project they wanted to do, but they thought they needed my help. Intriguing. I am the head of the psychology department. We went down the hall to the conference room. That conversation began a journey for me, a journey onto which I would bring a fellow psychologist and many of our students—a journey to be brave and loud and hopeful.

My colleagues told me they wanted to put on a play about the rape of a seven-year-old child that happened right here in our community. But they were afraid of the potential ripple effects. Would the play start a very difficult conversation but leave the cast, crew, and audience in a dark and vulnerable place? A place that my colleagues from Theatre didn't feel totally equipped to handle? I have lived in Alaska for twenty-five years. It is a place of extraordinary beauty and extraordinary danger, perilous mountains and waters and forests. There are predators here: bears in the forests, grizzlies in my yard. But there are other predators here: people who hurt people, adults who hurt children. Alaska has one of the highest rates of child sexual abuse in the nation. It is an unspeakable crime. But we need to speak about it if our community is going to confront this issue and help victims heal.

So, I told my colleagues that I was in, that psychology would provide the support needed to take this on, with counselors for the cast, crew, and audience. Then neurons started firing for all of us. Could we go bigger? We could have talkbacks following each performance so the audience had a voice. What about research?

Could some PhD students in psychology find a dissertation in this project? Could we take the play on the road and reach more of our state? Could we document the process for other campuses wanting to do something similar?

Yes, I was excited. These were to be the right ripples.

Brittany: I was invited to meet with a longtime mentor (Claudia) regarding a possible research project for my doctoral dissertation. Claudia thought my interests and experiences were a good fit. I recall being flattered at the time but also bewildered at the intersection of art and research. Looking back, I consider myself lucky and ultimately privileged to have been involved in the *STB* project. I walked away from the first meeting with a script that began a significant chapter in my own professional journey. The foremost goal of the *STB* project was to use theater to evoke social change. All involved believed theater was a tool of significant transformative power. The literature was filled with writers avowing the utility of theater to affect individuals and communities. But there was very little empirical support for this notion. I was going to collect data from audiences before and after viewing the play. I would measure their attitudes and beliefs about the impact of theater and changes that might occur in the weeks following the play.

Amanda: An email arrived in my inbox: "Seeking Process Evaluation-*Stalking the Bogeyman*." After reading a summary of the project, I knew I had to be part of it. As an aspiring psychologist who grew up performing in theatrical productions, it sounded like the perfect blend of my two passions and an unexpected opportunity to return to a life of the arts that I had largely checked at the door when I enrolled in college. I responded right away: I was interested. A meeting was held with Rebecca and Claudia later that week. They wanted a process evaluation. I needed an evaluation project to meet my PhD program requirements. And so, a match was made. I was now the designated fly on the wall, soaking in everything that was taking shape, meticulously taking field notes and formulating the questions that would shape and guide the

evaluation. As this project was taking shape, we wanted to be sure to document our process to share with others—our successes and our blunders.

And so it began, a two-year multidisciplinary project that brought together the University of Alaska Anchorage's Departments of Theatre and Dance, Psychology, and Art with community partners dedicated to one cause: Turning up the volume on the problem of child sexual abuse in Alaska.

PART II: BUILDING THE SAFETY NET

Brittany: Reading the first scene of the play left me devastated, concerned. The audience would bear witness to some of the most silenced, closeted violence in our society. By the end of the script, sitting motionlessly, I was awash with emotions and overwhelmed by thoughts. How can this darkness be present, so prevalent in our communities, and yet so absent in our conversations?

Rebecca: I knew the numbers at the start of this project. An estimated one in three Alaskan girls and one in five Alaskan boys are sexually abused before age eighteen (Alaska Children's Alliance). The negative effects of child sexual abuse include feelings of guilt, shame, and self-blame about the abuse. Survivors of child sexual abuse are at increased risk for depression, anxiety, trauma, and dissociative and eating disorders (Paolucci, Genius, and Violato). Suicide rates among child sexual abuse survivors are two times higher than the general population (Devries et al.). The Adverse Childhood Experiences Study not only documented a direct link between child sexual abuse and substance misuse, mental illness, and suicidality but also with chronic illnesses (such as cardiovascular disease, diabetes, and cancer) and early death among a sample of over seventeen thousand adult subjects (Centers for Disease).

That's right: child sexual abuse is related to psychological suffering, physical illness, and early death.

I think many Alaskans are aware of the high rates of abuse in the

state, be it through personal life experiences, exposure to awareness campaigns, or coverage by mass media. But myths about the problem abound, some placing blame on the very children who are abused, others perpetuating the "scary man in the van" myth that we know to be untrue (Finkelhor).

Truth be told, most children are abused by people they know, people they trust. Child sexual abuse knows no boundaries. It occurs across socioeconomic classes, races and ethnicities, and geographic regions (Whittier). These truths are scary. With numbers so high and predictability so low, we can certainly learn to feel helpless.

Brittany: The moment I felt most intimidated by this work came soon after I committed myself to the project. I was talking to my husband about the play, and shortly into my description, he, a lifelong Alaskan, exclaimed: "That case was famous in Alaska!" My gut dropped. Here I was, sharing this novel and exciting project with my husband. The last thing I anticipated was that he, far removed from academia, would have information about this story that I lacked. I hurriedly asked him to share his recollections. At that moment, I knew this project was not going to resemble other work I had been a part of. With this story, we were tapping into the collective narratives of people throughout the state.

Rebecca: Brittany's initial reaction to the script brought to light the personal reaction that each person would have to this story. The play involves subtle-but-obvious representation of the raping of a seven-year-old child. Our students, not professional actors, would play the cast of seven. The audience would be comprised of Alaskans. If the data were accurate on rates of child sexual abuse in Alaska, then our audience, and perhaps even our cast, would include survivors. While we wanted to push the boundaries of what is acceptable to represent in art and speak of in life, we also wanted to ensure the emotional safety and wellbeing of our students and community.

I met with David Holthouse and his partner, Priscilla, to learn

about their experiences with previous productions in North Carolina and New York City. They told of audience members standing up after the production and disclosing their own stories of child sexual abuse. Some named their perpetrators. Others spoke of breaking the silence. Seasoned actors played the six roles in the other productions, and some shared with David how acting in this play was more challenging than other productions.

The most pressing question at this point in my process was how to structure support for the student actors, who would soon be auditioning, in a way that allowed the emotional freedom to tap into the challenging roles, while protecting their emotional health and wellbeing. Likewise, how do we provoke critical and open dialogue about the topic while safeguarding vulnerable audience members?

Claudia: Although scary, this is not the first time our university had decided to take on the issue of "difficult dialogues." The Ford Foundation funded a campus-wide initiative to train faculty members to facilitate difficult dialogues in the classroom (Landis); I served as the assessment coordinator for the Difficult Dialogues grant. I also chair the Title IX Campus Climate Committee, which monitors incidents of sex- and gender-based misconduct and violence on our campus. These experiences, and my training as a social psychologist, have helped to make me comfortable talking about the difficult issues we face as a society. I have learned that there are better and worse ways to engage in such discussions. Having the discussions, however, is a must. I sympathize with proponents of "trigger warnings"; I know that it can be painful and traumatizing to have to confront hard personal issues in a classroom or campus setting. But as psychologists, we know that avoidance is not healing. To heal, one must engage. One must speak the unspeakable. The key is to have difficult dialogues in the right environment. And, if we are going to "poke the bear," we need to be prepared to see claws. That's why we needed to put together a team of mental-health professionals to support the cast, crew, and

community members who would be touched by *STB*. That's why I went to Rebecca. As a clinical-community psychologist, she was the perfect person to lead our team.

Rebecca: I put together a team of *advocates* (one MS student in clinical psychology, two PhD students in clinical-community psychology, and myself) to be present at all auditions, rehearsals, and productions. There was at least one advocate at each audition and rehearsal; multiple advocates were present at productions. We also worked with the art department to design participatory art projects, where audience members could contribute following the play. We centralized the concept of "giving voice" in all our activities. As the entire team of advocates was functioning in a context that differed from our previous experiences, we leaned into a few central tenets of healing: be present, listen, and trust the process.

Meanwhile, noting the gap in literature on how to support the wellbeing of actors, another research question emerged: How do you support actors taking on challenging theatrical roles? What strategies do actors already use to stay well? Can acting in a play of this nature cause harm? Can it transform?

Jennifer: In early January 2016, Claudia and Rebecca invited me to a meeting to talk about a potential dissertation opportunity related to the *STB* project. The research (broadly speaking): interviews with the actors about their experiences being a part of this production. Specifics had not been decided, but this project was to be a core component of the research resulting from the collaborative and multidisciplinary *STB* venture. I came to mind as someone who could bring that project to fruition, they said, and they hoped I would consider joining the team to do so. Their offer could not have been better timed. The next few months were a frenzy of activity as I immersed myself in the project and literature. Like Brittany, I found little empirical research on the experience of actors playing a victim or perpetrator of abuse. How do you step into and out of such emotionally intense roles every day for months on end? How does this affect the actors and what do they

do to stay well during the process? The risks seemed even graver given that the actors were still in training. I played the role of both researcher and advocate, attending rehearsals and productions once per week, supporting the cast and crew (and audience, during productions), as well as completing interviews with the actors.

With the safety net in place, two dissertations underway, and ongoing evaluation of our process, we moved forward with the project. Now was the time to break the silence. Now was the time to turn up the volume.

PART 3: TURNING UP THE VOLUME

Rebecca: Storytelling is at the heart of all healing. Be it through visual or narrative means, humans have shared stories of suffering across the millennia, sharing space and witnessing one another's experience. Trauma therapy often involves the careful reconstruction of a trauma narrative, witnessed by the therapist. This piecing together of the narrative places memories in their proper place in time. It builds meaning and promotes healing. This is also said to be true at a collective level, where theater resides. Theater can tell a collective story, perhaps different in content but similar in process, that taps the unspeakable, the underbelly of trauma. In this case, David's story touches a collective narrative—one of silence, shame, and violence. Each night as the lights dimmed and the audience grew silent, seven actors shared David's story. And each night, as the performance drew to a close, the audience was given a chance to speak.

Amanda: And speak they did. Audience members shared their stories. They disclosed their own experiences with sexual assault, some of whom had never done so before. Some cried out for justice and expressed anger and confusion that the perpetrator had not sufficiently paid for his crime. Some sought answers from the facilitators on what to do, how to prevent this from happening. Others inquired about the experience of the actors and what it was

like to take on the heavy content. Each talkback session created a new conversation.

But words often aren't enough. There had to be more. Art was a vehicle for that. A variety of interactive art projects surrounded the production and provided an outlet for the emotions provoked by the story, a place for those who may not yet be ready to speak.

The volume had been turned up and Alaska was abuzz with discussion about David's story and the production. Alaska media featured some aspect of the production or the surrounding projects twenty-two times between February 2015 and November 2016. Meaning, this story and the topic of child sexual abuse was permeating homes through television, news articles, Twitter, and Facebook, making its presence known. Time and time again in interviews, I asked people whether progress was being made on our goal—on turning up the volume. People reported consistently that the project was touching the community in numerous ways. Although there was no way to document all the conversations occurring in households and among friends across Alaska, I repeatedly heard stories of how the project and the topic of child sexual abuse had made their way into conversations, spanning dinner parties to salmon fishing on the Kenai peninsula. I mean, talking sexual assault while fishing. It doesn't get much louder than that.

Brittany: Over twelve hundred Alaskans attended a showing of *STB*. Of those solicited to participate in my research, 93.7 percent participated in a preshow survey and 24.1 percent completed all three intervals of the survey (preproduction, one-week follow-up, and one month follow-up). I measured whether *STB* viewers believed theater could be an effective tool to increase community awareness, act as an avenue for dialogue, and motivate people to action.

Jennifer: While the existing literature related to how actors are affected by the process of acting is incredibly sparse, one needs only to look at media headlines (Phillip Seymour Hoffman, Heath Ledger, Robin Williams, Nelsan Ellis) to gain a sense of the struggles

faced by actors in the work they do. Going into this project, we anticipated that it would be mentally and emotionally challenging for the actors. We aimed to minimize the likelihood that they would experience prolonged negative effects related to their roles in *STB*—something the research suggested was certainly possible, given the nature and content of the play and its roles.

Reflecting back on their experiences of being a part of the production, many of the actors described how a variety of supports (i.e., relationships with castmates, presence of the psychology team, and use of coping strategies) allowed them to fulfill a primary goal of the project: raising awareness about child sexual abuse and breaking the silence that surrounds it.

PART 4: TRANSFORMATION

Jennifer: In an interview with Indiewire, Tony Greco, an acting teacher who for decades worked closely with the late actor Phillip Seymour Hoffman, described his views about the transformative nature of theater: "When the play is done, you don't go home and not think about all the questions that these great roles bring up inside of you. If you really decide to go where these great roles will take you, then you come out of them a changed person. You come out of them different because a great role . . . when an audience sees a great role, it should make them question their own lives. And when an actor takes on a great role, it should make them question their lives. They change." Indeed, I found this to be true not only on a personal level but also in my conversations with the actors about their experiences.

Amanda: I think the real transformation here comes from how much larger it became than one story and one play. The many stories of those who had previously remained silent served as a powerful vehicle for transformation. Whether it was their own story or one of someone close to them, for me, listening as those stories were set free was deeply moving. The opening night of the

show, I sat in the audience and listened intently as the talkback occurred. This night, like others, someone stood up and disclosed their own experience of sexual assault and named the perpetrator. Tears that had been tightly bound in throughout the process quietly seeped out. In that moment, I was certain that this production, this project, would leave an indelible mark. I think I was right. As I interviewed project contributors after the production run was over, I heard others speak of moments like this one and their own transformation, each person telling different stories about how this project helped them to speak the unspeakable. Each touched deeply by not only the content of the play but the process of putting on a production that cut through the silence and the relationships that were built in doing so.

Brittany: *STB* provided the audience opportunities for expression during talkbacks—privately by contributing through interactive art exhibits and in one-on-one discussion with the cast, crew, and mental-health advocates. Most moving for me were reactions voiced by audience members. In my role as an advocate, I observed universality in the emotional reactions and a depth of diversity of thoughtful reflections voiced by audiences, indicating an illumination of the issue. Concerns regarding the safety of children, etiology of pedophilia, the system's responsibility, as well as very overt individual reactions of hatred, disillusionment, and anguish were voiced in every community we visited. The talkbacks felt like a process group; as an observer, participant, and facilitator, I felt keenly aware of tension in the room. For me, each audition, performance, talkback, and tour experience felt inundated with the pain of unspoken wounds, while also giving rise to catharsis and hope.

Claudia: Earlier, I talked about the danger and peril in our state. But twenty-five years in Alaska has also shown me incredible strength and resilience. The history of Alaska's first peoples has taught me about the human capacity to thrive and adapt in harsh environments—both physical and cultural. During this project, I heard many stories of abuse—not only David's, but also people

close to me. I saw how one man turned his story into a vehicle for helping others. He certainly spoke the unspeakable—with grit, bravery, and even humor. And he gave us all a gift. An opportunity to let his story open the hearts and minds of an entire community. We produced art. We produced science. And, most importantly, we started a very hard conversation. I hope it continues.

Rebecca: As a community psychologist, I was trained to *embrace paradox*. When the problems are big, for example, start small. One story. One play. Can one story, one play, transform our thinking about a problem of this size and moral value? I think it can, and now we have data to support this notion.

As the curtain draws closed on this chapter of our professional lives, ripples of the *STB* project continue throughout the community. On January 19, 2017, people gathered in theaters across America, lit candles, and pledged to be a light in our country, to recognize the role of theater in provoking social change, and to stand for those most marginalized among us. At University of Alaska Anchorage, on this date, we ceremoniously lit the lanterns created by the hundreds of people that attended *STB* in Alaska. The lanterns, comprised of messages penned out of anger, fear, and hope, are now a permanent installation in the fine arts building.

Among the messages found on these lanterns were three simple, powerful words for all to see: "Never suffer alone."

NOTES

1. David Holthouse, "Stalking the Bogeyman," Westword, May 13, 2004, https://www.westword.com/news/altitude-tv-back-on-directv-for-denver-nuggets-colorado-avs-fans-11539856.

WORKS CITED

Alaska Children's Alliance. "Empowering Alaska to Serve Child Abuse Victims." Accessed October 31, 2019. http://www.alaskachildrensalliance.org/.

Centers for Disease Control & Prevention. "The Adverse Childhood Experiences Study." Last updated April 2, 2019. http://www.cdc.gov/violenceprevention/acestudy/.

Devries, K. M., J. T. Mak, J. C. Child, G. Falder, L. J. Bacchus, J. Astbury, and C. H. Watts. "Childhood Sexual Abuse and Suicidal Behavior: A Meta-Analysis." *Pediatrics* 133, no. 5: e1331–44. doi:10.1542/peds.2013-2166.

Finkelhor, D., H. Hammer, A. Sedlak, and United States Office of Juvenile Justice and Delinquency Prevention. "Sexually Assaulted Children: National Estimates and Characteristics." US Department of Justice, Office of Justice Programs, Office of Juvenile Justice and Delinquency Prevention, 2008.

Greco, Tony. "Philip Seymour Hoffman's Acting Teacher Remembers the Actor: 'He Was Willing to Journey to Very Complicated Places.'" Indiewire. February 3, 2014. http://www.indiewire.com/2014/02/philip-seymour-hoffmans-acting-teacher-remembers-the-actor-he-was-willing-to-journey-to-very-complicated-places-30403/.

Holthouse, David. "Stalking the Bogeyman." Westword, May 13, 2004. https://www.westword.com/news/altitude-tv-back-on-directv-for-denver-nuggets-colorado-avs-fans-11539856.

Landis, K., ed. Start Talking: A Handbook for Engaging Difficult Dialogues in Higher Education. Anchorage, AK: University of Alaska and Alaska Pacific University, 2008.

Paolucci, E. O., M. L. Genuis, and C. Violato. "A Meta-Analysis of the Published Research on the Effects of Child Sexual Abuse." Journal of Psychology 135, no. 1:17.

Potter, M., & Holthouse, D. (Ed.). (n.d.). Stalking the bogeyman [Play Script]. New York, NY: Daryl Roth Theatrical Licensing.

Whittier, N. *The Politics of Child Sexual Abuse: Emotion, Social Movements, and the State*. Oxford: Oxford University Press, 2009.

CHAPTER SIX

STORYTELLING FOR THE NEXT GENERATION

How a Nonprofit in Alaska Harnessed the Power of Video Games to Share and Celebrate Cultures

Cook Inlet Tribal Council

Snow pummels the village. The people cannot hunt. The blizzard is unrelenting. Seeing that her village is close to starvation, one young girl sets out to discover the cause of the endless storm.

A boy taps the keys of his laptop computer.

Soon, the girl encounters trouble: a polar bear menaces her, chasing her over the snowy landscape—until help arrives in the form of a white fox.

A girl swipes her fingers across the screen of her tablet.

Together, the girl and the fox travel across the tundra, the mountains, and the sea, relying on each other for strength and safety.

A teenager presses the icon in the corner of his screen, opening a window to Iñupiaq culture—and creating a connection to his heritage. Welcome to *Never Alone (Kisima Iŋitchuŋa)*.

Never Alone is a first-of-its-kind video game based on traditional Iñupiaq stories and made in collaboration with the Iñupiaq community. The game launched the first indigenous-owned video game developer and publisher in the United States.

The story behind *Never Alone* is richer and more inclusive than your average video game. What started as a fantastical "what if" grew into a groundbreaking genre of video games and created a new model of sustainability for Cook Inlet Tribal Council (CITC), a tribal nonprofit organization in Anchorage, Alaska.

CITC was established in 1983 and serves Alaska Native and American Indian people in the Cook Inlet region of south-central Alaska through an array of supportive services, including education, employment and training, workforce development, family preservation, and support for those recovering from addiction and substance abuse.

Through education and employment services, CITC serves more than two thousand students annually and is heavily involved in science, technology, engineering, and mathematics (STEM) education. CITC provides students culture-based STEM classes in several local schools and offers additional programs through its fabrication laboratory (Fab Lab), a makerspace where students bring ideas to life with the help of computers and numerical controlled machines.

CITC employment services transition participants from welfare to employment and help others find meaningful or better-paying jobs. CITC also supports families in staying together and promotes the health and welfare of children through parenting and other life-skills training.

And finally, through its recovery-services initiatives, CITC provides comprehensive treatment to assist individuals within all stages of recovery from substance abuse or addiction.

A HISTORY OF SOCIAL ENTERPRISE MEETS A RISKY PROPOSITION

From the beginning, CITC envisioned a future in which its people, and particularly native youth, would have access to vast opportunities, along with the ability, confidence, and courage to advance and achieve their goals. Similarly, the organization's leadership understood that self-determination could only arise from sustained self-sufficiency.

"CITC, in its early days, really acted as an arm of the federal and state government," explained CITC president and CEO, Gloria O'Neill. Throughout most of its existence, about 90 percent of CITC's funding came from government sources. "For CITC to be used in its highest service to Alaska Native people, we needed to figure out how we could become more self-determined as an organization, and a critical piece of that was building a model of sustainability."[1]

As a result, CITC began what has been a long journey in social enterprise, starting with providing a variety of technical services to sister organizations in CITC's nascent years. Over time, the organization expanded into participant-based small businesses that focused on job training and work readiness to allow participants to gain real-life experiences in a supportive environment.

As the organization grew, it charted a new path toward self-determination and decreased reliance on government funding by taking a less-charted path: rather than establishing another socially minded nonprofit business, CITC created the for-profit corporation CITC Enterprises, Inc. (CEI), which would focus on creating additional revenue for funding programs and services through impact-based investments aligned with CITC's values. CEI's goal? To earn at least 50 percent of CITC's funding through self-generated sources.

It wasn't an easy road, recalled CITC executive vice president and CFO Amy Fredeen. "We explored the possibility of investing

in everything from storage businesses to funeral homes. But none of it was ringing true."

At the same time, CITC was closing in on celebrating thirty years of leadership and innovation. Looking to the next thirty years, the CITC board of directors resolved to embrace technology as a tool to preserve culture, engage youth, and advance CITC's mission.

"Remember," the board reminded CITC leadership, "we live in a modern world. We have to pick up the tools of technology to best use them for our people."

"It was important to me," Fredeen said, "to hear the voices of our youth, and help them reconnect with their culture."

Fredeen, who is Iñupiaq, had two teenage boys at home; she saw on a daily basis the struggles they faced growing up Alaska Native. "They don't necessarily have positive images of their people to grasp onto," she explained. "I wanted to reengage youth with how wonderful and how cool the Iñupiaq culture is."

CITC leadership met over a casual lunch and exchanged thoughts on how best to engage youth while preserving Alaska Native culture and storytelling and leveraging technology. In an almost offhand comment, O'Neill remarked: "We should make an Alaska survival video game."

At first, she wondered if the group's silence meant the idea was too crazy, too risky—too unfamiliar. After all, what did a nonprofit provider of social services know about making video games?

Then, the others began to smile. O'Neill's idea *was* crazy. It was definitely risky. It was also brilliant.

Recalling that lunch meeting now, O'Neill has to laugh: "Can you imagine, after saving for as many years as we saved, that we're like, 'We're investing in the video gaming industry?'"

IF THEY COME, WE WILL BUILD IT

"When we entered into this agreement to make a video game, my first thought was, 'How do we de-risk it?'" Fredeen admitted.

"Oftentimes, people think about de-risking as something really conservative, maybe investing in a bond. But for Alaska Native people, you de-risk by bringing good partners to the table."

CITC was embarking on an adventure in an industry about which they knew nearly nothing; it was crucial that the organization find a partner who not only had the expertise to bring their vision to life but one whom they could trust and whose values aligned with theirs. Representatives of CITC began fanning out, attending gaming conferences, talking to people in the gaming industry—searching for the right partner. One name kept coming up: E-Line Media.

An entertainment and educational video game publisher with development studios in Seattle, Washington, and Tempe, Arizona, E-Line is the leading brand for lasting-game franchises that tap into the natural curiosity and passions of gamers. The company had worked closely with leading foundations, government agencies, universities, and social entrepreneurs on impact-focused game projects—and, as a result, had built a solid foundation for its portfolio.

"Tell you what," O'Neill said when the idea of partnering with E-Line was presented to her. "If they're willing to come to Alaska, first week of January, I'm willing to truly engage with them."

Cue the blizzard.

Under one of the harshest storms Anchorage had seen in a decade, E-Line's team arrived in Alaska to talk about a potential partnership. The good news? E-Line loved the CITC mission and believed in it.

The bad news? They wanted to talk CITC out of the video game idea.

"They didn't want us to risk our capital on something so uncertain," Fredeen explained.

E-Line's concern, along with its genuine respect for CITC's mission, immediately earned her trust. The roundtable where she and other CITC representatives sat with the E-Line team was a safe

space that drew out of her a desire to share her Iñupiaq values. The group talked about the oral tradition of the Iñupiaq, how stories have been used through the ages to pass on value, culture, and history. As they spoke, the E-Line team began to see how this tradition of storytelling aligned with the idea of developing an immersive gaming experience. They were inspired.

The last hurdle was board approval. O'Neill and the CITC executive team had come up with a way to fulfill the board's vision of leveraging technology to engage youth, generate funds, and work toward self-sufficiency. But it was still a risk.

"They took it," O'Neill said. "They had the courage to say, 'This is bold.'"

The CITC board saw the connection between video games and the oral storytelling tradition, viewing one as the modern iteration of the other. They recognized how games could reach a tech-savvy generation while also sharing Alaska Native culture and challenging the stereotypes about indigenous cultures Fredeen had seen her boys come up against. The board also perceived the unique ability of video games to allow players to fail in a safe environment and encourage them to keep trying to find solutions to problems.

Based on this perception of games as a venue for developing problem-solving skills and tenacity, the team behind *Never Alone* would eventually decide that their game would be an atmospheric puzzle platformer in which a gamer moves through levels by guiding an avatar through a landscape while solving practical problems and finding creative ways to overcome challenges.

With the green light from the board, CITC and E-Line signed an agreement to cocreate their first project—an innovative video game that could delve into the traditional lore of the Iñupiat people and draw fully upon the richness of a unique culture to create a complex and fascinating game world for a global audience. That game would be *Never Alone*.

BRINGING IN ALASKA-NATIVE PARTNERS

I will tell you a very old story. It is said that a girl lived with her family in a place far from here. One day, a powerful blizzard came. It was followed by another blizzard, and another. The girl's village was no longer able to hunt. Her people faced starvation. But the girl wondered—what could cause the weather to be like this? And so she set out to find the source of the blizzard.

Robert Nasruk Cleveland had told the "Kunuuksaayuka" story all his life. He had received it from his elders and had passed it on to his children before passing away. It was a simple story that held, at its core, many of the same values CITC embodied: resilience, interdependence, respect, accountability. The story of a young Iñupiaq girl who, with a white fox as her only companion, sets out to overcome obstacles and challenges as she searches for the cause of an endless blizzard that has threatened her village with starvation inspired both CITC and E-Line Media.

"Since we wanted to use Robert Cleveland's story as the spine of the game, we needed to go gain the correct permission," Fredeen explained. "But Robert had passed away many years ago. So the story was held by his eldest surviving child, Minnie Grey."

Grey, the keeper of her father's story, not only granted CITC permission to use "Kunuuksaayuka" as the basis for *Never Alone*, but she also taught CITC the importance of storytelling, and how each teller uses the same story for different purposes. The knowledge and guidance she imparted to the game-development team was something they could receive only from an Alaska Native elder. It also reinforced the team's desire to make Alaska Native people active partners in the effort to bring their culture and their stories into the virtual world.

"So there were twenty-four cultural ambassadors," described Fredeen, "and it ranged from very technical advice, like how to use a bola, to very ethereal and values-based advice about why it's important to portray a character a certain way."

By establishing a new collaborative and inclusive development process that included Alaska Native elders, youth, writers, artists, and storytellers in the effort to create a video game based on a traditional indigenous story, CITC made *Never Alone* the first of its kind: never before had there been a game like this, developed in in this way. Members of the Alaska Native community, CITC, and E-Line Media grew into a cohesive, interdependent team that worked on *Never Alone* together for more than two and a half years.

DIMA VERYOVKA

One way in which the participation of Alaska Native people would play a crucial role became evident in the initial artwork developed for *Never Alone*.

"We had E-Line come up and visit again to show some drawings around the concepts of the game," Fredeen recalled. "And they were beautiful. But they kind of looked like Disney [animation]. It didn't reflect us as a people."

"We wanted to make sure the characters reflected our people, the place, the Arctic—that you felt it when you were immersed in game play," O'Neill agreed. "That the colors were right in the sky, that people understood the ice and how it moved."

E-Line heard CITC's feedback and set out to find an artist whose aesthetic would align with what the team envisioned for the game's visual style. Enter Dima Veryovka, a sculptor and designer who grew up in a family of artists in the Ukraine and had created toys and characters for Disney, Mattel, and other companies before launching his career in interactive entertainment. Veryovka had long been interested in native art and mythology, and early in his career, many of his stone and bronze sculptures were heavily influenced by Inuit art.

"He immediately started taking pictures of our traditional sculptures and using it to inspire what the characters should look like," Fredeen said.

As *Never Alone*'s new art director, Veryovka traveled to Barrow, Alaska, several times to meet with Iñupiaq artists, teachers, hunters, and students; he visited the Anchorage Museum to get an up-close look at authentic native art, tools, and clothes. Based on the beauty he witnessed in Iñupiaq culture and craft, Veryovka created a unique visual style, developing artwork that accurately represented Alaska Native people and culture.

"All of this is not normal practice for game development in general, which is why *Never Alone* has been one of the most interesting and creative projects I have ever contributed to," Veryovka said in an interview for the official *Never Alone* blog.[2]

CREATING A CONNECTION TO THE PAST— AND PRESENT

A bold decision was made to not provide narration to the story that provides the framework for *Never Alone* in English but in the Iñupiaq language instead, with subtitles, exposing players to a beautiful language infrequently heard outside of small Alaskan communities. CITC and E-Line envisioned players immersed in the narration, which would recreate for them the powerful experience of being told a story by an elder.

While *Never Alone* is based on a traditional story specific to the Iñupiaq culture, in choosing to use "Kunuuksaayuka" as the foundation of the game, CITC and its native ambassadors had selected a tale capable of reflecting cultural values and ideas shared by all Alaska Native people. To further incorporate Alaska Native culture and immerse gamers in the world of *Never Alone*, the game-design team filmed over forty hours of documentary footage then distilled it down to twenty-six minidocumentaries (or "insights," as the game refers to them), each about one to two minutes long, embedded throughout the game. Each cultural vignette introduces players to an aspect of Alaska Native language, culture, history, stories, and values, enriching the gaming experience to offer much more than entertainment.

For Fredeen, the insights also augmented the purpose she hoped the game would ultimately serve for young gamers like her sons: to provide positive images of native people. *Never Alone* would give young natives an image they could connect to, one that countered the negative stereotypes and imagery of Alaska Native and American Indian people that too often crop up in popular culture. As the minidocumentaries began to take shape, the excitement over their potential to do good was palpable. *Never Alone*, the development team began to understand, could play a part in changing the way Alaska Native youth saw themselves and their own potential.

WORLDWIDE RECEPTION

On November 18, 2014, *Never Alone* was launched for a global audience.

"The reception we received worldwide was unbelievable," said O'Neill. "It was overwhelmingly positive."

Never Alone was, to CITC's astonishment, an instant hit. Initially garnering 2.2 million downloads, the game was the subject of over seven hundred and fifty feature articles and glowing reviews in media outlets like *Time*, National Public Radio (NPR), the *Guardian*, the *New Yorker*, *Forbes*, *PC Gamer*, IGN Entertainment, *Scientific American*, the A.V. Club, Eurogamer.net, and CBC News.

Early PlayStation, Steam, and XBox users consistently rated the game 4.5 or 5 out of 5 stars; millions of players and reviewers created YouTube and Twitch.tv videos about the game. By the end of 2014, *Never Alone* was included on more than fifty video game "best of" lists and was nominated for every major video-game awards program, including Best Debut from Game Developers Choice Awards, Cultural Innovation from South by Southwest, and Best Gameplay from Games for Change.

"Probably the most exciting award that we won was a British BAFTA," O'Neill shared. *Never Alone* was honored with two 2014 British Academy of Film and Television Arts (BAFTA) awards for

Best Story and Best Debut Game; CITC sent Dima Veryovka and *Never Alone*'s Iñupiaq writer Ishmael Hope to London to receive the award.

The following year, *Never Alone* would also win Games for Change awards for Game of the Year and Game with Most Significant Impact.

While the accolades were gratifying, CITC viewed the game's impact as proof that the risk they'd taken had been worth it. The power of the game to reach beyond the Alaska population to affect players worldwide became quickly evident. Suddenly, gamers in England, Ireland, Spain, Norway, Korea, Japan—all across the world—were getting an immersive look at the amazing culture of the Iñupiaq people and a truer image of and connection to Alaska Native people.

"When was the last time a video game told you about a whole other culture . . . and let the people who've lived there speak to you in a generations-old voice?" wondered Evan Narcisse in a review for Kotaku.com. "*Never Alone* does that all-too-rare thing."

"[*Never Alone*] teaches that the preservation of history is its own reward, and proves that video games have as much right to facilitate that process as any other art form," wrote another reviewer for PC Gamer.[3]

The game's popularity continued to gain steam as versions were developed for Macs and PCs; soon, E-Line developed its first expansion called "Foxtales," a new adventure for the *Never Alone* heroes, Nuna and Fox, drawn from another Iñupiaq story called "Two Coastal Brothers." Once again, gameplay relied on players using both characters to work interdependently as they navigated through a puzzle platform that teaches the values of tenacity, collaboration, respect, and resiliency.

Closer to home, the cultural ambassadors who had contributed to the game were thrilled to see the product of their labor. The game was previewed at the 2014 Elder's and Youth Conference and the Alaska Federation of Natives Conference to much excitement

and positive feedback. Nationally, the game crept into wider pop culture as fans began to create and post original art based on their experiences with the game and developed their own cosplay Nuna and Fox costumes for gaming conferences. The game even became the subject of a question on the popular game show *Who Wants to Be a Millionaire?*

Never Alone has served as the foundation of a new video game genre—world games—which would highlight the shared values that tie people together across cultures by presenting traditional stories through the digital medium while remaining faithful and authentic to the people and culture to whom the stories belong.

"We were just so heartened," O'Neill recalled, "that the world was ready to use the immersive power of video games to share and extend culture—that people responded to that in such a positive way."

THE NEXT BOLD IDEA

Meanwhile, back at CITC, the phone started ringing.

"We started getting phone call after phone call," Fredeen remembered. "Not only about the game, but 'How did you do this?' and 'Why did you do this?' There was a hunger for this type of game, and this type of process in the media."

Never Alone possessed the power to spark a movement. Representatives from CITC were invited to copresent at conferences with E-Line to share how they had created a totally new and inclusive process to develop a game reflecting the rich storytelling tradition of Alaska Native people.

"This game has definitely honored my culture," Fredeen described. "I really do think the way it was developed, through interdependence with the E-Line team, and the process we used for bringing voices in, really speaks to the way traditional support systems for the Iñupiaq people are reflected in day-to-day life."

"We need more of this in the gaming industry," O'Neill realized.

"We need more games where people can understand one another, where we can be immersed in somebody's story, someone's culture, and get a glimpse into their way of life."

Never Alone had been a game changer for CITC—a bold, risky idea that had paid off. It had started with a strong partnership between CITC and E-Line Media. And there was potential for this partnership to do more. After a period of collaborative strategic planning, the two organizations concluded that their shared vision would be better realized through the integration of CITC's newly formed video gaming company directly into E-Line. CITC (through its for-profit corporation called CEI) became the largest shareholder in E-Line Ventures.

The move would streamline operations, combine management strength, and spread CITC's investment over a larger portfolio of games and services. One of these games was already underway. *Historia*, CITC and E-Line's second project, is a digital translation of the effective classroom civilization-building board game created by two teachers to inspire their students.

A POSITIVE FUTURE

The positive worldwide response to *Never Alone*, especially from Alaska Native video game players, continues to be a potent measure of success and impact far beyond financial returns. Since initially releasing the game, E-Line has launched *Never Alone* on additional platforms, including Mac OS, Linux, Nintendo Wii U, Sony PlayStation3, and Android NVIDIA Shield; in June 2016, the company released a mobile version, *Never Alone: Ki Edition*, for iOS and Android.

Following the strong reception to *Never Alone*, E-Line has engaged in discussions with cultural partners like the Sami peoples of northern Norway, native Hawaiians, the Roma peoples in Europe, and the indigenous Irish people as it seeks its next World Games project. Meanwhile, the company has identified additional

sectors of the consumer game market in which its approach to meaningful entertainment can help establish lasting value.

The company is developing two design games, including *Fab: The Game*, a game anchored in the future of digital fabrication and materials, in cooperation with CITC, the Fab Foundation, and the MIT Center for Bits and Atoms. In the world of Impact Games, E-Line is developing and raising funds for games that tackle critical global issues, and the company continues to develop learning programs that include workshops, competitions and festivals, and curriculum support.

Today, CITC is the largest shareholder in E-Line Ventures and has significant roles in the management and governance of the company. With the two companies' interests and futures now wholly aligned, CITC's journey toward self-determination through social enterprise is gaining real momentum; the organization is in the process of establishing a fifty million endowment, thanks to its long-term investment in E-Line Media. Though the decision to invest in the video gaming industry was initially a risky one, CITC's bold decision to do so has served to help diversify the revenue generated by its social enterprise companies.

More importantly, *Never Alone* and CITC's investment in video games created a powerful avenue through which to reach and engage Alaska Native youth. To supplement the game and integrate it into classroom lessons, CITC created a curriculum guide for teachers that has been shared with schools across Alaska. The game's impact has reached beyond Alaska Native youth to give other young Natives an image they can connect to that positively reflects their cultures and values.

As one reviewer with Eurogamer, Daniel Starkey, put it:

I'm American Indian, and the fact that my culture and my people are moving closer to extinction all the time isn't something I often forget. . . . I've internalized this casual belief that there's no point in trying to keep traditions alive, because in a few generations they'll

be lost no matter what I do. *Never Alone*'s very existence challenges me. Instead of eliciting self-pity, it stands in absolute defiance of everything that I've grown to be, not only telling me to be better, but showing me how.[4]

When the idea of creating and investing in an Alaska Native video game first occurred to Gloria O'Neill, she and the rest of the CITC team could not have predicted a response like Starkey's. But they hoped their idea would be more than a revenue source. Today, that risk has paid off, creating a funding stream that supports CITC's mission to provide services to Alaska Native and American Indian people, while simultaneously establishing a new way of developing games that explore and share cultures using a model that is inclusive and collaborative and can be replicated.

"We will continue to build out a portfolio of games," O'Neill said, regarding CITC's partnership with E-Line. "I think there's a huge future out there—we're not sure where this investment is going to take us. But I'm pretty excited about the ride."

NOTES

1. Quotes in this chapter not cited with a secondary footnote come from the original staff interviews for the initial video version we produced in-house and related conversations/interviews by our CITC staff, with the subjects. See CITCAlaska, "*Never Alone*: The Making Of," YouTube, November 16, 2016, https://www.youtube.com/watch?v=d9ndBVFrc2U.
2. Dimi Veryovka, "*Never Alone* Interview Series: Dima Veryovka," Never Alone, November 13, 2014, http://neveralonegame.com/never-alone-interview-series-dima-veryovka/.
3. Edwin Evans-Thirlwell, "*Never Alone* Review," PC Gamer, November 24, 2014, https://www.pcgamer.com/never-alone-review/.
4. Daniel Starkey, "*Never Alone* Review: It's Cold Outside," Eurogamer, February 9, 2015, https://www.eurogamer.net/articles/2014-11-20-never-alone.

WORKS CITED

CITCAlaska. "*Never Alone*: The Making Of," YouTube, November 16, 2016. https://www.youtube.com/watch?v=d9ndBVFrc2U.

Dimi Veryovka. "*Never Alone* Interview Series: Dima Veryovka." Never Alone, November 13, 2014. http://neveralonegame.com/never-alone-interview-series-dima-veryovka/.

Evans-Thirlwell, Edwin. "*Never Alone* Review." PC Gamer, November 24, 2014. https://www.pcgamer.com/never-alone-review/.

Starkey, Daniel. "*Never Alone* Review: It's Cold Outside." Eurogamer, February 9, 2015. https://www.eurogamer.net/articles/2014-11-20-never-alone.

TELLING STORIES DIFFERENTLY

Writing Women Artists into Wikipedia

Amy K. Hamlin

February 1, 2014: A sub-zero Saturday evening in Minneapolis finds a small group of art nerds seated around a classroom table in the Regis Art Center at the University of Minnesota. The photograph documents the smiling faces of a Wikipedia ambassador, an art critic, an art professor, a gallery director, and an art history student. As the woman behind the camera, and the representing art history professor, I, too, no doubt wore a smile on my mug. We were hardly a diverse congregation: predominantly cisgender female, able-bodied, and white. The table in the dimly lit seminar room was set with our laptops, one canary-yellow water bottle, several books, and fewer than a half-dozen enormous chocolate cupcakes. Apparently, we meant business.

This group of strangers and acquaintances was summoned the day before via email by the art critic at the table, the inimitable Janet Koplos, a senior editor at *Art in America* and recent transplant

from New York City. The email's subject line read simply: "Wikipedia Edit-a-thon." "What did this mean?" I wondered to myself. I was of course familiar with Wikipedia but had never heard of an edit-a-thon. Intrigued, I clicked on the message. The economy of her call was compelling enough: "We'll figure out the editing process and set some goals for new inclusions or further research on existing Wikipedia entries on women in the arts" (Koplos).

The spring semester was just around the corner for me, and I was looking for ways to invigorate my art history course on Women in Art in the College for Women at St. Catherine University (hereafter, St. Kate's). Not knowing quite what to expect from this Saturday evening gathering, I nonetheless convinced my teaching assistant to join me. Off we went to Regis to participate in the first international Art+Feminism Wikipedia Edit-a-thon.

We soon learned that Koplos's message was in line with the spirit of this grassroots effort. An edit-a-thon is a phrase—a portmanteau of "edit" and "marathon"—that describes an event aimed both to improve the quality of online information and provide participants with training. The Art+Feminism Wikipedia edit-a-thon was initiated January 2014 by four arts advocates based in New York City—Siân Evans, Jacqueline Mabey, Michael Mandiberg, and Laurel Ptak. Their edit-a-thon initiative would focus on "information activism in the realm of gender politics on the web" (Evans et al., 195). At the time, their self-appointed charge was to close Wikipedia's gender gap in participation and content related to feminism and the arts (Wikipedia, Art+Feminism).

Since that evening in early February 2014, the initiative has grown considerably, as reflected in its new mission statement:

Art+Feminism is a campaign improving coverage of cis and transgender women, feminism and the arts on Wikipedia. From coffee shops and community centers to the largest museums and universities in the world, Art+Feminism is a do-it-yourself and

do-it-with-others campaign teaching people of all gender identities and expressions to edit Wikipedia (Art+Feminism).

As this statement suggests, it has grown rhizomatically to produce shoots above and roots below the surface of our popular culture of knowledge. The evidence above ground is apparent in the augmented quality and quantity of Wikipedia articles on artists who identify as women and topics related to feminism and the arts. For instance, in the fifth annual Wikipedia Edit-a-thon, the most recent, nearly twenty-two thousand Wikipedia articles were improved or created as a direct result of this initiative (Art+Feminism, "2018 Edit-a-thon Results").

Harder to quantify, but no less generative, are the roots planted by the scores of new editors recruited to Wikipedia by this initiative. The now well-known 2010 Wikipedia Survey revealed that only about 13 percent of Wikipedia contributors identify as women (Glott et al., 7). This disparity is a problem, especially when you consider that Wikipedia is not only the largest general reference site on the internet, but also one of the most popular. A key achievement of this free resource is, however, also a liability: anyone can edit Wikipedia but opportunity runs close to the winds of social inequality. On balance, women—especially women from historically marginalized groups—have less free time to devote to editing and may feel less empowered to share their knowledge in public spheres. How else does one explain why there are more Wikipedia articles on porn stars than there are on children's book authors? Knowledge with significant bias quickly becomes reified by content producers and gatekeepers from demographics that have power in the privilege of social capital.

I recognize that I am making some specious assumptions in these claims, but in risking essentialism I merely aim to draw attention to the work that must and can be realized through campaigns like Art+Feminism. I also recognize that this is an uncontroversial

argument given my many privileges as an educated cisgender able-bodied white woman. Put a bit differently: How am I complicit in perpetuating participation in a system that has already demonstrated itself to be unequal? In her recent book *Living a Feminist Life*, Sara Ahmed names the difficulty in benefiting from the institutions one critiques. She writes: "There is no way of overcoming this difficulty, other than by starting from it" (263). If we find the system to be truly beyond repair, then we may well choose to start from elsewhere.

For the time being, however, I argue that this is work that advocates well for the arts and humanities. It is work that we can get behind because it shifts the narrative of crisis to one that foregrounds creativity, community, and collaboration. In what follows, I offer episodes that have shaped my experience with Art+Feminism and the ways in which this campaign has forced me to challenge my assumptions about my students and my field of study, to ask new questions of art history, to transform tired pedagogies, and to create alternative pathways for knowledge sharing and production. Ultimately, this work is about and for all of us. So, let us begin here.

ASSUMPTIONS CHALLENGED

April 26, 2014: The photographs show my Women in Art students sitting on the floor and at desks in the small computer lab of the visual arts building at St. Kate's (figures 1–3). None of them look into the camera but rather deep into the screens of their computers; I prompted them to hold their work poses as they edited the pages of the women artists they had spent the semester researching. "I want action shots!" I playfully exhorted. A radius of open notebooks, file folders, and art history monographs frame the computer station of one student, whereas another tucks a photocopied article close to her chest while she types on the laptop resting on her legs. Our intrepid Wikipedia ambassador, the very same who attended the

Figures 1–3. Students participating in the first Art+Feminism Wikipedia Edit-a-thon at St. Kate's, April 26, 2014. Courtesy of Amy Hamlin.

February meetup (and who brought those chocolate cupcakes), tolerates my documentary impulse as he records the names of the artists, those whose Wikipedia articles my students were editing. With most of my students in attendance, plus a handful of peers from arts organizations in the Twin Cities, the turnout was better than I expected. It was a full house.

Earlier in the semester, when I announced to the class that we would host an Art+Feminism Wikipedia Edit-a-thon at St. Kate's in the spring, I was not at all confident that turnout would be high. Because I was a novice Wikipedia editor, I had neither the knowledge nor the time to develop an assignment for Women in Art that would integrate the initiative in a meaningful way. In short, I did not require my students to attend the Saturday afternoon edit-a-thon. At the same time, I believed they should be exposed to the effort and be guided in its most basic principles with the help of emerging online resources and our ambassador, who provided the class with a crash course in editing a few days prior to the meetup. So, I gently encouraged them to attend by appealing to their newfound expertise as well as their sense of camaraderie and hospitality. They had just completed their research papers on a contemporary woman artist of their choice, and I invited them to press that knowledge into service at the edit-a-thon. In keeping

with the democratic spirit of the initiative, I advertised the gathering widely and opened it to the public. I urged my students to think of themselves as scholars in the public arena, scholars for whom intellectual exchange and conviviality go hand in hand.

To my surprise, they showed up when they didn't have to and were engaged in ways I didn't at all anticipate. I'd like to believe that the combined civic and intellectual dimensions of the initiative, while certainly buoyed by the group's good chemistry, encouraged participation. Students saw themselves in a new light, if not for the first time, as producers of knowledge. The frisson of this revelation, on a site where they are accustomed to seeing themselves as consumers of knowledge, is best exemplified in the act of clicking the Save Changes button on the Edit and Edit Source screens of any Wikipedia article. In this gesture, the edits are immediately registered and can be read by anyone with access to an internet connection.

How do we know what we know? In my essay "Approaching Intellectual Emancipation: Critical Reading in Art, Art History, and Wikipedia," I begin by highlighting the epistemological nature of Wikipedia as a powerful deposit of what we know (Hamlin, 105). Given the open structure and participatory mode of the site, students are empowered by the license to shape the discourse of general knowledge. More importantly, they begin to grasp the enormous responsibility that attends that license. Contributors are expected to cite responsibly by synthesizing reliable, published sources (Logan et al., 2).

Although editing Wikipedia is not a place for original research, the editorial process is nonetheless a rigorous exercise in discernment. I train my students to be curators of knowledge they ordinarily would be expected to assemble for a traditional research paper. In the Wikipedia assignment I have since developed and put into practice, I require them to craft an annotated bibliography from which to source their amendments and additions to the article on a notable woman artist (Hamlin, 113–19). Teaching socially

responsible citation practices in this context is especially political, because those practices have the potential to shift, however incrementally, the lines of power in art historical discourse.

ASKING NEW QUESTIONS

January 1971: On the cover of *ARTnews* is a cropped reproduction of the early nineteenth-century portrait of an artist by Marie Denise Villers. The young white woman in the picture gazes at the viewer with lidded eyes, her heart-shaped face illuminated by soft light that filters in through the window behind and slightly to the right of her. She is seated; with her left hand and arm she steadies at an angle an oversized leather portfolio on which rests a sheet of white paper. In her right hand, held in abeyance at her side, she holds what appears to be the slender shaft of an ink pen. Beneath the magazine's sans serif masthead, which hovers at a modest distance above the woman's head, read the words: "Women's Liberation, Women Artists and Art History."

Flipping through the pages of this winter issue is an article by Linda Nochlin. Where a declarative title might have otherwise sufficed, she poses a question: "Why Have There Been No Great Women Artists?" This was a novel inquiry at a moment that crested on a wave of social change at the intersection of civil rights and women's liberation. Nochlin accomplishes many things in this essay via this interrogative mode. Among them is her provocative pivot away from the primary objects of art history (i.e., its paintings, sculptures, etc.) to its discursive, and therefore also political, practices. Her question catalyzed feminist art history and helped invigorate the practice and purpose of the field writ large.

In 2018, a more modest proposal might be to ask: Why aren't there more Wikipedia articles on notable women artists? Rather than "tacitly reinforce its negative implications," as Nochlin feared some feminists might respond, the question must first be interrogated for the assumptions it makes (Nochlin, "Why Have," 148).

The word "notable" is as key as the word "great" was for Nochlin; both terms are seemingly inviolable benchmarks of achievement and, at the same time, products of societal norms that tend to privilege white men. Notability, according to Wikipedia, presumes that the subject or individual has "gained sufficiently significant attention by the world at large and over a period of time" (Wikipedia, "Notability"). This standard is affirmed in reliable secondary sources marshaled as evidence in the article's creation. For example, the self-described "black feminist performance artist" Gabrielle Civil has met this notability requirements for some time, but it was only recently—at an Art+Feminism Wikipedia Edit-a-thon at St. Kate's—that she received a Wikipedia page. Much has changed since 1971, but there is much yet to do.

In my blog post for Art History Teaching Resources Weekly titled "Art History, Feminism, and Wikipedia," I pose a related question, inspired by Nochlin's approach: Could Wikipedia be a new frontier in art history? (Hamlin). As I proposed in the previous section, citation practices have the potential to redraw the lines of power in art history. Within the logic and structure of Wikipedia, this extends to articles devoted to canonical works of art. As an essential condition of modernist painting within the prevailing modernist discourse of art history, Pablo Picasso's *Les Demoiselles d'Avignon* (1907) is one such example. When I participated in the second annual international Art+Feminism Wikipedia Edit-a-thon on March 8, 2015, I noticed that there was no reference to the numerous feminist analyses of this painting in the otherwise well-sourced and abundantly cited article. Writing under my Wikipedia username Hesse1984, I created a new section in the article titled simply "Feminist Interpretation," and I populated it with a trenchant quote from Carol Duncan's landmark 1973 article "Virility and Domination in Early Twentieth-Century Vanguard Painting." As of this writing, this section on "Feminist Interpretation" has been expanded by other Wikipedia editors to include references

to a broader swath of feminist approaches to Picasso's painting (Wikipedia, "Les Demoiselles").

Much has changed since 2015, but there is much yet to do. Troubling hagiographic accounts of great artists brings to mind another one of Nochlin's observations. Writing in 1974, she observed how "feminism forces us to be conscious of other questions about our so-called natural assumptions. That is one way in which feminism affects cultural institutions: it sets off a chain reaction" ("How Feminism," 82). The combined feminist sensibility and iterative nature of the Art+Feminism edit-a-thons ensure such chain reactions, helping to fortify the content of Wikipedia, which has emerged as a powerful cultural institution in the early twenty-first century. But what are the conditions that might dramatically accelerate these reactions? As an educator, I turn to the classroom.

TRANSFORMED PEDAGOGY

1994: The cover of bell hooks' *Teaching to Transgress: Education as the Practice of Freedom* is as distinctive as its contents. Centered within a bright-yellow field is a line drawing of *La escalera*: the ladder. This quotidian object occupies the seventh position in the *Lotería*, the Mexican card game of chance. The green-and-red reproduction of the card is a fitting sigil for hooks' influential book. The ladder recommends a step-by-step ascension, progress earned through a combination of patience and aspiration, intentionality and opportunity. hooks concludes the introduction to her new book, which explores principles of engaged pedagogy in a series of wide-ranging essays, with the following assessment:

> There is a serious crisis in education. Students often do not want to learn and teachers do not want to teach. More than ever before in the recent history of this nation, educators are compelled to confront the biases that have shaped teaching practices in our

society and to create new ways of knowing, different strategies for the sharing of knowledge. We cannot address this crisis if progressive critical thinkers and social critics act as though teaching is not a subject worthy of our regard. (12)

Current educators in the arts and humanities will be well familiar with this crisis narrative, which has acquired new plot points since the early 1990s. Political polarization, the rise of neofascism, the persistence of anti-intellectualism, income inequality, climate collapse, bloated and siloed university structures, the adjunctification of the professoriate, and student debt, to name just a few, condition the crisis narrative in higher education in 2018. For hooks, then and now, the college classroom is a potential site of social transformation if we embrace inquiry-based learning, self-actualization, and vulnerability. What better way to cultivate this "practice of freedom" than through the excitement activated in engaged pedagogy? Easier said than done. In keeping with the *Lotería* ladder as visual metaphor, this approach allows for rise and fall, progress and setback.

A key ingredient to hooks's philosophy is her understanding of the classroom as a communal space in which "everyone's presence is acknowledged" and "excitement is generated through collective effort" (hooks, 8). But what happens if the collective is neither willing nor interested, despite the enthusiasm of a few individual learners? After the initial success I experienced integrating the edit-a-thon into Women in Art, I was met with a cohort that was, on the whole, underwhelmed by the initiative and, to my disappointment, the assignment I had crafted around it. I felt I had tried everything in my pedagogical toolkit to arouse their curiosity, and while they generally did well in the course, the dynamic in the classroom often left me—and no doubt them—enervated and disappointed. What had changed? What might I have done differently?

At the time, I happened to be learning about the artist and

educator Sister Corita Kent, who led a progressive art department in the 1960s at the Immaculate Heart College in Los Angeles. In particular, her ten rules for teachers and students, crafted between 1967 to 1968, inspired me to incorporate the rules into my own classrooms. I piloted the idea toward the end of that disappointing semester by parking time at either the beginning or the end of class to reflect on the rules. After giving students a few minutes to do this, I invited each student to claim one that resonated that day and share their reasons why. Occasionally, I did the same, making myself awkward and vulnerable in the process. The resulting flashes of recognition in the rules generated a social intimacy in the classroom that affirmed hooks's conviction that "students had to be seen in their particularity as individuals . . . and interacted with according to their needs" (7). It also gave new meaning to Kent's first rule, and my perennial favorite: "Find a place you trust and then try trusting it for a while" (1). Although this exercise was in no way a panacea to the reluctance I encountered in that particular cohort, it constituted a step toward creating a communal space in which teaching to transgress might be possible.

This is also a space in which educators must be prepared and open to their students' ambivalence and skepticism. These responses are generally articulated in the critical reflection part of the assignment, following the research and editing process. On the whole, the reflections are generally positive; most students recognize the benefits of the editing initiative. But like many other projects that aim to remedy social inequality, it has its deficiencies that risk undermining the effort and calling it into question. These were brought to my attention early on by C. Zieke, a student who observed the following in their critical reflection paper:

> After realizing how white and male-blurred Wikipedia's knowledge is, I don't know if I can be a good-faith member of that community. I'm torn: half of me wants to fix the site and express female/queer/ POC friendly knowledge, but the other half has already run far

away. This initiative is a feminist one because it has intentionally been laid out as such, but that doesn't mean it's my type of feminism. It may be. I haven't decided yet. (Zieke)

Indeed. Zieke is neither first nor last to scrutinize the amenability of the edit-a-thon enterprise to real social change, and they may well be right that our efforts might be better spent elsewhere. Certainly they were the first to alert me to this insight, which exemplifies the spirit of hooks's engaged pedagogy. Teachers have much to learn too. As hooks observed in 1994, students "want and demand more from professors than my generation did. . . . They want knowledge that is meaningful" (19).

ALTERNATIVE PATHWAYS

March 11, 2017: Two file tote boxes sit side-by-side atop the registration table at the fourth international Art + Feminism Wikipedia Edit-a-thon on the second floor of the Minneapolis Central Library (figure 4). Participants wait in line to register a Wikipedia user account, to collect various sheets of paper that describe the basics of Wikipedia editing, and—by request—to receive a packet of information on a notable woman artist whose life and work are underrepresented on Wikipedia (figure 5). The tote boxes contain over three dozen manila file folders bristling with tabs inscribed with the names of women artists; the file contents include copies of scholarly articles on the artist from books and journals, curriculum vitae, and exhibition reviews. Slipped between the front file folder and the transparent face of the tote boxes is a flier that riffs on Alexander Rodchenko's canonical constructivist image from 1924 titled *Books (Please!) In All Branches of Knowledge*. The clever appropriation retains the overall design of Rodchecko's poster, including the tondo portrait of Lilya Brik, but replaces the Cyrillic text of the original with a simple English imperative:

The idea for these research files, intended to seed edits to

Wikipedia while bridging to the individual interests of participants, grew out of the extraordinary partnerships established in that initial meetup in February 2014. The ad hoc Art+Feminism organizing committee in the Twin Cities has since grown to include representatives from the American Craft Council, the Minneapolis Institute of Art, the Walker Art Center, Midway Contemporary Art, the Minneapolis College of Art and Design, St. Cloud State University, St. Kate's, and the Minneapolis Central Library.

Artists with research files are crowdsourced from the collective knowledge of this committee; files continue to be added and retired as the information within them is filtered, synthesized, and assimilated into Wikipedia at subsequent meetups. The essential step in this process is, however, a relational one. Before an artist's file is selected, an exchange occurs between an edit-a-thon volunteer and the participant to determine what in her experience might resonate with the work of a given artist. For example, a participant interested in contemporary Native American cultures might be referred to the work of Sičangu Lakota artist Dyani White Hawk, whereas a participant interested in modern European textiles might want to learn more about the Austrian designer Martha Alber.

Remarkably, many of the relational methods that attend Wikipedia edit-a-thons recall basic practices of 1960s community organizing. In his *Rules for Radicals: A Pragmatic Primer for Realistic Radicals*, Saul Alinsky asserts: "An organizer can communicate only within the areas of experience of his audience; otherwise there is no communication" (69–70). In this way, the artist's file becomes a potential coin of communication and discovery as the happening that is the meetup is transformed into an experience: "Happenings become experiences when they are digested, when they are reflected on, related to general patterns, and synthesized" (Alinsky, 69). As an analogy to the research process, this transformation fortifies the edit-a-thon as an alternative pathway to an experience that is education. By claiming the place, time, and support for

impromptu research, the production of new knowledge emerges through synthesis.

LESSONS LEARNED AND CLAIMING SPACES

Space is as important to this effort as process. Many Art+Feminism Wikipedia Edit-a-thons take place in elite art spaces such as museums and galleries and risk becoming barriers, however unintentional, to participation. Tacit assumptions informed by long histories of oppression and discrimination about who is allowed in a space, much less access to the experience of research and knowledge production, contribute to a demographic of participants that tend to be educated cisgender able-bodied white women. In recent years, the organizing committee—largely composed of this demographic—has resolved to host more meetups in public libraries and community centers with the intention of cultivating authentic relationships with more diverse participants across race, class, gender expressions, and ability.

The Minneapolis Central Library has become both site and collaborator in this shift, but progress has been slow. Cultivating this partnership and expanding participation will take time as well as sustained effort by individual committee members to expand its association. More than making space at the table, we must reimagine and decenter whiteness and adherence to the gender binary at the table by listening carefully to the counsel and testimony of historically marginalized voices. As the former program coordinator and newly appointed director of Art+Feminism, McKensie Mack holds their cisgender white collaborators accountable while exhorting all editors who identify as women to claim space (Art+Feminism, "McKensie Mack Appointed Director"). Mack had this to say in a 2017 blogpost:

> I'm here because who writes and edits our histories as marginalized people makes a difference in how we perceive the world, how

the world perceives us, and how we perceive ourselves. Access to knowledge is power, but if that knowledge is skewed by a view that says that we don't matter- how can it be useful to us? . . . Art + Feminism seeks to amplify that number [of women editors] by welcoming cis-women, trans-women, femmes, queer women, and women of color to claim space for themselves in the writing and editing of histories and stories, not unlike their own. This year [2017], I proclaim the theme of my work with Art + Feminism to be "Claiming Space."

If this campaign is to survive, it must listen to voices that challenge the systems of oppression and discrimination embedded in cultural institutions and epistemological structures such as Wikipedia. To be sure, it must also be willing to countenance its own uncertain future, if not its own failure.

IN LIEU OF A CONCLUSION

Future date, TBD: If the stories we tell about the past shape our present, then stories we tell about the present shape our future. What are the stories we tell about today? More importantly: Who is telling them? How are we telling them? Why are we telling them? In *Why Stories Matter: The Political Grammar of Feminist Theory*, Clare Hemmings offers a cautionary tale of the amenability of Western feminism's narratives of progress, loss, and return to staid repetition at best and to politically reactionary forces at worst. Rather than endorse corrective strategies, Hemmings attends to the conditions of narrative construction, citation practices, and the politics that have produced these narrative tropes. The point, she argues, is not how to tell different stories but rather how to tell stories differently (16). It seems to me that as advocates of the arts and humanities we have something to learn from this lesson. How might we tell the story of the arts and humanities differently? By turning the interrogative into an exhortation, we would do well

Figures 4–5. From the Art+Feminism Wikipedia Edit-a-thon at the Minneapolis Central Library, March 11, 2017. Courtesy of Amy Hamlin.

also to listen to long-absent narratives. For Hemmings, the point of this work is to introduce to our future some unpredictability (226). How ready are we all to discover something new about ourselves?

WORKS CITED

Ahmed, Sara. *Living a Feminist Life*. Durham, NC: Duke University Press, 2017.

Alinsky, Saul. *Rules for Radicals: A Pragmatic Primer for Realistic Radicals*. New York: Vintage, 1971.

Art+Feminism. "2018 Edit-a-thon Results." May 22, 2018. http://www.artandfeminism.org/2531-2/.

Art+Feminism. "McKensie Mack Appointed Director." July 19, 2018. http://www.artandfeminism.org/mckensie-mack-appointed-director/.

Art+Feminism. "Home" (website). Accessed July 22, 2018. http://www.artandfeminism.org/.

Evans, Siân, Jacqueline Mabey, and Michael Mandiberg. "Editing for Equality: The Outcomes of the Art+Feminism Wikipedia Edit-a-thons." *Art Documentation: Journal of the Art Libraries Society of North America* 34, no. 2 (2015): 195–203.

Glott, Ruediger, Philipp Schmidt, and Rishab Ghosh. "Wikipedia Survey— Overview of Results." United Nations University. March 2010. http://www.ris.org/uploadi/editor/1305050082Wikipedia_Overview_15March2010-FINAL.pdf.

Hamlin, Amy. "Approaching Intellectual Emancipation: Critical Reading in Art, Art History, and Wikipedia." In *Critical Reading Across the Curriculum*. Vol. 1: *From Theory to Practice: Literature, Humanities, and the Arts*, edited by Robert DiYanni and Anton Borst, 104–22. New York: Wiley Blackwell, 2017.

Hamlin, Amy. "Art History, Feminism, and Wikipedia." Art History Teaching Resources Weekly, December 11 2015. http://arthistoryteachingresources.org/2015/12/art-history-feminism-and-wikipedia/.

Hemmings, Clare. *Why Stories Matter: The Political Grammar of Feminist Theory*. Durham, NC: Duke University Press, 2011.

hooks, bell. *Teaching to Transgress: Education as the Practice of Freedom*. New York: Routledge, 1994.

Kent, Sister Corita. "Immaculate Heart College Art Department Rules." 1967–1968.

Koplos, Janet. "Re: Wikipedia Edit-a-thon." Email received by author, January 31, 2014.

Logan, Darren W., Sandal M. Massimo, Paul P. Gardner, Magnus Manske, and Alex Bateman. "Ten Simple Rules for Editing Wikipedia." *PLoS Computational Biology* 6, no. 9 (2010): 1–3.

Mack, McKensie. "I'm So Here for It: A Coming-of-Age Tale about Joining Art+ Feminism." Art+Feminism Tumblr, February 1, 2017. https://artandfeminism.tumblr.com/post/156676795875/im-so-here-for-it-a-coming-of-age-tale-about.

Nochlin, Linda. "Why Have There Been No Great Women Artists?" *Women, Art, and Power and Other Essays*, 145–76. New York: Harper & Row, 1988.

Nochlin, Linda. "How Feminism in the Arts Can Implement Cultural Change." *Arts in Society: Women and the Arts* (Spring–Summer 1974): 80–89.

Wikipedia: The Free Encyclopedia. "Les Demoiselles d'Avignon." Wikimedia Foundation, Inc. Accessed August 5, 2017. https://en.wikipedia.org/wiki/Les_Demoiselles_d%27Avignon.

Wikipedia: The Free Encyclopedia. "Wikipedia:Meetup/ArtAndFeminism." Wikimedia Foundation, Inc. Accessed July 25, 2017. https://en.wikipedia.org/wiki/Wikipedia:Meetup/ArtAndFeminism.

Wikipedia: The Free Encyclopedia. "Wikipedia:Meetup/ArtAndFeminism 2014." Wikimedia Foundation, Inc. Accessed July 22, 2018. https://en.wikipedia.org/wiki/Wikipedia:Meetup/ArtAndFeminism_2014.

Wikipedia: The Free Encyclopedia. "Wikipedia:Notability." Wikimedia Foundation, Inc. Accessed August 5, 2017. https://en.wikipedia.org/wiki/Wikipedia:Notability.

Zieke, C. "Critical Reflection." Assignment for Women in Art, St. Catherine University, St. Paul, Minnesota, May 9, 2015.

CHAPTER EIGHT

POSTER DREAMS

The Art of Protest and Social Change

Ella Maria Diaz

Why would anyone study art in this day and age, when they are repeatedly reminded that it is not easy to pay bills or afford life as an artist, art critic, or art historian? The worries the debate provokes, however, are misleading: art has never been easy and the humanities are not what you *do* for a living; rather, they *are* living. Put another way: art, literature, music, and other modes of creative expression are not recreational hobbies that enhance life's pleasures or quality. The humanities *are* life, and they enact social change through processes of consciousness-raising that counter political and economic forces that undermine all lives, and some more than others.

Like smoke on a cold day or steam from a hot shower, both of which scatter upon contact with cooler air, worries over one's career and economic security dissolve when confronted by the sheer force of humanities work. Moments of profound encounter,

of self-discovery, and of bearing witness to a person, place, or event, jolt the mind adrift amid worrying over immediate and future economic concerns. These profound encounters are the building blocks of stories, which the humanities teach us to craft and share, and it is the sharing of such stories that is the foundation of all human cultures and societies.

For me, working as a humanities professor is about working with people, something I have come to call the art of building relationships—from teaching and mentoring students to working collectively on ideas that transform into tangible projects and enact political change, even at the individual level. I was reminded of what originally led me to study Chicano/a art, (and specifically the murals and silk-screen posters of a Chicano/a arts collective founded in the early 1970s in Northern California), shortly after the 2016 US presidential election.

On Friday, November 11, 2016, students at Cornell University joined college communities across the nation by assembling and marching in protest against the xenophobia, misogyny, and hate speech that characterized Donald Trump's presidential campaign.[1] A student-organized action, the march and rally comprised nearly one thousand students, faculty, and staff.[2] Many of those in attendance were directly impacted by Trump's campaign promises—several of which are now implemented.

I attended the campus protest out of concern for the safety of my undergraduate student who had silk-screened one hundred posters for the event the night before. A simple and one-color poster titled "The People's Walkout," the rough strokes my student used to create the poster's image simulated the quick use of a paintbrush or large-tipped marker in producing protest signs. The words and images on his poster are also surrounded by paint splatters, further imparting a sense of urgency and the anxiety felt by many students following the 2016 election. My student's poster is part of a tradition of protest art that simultaneously enacts resistance to the status quo, or how "things" are in the nation, while

envisioning another possibility—a dream of a future world that is fair, free, and accessible to everyone.

While making posters for a campus protest was nothing new for my student, my presence at the event was new for him because it prevented him from marching on the frontlines. Instead, he hung back and stood with me. As his college advisor of four years, I guided him through his double major in art and American studies, shaping his knowledge of 1960s and 1970s Chicano/a art and that of the Third World Liberation Front strikes in the San Francisco Bay Area—artwork for which we both share a passion and that he finds to be a vital source of comfort and hope as he lives with precarious immigration status. Chicano/a art helps him survive emotionally and psychically. It also sustains his intellectual passions.

My student is "DACAmented," an informal term made popular by students and allies to refer to the status of those who go to school under the Deferred Action of Childhood Arrivals (DACA) program. [3] Although not perfect in scope or execution, DACA allowed my student to be visible as a member of Cornell University, to work for financial support through nonfederal channels, to apply for nonfederal fellowships, and to travel safely. It is not my place to tell his story, but having heard it in detail the day after the presidential election, I was struck by the different paths that led us to study the art of the 1960s and 1970s US civil rights movement, the artists and students who made it, and the sociopolitical dreams their artwork reflects.

Until that day in my office, I never heard an undocumented student's migration story. I stood in solidarity with undocumented students, ensuring their visibility in my classes, listening to difficult issues, and teaching them what I know. But I never implicated myself in their lives by hearing stories of eight-year-old bodies stowed away in the luggage compartments of buses for over thirteen hours; pistols held to their small heads as smugglers shook down accompanying adults for more money; their confusion, exhaustion, and relief when they reunited with family members.

After my student told me his migration story, he concluded that he welcomes the challenges of college because he has a different understanding of adversity than the majority of his classmates. "Write a paper? Read a book? I can do that," he remarked. As I listened to him, I drifted back to my college years—recalling the nights I spent in anguish over never-ending assignments, realizing now, as a middle-aged professor, the luxury of my anguish or, as Michael Olivas more eloquently writes, "the gift and accident of my nationality, conferred on me through no effort of my own."[4] My student and I arrived very differently at the university but, while we were together, we studied, created, and shared knowledge about the art of protest and social change as we pursued the future vision that such artwork represents.

In this chapter, I share my experiences of joining my student at the campus protest and what it means to witness a work of art being made and used in the moment for which it was created. I do so to suggest that the production of silk-screen posters, called serigraphy in the academy, addresses many of the values and ideals upon which the humanities are premised: societal inclusion and enfranchisement, cultural visibility and representation, and, ultimately, what it means to be a human being despite categories of nationality, citizenship, and other statuses that push us farther away from a common humanity.

I make my case by offering a testimonio—a personal story told in a collective mode, which means that it resonates for a community of people because it speaks to larger social and historical contexts and usually the obstacles that occur in one's life through forces beyond one's control: from wars and economic crises to transnational treatise and state and federal laws that control knowledge—or what is remembered about a nation and what is taught to younger generations. I then return to the story of my student's poster and the future world it envisions through the inclusion it offered other students as a shared message and as a collaborative work of art.

WHITE OUT: EDUCATIONAL EXCLUSIONS OF CHICANO/A ART

As a child growing up in a small town in Northern California, I always felt that I existed between two worlds. There was the world of school, classmates, and friends, and, then, there was my world at home. School consisted of lessons on American history and culture—from Plymouth Rock, Ben Franklin, and the American flag to regional histories like the Oregon Trail and the California Gold Rush. Along with classmates, the majority of whom were white, I took field trips to forts and mining camps turned state parks where we wore bonnets, learned to churn butter, and played pioneer. I also recall an imaginative trip to Hawaii in which an inspired fourth grade teacher taped the floor and rearranged the classroom into an airplane that we boarded and watched an in-flight movie before we arrived as tourists in Hawaii. Exiting the plane, we toured the school grounds, and I saw the island's flora and fauna and felt the ocean breeze, despite the reality of being landlocked and surrounded by scrub oaks and the yellow fields of Northern California.

The details of these lessons are lost to old age, but their structure shaped my identity—my "Americanness"—in both space and time. My sense of place in the nation was always far away from me and never *within* me. It was located 2,234 miles to the east of California and in the colonial history of the United States—from the thirteen colonies to the nineteenth century's westward expansion, or the story of *how the west was won*. My teachers "believed that culture always lived somewhere else—never in our own backyard," as scholar José David Saldívar writes in *Border Matters*.[5] Subsequently, my worldview was a mixture of pioneer dreams of the future and tourist encounters of other peoples, places, and things as being totally foreign to me. Both perspectives are rooted in a colonial gaze that is more attuned to the differences—and not the similarities—among peoples, places, and cultures.

Meanwhile, at home, Spanish was spoken on the phone to relatives or at family gatherings. I recall dinners at which my father told tales about the Aztecs—stories that solidified when we visited sites of pre–Columbian civilizations in Mexico during my adolescence. Listening to his stories, hearing Spanish, and being with my extended family during holidays, I felt a profound sense of difference between my worlds: school, classmates, and friends felt like "America," while home and family felt like something deeply private or outside of the American public that I had been taught in school and through mainstream culture's representations of what and who is American on TV, radio, and film.

The split between my worlds defined my intellectual choices, which were never really choices but decisions I made from what was made available to me by teachers who are obligated to meet state requirements for public school education in their lesson planning. I excelled in reading and loved the American literary canon: Nathaniel Hawthorne, Mark Twain, and F. Scott Fitzgerald, among other Anglo-American authors, continued to shape my understanding of the nation and, in turn, my Americanness. While I had some access to Mexican culture and history at home through my family, Mexican American and Chicano/a history, literature, and art were not taught in my public-school classrooms, where a particular cultural vision of American art, literature, and history was definitely taught. Educated in Northern California's public schools, including my undergraduate studies, I did not know of a single Mexican American author, poet, artist, or historical figure. College classes on Chicano/a literature and history certainly existed in the subfields of degree programs, but I did not know how to look for them or, even, to think to look. My lack of exposure to the breadth and diversity of American stories in elementary and secondary school stunted my intellectual curiosity, leading me to passively accept the absence of Chicano/a art, history, and literature in college.

When I decided to go to graduate school, I selected a university

in the US Southeast to study American literature and history because it was at the center—the heart—of the nation's story. A chance encounter with a newspaper article about a Chicano/a mural in downtown Sacramento, California, and the Chicano artists who made it, rerouted my intellectual path in graduate school. Having relocated 2,234 miles away from California in 2000, I discovered that I was a Chicana by studying the art of this particular Chicano/a art collective.

Chicano/a art tells the story of American people who are both essential to the economic prosperity and cultural wealth of the United States and, yet, largely excluded from its mainstream culture and understanding of itself—by which I mean its shared history, media coverage, and the lessons given in public school classrooms. Mexican American histories in the United States are as old as the nation, and there are fifty years of Chicano/a art history—beginning in the 1960s when the term *Chicano* was introduced as a political identity for Mexican Americans through a civil rights movement that coincided with that of African Americans, indigenous peoples, and other racial-ethnic groups excluded from political participation and historical recognition in the United States.

As a field of study, Chicano/a art encompasses poetry, music, theater, and performance, but it is historically rooted in visual art; namely, silk-screen posters and murals that were produced in tandem with the 1960s and 1970s Chicano movement, a multipronged civil-rights platform that called for educational, political, and labor equality for Mexican Americans and indigenous peoples, in addition to land rights. The images and symbols drafted on paper and painted on walls during this movement infiltrated the absence and redressed the stereotypes of Mexican Americans in US mainstream culture and the public-school curriculum that informs the citizenry on who it was, is, and will be.[6] Walls and paper became a central space for Chicano/a artists to talk back to societal exclusions and racist characterizations of their communities.[7]

I don't remember the first time I encountered the American bald eagle and, perhaps, I feel that I have always known the iconic symbol of our nation. Typically set against a red, white, and blue flag, the bald eagle radiates themes of freedom and patriotism to the citizen-viewer. On the other hand, I remember clearly the moment in 2000 when I first encountered the eagle of the United Farm Workers (UFW) union in a Chicano/a mural. Returning to Sacramento during my first break from graduate school, I arranged to meet with the two Chicano artists who had created the mural that I had read about in the newspaper prior to leaving for graduate school. One of the artists, Esteban Villa, pointed out the eagle in his mural. The symbol of the UFW union, the eagle is usually black and set against a white circle on the red flag of the UFW. By shape and design, it is an Aztec eagle, but it also resonates with the iconic bird of the United States.[8] Hidden within a backdrop of Sacramento's city skyline, the UFW eagle that Esteban Villa created in his mural powerfully signifies the Mexican and Mexican American laborers who built the agricultural and transportation industries of the state's capital city. For me, and for so many second- and third-generation Chicanas/os, the UFW eagle is a symbol of pride, of location, and recognition in the United States. While not a farmworker or having grown up in a farm-working family, I experienced a deep sense of belonging to my region of California and to my ancestry by looking at the UFW eagle, a symbol that tells a story about cultural contributions and the convergence of the political ideas of the nation and its marginalized populations.

In addition to readable symbols like the UFW eagle, Chicano/a artists produced an iconography of historical figures through portraiture on posters. Crisscrossing geopolitical borders and space and time, Chicano/a artists and, particularly those from Northern California that I studied in graduate school, emblazoned silk-screen posters with portraits of César Chávez and Dolores Huerta, founders of the UFW union, as well as revolutionary leaders throughout the western hemisphere and local Chicano movement leaders in

California. The collection of readable icons also includes murdered activists like Ruben Salazar, the *Los Angeles Times* reporter who was killed by law enforcement officers during the 1970 Chicano moratorium protest against the Vietnam War. These portraits are a visual shorthand for many viewers, communicating the human rights platforms of the Chicano movement and ongoing social justice campaigns. In the twenty-first century, Chicano/a art is everywhere, whether acknowledged or not, and its visual iconography is not the only significant elements of this distinctly American art. Rather, the formal choices in Chicano/a art abound in visual cultures in the United States, including its mainstream and social media, as well as the concepts taught in university art classes.

WHAT'S IN A POSTER?

Writing about the history of Chicano/a posters, art critic Terezita Romo contends that their content (images, text, colors,) and form (method, medium, material) work on multiple levels of meaning at the same time.[9] The mixture of colors and symbols, like a black and angular eagle set against a red and white background and the given text including words like "huelga" (or strike) and "la causa" for "the cause," disrupts the distinctions we make between image and text, after years of public schooling where we were taught to separate printed words from pictures. Typically, we don't "read" images and, often, we skip over them when reading a textbook. We also practice a reading style that moves from left to right and chronologically. Reading Chicano/a posters, however, is not a chronological process but a simultaneous one, since the titles, messages, and visual components of color, shape, and style create the poster's aesthetic experience. I add that the aesthetics of a poster's message includes the location of the artist, or who and where the artist is, as integral to the viewing experience.

Because we are trained on how and what to read, we only *see* images and, perhaps, their shape or coloring, when looking

at visual art. This is how art becomes an object as opposed to a process. But what about the materials the artist used and how? What about the artist's movements in making the artwork? Who helped the artist create it and where was it made? These questions are typically asked and answered many years later in regard to all visual art. For 1960s and 1970s Chicano/a posters, removed from their original contexts by several decades, they are restaged in art shows that treat them as historical artifacts of a time that has passed.[10] Nevertheless, Chicano/a posters resonate "in the hearts and minds of people today," scholar George Lipsitz writes, because their "dazzling designs and accessible images . . . reflect the imagination and artistry of their creators [and] the practical imperatives of the poster form: to attract attention, communicate clearly, and encapsulate a complex message in a compressed form."[11] Lipsitz explains why, in the twenty-first century, 1 looked at a UFW eagle in a Chicano/a mural and a portrait of slain journalist Ruben Salazar in a poster and felt a deep sense of connection to my ancestry and region, alongside a growing sense of political resistance to the systems of knowledge (public schools, TV and film, social media, etc.) that had denied me this knowledge. 1 am not foreign or different than the citizenry but, rather, 1 am historically rooted in the nation's origin story and the ongoing struggles for visibility and recognition that Chicano/a posters make possible.

Both of the authors to which 1 refer (Terezita Romo and George Lipsitz) are formative Chicano/a art scholars, and their essays appeared in the catalog for ¿Just Another Poster? Chicano Graphic Arts in California (2001). The first institutionally supported Chicano/a poster show in the United States, ¿Just Another Poster? toured university galleries and regional museums, showcasing the artworks of artists from the 1960s and 1970s Chicano movement and the evolution of a Chicano/a aesthetic during the 1980s and 1990s. Largely composed of posters from archival collections that were amassed during the late-twentieth century by university libraries, ¿Just Another Poster? traveled for three years, and the

catalog of the same name continues to provide foundational background and theoretical frameworks for contemporary artists and scholars like me.[12]

Since ¿Just Another Poster?, there have been poster shows at the national level, where artworks once created "for everyday use in homes and offices, on bulletin boards and lamp posts, in schools and community centers" to give voice to "aggrieved communities of color in the U.S." and their "nationalist struggles against colonial domination" are now displayed on white walls and in quiet rooms for individual contemplation.[13] By noting the transition of these posters from the frontlines of protest to the removed spaces of elite art institutions, I do not mean to criticize the collecting efforts and institutional exhibitions of posters made for real sociopolitical change. After all, the efforts to preserve and share such artwork, largely done by trailblazing librarians, is how I was able to access them and learn the stories they tell. But I want to draw attention to the consciousness raising that such posters *enact*, or the experience of bearing witness to a poster used in its intended space and doing the work for which it was created. What does it mean to witness the creation of a poster's message in the moment of its production and to be present for its original purpose?

POSTERS AS INSURGENT SPACE

As Cornell University students assembled for a protest in reaction to the presidential election in November 2016, my student and his friends carried sets of his poster, distributing them by hand throughout the crowd. He looked tired and I asked him when he found the time to make one hundred posters, given that it was the end of the semester and final exams approached. He replied that he finished them in the early hours of the morning. "Part of the appeal of the silk-screen for activist artists," George Lipsitz writes, "stems from its economy and efficiency; it requires no printing press, enables large runs without deterioration of the matrix (the

screen), and can be produced completely by hand."[14]A fast and furious method for art-making, the silk-screen process is positioned by Lipsitz as the center of the artistic creation, or the art object itself; but I wondered about my student, the artist, who drew and cut the stencils by hand and held certain stances with discipline for hours, while intermittently twisting and turning his body and shifting his legs in miniscule degrees to print each poster. This is the *work* of art; this is the artist's physical sacrifice for a purpose greater than one's self.

Elsewhere, I have written about the performance nature of poster production on the frontlines of the 1960s and 1970s Chicano movement, observing how Chicano/a artists set up silk-screen stations in Volkswagen buses, creating mobile art studios that became types of traveling performances. Their on-site poster production mirrored the protests taking place by farm workers during the UFW union strikes in California's Central Valley, and the student walkouts and antiwar rallies in Los Angeles, California.[15] Moving silk-screening out of traditional spaces for art and into farm fields and automobiles, Chicano/a artists identified their art as labor and a form of protest, rebelling against traditional notions of where art can happen. This generation of Chicano/a artists was also as different and unruly as the spaces in which they chose to make their art. No one had invited them to become artists, George Lipsitz asserts, adding that "they invited themselves," using GI Bill funds earned from service in the Korean and Vietnam Wars to attend art schools that were impossible dreams without financial aid.[16] They broke through barriers of class and race in a nation that conscripted their bodies to fight in wars that they would come to ideologically oppose based on growing awareness of the colonial legacies in the western hemisphere, which repackaged histories of empire and expansionism as patriotic messages to fight against the spread of communism. *Chicanas* also broke through the intersections of race, class, and gender by becoming artists during the 1960s and 1970s Chicano movement. Making art for racial and ethnic

equality, Chicana artists challenged the sexism of the dominant culture and that of their communities that enforced a patriarchal tradition of women staying and working in the home.

While not on the outskirts of a farm field or on a city street, but taking place on a college campus, hundreds of students transformed the university into the epicenter of political uprising infused with hope, excitement, and possibility. They created a "movement space," or site of "direct oppositional activity" that Lipsitz claims is essential "for the creation of new kinds of people—activists, artists, and community leaders—individuals speaking clearly and acting confidently, people emboldened by the energy and imagination of the movement."[17] The transformation of university space began with the creation of my student's poster, which, through the production process, begins the oppositional process "where insurgent consciousness could be created, nurtured, and sustained."[18]

My student's visual choices, for example, enabled others to enter the poster, making it their own by merging images with words. The poster's central image is of a person whose race, ethnicity, and gender are purposely ambiguous, and their prominence is further emphasized by their imposition on the poster's title. The person's head cuts off the *t* of *walkout*, and the bullhorn raised to their open mouth seems three dimensional, as if jutting out from the one-dimensional space of the poster to disrupt the visual experience, challenging viewers to *hear* the message. In other words, the poster speaks its title and talks back to power.[19] Framed on the right side by a cityscape labelled "Cornell," the figure is also captioned by two more textual lines: "No More" and "Stand Up For." The captions include underlined spaces, prompting viewers to enter the poster's message and write what they denounce and what they support. By doing so, viewers participate in the poster's message of resistance and simultaneously share in its hopeful vision of a better future.

As the posters moved through the crowd, a student would take one and pass them onto the next person. The movement of the posters was seamless and visually echoed a political call and

response, where people listen to a political call, hear the response, and then join the chorus in the next round. Poster recipients watched and quickly learned what to do next, passing the remaining posters to the next person in line. Pens appeared from pockets and out of book bags, as students knelt on the ground or used each other's backs to write in their own messages. Much like the posters that he *pulled* (a term for moving paper through the stenciled screen in the mass printing of posters), my student's artistic vision was realized as others joined him in the space of the poster—the oppositional space of dreams—and performed a political act by writing in their specific issues and concerns. Allowing others to enter the space of his poster and take ownership of it by creating their own relationships to the text and image, my student enacted the poster's message: The People's Walkout (see figures 1 and 2).

Looking around and seeing his poster in the hands of countless students, I asked my student what it felt like to see so many people with his art in their hands. He smiled as we scanned the crowd and the long line of marchers carrying posters, occasionally making eye contact with students who, charged with the political energy of the moment, glared at us and had no idea why we were looking at them and smiling. The anonymity of the artist whose art and, really, whose labor, they carried in their hands was a powerful feeling and, in that moment, it yielded another layer to the experience of the poster's message. The poster and its maker defied dominant cultural assumptions about who and what an artist is, assumptions that continue to be shaped by notions of beauty as an individual domain, or a solitary genius separate from communities of people and political function. These myths persist despite the reality that most art is made at the crossroads of political uprising and social and cultural change.[20] Labels of "community art," "folk art," and "political propaganda" suggest inferior status for posters that reflect a collective vision—that transcend an artist's individual desires and serve as an abridged version of a complex political platform. Because of the accessibility of the art form,

Figures 1 and 2. Cornell University student protest, November 11, 2016. Photo courtesy of Ella Diaz.

silk-screen posters are also considered amateur by many art critics and museum staff who view them as "too commercial and contemporary to qualify as 'folk art,'" while others regard them as too simple to be modern art.[21] And yet, posters continue to be made, to be carried in protest, and displayed in community centers, or hung on doors, walls, and lampposts, transforming built environments into oppositional spaces and moving people toward a shared goal.

The sociopolitical dreams encapsulated in a poster, however, are not the means to an end or a social balm that soothes and heals the historical wounds of political disenfranchisement and sustained oppression. Consciousness raising is not often a positive experience, with a soundtrack playing "We Shall Overcome" in the background of a sit-in, procession, or rally. It has been reimagined and romanticized in this way, particularly in US popular culture as a means by which to sanitize and, really, anesthetize new generations of viewers who mistake consciousness raising as unadulterated affirmation, or a straight-and-narrow path to empowerment, brimming with feelings of agency and unity. But consciousness raising is often frightening for those who take positions publicly and draw their lines, realizing the risk they are making at their own expense. The risk can be arrest, job loss, and even death. An ugly mixture of alienation, anticipation, and fear, consciousness raising occurs when people put their physical bodies and, more abstractly, their futures on the line for something bigger than themselves.

After the students marched through the campus streets, several young white women grew anxious. The march had culminated in a rally in the arts and sciences quad and I overheard one of the female students, who held my student's poster, ask her friends about the threat of arrest by police. "Are the police here?" "When is the rally over?" Wide-eyed, she looked at her friends who fell silent as they, too, contemplated her questions and felt her concerns, realizing that "oppositional movements ask people to take risks to imperil their security in the present in hopes of building a better future."[22] Her poster, with its "shared cultural signs and

symbols" that draw on "the legacy of past struggles, or the urgency of impending actions," remained firmly held in her hands but was now lowered.[23] The hope of a silk-screen poster's message is only half of the journey to consciousness raising; the other half involves the viewer making the decision to stand with others and to actively build insurgent consciousness by "speaking back to power, subverting its authority, and inverting its icons as a means of authorizing oppositional thinking and behavior."[24]

Familiar with the physical sensations and psychological risks of being an undocumented person in the United States, my student turned to the young women and pointed to other students wearing white armbands. "Those are student ambassadors to the police," he explained, adding that "the rally will end soon and there will be no interaction with the police. We're safe." Let his words sink in; take a moment and mull over the scene that I witnessed: my student who was one of the most vulnerable people at Cornell, and in the nation, offered comfort and support to students who were more than likely citizens and privileged, or have access to the means by which to deal financially and legally with the consequences of exercising their rights to free speech and the right to assembly. In the days following the student protest, I witnessed several moments in which my student and other DACA-mented students comforted their peers and faculty, many of whom were experiencing for the first time the physical and psychological sensations of consciousness raising or the self-awareness that disenfranchised and vulnerable peoples have lived with for centuries.

Art changes the consciousness-raising process that is experienced in the body—the individual and social bodies that define us. Silk-screen posters continue to be made in the twenty-first century because they are an urgent and immediate response to cultural norms and societal laws when both are pushed too far and threaten the lives of some for the maintenance of the status quo. For some US citizens who exert their authority over those of us living, working, and struggling in the nation, art is expected to

be pleasurable and entertaining because the rules and laws of the nation-state make their lives pleasurable and entertaining.[25] But for many others, art and, in this case, the silk-screen poster, is the space of dreams for a future world where their lives matter, where visibility and recognition is shared and democratic, and where life is simply more livable.[26]

NOTES

1. Holly Yan, Kristina Sgueglia, and Kylie Walker, "'Make America White Again': Hate Speech and Crimes Post-Election," CNN, November 15, 2016, http://www.cnn.com/2016/11/10/us/post-election-hate-crimes-and-fears-trnd/.

2. Ryan Ruff, "Students Walkout of Classes at Cornell University to Protest Hate Speech Surrounding the Election," My Twin Tiers, November 11, 2016, http://www.mytwintiers.com/news/local-news/students-walkout-of-classes-at-cornell-university-to-protest-hate-speech-surrounding-the-election.

3. DACA was implemented in 2012 after the introduction of the Dream Act and its failure to pass Congress in the early 2000s. President Obama signed DACA under pressure from undocumented students and organizations that participated in processions, sit-ins, and social-media tactics during his reelection campaign. See Elise Foley, "Obama Administration to Stop Deporting Younger Undocumented Immigrants and Grant Work Permits," Huffington Post, June 15, 2012, http://www.huffingtonpost.com/2012/06/15/obama-immigration-order-deportation-dream-act_n_1599658.html.

4. Michael A. Olivas, *No Undocumented Child Left Behind: Plyer v. Doe and the Education of Undocumented Schoolchildren*. New York: New York University Press, 2012, 3.

5. In *Border Matters* (1997), José David Saldívar explores the consequences of "regional hegemony" or the idea that peripheries of the nation are brought into the center by homogenizing regional particularities through the teaching of one master narrative. He reflects on his education in his hometown of south Texas, which, while very much the center of Saldívar's universe, was also a place "where history began and ended with the master periodizing narratives of the Alamo," as he "learned all the hard facts about regional hegemony and global colonialism's cultures, for culture, my teachers believed always lived somewhere else—never in our own backyard" (160).

6. I reference a stanza from Gloria Anzaldúa's poem "El otro México" in

Borderlands-*La Frontera* (1987): "This land was Mexican once, / was Indian always / and is. / And will be again" (25).

7. Tatiana Reinoza makes this claim in "No Es un Crimen" (2017) in which she considers the role of paper in Chicana/o art, arguing that it became "critical to the dissemination of a counter-information campaign aimed at dispelling racist characterizations by police and the mainstream news media" (240).

8. The Royal Chicano Air Force artists produced numerous announcement posters for UFW boycotts, events, and other actions. The Calisphere site includes an image of a UFW "huelga" (strike) flag made by RCAF member artists Ricardo Favela and Luis González. See, https://calisphere.org/item/ark:/13030/hb0199n93x/.

9. Terezita Romo, *Malaquias Montoya* (Berkeley: University of California Press, 2011), 10.

10. George Lipsitz, "Not Just Another Social Movement: Poster Art and the Movimiento Chicano," in *¿Just Another Poster? Chicano Graphic Arts in California*, ed. Chon A. Noriega (Santa Barbara: University Art Museum, University of California, Santa Barbara, 2001), 72.

11. Lipsitz, "Not Just," 72.

12. Organized by the University Art Museum at the University of California at Santa Barbara, *¿Just Another Poster? Chicano Graphic Arts in California* used posters in collection at UC Santa Barbara's California Ethnic and Multicultural Archives (CEMA). The *¿Just Another Poster?* exhibition was hosted at the Jack S. Blanton Museum of Art at the University of Texas at Austin from June 2 to August 13, 2000; it toured UC Santa Barbara's University Art Museum from January 13 to March 4, 2001. It was also hosted at Sacramento's Crocker Art Museum from June 20 to September 14, 2003. The local and historical center, La Raza Bookstore and Galería Posada, cosponsored the exhibition in Sacramento.

13. Lipsitz, "Not Just," 72.

14. Lipsitz, "Not Just," 82.

15. Ella Maria Diaz, "The Necessary Theater of the Royal Chicano Air Force," *Aztlán: A Journal of Chicano Studies* 38, no. 22 (2013): 41–70.

16. Lipsitz, "Not Just," 72–73.

17. Lipsitz, "Not Just," 74.

18. Lipsitz, 74.

19. Lipsitz, 76.

20. Lipsitz asserts: "Standards of artistic evaluation that separate art from politics do a disservice to both" (83).

21. Lipsitz, 83.

22. Lipsitz, "Not Just," 76.

23. Lipsitz, 76.

24. Lipsitz, 76.

25. I am referring to a November 2016 news story in which Vice President Mike Pence attended a staging of the Broadway show *Hamilton* and, following the performance, the cast addressed him directly. In the days that followed, several news commentators debated the "appropriateness" of the cast's address, and I recall one media personality deciding that the cast was out of line because the vice president had a right to enjoy the show and be entertained. I found this definition of the theater arts—a form of entertainment—misleading and ahistorical, given the history of protest theater in the United States, Latin America, and in Europe.

26. The notion of livable lives for some at the expense of many other lives is an idea put forward by Judith Butler in *Undoing Gender* (New York: Routledge, 2004).

WORKS CITED

Anzaldúa, Gloria. "El otro México." *Borderlands*-La Frontera. San Francisco, CA: Aunt Lute Books, 1987.

Butler, Judith. *Undoing Gender*. New York: Routledge, 2004.

Calisphere. "Flag for Huelga - RCAF - UFW AFL-CIO." UC Santa Barbara, Library, Department of Special Research Collections. Accessed December 10, 2017. https://calisphere.org/item/ark:/13030/hb0199n93x/.

Foley, Elise. "Obama Administration to Stop Deporting Younger Undocumented Immigrants and Grant Work Permits." Huffington Post, June 15, 2012. http://www.huffingtonpost.com/2012/06/15/obama-immigration-order-deportation-dream-act_n_1599658.html.

Lipsitz, George. "Not Just Another Social Movement: Poster Art and the Movimiento Chicano." In *¿Just Another Poster? Chicano Graphic Arts in California*, edited by Chon A. Noriega, 72. Santa Barbara: University Art Museum, University of California, Santa Barbara, 2001.

Maria Diaz, Ella. "The Necessary Theater of the Royal Chicano Air Force." *Aztlán: A Journal of Chicano Studies* 38, no. 22 (2013): 41–70.

Olivas, Michael A. *No Undocumented Child Left Behind: Plyer v. Doe and the Education of Undocumented Schoolchildren*. New York: New York University Press, 2012.

Reinoza, Tatiana. "No Es un Crimen: Posters, Political Prisoners, and the Mission

Counterpublics." *Aztlán: A Journal of Chicano Studies* 42, no. 1 (Spring 2017): 239–56.

Romo, Terezita. *Malaquias Montoya*. Berkeley: University of California Press, 2011.

Ruff, Ryan. "Students Walkout of Classes at Cornell University to Protest Hate Speech Surrounding the Election." My Twin Tiers, November 11, 2016. http://www.mytwintiers.com/news/local-news/students-walkout-of-classes-at-cornell-university-to-protest-hate-speech-surrounding-the-election.

Saldívar, José David. *Border Matters*. Berkeley: University of California Press, 1997.

Yan, Holly, Kristina Sgueglia, and Kylie Walker. "'Make America White Again': Hate Speech and Crimes Post-election." CNN, November 15, 2016. http://www.cnn.com/2016/11/10/us/post-election-hate-crimes-and-fears-trnd/.

HABLAMOS JUNTOS: TOGETHER WE SPEAK

Bringing Latinx Art to Young Writers as Inspiration

Betsy Andersen and Julia Chiapella

When the Young Writers Program staff members Julia Chiapella and Mariah Goncharoff attended a writing pedagogy conference in 2016, one of the breakout sessions caught their eye: a big city art museum in collaboration with a local writing program was highlighting an aspect of a class taught collaboratively at the museum. Because the class focused on the use of artwork as inspiration for writing, they were interested.

THE HABLAMOS JUNTOS PROJECT

Betsy: This type of collaboration was exactly the impetus for the Hablamos Juntos book projects, begun in 2014 as a partnership between Museo Eduardo Carrillo and the Young Writers Program. The organizations are both located administratively in Santa Cruz, California, although Museo's online museum is accessible

anywhere with access to the web. As executive director of Museo Eduardo Carrillo, I am passionate about promoting the work of painter and UC Santa Cruz professor of art Eduardo Carrillo (1937–1997), after whom the organization was named. But bringing awareness to the art has not been enough. Museo wanted to make sure Carrillo's inclusive spirit, his desire to bring everyone along, was also evident.

What's most exciting about the Hablamos Juntos (Together We Speak) project is that it brings the work of contemporary California Latinx artists to Santa Cruz County middle and high school students to use as inspiration for their own narrative writing. The project is based on the Greek tradition of ekphrastic writing—writing that describes a piece of visual art. But what we've done is deviate slightly from the tradition and encourage students to move from interpretation to reflection, writing personal stories inspired by artwork that reflects their cultural lives.

Once presented with a piece of art from Museo Eduardo Carrillo's online museum, our students learn basic art terms and components, make associations, and then connect the artwork to their own lives, attaching inference and meaning to what they see. Students' personal or fictional narrative pieces are then crafted with the help of trained writing mentors. At completion, the writing and artwork are published in a professionally designed and produced, full-color book.

NATIONAL WRITER'S CONFERENCE

Julia: But let's get back to that breakout session.

We sat around a table with approximately twenty other educators who were eager to hear how they might add an additional strategy to their writing pedagogy toolbox. Demographically, it wasn't a diverse crowd. With the exception of an African American man across the table and an east Indian woman sitting to my right, everyone at the table was white and female, a distribution that,

Figure 1. All five books in the Hablamos Juntos series, including the 2019 release, *Art/Work*. Courtesy of the Young Writers Program.

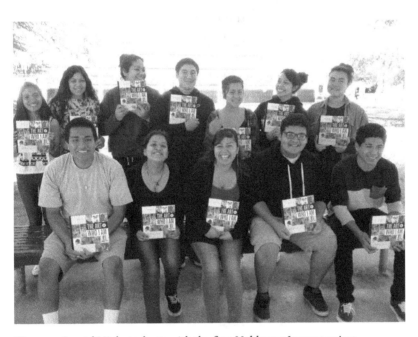

Figure 2. Soquel High students with the first Hablamos Juntos project book, *The Art of Who I Am*, in 2015. Courtesy of the Young Writers Program.

according to the US Department of Education's National Center for Education Statistics (NCES), doesn't reflect the virtually split ratio of men to women in the United States: 77 percent of teachers are women.[1]

The representation at the table did mirror another metric in the report: during the 2015 to 2016 school year "about 80 percent of all public school teachers were non Hispanic White, 9 percent were Hispanic, 7 percent were non-Hispanic Black, and 2 percent were non-Hispanic Asian." In contrast, according to NCES, children of color have been the majority of the US public school population since the fall of 2014. Hopefully, as more students from our diverse communities make their way to college and become classroom leaders, our teachers will become representative of the students they teach. Until then, it is the job of educators to check their assumptions and invite the voices of all members of the community to be represented equitably.

The breakout session was led by a museum staff member and a representative from the local writing project, both enthusiastic about their presentation—a hands-on lesson from their curriculum that was hosted by the museum. Papers were passed out and instructions given. We were to look at the eight thumbnail depictions on the page—all works of art from the Western pantheon. Underneath each thumbnail, a blank line was provided on which to write a caption or title for the piece. We were to look carefully at the pieces of art, imagining the circumstances, extending our thinking. The only elements on the page were the thumbnail representations of the artwork and the lines beneath them; no additional context on the art or artists was provided.

Each of those eight pieces of art was from the impressionist era and depicted Europeans in various leisure and work activities: boating, chopping wood, picnicking, etc. Were this an art history conference, the case could have been made for the choice of artwork: it is worth knowing about impressionism and its rise from

realism, how it led to the impressionistic spinoffs of post- and neo-impressionism and, eventually, expressionism. But this was a conference meant to encourage and engage young minds in the skill of writing, to hone their voices—voices that are often marginalized due to skin color.

"I'm surprised at the artwork they've chosen," I offered, sotto voce, as we were collectively reflecting on our captions for the artwork. My east Indian neighbor leaned slightly in my direction.

"I don't know what to write," she said, with a trace of annoyance, flicking her hand down in the direction of the thumbnail pictures. "None of this means anything to me. I can't relate."

The group continued with the task at hand, creating our titles and ultimately putting up pages on the wall for a "gallery walk." We gathered at the conclusion for questions and comments, and Goncharoff and I were anxious to hear if anyone would speak to what we knew to be a glaring omission on the part of the presenters. At the time, I thought it would have been inappropriate for us to speak up when there were people of color at the table. Advocating for others from a place of privilege requires the ability to step out of the way, acknowledge one's privilege and let others speak their mind. Fortunately, our friend sitting beside me voiced her concerns, repeating what she had told me at the outset and citing the need to depict scenes with which students can identify. We then felt it appropriate to describe the Hablamos Juntos project.

To our delight, we hit a nerve: hands reached for our business cards; the one copy of the book I'd brought was passed around. These educators were hungry for the kind of representation in their classrooms that students could relate to and find meaningful. Beginning with this kind of art-based inspiration, the Hablamos Juntos project seeks to encourage conversations that can generate understanding and lead to cultural shifts. Students' stories need to be told, and artwork can be a catalyst for personal narrative.

Figure 3. E. A. Hall Middle School students receive a copy of their Hablamos Juntos project book, *La historia en la arte*, from Young Writers Program volunteer coordinator Robin Estrin at the program's year-end reading at Bookshop Santa Cruz. Courtesy of the Young Writers Program.

BETSY: EDUARDO CARRILLO AND THE HABLAMOS JUNTOS PROJECT

Considered a "pioneering artist" by Notre Dame University professor of sociology Gilberto Cardenas, Eduardo Carrillo was one of a handful of people of color joining the faculty at UC Santa Cruz in the early 1970s. He was not only a visible presence as a Mexican American artist and professor, but he was also a first-generation youth attaining a higher-education degree, having received both his BA and MFA from UCLA in the 1960s. In 1998, Museo Eduardo Carrillo was conceived by his widow, Alison Carrillo, along with a group of artists, Eduardo's gallerist Joseph Chowning, and some of his University of California, Santa Cruz, colleagues. They had a clear objective: to ensure that Carrillo's art and influential legacy would not be forgotten.

But to have an impact as a museum, Museo Eduardo Carrillo needed to engage the community. In creating the Hablamos Juntos literary project with the Young Writers Program, Museo wanted to build upon the specific legacy Carrillo inspired—what visual artist and MacArthur fellowship award winner Amalia Mesa-Bains called a "cultural reclamation."[2] It was crucial that all students be able to see themselves represented and that the creativity of all cultures be honored.

With the twofold objective of creating community and honoring Carrillo's legacy, Museo sought to understand if and how American Latinx art was being used in countywide middle and high schools. In a conversation with the local arts council, we found it wasn't being used at all. Teachers had easy access to Frieda Kahlo and other well-known artists of the past, but access to contemporary American Latinx artists required a deeper dive. Yet, time was already stretched tight for teachers.

I came to realize there was an acute need to develop and provide materials that teachers could use immediately—especially for middle and high school students—about contemporary American Latinx art. I knew Museo could fill that need. We were already networked into the California Latinx art community through our online exhibitions and participation in national Latinx art conferences.

Beginning with a broadside project in conjunction with local arts advocate Arlene Gotschalk and the Pajaro Valley Arts gallery, Museo developed a series of ten colorful and media-diverse posters. They were designed, printed, and laminated for distribution and available at Museo's site online for free download. In 2014, aware that having resources was only part of the impact we could make, Museo approached the Young Writers Program about combining our efforts to bring artwork and narrative writing into the classroom.

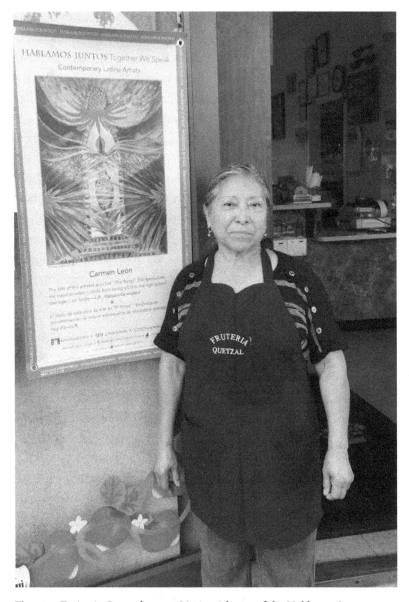

Figure 4. Fruiteria Quetzal owner Maria with one of the Hablamos Juntos posters on her storefront door in Watsonville, California. Courtesy of Betsy Andersen.

The Young Writers Program
History and Impact

Julia: As the executive director of the program, since 2012, I'd created a successful history of embedding trained community members in the classroom to work with small groups of students on their writing. Community members met twice a week with students for six to eight weeks and, at the end of that time, the students' writing was gathered, lightly edited, and professionally laid out into beautifully designed publications. Students and mentors received a free copy of the book produced by their class, which was also available for purchase at our local independent bookshop. Incorporating Museo's artwork into this process seemed a natural fit.

The curated works by contemporary Latinx artists displayed by Museo for students to use as inspiration for their writing not only brought important works by underrepresented artists to teens, but the students were also encouraged to practice "sustained looking" when viewing the artwork. With the support of their writing mentors, this "slow looking" helped students identify aspects of the art that related to their own lives, an especially significant aspect for students of color who don't necessarily see themselves reflected in the culture.

"I'm Mexican and proud of that. I wouldn't change it even if I could," said a student participating in the project who was inspired after looking at the collaborative artwork of Jesus Barraza and Melanie Cervantes *La Cultura Cura*.[3] Also using this piece of art as a springboard for his writing, student Jose Antonio Ortiz reflected on a time he spent in juvenile hall and its impact on him and his family: "I regretted everything I did—I lost my freedom when I was in Juvenile Hall. That's all I could think about on my way to the hall. Being free is everything. That's why la cultura es un derecho humano" ("culture is a human right.")[4]

Writing on the work of Eduardo Carrillo's *The Artist Dreaming*

Figure 5. Eduardo Carrillo, *The Warrior*, 1990. Oil on canvas, 56 in. x 46 in. Courtesy of and with permission of Jesse Bravo.

of Immortality in the House of His Grandmother, high school student Josie Moreno wrote: "My grandpa's farm is this painting. The landscape is comforting, like a hug to me. I don't have to deal with people or technology or busy streets, cars or restaurants. Instead of those sounds, I hear the wind lightly brush the tall grass."[5]

Trained writing mentors working to support students writing were inspired by the program as well.

"As a Latina, who comes from a similar background as most of the students, I find that most of these students (including myself prior to college) have never been exposed to art produced by people of color that replicates our struggles," said UC Santa Cruz student and trained Young Writers Program writing project assistant Yesenia Matias Chavez. "My students have allowed themselves to let out their stories because of the art they've chosen."[6]

Artist Mesa-Bains concurred: "The Hablamos Juntos project is a unique opportunity to bring contemporary Latino art to young people who may know little about it. Engaging youth, particularly Latino and immigrant youth, in looking at and interpreting this art gives insight into cultural material that is in some way familiar to them. Seeing Latino images that deal with personal themes, issues of immigration and labor, as well as memories of community life, opens the door for youth to reflect on their own lives."[7]

The student population in Santa Cruz County's public schools is nearly half Latinx. They come primarily from Mexico and El Salvador. Many of them speak only Spanish at home. Some of them are Dreamers. Local school districts work hard to address the challenges these students have in acquiring the language skills necessary for academic success but students continue to struggle. Classes are large; families living in an area known for its high cost of living contends with myriad challenges, and many students become disenchanted with curriculums they see as having little relevance to their lives and futures.

The National Commission on Writing's "The Neglected 'R'" (2003) defines writing as "an essential skill for the many" that "has helped transform the world." It also points out that writing is "increasingly shortchanged throughout school and college years."[8] A simple truth is that we do not always teach writing in a way that allows students to experience its transformative power. Often we do not provide enough opportunities to experience writing as a vehicle for making sense of themselves and the world around them. As a result, writing is not always viewed as a practice. Rather, in

some classrooms, it is procedure or product. Robert Yagelski (2012) asks what would happen if we dared to view writing as something other than a procedure or product? "What if we understood writing as praxis?" (189).

To consider writing as praxis is to consider what happens as we write—an act equally important for students and writing instructors. Peter Elbow (1973) points out that control, coherence, and knowing your mind are not what you start out with but what you end up with. And while we do not exist because of writing, writing can bring our existence more sharply into focus. Inherently, writing is an act of connecting. When students participating in the Hablamos Juntos project look at artwork that contains everything from brown-skinned people standing proudly among flowering almond trees to more contemporary subjects that reflect the struggle of gang life, they see their culture in all its permutations, beauty, and challenges.

A private/public entity that is a project of the Santa Cruz County Office of Education, the Young Writers Program hoped to address some of these issues. We wanted to give students the writing support and project engagement that could inspire them to become not only enchanted with the writing process but also encourage the reflective and critical thinking that enables students to pursue the process of writing to which Elbow refers.

Modeled after 826 Valencia in San Francisco—a non-profit organization in the Mission District of San Francisco, California, dedicated to helping children and young adults develop writing skills and to helping teachers inspire their students to write—the Young Writers Program began with an in-classroom project, training volunteers in five, two-hour trainings that took place over the school year. The idea was to provide grade 4–12 public classrooms with five to eight trained volunteers. These volunteers would then work with small groups of three to five students for six to eight weeks a couple times a week in hour-long sessions. In 2012 to 2013, the first academic year of the program,

Figure 6. E. A. Hall Middle School eighth grade students celebrate the publication of the Hablamos Juntos project's third publication, *La historia en el arte*, with teacher Rosa Lona (right). Courtesy of the Young Writers Program.

we served one hundred and seventy-five students in seven classrooms and produced four books, a poster, a magazine, and a newsletter. The feedback was positive and encouraging. Teachers like middle school teacher Jessica Olamit, who spoke in front of the trustees of the Santa Cruz County Board of Education, have been consistent in their validation of the program and its impact on students: "The Young Writers Program was one of my students' favorite projects every year," said Olamit. "The volunteers are impeccably trained and created a wonderful bridge between community members and young people in our public schools. It was inspiring to see my students become published authors at the culmination of each project."[9]

By its fifth year, the program was serving four hundred and twenty-five students in eleven classrooms. It had also initiated the Word Lab, an after-school project launched in 2016 in the Santa Cruz Museum of Art & History. Funded in part by a National Writing Project grant, the Word Lab was conceived to accompany the Chamber of Heart & Mystery, an adjacent interactive gallery that acted as an inspirational portal to the after-school site. Additional projects of the Young Writers Program include a dedicated writing room at a local middle school, the annual Personal Statement

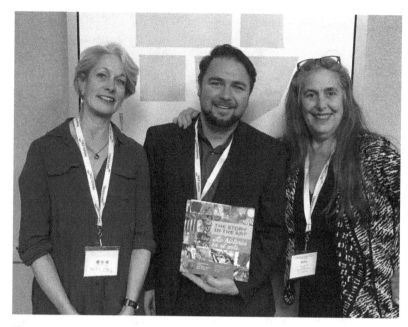

Figure 7. Young Writers Program executive director Julia Chiapella (left) and Museo Eduardo Carrillo executive director Betsy Andersen (right), with principal advisor to the California State Superintendent of Public Education, Jason Spencer. The organizations were receiving the Superintendent's Award for Excellence in Museum Education on February 6, 2018, for their curriculum, Creating Bridges: Personal Journeys Into Art and Writing, based on the Hablamos Juntos project. Photo courtesy Young Writers Program.

Workshop for high school juniors and seniors working on their college application essays, and the Hablamos Juntos project.

COLLABORATING FOR EXCELLENCE

Embarking on its fifth year of collaboration, Museo Eduardo Carrillo and the Young Writers Program received the superintendent's award for Excellence in Museum Education for their curriculum Creating Bridges: Personal Journeys Into Art and Writing. Conceived by the collaborators and developed in conjunction with middle school master teacher Wendy Thompson, the curriculum

Figure 8. An E. A. Hall Middle School student reads her work from the Hablamos Juntos project at the Young Writers Program year-end reading at Bookshop Santa Cruz. Courtesy of the Young Writers Program.

follows and expands upon the Hablamos Juntos series experience, providing teachers with an eight- to ten-week unit, exclusively using American Latinx artwork as the inspiration for personal narratives. The curriculum is also appropriate for use in museum settings.

"Creating Bridges: Personal Journeys Into Art and Writing was created to introduce students in middle and high school to the richness of contemporary Latinx art while tapping into their own thoughtful and personal stories that the art triggers," said Thompson. "The unit includes step-by-step slideshows in contemporary art appreciation and art vocabulary. These give students a language to use when describing how art evokes feeling and can lead to narrative writing."[10]

We noticed the existence of a general perception that teachers seldom have the cross-disciplinary knowledge and pedagogical skills to lead students in the creation of personal narratives inspired by artwork. That's why we developed a curriculum with mini-lessons in both art appreciation and writing.

It became evident that teachers were often as reserved about connecting to the stories in the art as the students. They needed a thruway to guide students on how the elements and images in a work of art, when studied and reflected upon, can remind them of a time, a place, or a memory that's worth capturing in a narrative. Together with the Young Writers Program, Museo decided we could produce a curricular unit that would be adaptable by teachers in middle and high school arenas.

Building on the idea that equity and access are essential for all students and readers, the collaboration between the Young Writers Program and Museo Eduardo Carrillo moved into its sixth year, with an exhibition at Watsonville's Pajaro Valley Gallery funded in part by the National Endowment for the Arts. Local students had the opportunity to see the art used as inspiration for their writing in its original form, extending and validating not only their writing but the notion of the contemporary artists working in the

field with whom they've developed a liminal relationship. "Exposing Latinx youth to the various current artistic practices produced by Latinx artists is imperative to forming a positive identity," said Los Angeles-based art historian Dianna Marisol Santillano. "Their confidence blossoms with the awareness of diverse artistic and cultural productions with which they can identify.[11]

NOTES

1. National Education Center for Statistics, "Characteristics of Public School Teachers," last updated April 2018, https://nces.ed.gov/programs/coe/indicator_clr.asp.
2. Young Writers Program, "Hablamos Juntos: Together We Speak," 2016, i.
3. Young Writers Program, "Hablamos Juntos: Together We Speak," 2016, 31.
4. Young Writers Program, "Hablamos Juntos: Together We Speak," 2016, 31.
5. Young Writers Program, "Hablamos Juntos: Together We Speak," 2016, 37.
6. Yesenia Matias Chavez, personal communication with author, 2016.
7. Young Writers Program, "Hablamos Juntos: Together We Speak," 2016, i.
8. National Commission on Writing, "The Neglected 'R': The Need for a Writing Revolution," *report on the National Commission on Writing: In America's Schools and Colleges* (New York: College Entrance Examination Board, 2003), 10–14.
9. Jessica Olamit, speech in front of the trustees of the Santa Cruz County Board of Education, 2013.
10. Wendy Thompson, personal communication with the author, 2018.
11. Dianna Marisol Santillano, personal communication with the author.
12. Santillano, personal.

"That moment of connection between the viewer and the work of art cannot be underestimated, and goes beyond aesthetics: its potential lies in bringing about a heightened sense of agency and the formation of new perceptions by the viewer," continued Santillano. "If we understand art to have at its core the ability to communicate, it then also has the nature to produce meaning, and these meanings and markers have the power to transform our consciousness. That is the true power of art."[12]

The partnership between art and writing has its own power. As the impetus for the collaboration between the Young Writers Program and Museo Eduardo Carrillo continues to expand, our goal is to reach more students

with more artwork that inspires more writing—writing that equitably reflects all members of our community. We want all students to be able to say, "I see myself represented here."

WORKS CITED

Barraza, Jesus, and Melanie Cervantes. *La Cultura Cura*. Digital print, 20 in. x 29 in. Museo Eduardo Carrillo, 2009.

Elbow, P. (1973). Writing without Teachers. New York, NY: Oxford University Press.

National Education Center for Statistics. "Characteristics of Public School Teachers." Last updated April 2018. https://nces.ed.gov/programs/coe/indicator_clr.asp.

National Commission on Writing. "The Neglected 'R': The Need for a Writing Revolution." *Report on the National Commission on Writing: In America's Schools and Colleges*. New York: College Entrance Examination Board, 2003.

Yagelski, Robert. "English Education." National Council of Teachers of English, January, 2012.

CHAPTER TEN

HUMANIZING AMERICAN PRISONS

Margaret Graham

BACKGROUND: THE TEACHER[1]

I decided to go back to graduate school to pursue my doctorate after working for over a decade as an adjunct instructor and academic administrator. Like many graduate students, this meant trying to find a balance between having enough time to write my dissertation and having enough money to pay my tuition and support my family. So, in my final year, I took an adjunct position for a liberal arts college in another state. The position sounded intriguing: college preparation and tutoring for students incarcerated in a maximum-security prison for men.

I was not unfamiliar with prisons: my father was a prison guard while I was growing up. It is not surprising that his work-related horror stories were a lens for my world in formative ways. He complained of inmates throwing bodily fluids at him, "acting up" after days of solitary confinement, scheming to hide contraband, and lashing out at guards. His stories were filled with violent, despicable

"animals" (mostly black, Latino, or homosexual men) whose sole purpose was to harm "good," "decent" people like ourselves.

I am ashamed to admit that my father's bigoted viewpoint informed my perspective in my early years. I parroted my father's beliefs about the world as other children did. After he left my daily life, I actively sought to deprogram myself. Fortunately, my education included courses in humanities that forced me to recognize my biases. These insights led to my lifelong commitment to social justice and equality, culminating in my career in education. I passionately mentor and support my students in part because I am far too familiar with the types of biases they face on a daily basis.

Like most people outside the prison world, for years I drove by numerous secure facilities in my area without a second thought to their residents. County jails, state prisons, federal penitentiaries dot our landscapes as familiar structures we never enter. The colleges I worked for filled my campus classrooms with students on my behalf. I only sought out prison classrooms out of financial necessity, and given my background, I was sure I could handle the challenges of teaching in a prison.

Still, I was hesitant as I drove up to the prison for my first day of class. The orientation by the prison focused on "games inmates play" to subvert staff attention from safe containment practices. While the college course instructors do not know the criminal histories of individual prisoners, the staff assured us our classrooms in the maximum security prison would be filled with rapists, murderers, drug lords, gang members, and child molesters. We were not allowed to have physical contact with inmates at any time. Guards were posted outside our classroom doors and frequently checked to make certain the inmates and instructors were adhering to the protocols.

There were eleven gates between my car and my classroom: matte gray or black-painted bars that rolled open as I waited and clanged shut behind me. There was even a stout, unsmiling guard with a large brass key to open one of the doors I would have laughed on my first day if I hadn't been so nervous.

CAST: THE STUDENTS

Who were my students? Why were they in my classroom? I asked them these questions the first day, opening my discussion-based class the same way I would a campus course. I was not seeking the details of their crimes; rather, I was asking them why they had chosen to apply for the college program. The responses from the prisoners were illuminating.

For those with little hope of release, it was a simple: "I don't want my brain to rot" or "I want to make my children proud of me." Those who would be released in the coming years said, "I want to prove that I am worth something" or "I want to better myself so I don't make the same mistakes when I get out of here." They saw education as a way to change the perceptions the world has of them and they had of themselves. Most of them had never set foot on a college campus. For many, this college prep course was their first experience with the humanities and interaction with people outside their family. It would also be the first time in a long time they would be allowed to feel human again.

The perception of "the prisoner as inhuman" is one that was not only presented by my father and the prison orientation leaders, but it is also confirmed as pervasive in twenty-first century North American society. Justin Piché and Kevin Walby (2010) have noted that "dominant stereotypes of prisoners as predatory animals in need of incapacitation" (574) pervade the public's view of incarcerated individuals. Yet, in my daily experience, my prison students gave me no cause for alarm; I saw no signs of the "animals" I was warned of. On the contrary, my students were eager to learn, attentive, and well prepared for class. With no access to electronics, they stayed focused on their learning in class. They were polite and respectful, almost to a fault, and it took weeks to earn their trust so I could give them feedback on their assignments. When I discussed my rejection of the stereotype with one of the counselors in the prison, he assured me that I was mostly wrong and it was

only because I was seeing the best of the prison population that I held this skewed impression. I did not believe him.

I designed my college prep course to help students with a high school diploma or general equivalency degree (GED) get ready to take college courses, specifically those offered by the liberal arts college that hired me. The majority of the students had graduated high school or earned their GED years ago, and few of them had participated in the rigorous academic preparation seen in the top secondary schools that typically send students to this liberal arts college's physical campus. While few of the incarcerated students will ever visit that campus, the college administrator's goal was to offer the same courses in literature, history, sociology, political science, mathematics, and other academic fields to the students at the prison. She believed higher education could be a means of mitigating the damages of mass incarceration in the United States.

I decided to use entry-level humanities texts such as short stories, essays, and poetry as the groundwork for the course. At the end of the college prep course, the successful student would be able to understand basic and critical comprehension of college-level texts and demonstrate that understanding through discussion, written responses, and summaries. They would compose well-structured essays that show mastery of organization, focus, and development. And we would revise writing to include standard English grammar, syntax, diction, and spelling.

The course met once per week for fifteen weeks for two-and-a-half hours and students who passed the college prep course (about 80 percent finished) were allowed to take any of the liberal arts courses the next semester. I also ran a tutorial one night per week where students from any course could get support on their academic work. These tutorials were less structured and included ample time for one-on-one feedback on essays and homework. Over time, the students came to understand something very important; namely, that my role was more as a mentor and a guide than a judge.

Humanity started on the first day of class with a basic statement of self. For years, I have asked students to write their names on tent cards and place the cards in front of them so that their classmates and I could remember them. But in prison, this simple task immediately became something else.

"What name should we write?" my new students asked.

"Write the name you wished to be called in this classroom," I responded. I randomly selected a green marker from the rainbow pack I had brought in with me, scrawled "Maggie" on a tent card and perched it on the chalkboard's tray.

"First name or last name?" they asked me, peering at my tent card.

"Whatever name you want us to use," I replied.

"Even if it is not our real name?"

"Whatever name you want us to use," I repeated.

"Do we need to put our ID number on it?" they asked.

"No." I told them.

They examined the markers. "What colors can we use?" I did not realize at that point that use of color was so closely dictated within prisons. In this case, green was a prisoner color, blue was a guard color, and red and black were often gang-affiliation colors. (I learned about color-coding later from a prison counselor.)

"You can use any colors you like," I replied. Slowly and with many sidelong glances, the new students named themselves. The tent cards revealed a mix of first names and surnames, with a few obvious nicknames here and there, in a variety of colors.

I proceeded with the first day of class, using the names they had chosen and asking them to do the same for me. Their homework for the first week included the Henry Louis Gates Jr. essay "What's in a Name?" (2012), a compelling vignette on the power of names. Later in the term, our discussion cycled back to names and the meanings of names. By then, the students could talk about why they struggled using my name, often calling me "professor" out of fear of sounding disrespectful, despite the fact that I asked them

to call me "Maggie." (They eventually settled on "Miss Maggie" as a compromise between my preference and their valid concern that using just my first name would sound overly familiar and thus cause friction with the guards.) As relationships and classroom dynamics evolved, a few students changed the names on their tent cards or stepped forward to ask us to call them new names—names that were more personal, more meaningful, more truthful to them. And at the end of the term, many of the students even asked to keep their tent cards as mementos of the course.

This exercise, which had been a simple, standard mnemonic in my teaching toolkit for many years, was utterly transformative in prison. For the first time, I observed the stark difference between asking students to give me their names and asking them to name themselves, and how those names that they had chosen to respond to empowered them, or not, in this setting. For many of the students, the name they were called in the classroom came to represent a nascent life of the mind that they had chosen to pursue. These names became badges of honor and identified those who began to define themselves as individuals in relationships removed from normal prison life. One student, who had a male name since birth, decided to move forward with a female name and presentation for the first time in her life. I was honored to be one of the first people she asked to call her "Victoria," and I remember her beaming as she made herself a new name card. She chose the name because it represented her victory over tremendous obstacles in her life. With her permission, her choice also led to fascinating and frank classroom discussions about gender and identity in prison and in the outside world. When last I saw Victoria, she was about to be released from prison and sent to a homeless shelter during her probation. We talked about how her experiences in prison and in her college courses prepared her for life ahead. I think of her often, though we have no means of contacting each other.

One of my favorite moments came at the midpoint of the course. I put the William Carlos Williams poem "The Red Wheelbarrow"

(1923) on the board, and I asked the students to create a detailed record of their entire thought process as they analyzed the poem. At this point in the exercise, my campus students used to roll their eyes and take up their pens. But my prison students didn't.

"What is it?" they asked.

"It's a poem," I told them. They looked dubiously back and forth between the poem and me. I asked them to trust me and reiterated that the point of the exercise was to record all of their thoughts during the analysis. So, they tentatively began to write. As I watched, one-by-one, they began to put aside their preconceptions and grapple with the exercise. Slowly, they wrote their first thoughts: "Is this really a poem?"; "I don't get it"; "Why is Maggie having us do this?"; "This is a waste of time." They looked to me: "Would the exercise end soon?" I shook my head and asked them to keep working. They looked at the poem again. And somewhere during these cycles, they started to think about what could be beyond the spare words on the page. They began to pick apart individual words and thoughts and connect them to concepts outside Williams's vignette. Their writing picked up speed as one by one the sight of the poem and the sounds of other pens scratching out thoughts and meanings on paper inspired them.

And suddenly a whole world opened up: beyond the superficial interpretations of words and actions, they discovered deeper layers of meaning and connections that they had never seen before. They learned to open their eyes in a new way, to embrace ambiguity and paradox, to start exploring cognitive dissonance, and grow from all of these experiences. After the exercise and without any prompting from me, they started to share their own poetry and prose to discuss with their peers. Several were working on books based on their experiences. One man brought me a chapter of a manuscript that he was working on and asked for edits. Another brought in drawings he had made: illustrations from scenes in books that he had read, and talked with the class about the symbolism and the importance of interpreting readings into a visual form. My

students started to understand that education and learning are part of humanity and humanness.

When I began teaching in the prison, I thought I understood my job: I was to help incarcerated students get ready to take college courses. But that was not all of what I did. I treated my students like humans, like students. I listened to the parts of their stories that they wanted to share. I did not offer treatments or therapy, but sometimes in the midst of building critical-thinking skills, students gained insight into their own experiences. They looked back at their experiences and identified logical fallacies they used in the past, and they structured appeal to their lawyers using the sound arguments we worked on in class. They made decisions about how they wanted to move forward in their lives in ways that embraced the values they had selected and explored in our classroom. Despite their initial reluctance, the prisoners built interpersonal connections to one another as they discussed academic material. I came to the conclusion that, yes, these skills and connections, as discussed by Howard Gordon and Bracie Weldon (2003), might very well lie at the heart of the decrease in recidivism seen in prisoners who participated in college education during their incarcerations (206).

SETTING: THE PRISON SYSTEM

According to Nick Haslam (2006), one method of dehumanizing people is to deny characteristics that make them uniquely human, including "civility, refinement, moral sensibility, rationality, logic, [and] maturity" (257). By rejecting or minimizing these attributes in individuals or groups of people, we allow ourselves to think of them as less than humans. Once we believe they are subhuman, we give ourselves permission to treat them inhumanely.

The prison system tells inmates that they are animals. While the official mission statement of the Department of Corrections focuses on the inmates' needs and treatment, in the eyes of the guards, the real mission is punishment. Strip searches and shackles

are required for safety. Referring to the daily meals as "feed runs" does not enhance safety, nor does reference to inmates by counselors and guards as "morons" or "assholes" (as I witnessed repeatedly). Guards openly discussed "a good kill" when an inmate died while being moved in restraints, noting that the guards involved were "blameless." One officer even mimed shooting a would-be prisoner while snarling: "Are you speaking fucking Arabic to me?" Everywhere you looked, there were orders stamped on every surface— "Staff only" on the drinking fountain, "No talking"; "No standing in doorways"—all accompanied by the number of the conduct code that states inmates must obey staff.

I found myself staring at the drinking fountain one evening as I waited at the last gate before my classroom. The "Staff Only" sign hanging just above the fountain had faded but was still clearly legible. I wondered who had hung the sign and who would replace it. A guard? A "civilian" administrator? A prisoner? My stomach clenched as I thought of the thousands of "Whites Only" signs that marked our shared history in the United States. I asked the two or three guards standing there what they thought of the sign, wondering if they could see the parallels to the Jim Crow laws of the mid-twentieth century. They looked down, away from my eyes, and muttered something about rules and safety. They seemed relieved when someone came with the key to let me into my classroom.

Some of the guards actively tried to discourage me from continuing to teach. They explained in great detail how they felt about the college courses at the prison. They claimed they were angry that the instructors put themselves in harm's way by teaching prisoners "who were only waiting for opportunities" to rape us. "And for what? To talk about stuff like that?" referencing the dog-eared copy of *Moby Dick* I carried.

The guards denied they were envious because they themselves often lacked a college education. "Why would I spend money on learning stuff like that?" they asked, pointing to the poetry anthology in my work bag. They wanted to know where the money for

the program came from. When I told them private donors and philanthropists provided funding, the guards scoffed and mentioned a litany of groups that were more deserving of education. They wanted to know if I was paid or a volunteer. "You must be paid. Why would anyone volunteer to do this?" they demanded. I nodded that I was paid and wondered to myself if I would volunteer for this work. They asked me what my husband thought of me working with prisoners. They repeatedly told me that no matter how unattractive a woman was, the inmates would view her sexually. Subsequently, any female instructor must enjoy being the object of such attention. They tried to scare me with purportedly true stories of civilians and guards who were manipulated and assaulted by prisoners. I answered their questions and listened to the guards' stories calmly, using my training and personal history to remain an objective observer despite their lines of reasoning. My calmness confounded them and caused some to redouble their efforts.

My students would rarely speak of a guard who had shown particular sensitivity to a prisoner's situation. One told me about how he had requested compassionate leave to visit his dying father. His request was denied and he was consumed by guilt and depression. A few days later, a guard called him out of the exercise yard and into an empty stairwell to tell him that his father had died. Grief-stricken, the prisoner sat on the steps and dissolved into tears. Rather than immediately return the prisoner to the exercise yard as protocol required, the guard let him cry in private, away the eyes of the other prisoners and the guards in the yard. "That guard sat next to me in the stairwell" until he was able to collect himself, my student told me. He had thanked the guard surreptitiously afterwards, he said, emphasizing to me the caution necessary to acknowledge such a human gesture.

Few of the guards seem to recognize that the dehumanization process cuts both ways. Sunny Schwartz and Leslie Levitas, who were correctional officers themselves, noted: "The nature of the

prison system encourages each of us to take sides and dehumanize everyone on the other side" (38). They described the process of preparing correctional officers as "training for the monster factory" (38) that focuses on personal and institutional defense rather than understanding human perspectives. By treating prisoners with brutality and contempt, as animals just waiting to pounce on their prey, the guards demonstrated the very uncivil, immature, illogical, and instinctive behaviors they ascribe to the prisoners. Yet the guards were rarely held accountable for their actions in the prisons (Jeffrey Ross, Richard Tewksbury, and Shawn Rolfe) and only held accountable outside the prison when their paramilitary brothers in law enforcement deemed the crimes sufficiently heinous. Thus, the cycles of violence and dehumanization spread far beyond the walls of the prison to the communities and to society at large.

Of course, the brutality in the prison is rarely discussed. My prison students dodged both guards and the other inmates who were jealous of those who have earned the privilege of enrolling in college courses. Students of color and those convicted of pedophilia were particularly seen as "undeserving" and singled out for harsh treatment. Every interaction was a chance for guards to impress their power on the prisoners. For their own safety, inmates learned to avoid eye contact, smiling, expressions of individuality, or indications of weakness. The prisoners developed deep camouflage to avoid attracting the attention of the guards or fellow prisoners.

Many of my students lost that camouflage when they decided to take college courses. They were outed by their presence in the line for college classes after meals, or their textbooks in their cells, or by their choice to work on homework rather than watch television. They were targeted because they were suddenly viewed as a threat for trying to better themselves. They were beaten and harassed, their books were stolen, their homework intentionally destroyed, all for choosing to get an education. Some students dropped out of the college prep course, unable to cope with the loss of anonymity.

Others held on. Their commitment to their education in the face of abuse inspired me to continue teaching courses about what it means to be human through the humanities—work I love despite the toll it takes on me.

ACTION: EXPECTATIONS AND TODAY'S PRISON REFORM

Neal Lester, dean of humanities at Arizona State University, once said: "The humanities address the question of what it means to be human and how we, as humans, interact with each other." This idea was at the core of my work with the students at the prison. While college preparation and college courses deal with content such as grammar, composition, literature, philosophy, and history, they also challenge our students to examine the concept of humanity in the materials we present to them.

The development of a critical mind does not begin or end in a classroom. Once their eyes and ears and minds were opened, it was difficult for some students not to turn those same skills to analyzing their daily existence in prison as well as their futures. Their poetry and artwork alluded to a wider world of literature while reflecting the limitations of prison life. Their letters to various corrections officials and appeal boards relied on Aristotelian rhetoric to elucidate the long-term and far-reaching dehumanizing effects of incarceration. They encouraged their friends and families to attend college so that not only could they too understand the freeing power of education but also because these newly minted students craved intellectual connection to those they cared most about.

What does the future hold for the humanities in prisons? College courses and degrees for prisoners were prevalent in American prisons prior to the Violent Crime Control and Law Enforcement Act of 1994. As part of that legislation, incarcerated individuals were no longer allowed to receive federal student aid in the form

of Pell Grants. Most college programs in prison relied on Pell funding and were forced to close after the mid-1990s. In 2016, President Barack Obama's administration opened a three-year pilot program of sixty-seven colleges across the United States to access Pell funding for prisoners. While the results of the pilot will not be available until after 2020, given Donald Trump's positive rhetoric on increasing incarceration, it is unlikely that the pilot will be renewed or expanded. This is why other means of human outreach to prisoners are necessary now and will be necessary for the foreseeable future. Programs such as college education, reading groups, poetry circles, and debate clubs will need private funding to continue their missions of stimulating critical reading, writing, and speaking. Changing and humanizing our response to the prison industrial complex will require innovation and energy from a broad variety of people (Michelle Alexander) as well as social justice reformers, grassroots movements, and researchers (Tim Goddard, Randolph Myers, and Kaitlyn Robison).

ENCORE

In a place filled with hatred, loneliness, oppression, fear, and the dehumanization of both the prisoners and the guards, little is needed as much as the balm of humanity. The beauty of a well-phrased description, a well-reasoned argument, a shared connection over the enjoyment of ephemeral moments soothes souls in ways no regimented treatment can. Humanities education in prison brings meaningful changes to both incarcerated individuals and their communities. As academics, we need to support these programs not only in spirit but also with our most precious resource: our time. If we truly believe that "addressing what it means to be human" is a worthwhile venture, we must take that message not just to our conveniently available college students but also beyond our campuses to the dehumanized people among us who might never hear the message otherwise.

NOTES

1. For privacy reasons, names of institutions and individuals have been omitted from this narrative as much as possible.

WORKS CITED

Alexander, Michelle. *The New Jim Crow: Mass Incarceration in the Age of Colorblindness*. New York: New Press, 2010.

Gates, Henry Louis, Jr. "What's In a Name?" In *Patterns for College Writing: A Rhetorical Reader and Guide*. Edited by Laurie G. Kirszner and Stephen R. Mandell, 2–4. Boston, MA: Bedford/St. Martin, 2012.

Goddard, Tim, Randolph R. Myers, and Kaitlyn J. Robison. "Potential Partnerships: Progressive Criminology, Grassroots Organizations, and Social Justice." *International Journal for Crime, Justice and Social Democracy* 4, no. 4 (2015): 76–90.

Gordon, Howard R. D., and Bracie Weldon. "The Impact of Career and Technical Education Programs on Adult Offenders: Learning Behind Bars." *Journal of Correctional Education* (2003): 200–9.

Haslam, Nick. "Dehumanization: An Integrative Review." *Personality & Social Psychology Review* 10, no. 3 (2006): 252–64. doi:10.1207/s15327957pspr1003_4.

Lester, Neal "Humanities Tell Our Stories of What It Means to Be Human." https://asunow.asu.edu/content/humanities-tell-our-stories-what-it-means-be-human 2012.

Piché, Justin, and Kevin Walby. "Problematizing Carceral Tours." *The British Journal of Criminology*. 50, no. 3 (2010): 570–81.

Ross, Jeffrey I., Richard Tewksbury, and Shawn M. Rolfe. "Inmate Responses to Correctional Officer Deviance: A Model of Its Dynamic Nature." *Corrections* 1, no. 2 (2016): 139–53.

Schwartz, Sunny, and Leslie Levitas, "A New Vision for Correctional Officers." *Tikkun* 27, no. 1 (2012): 37–40.

Williams, William C. *Spring and All*. New York: Contact, 1923.

TOWARD A BROADER HUMANITY

Expanding Partnerships and Shifting Paradigms

THE HUMANITIES BIOSPHERE

New Thinking for Twenty-First Century Capitalism

Susan M. Frost, M.A.

Change in the twenty-first century has cranked to warp speed. The 105-year distance between the first and second industrial revolutions shrank to fifty-five years between the second and third. The third began in 1969, and the fourth, sometimes titled Industry 4.0, is simply dated as "today."[1] Finding our way through this vertiginous environment presents an unprecedented challenge. Data, even if a month old, is dated. Added to this mix is a super-sized millennial generation, our emerging workforce that brings a revolutionary perspective calling for change, for collaboration, for justice, and for new value systems. We may be up for a choice: change or die. If, as Albert Einstein is attributed to saying, "we cannot solve our problems with the same thinking that created them," what does a new thinking paradigm look like?[2]

This, I would argue, requires an entirely new business perspective. What if we turned our approach to leadership and business

on its head and, instead of thinking of separate disciplines, considered a comprehensive method, one that didn't foster discipline silos; how would we approach this brave new world? I propose an even more heretical challenge: Thinking Through the Humanities, a biosphere within which all other disciplines function.

"Are you anticapitalistic?" the dean of the business school asked after reading my syllabus for Humanities, Business & Critical Thinking, a course taught in the letters and sciences school rather than in the business school. He was especially disturbed by the assignments of Karl Marx and Upton Sinclair, texts I use to unpack management principles and empathetic leadership. Since the new dean oversees the business department and I teach a humanities course for students interested in business, I felt it important for him to understand that this leading-edge-applied approach is geared toward preparing students for an unknown future workplace and a model for teaching futuristic and innovative thinking.

More and more authors are questioning the future of capitalism and whether it is about to enter a new phase. Our current system of teaching to the test, of imparting hard facts, stultifies thinking. I am not alone. Current business writers see change and capitalism differently in the future. Adam Grant's *Power Moves: Lessons from Davos*, Robert Reich's *Saving Capitalism*, Thomas Piketty's *Capital in the 21st Century*, John Mackey and Raj Sisodia's *Liberating the Heroic Spirit of Business: Conscious Capitalism*, and Peter Diamandis and Steven Kotler's *Abundance: The Future Is Better Than You Think* are among the works suggesting we are in line for a serious change in the capitalist project. The millennials are only now beginning to hit their stride, and their values align with a new capitalism.

If you think me a pie-in-the-sky, bunny-hugging liberal from a humanities department, clueless about business and shoving off bleeding-heart, anticapitalistic, and Marxist principles aimed at destroying our economy, you are dead wrong. A product of generations of business owners, I founded a marketing company with long-term client relationships decades ago. My company has

represented national manufacturers, business-to-business and retail firms covering over-the-road trucks, jewelers, HVAC equipment, health care, and even a Tennessee Treeing Walker Coonhound (a dog at stud). To be effective at marketing, you learn many businesses and I understand business. As a consultant, I apply the humanities to business, to leadership workshops, and to teaching the humanities as a method of futuristic thinking and application.

Returning to the coffee conversation, I was presenting a very different approach to interdisciplinarity, and not only to accounting, marketing, corporate finance, and human resources. Rather, I was suggesting that learning to think through the humanities prepares students to become visionary critical thinkers, ready to take on the challenges of twenty-first-century conscious capitalism, to thrive in an unknown workscape, and to change fact-based learning methods into larger concepts of seeking consilience and interrelating seemingly unrelated disciplines.

Burdened by terrifying debt loads, students are looking for ways to satisfy creditor demands. But they are often young, unsure of their lives, and many times so focused on the short-term demands of the job market that they miss the long-term ramifications. The science, technology, engineering, and mathematics (STEM) push of the 1960s put us on the moon, but it also produced an overabundance of engineers. In the nineties, we saw computer engineers graduating to enormous salaries. Students flooded the field only to over-supply the market and drive down wages. "Tell me what I need to know, give me a test, and get me out of here" attitudes will not prepare students to be visionary in this new economy. Business and the humanities are not at odds; and business, a human endeavor, works far better when existing within a humanities biosphere, where disciplines are interrelated.

How do I know this? Because I apply the humanities every day; I wear bifocals—business glasses with humanities readers, which is why the humanities form the basis for my marketing programs, for my university courses, and for the workshops I facilitate. Arriving

at this concept has been a journey. The model, Thinking Through the Humanities, rather than linking disciplines, approaches the humanities as a biosphere that infuses other disciplines with an empathetic understanding of mutual impact: one discipline affects and informs another. Above all, this biosphere insightfully provides a complete picture, considering the impact of STEM disciplines and their effect on society. No single decision is limited in the scope of its own world and STEM is only as effective as its ability to function within a society.

Futurists see cycles, trends, and new applications. The biosphere model, Thinking Through the Humanities, presents those cycles, trends, and, above all, insight—hallmarks of futuristic thinking. Business relies on case studies that examine specific situations within a business and applies them to economic success or failure. Nothing new there. Thinking Through the Humanities expands the case study and provides a vision of how developments impact the greater spectrum of society. A recent example: the decline in department store sales and the ultimate closing of established stores could have been foreseen by studying the effects of the second Industrial Revolution. The advent of mass production and the invention of the steel beam allowed expansive emporiums to sell inexpensive goods that were copied from aristocratic tastes and are responsible for the birth of consumerism.

Today, as the internet matures, the growing collapse of these venerable institutions could have been predicted. Investors would be far less chagrined had they read Émile Zola's *Au Bonheur des Dames*, a dissertation on the birth of the department store, child of the second Industrial Revolution. Shopping has shifted from the spectacle that once drew fashionably dressed women to newly transformed cities to online shopping, which demands no social uniform and allows people to shop in their pajamas from bed. Amazon Prime has supplanted the grand dames of retail. This is not a new shift and it is lodged in human behavior and values. In the second half of the nineteenth century, the department store

edged out the small family business, which was not just a business shift but the upending of a once-secure social structure.

Knowing how this unfolded—and how consumers behaved then—provides a far better understanding of coming trends. If it broke once, surely it will break again, especially when examined through the humanities, because the human condition never changes. In the example of Zola, the story is not a case study but a window into interrelated structures, a way to examine the interdependency of disciplines—economic change, the rise of consumerism, modern marketing principles, shifts in family values, city development, and changes in law—none of them operating within their own world but seriously impacting one another: *this is the humanities biosphere.*

In an era when liberal arts are being replaced at many universities with vocation-centered STEM education, it is time to step back and take a fresh look at the humanities, not as one more discipline sacrificed to budget constraints but as the muscle that makes STEM work harder, smarter, and acts as a foundation for sustainability. The humanities, when envisioned as the biosphere in which all other disciplines function, alters the STEM paradigm. The movement to focus on science, technology, engineering, and mathematics as primary studies, subjugating the humanities to second string, occurs in every Industrial Revolution. Each revolution has brought forth the same issues. It should be no surprise, as we embark upon this fourth Industrial Revolution—Industry 4.0, that technology's siren song would lure us away from the nebulousness of the human condition in favor of the predictability of technology. No matter what advances technology creates, they will always function within the human environment.

For all that liberal arts advocates promote adding an *A* for arts to STEM and creating STEAM, yet another silo, Thinking Through the Humanities gives us a new paradigm that examines more than the ways disciplines are interdisciplinary. It becomes the critical uniting element. The iPad is not simply a new device—it is a

development that changes a society. It both adds to communication and disrupts it. Even Emily Post, doyenne of manners, is queried, "May I take a call at a dinner party?"[3] Deeper questions may be evoked as to whether people truly communicate, and the reply is that this may well lay open a social problem that will impact how society functions or it will harken a new business opportunity.

The humanities became an epiphany when I returned to school for a graduate degree in modern studies. After researching disciplines, I realized that cultural studies would provide an in-depth approach counter to the university's advice to pursue an MBA. As an experienced marketer, understanding cultural foundations better positions one to recognize and even forecast market trends. The curriculum became a crash course in a new academic language and challenged me to understand the academic perspective. While they delved into theory, my no-nonsense need for application repeatedly saw literature carrying memorable business and leadership lessons. Slowly emerged the concept that story and empathy were the two most important functions in applying the humanities, and I began seeing opportunities and connections that formed a platform for marketing. The theory I once balked at helped me read between the lines and raised my marketing and leadership expertise to a new plain. I began enlarging my clients' world and their influence and producing marketing initiatives that ran far deeper than simple marketing campaigns.

When a community transitioning from a rural township to a residential community came to us to develop a brand, we looked to the township's history. Their goals were to attract population, unite rural and city residents, increase civic engagement, and draw a business tax base. Changing from their historic rural name to a slick modern name, much like thousands of new towns that dot modern America's suburban landscapes, further clouded their identity. Their story and their history became their brand.

"Stories from the Ledge," an oral history collection named for their location on the Niagara Escarpment referred to as "The

Ledge," sought longtime residents so they might tell the community's stories. We focused on lifestyle and business in the community, and looked for quarrying, dairying, governance, and farming stories. Residents' responses spanned a century-and-a-half, as elders recounted not only their stories but also those of their grandparents, including clearing farmland, the one-room school experience, and the changes brought by electricity. Interviews resulted in a media file of tapes on which to base a unique branding campaign. In our read-resistant society, people still seek out, remember, and share narratives. The underlying message of the campaign was that this was a community where families belonged and one that had, from its founding in 1839, been blanketed with farms, quarries, and cheese factories. Business is fundamental here—it's a way of life.

This prototype was repeated for an assisted living marketing program. Living History with . . . , a program based on an understanding that elders have lived history, told the back-stories—often those that don't appear in history books. These are not the leaders' stories; they are the stories of the people. The goal was to separate the facility from the many others—cold, corporate, and led from afar. For the residents, it promoted value and respect. Interviews appeared in newsletters and eventually expanded to a local university's English course, where students learned interviewing techniques and wrote essays on their experience, sharing what they learned. Several students interested in World War II heard firsthand experiences from old men who, at the students' same age, had risked their lives for their country. Articles on the project drew feature articles in the daily newspaper. In the fall of 2009, the project was invited to the University of Wisconsin Oral History Project, garnering more public relations recognition.

Living History with . . . evolved into a newspaper advertising series. "Christmas Memories" drew readers, as did a Memorial Day ad. "In Gratitude" saluted those who served in World War II, Korea, and Vietnam, picturing veterans in uniform as they reflected on the lessons of their service. Of the three ads in the series, "A

Valentine to the Community" carried the most impact. Residents married for forty, fifty, sixty years and more shared their wisdom on marital happiness along with their wedding portraits. Community appreciation poured in as the phones rang thanking the client for this gift. When the business discussion of the triple bottom line—people, planet, and profit—arises, humanities-based hardcore branding tops testimonial platforms hands down, inspiring trust and evoking audience engagement.

By 2050, it is estimated that the number of people who need memory care will triple. Growing research shows that humanities-based programs make a significant difference in keeping people active by activating brain function. New initiatives are popping up across the world. Music remains in the brain the longest. Storytelling is creative, not relying on facts, and thus requires no memory. Dance combines music and movement. Art stimulates and provides expression.

When an assisted-living client asked us to market their new memory care unit, we advised that the marketing focus needed to be more than a lock on a room, and that innovative resident programming should be the campaign foundation, setting them above the competition. But programming can be expensive. While we were looking for ways to meet this challenge, the community's well-regarded liberal arts college was completing acceptance in a little-known federal Work College Program, which funds liberal arts education for lower income students. Work experience is a key element, and students must work in their field while acquiring their degree. The college's need for student jobs, and our need for programming, created a perfect solution, blending curricula, jobs, and the application of the humanities. The school's music department had developed a music and movement program for memory care. Based on their experience, we challenged them to create a similar program for the disciplines of the humanities—literature, storytelling, writing, and art—to also include their nursing program. The mutual benefits included cost reductions for students,

developing application of the liberal arts, and creating innovative low-cost programs for the long-term care facility—everyone won. In the future, the project will evolve into articles on innovation in business, academics, and health-care publications, garnering further publicity.

In search of an adjunct humanities professor for an intro course, the University of Wisconsin–Green Bay's humanistic studies department inquired as to my interest in teaching. When I asked, "What exactly do you want me to teach?" the department chair responded, "Anything you'd like from the Baroque to the Modern." Preparing the course, I explored information-packed humanities text books—slick, picture-filled, internet-linked, turnkey, and expensive. It appeared that students would be likely to leave the course with little lasting knowledge; it would be of little use and a costly waste. The burning question became: If this is the only humanities course a student ever took, what would they need to make this memorable and useful?

Using accessible and resaleable seminal texts, the course was developed in three sections: philosophy, literature and analysis, and cultural analysis. Students first examine old texts—essays, poetry, literature, theater—only to discover they are highly relevant in today's world as we consider consumerism, governance, education, labor, and moral codes. The second section uses the theory learned in the first section to analyze Sinclair's *The Jungle*, Zola's *Au Bonheur des Dames*, and Ibsen's play *An Enemy of the People*.

Finally, we explore modern culture, with an eye to the past and to the future. Advertising, marketing, photography, and technology, the relatable elements that drive their world, fascinate students. As we unpack and apply concepts, they see the interrelationships and influences the market holds over their lives. After a decade of teaching Introduction to the Humanities II: From the Baroque to the Modern, many notes from former students recount the class's lasting effects. Now, I open my classes with this admonition: "This

is the most important class you'll ever take, because it relates to absolutely everything, opens new horizons, teaches you to be transformative, and will take you into jobs now unimagined. This is not job training, it is education for life."

Fierce innovative thinkers need the vehicle to travel to new territories with confidence and understanding. Preconceived ideas and prejudices limit discovering new experiences. Students are required to attend the theater, symphony, and museum. Their excursions are complemented by guest speakers: visits by a theater director, museum director, and conductor are up-close and personal opportunities to see passion at work, find new venues, and introduce fields many have not considered. One student who fell in love with museums was surprised to discover she could feed her new passion and use her accounting major.

The more I taught humanities application, the more I envisioned a course specifically designed to align with business. The dismissal of humanities courses as unrelated to business will not bode well for future business innovators and leaders. Thinking Through the Humanities produces deep insight into the concepts of conscious capitalism and the triple bottom line. My university, with its history of innovative curricula, welcomed a proposal for Humanities, Business & Critical Thinking as an addition to their online offerings, highly populated with working adults. Opening in 2013, working adults joined traditional students in discussions, offering adult students a window into the millennial mind and offering traditional student insight into real-life experience—everyone benefits. Students find new insight into their jobs, learn to integrate family and work, and discover innovative management. Outside the class discussions, students write me about how the course work traveled back to the office, to the lunchroom, and changed their business culture.

Daniel Pink's *A Whole New Mind: Why Right Brainers Will Rule the Future* launches the course and shifts students from fact-based learning to Thinking Through the Humanities. Course content

includes independent thinking from Immanuel Kant—one of their favorite authors—and managing a workforce based on the insights of Karl Marx. It examines diversity and negotiating principles with Sui Sin Far's *Mrs. Spring Fragrance*, managing difficult employees with Melville's *Bartleby the Scrivener*, and a retrospective on bad management through Arthur Miller's *Death of a Salesman*. Novels take business out for a walk in the biosphere. Sinclair's *The Jungle* examines labor and the blue-collar; Zola's *Au Bonheur des Dames* deconstructs modern retailing, desire, and the birth of the white-collar; and Tom Wolfe's *Bonfire of the Vanities* deconstructs the social fallout of economics. Three assigned papers require students to explain how the readings inform modern life, leadership, management, and their jobs, sending them in search of meaning.

Teaching Ibsen's *An Enemy of the People* is a productive exercise in empathy and negotiation. Used in every course I teach, it has evolved into a workshop series for government, business, and health care. Classes and workshops focus on empathy, negotiation, and leadership. The five perspectives explored—governance, science and technology, media, business, and community power brokers pay off richly. Whatever one's field or belief, other perspectives can open a host of new ideas. A syllabus for a new course, The Humanities, the Healing Arts & Critical Thinking for online, face-to-face, and medical college students is in development.

Humanities, Business & Critical Thinking opened yet another opportunity when I discovered the continuing education programs of the International Institute of Municipal Clerks. They developed a Socratic book-based, literature-based program, Athenian Dialogues. Over six hours, clerks examine biographies and histories for leadership, management, and government application under the direction of a certified facilitator. Their dialogue program dovetailed with my coursework, opening a new initiative in an entirely new area: training.

Course materials grew into workshops on negotiations and critical thinking through Ibsen. Sui Sin Far's short story evolved

into Mrs. Spring Fragrance Teaches Negotiation & Diversity, and Pink's work fostered a session entitled Would the Chaos Please Come to Order. Future workshops exploring the Humanities Biosphere include *Death of a Salesman*: A Management Retrospective and Dealing with Difficult Workers, using Melville's *Bartleby the Scrivener: A Story of Wall Street*. The creative possibilities are endless, and the payoff is enormous in transforming our culture into creative thinkers.

Make no mistake: I am indeed a capitalist, and what I teach is a new thinking model to foster creative twenty-first-century conscious capitalism. Preparing a population to think in a holistic way requires a different approach based on empathy and the story. It will transform our world into a more sustainable and livelier capitalism as we confront the future: change or die.

NOTES

1. Sentryo, "The 4 Industrial Revolutions," Cisco, February 23, 2017, https://www.sentryo.net/the-4-industrial-revolutions/.
2. David Mielach, "5 Business Tips from Albert Einstein," Business News Daily, April 18, 2012, https://www.businessnewsdaily.com/2381-albert-einstein-business-tips.html.
3. Jura Koncius, "Cellphones at the Dinner Table? An Etiquette Expert Weighs In," *Washington Post*, February 14, 2019, https://www.washingtonpost.com/lifestyle/home/cellphones-at-the-dinner-table-silence-please/2019/02/11/7a5e00b0-20ca-11e9-8e21-59a09ff1e2a1_story.html.

WORKS CITED

Far, Sui Sin, Amy Ling, and Annette White Parks. *Mrs. Spring Fragrance and Other Writings*. Urbana: University of Illinois Press, 1995.

Ibsen, Henrik, and Arthur Miller. *Arthur Miller's Adaptation of an Enemy of the People*. New York: Penguin, 1977.

Kant, Immanuel, and Lewis White. *Kant: Selections*. New York: Macmillan, 1988.

Koncius, Jura. "Cellphones at the Dinner Table? An Etiquette Expert Weighs In." *Washington Post*, February 14, 2019. https://www.

washingtonpost.com/lifestyle/home/cellphones-at-the-dinner-table-silence-please/2019/02/11/7a5e00b0-20ca-11e9-8e21-59a09ff1e2a1_story.html.

Melville, Herman. *Bartleby the Scrivener: A Story of Wall Street*. New York: Simon & Schuster, 1997.

Mielach, David. "5 Business Tips from Albert Einstein." Business News Daily, April 18, 2012. https://www.businessnewsdaily.com/2381-albert-einstein-business-tips.html.

Miller, Arthur. *Death of a Salesman: A New Play*. New York: Viking, 1949.

Pink, Daniel H. *A Whole New Mind: Why Right-Brainers Will Rule the Future*. New York: Riverhead, 2006.

Sentryo. "The 4 Industrial Revolutions." Cisco, February 23, 2017. https://www.sentryo.net/the-4-industrial-revolutions/.

Sinclair, Upton. *The Jungle*. New York: Penguin, 2006.

Tucker, Robert C, Karl Marx, and Friedrich Engels. *The Marx-Engels Reader*. New York: Norton, 1978.

Wolfe, Tom. *The Bonfire of the Vanities*. New York: Farrar, Straus & Giroux, 1987.

Zola, Émile, and Robin Buss. *Au Bonheur Des Dames—The Ladies' Delight*. London: Penguin, 2001.

MONEY OVER MEANING

Tech Is Winning Minds but Not Hearts

Bailey Reutzel

It was a lot of rooms in a lot of houses—crashing on friend's, friends of friend's, and stranger's couches, extra beds, floors, whatever I could get.

Cliff's bedroom. Black metal, punk, and hardcore show flyers are pinned slapdash to the white walls. In the corner, there's an altar of sorts—little bird shit-like mounds, diminished incense sticks, a gold chalice surrounded by the bones of various Coloradan woodland animals.

John's loft. Records from Bob Dylan, Jimi Hendrix, The Who line the wall like crown molding. A huge Grateful Dead fabric poster hangs over a '70s-style patterned couch. There's a thrift store bookshelf full of Hunter S. Thompson, Jack Kerouac, and other bums.

This is where I ended up. I had a dream, a blog, a book, and called it *Moneytripping*; more than twenty-six thousand miles

scouring the United States landscape, trying to figure out what the country had become. I began the adventure, hands on the wheel of a 2008 Ford Escape, in my parent's driveway in Missouri thinking I'd be collecting thoughts on how people use, abuse, and interact with money, but it quickly became clear that for most Americans, money is political and politics is polarizing. Moneytripping became, as my hands grew calluses from gripping the now-worn steering wheel, a look at how politics and its sought-after accomplice, money, shapes American citizens.

And never once did I see the sleek surface of an iPhone on a poster or Snapchat's ghost icon memorabilia or Uber wall hangings.

I wrestled with the state of the states, talking to shopkeepers and students, military vets and disabled homeless, bankers and policy advisers.

Conversations did not revolve around technology. Discussions were not grounded in the gadgets we held in our hands. Arguments did not hinge on Silicon Valley. No one had ever heard of financial technology or Bitcoin or blockchain—the topics of my trade.

When I asked about these things—blockchain, fintech, broader Silicon Valley goings-on—many people shrugged. And even if they had heard theses name, they didn't understand how those systems worked. They didn't care.

Or maybe it was something else, that technology has made us feel apart from these things, like we've been tricked into thinking that money and technology and their accumulation are all that matters, that it's the way to get the core things we want.

They cared about being a part of the humanities—the study of how people process and document the human experience, to philosophize, to speak, to tell stories.

They cared to be listened to.

*

Technology has become the principal religion, the new unseen deity that is worshipped without critical thought. We throw

money, lots of money, into the collection plates. We ignore the inequality it exacerbates, the fading out of art and literature to help us interact with humanity.

We've been taught to deify entrepreneurs—not the starving musicians and broke photographers but the apostles who drop out of university, giving up all their mainstream possessions like the followers of Jesus, becoming martyrs at the hands of investors.

Another technology writer I talked to (he types his messages; I handwrite mine) doesn't see it the same way.

"Paints, photographs, and anything else you might declare as art-making devices are technology." And later, "Nor am I particularly swayed by those who try and dictate what is and isn't art."[1]

I see what he's saying, that art-making devices are technology in the definition that is used today—something that iterates on something else. But, it's worth asking what the words mean.

The Merriam-Webster definition of technology is "the practical application of knowledge especially in a particular area."[2]

Practical. Would you call art that? I wouldn't.

An application? I don't think I'd use that term for art either.

Knowledge? Sure, but an emotional kind of knowledge, a humanities-based kind of knowledge; not one that is defined later as a "manner of accomplishing a task especially using technical (mechanical or scientific) processes or methods."[3]

And so, his argument becomes: everything is art. Everything is technology.

And it seems a lot like: everything is beautiful.

But these are wrong. Loose definitions. One might be able to say that everything is everything and everything is good. But some things are technology and some things are art, and some things are closer to good and others are closer to bad.

But what to do with something that challenges these assumptions?

"Is that your car outside? With the Bitcoin sticker?"

A stout young man with greasy hair falling over his ears asks

when he walks into the hostel kitchen where I'm eating the last of my bread with a single cup of peanut butter.

"It is."

The first person in forty-seven states that's asked me about it.

"You know about Bitcoin?"

He did. For reasons, I find, that are similar to most people's experience with the digital currency: because he was selling drugs. Granted, it was kratom, a plant with opiate-like effects, which, at that time, was still legal in South Carolina but definitely a good in the gray area.

Yet, this isn't me making a judgment. This is Bitcoin's best-use case, what many now call *regulatory arbitrage*, the process of finding ways around regulations. And the regulations Bitcoin allows people to get around are the censorship of the digital payment systems, the blockading of financial freedom.

A more open and collaborative system is where my interest in Bitcoin starts, in late 2012. It's a system that needed its constituency to make the system work, unlike how I, and many others, felt and still feel about the governing class around me.

And while Bitcoin has been co-opted by paranoid Libertarians and the tech elite, there's still an inkling of a "good" technology.

I define good technology as one that allows us to better capture all of humanity instead of just a tiny sliver, when it allows us to socialize and connect with a greater humanity. Like the work of one student of Stanford professor Terry Winograd, who developed a Google Glass application that connects to a smartphone app to help autistic children recognize human emotion through facial expressions. This is good tech because it allows people that have been unable to, to understand a broader humanity.

But these applications, much like the arts and humanities, are suffering from a lack of funding.

And that's what's really worrisome.

The technology being pumped out today is just iterations on

the technology we already have, recreating the systematic inequalities and unwanted prejudices.

Today's technology—more messaging apps with more filters to abstract the world—feels more like an anthem for apathy: "With the lights out, it's less dangerous / Here we are now, entertain us / I feel stupid and contagious / Here we are now, entertain us," says Kurt Cobain in Nirvana's "Smells Like Teen Spirit."[4]

And the technology industry sees that, which is why it takes terms meant for human interactions, trying to morph them into ideas that define technology. *Engaging*, for instance, is the term the technology industry uses to describe sleek, easy-to-navigate user interfaces.

But it's not the user's interface that's engaging: it's the person on the other end of that telephone call, that message, that status update who is engaging. When I'm using WhatsApp to send voice messages back and forth to my niece, it isn't the smartphone, it isn't the application, it isn't the software that's engaging: it's a six-year-old's voice saying, "I love you" that gives me butterflies and makes my face flush.

Tech, then, is just the middleman, the intermediary connecting us to what we love and enjoy, what scares us and makes us cry, all those different emotions, the human experience, the humanities.

And yet, the technology industry is not looking further into the humanities than what its artificial intelligence program can deduce from the way our eyes move through a website. And with the tech industry seemingly not caring about the humanities, the rest of us have followed suit.

Although, we might be starting to see a pushback, one that will have an uphill battle, as federal, state, and even private funding for the humanities has decreased significantly from a few decades ago.[5] Plus support from the public and, in turn, Congress and other legislators has slid, with leaks coming from the White House not but three months after current president of the United States,

Donald Trump, got sworn in that he was planning on defunding National Endowment for the Arts and the National Endowment for the Humanities.[6]

But the arts have given us the kindling for this revolution. *Black Mirror*, the widely popular Netflix original dystopian sci-fi TV series, demands people talk about tech by pushing the bounds with the question: How far will we let it go? Add to that the art of Luis Quiles, which uses almost Disney-like characters in disturbing scenarios to highlight how disgustingly infatuated we've become with technology instead of real human interactions.[7]

The naysayers are finding a microphone. And that's because their outlooks are based on a knowledge of humanity and the way it interacts in a system of profit maximization and a neglect of infrastructure (meaning both its people and the things built by the people).

And that's really what Moneytripping became—a search for humanity in the finance and technology, in the money, that I had surrounded myself with. And what I found, as I traveled from state to state, were industries out of touch. And consumers that followed their lead, because that's where the money leads.

As a white-haired shopkeeper in Michigan said, "Money is the root of all evil."[8]

But it's not the money, not the tech, that's evil—it's the lack of humanity it considers.

NOTES

1. Technology writer A, personal communication with the author, date unknown.
2. See Merriam-Webster, "technology," definition at https://www.merri-am-webster.com/dictionary/technology.
3. Merriam-Webster, "technology."
4. "Smells Like Teen Spirit," on Nirvana, *Nevermind*, DGC Records, 1991, compact disc.
5. Gretchen Busl, "Humanities Research Is Groundbreaking, Life-changing . . .

and Ignored," *Guardian*, October 19, 2015, https://www.theguardian.com/
higher-education-network/2015/oct/19/humanities-research-is-ground-
breaking-life-changing-and-ignored?CMP=share_btn_tw.

6. Alexander Bolton, "Trump Team Prepares Dramatic Cuts," The Hill, January
19, 2017.

7. Luis Quiles, "Luis Quiles Artworks," Facebook, February 7, 2014, https://
www.facebook.com/luisquilesart/.

8. Shopkeeper A, personal communication with the author, date unknown.

WORKS CITED

Busl, Gretchen, "Humanities Research Is Groundbreaking, Life-changing . . . and
Ignored." *Guardian*, October 19, 2015. https://www.theguardian.com/high-
er-education-network/2015/oct/19/humanities-research-is-groundbreak-
ing-life-changing-and-ignored?CMP=share_btn_tw.

Bolton, Alexander. "Trump Team Prepares Dramatic Cuts." The Hill, January 19,
2017.

Nirvana. *Nevermind*. DGC Records, compact disc. Originally released in 1991.

Quiles, Luis. "Luis Quiles Artworks." Facebook, February 7, 2014. https://www.
facebook.com/luisquilesart/.

HIT ME WHERE IT HURTS

The Intersection of Theater and Climate Change

Chantal Bilodeau

Artists reflect and shape culture. We tell stories in words, movements, sounds, and images, and these stories embody the beliefs and values of a specific time and place. Think of Egypt and Rome. Think of the Maya and the Aztecs. We know these ancient cultures thanks to the art they left behind. Artists also carve paths to move societies to action. They denounce abuses, shine light on injustices, and point out where we're falling short of being our best selves. It's no coincidence that dictators everywhere try to silence them. Our work can reinforce the status quo or it can openly question and challenge. When used well, art is a powerful tool of resistance.

I'm a playwright, and like most of my peers, my early career was devoted to writing about a variety of topics; each play was an opportunity to explore something new. Then, about ten years ago, I turned to climate change and never looked back. A trip to Alaska is what sealed the deal: I fell in love. I fell for the geography

and climate of the Arctic, for its strength and fragility, and for the humility and resourcefulness of its people. I fell for the feeling of smallness one gets standing on the tundra with nothing but rock and ocean on the horizon, and I fell for the beauty and rawness of a place where so much life hides in plain sight. But along with this love, I experienced the vivid and excruciating pain of knowing that it may all go away very soon—and us with it.

A year prior to that trip, I saw Al Gore's first documentary, *An Inconvenient Truth*. It was shocking to say the least—a sober look at how out of balance our climate was and how we had created—inadvertently in some cases, recklessly in others—the perfect conditions for this crisis to occur. Suddenly, with this film, climate science was right there in the open. Thanks to Gore and others like him, it leapt out of obscure scientific papers and permeated popular culture. Of course, I knew about climate change, but I knew about it the way one knows about cancer; it's somewhere out there and there doesn't seem to be much we can do about it. This all changed when I returned from Alaska. Witnessing climate change's impact on the Alaskan people and landscape created a shift: it became personal. Suddenly, I was hit where it hurt.

As dramatic as this may sound, I'm not unusual. Humans are creatures ruled by emotions. Graphs and charts don't make our guts churn or our heart beat faster; if they did, we would marry based on carefully researched data, not on how we feel about our partner. As an artist, I understand this concept intimately. The arts traffic in emotions; it's their most important currency. They talk to us on a level that bypasses our bulletproof intellectual barriers, our walls of cherished opinions and beliefs, and our deeply held values. They reach our most vulnerable places and move us in ways no scientific argument ever could. At times, they shake us to our core and provide experiences so visceral that they exist beyond language.

It is this belief in the power of the arts that led me, ten years ago, to embark on an artistic exploration of climate change. This was a time when most Americans were unaware that the United

States was an Arctic country and that our actions in the Lower 48 were having huge repercussions on people who live at the top of the world. It was also a time when few of us understood that what happens in the Arctic doesn't stay in the Arctic—it affects us all. I reasoned that if I could take audience members sitting in a dark theater to the Arctic for an hour or two, if I could hit them emotionally the way I was hit, maybe they would see the connection; maybe they would be moved to learn more. Or, better yet, maybe they would be compelled to take action.

Little did I know that this would require establishing partnerships that went beyond what I had been used to as a traditionally trained playwright, and that this process would come to redefine my entire artistic practice.

EXPLORING CROSS-DISCIPLINARY COLLABORATION

Fast forward to August 2009, and I'm sitting on a plane staring at a vast expanse of tundra dotted with tiny blue lakes. I'm heading to Baffin Island in the territory of Nunavut to learn more about the Canadian Arctic and its inhabitants. I have been commissioned by the now defunct Mo'olelo Performing Arts Company in San Diego to write a play about the intersection of race, class, and climate change. For the first time in my career, armed with a handful of names and email addresses, I'm seeking knowledge in a place I have never been, from people I don't know, who do things I don't completely understand to translate into theatrical stories.

My initial idea is to write about the opening of the Northwest Passage. With sea ice melting and the possibility of an Arctic shipping route opening soon, there's going to be significant impact on local Inuit communities—in my mind, a classic tale of good versus evil. But after spending three weeks on Baffin, after talking to scientists and government officials, Inuit activists and elders, environmentalists and tourists, after hiking the pass in Auyuittuq National Park and eating arctic char and caribou, I realize that my

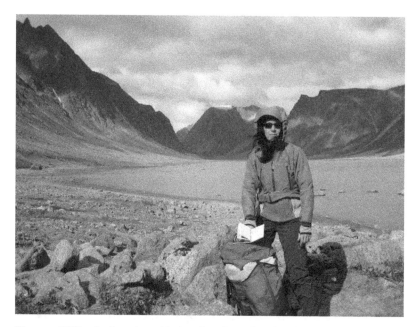

Figure 1. Hiking in Auyuittuq National Park, Baffin Island, Nunavut, Canada. Photo courtesy of Michael Johnson Chase.

idea is too simplistic, and that to capture the complexity and magnitude of the drama unfolding at the top of the world, I need to rethink how I write my plays.

One encounter proves particularly meaningful in helping me reframe my thoughts: I have the opportunity to meet Nobel Peace Prize nominee Sheila Watt-Cloutier while she collects heather for her tea cozy in Sylvia Grinnell Territorial Park, just outside of Iqaluit. Watt-Cloutier, a warm and quietly charismatic Inuit climate change activist, has long argued that climate change is a human rights issue. On our walk, she reminds me that Inuit communities are disproportionately affected by warming temperatures yet emit little CO_2 and have few resources to mitigate the impacts. If they are to remain in the Arctic, where they have lived for millennia, Inuit need to develop their economy in order to build infrastructures and address pervasive social problems. In such an

isolated and forbidden territory, this likely translates into resource extraction. Suddenly the classic tale of good versus evil no longer makes sense. If I privilege one perspective over the others, I risk cheating the people and place I want to honor and limiting the audience's understanding of the region.

In Inuit mythology, *sila* (pronounced SEE-la) is the primary component of everything that exists. It means air, climate, or breath. This concept became both the title and the organizing principle for the play, creating a container for as many, often conflicting, perspectives as possible. *Sila* follows seven characters, including a climate scientist, an Inuit activist, two Coast Guard officers, and a polar bear, as they see their values challenged and their lives become intricately intertwined. Embracing complexity, it tells a story where everyone belongs and has a say, including animals and gods, but no one holds the definitive view; where every language is spoken and every realm (here on Earth, below and above) is represented, a sort of cubist story where it's impossible to reduce the work to a single perspective.

While in film or TV, it's common for multiple writers to collaborate on a piece; single authorship in the theater is highly valued and respected. Yet, as I was writing *Sila*, it quickly became apparent that I couldn't be the only voice in the play. Because climate change is global and affects every aspect of our lives, it requires that we work collaboratively across disciplines. In that spirit, I approached Inuit spoken-word poet Taqralik Partridge and asked permission to include her poetry in the play. When Partridge graciously agreed, I created the character of Veronica, a young mother and spoken-word poet who is fighting for the well-being of her community. Veronica performs two of Partridge's poems as part of the play, addressing the high rate of teenage suicide in the north and the historical trauma of residential schools.

Another way in which *Sila* departs from my previous work is that it features three different languages—English, French, and Inuktitut. Early on, I decided that characters had to speak the

language they would normally speak in any given situation. Having everyone speak perfect English, the simplest choice, would have erased the complex cultural dynamics at play in Canada and perpetuated colonial injustices. I'm fluent in English and French, but I had to work with a translator for the Inuktitut. Saimata Manning, a young woman who had recently moved from Baffin Island to Montreal, helped me with the initial translation. Later, Inuktitut scholar Tamalik McGrath refined it for publication.

However, collaboration in the theater is not new. Before the play goes up, it is often developed over several years through workshops hosted by theater organizations. During those workshops, playwrights get together with actors and a director; they read the play out loud, ask questions, discuss sticky points, rewrite, and then do it all over again until the play is ready for production. From 2009 to 2014, I collaborated with several theatre companies on the development of *Sila*, including Playwrights' Workshop Montréal (PWM) in Canada. One particular challenge was to find Inuit actors to read the Inuit parts, which PWM was able to do—a rare feat. Together, we dove into the text, explored cultural relationships past and present, discussed politics, and compared notes on creation myths and flirting tactics. Many of those conversations are woven into the fabric of the play.

I also sought the help of a climate scientist friend of mine, Bruno Tremblay from McGill University, who provided feedback on some of the more technical aspects of the play involving a climate scientist taking measurements of sea ice in the High Arctic. Bruno helped me figure out a particular plot point where I needed the character to be involved in a high-stake scientific event. We created the conditions for a multiyear ice shelf to break away from the coast—a phenomena usually only witnessed by satellites. This fictional event added a sense of urgency to the character's journey and provided a window into what scientists actually do.

Ultimately, *Sila* premiered at Underground Railway Theater in Cambridge, Massachusetts, in 2014 as a Catalyst Collaborative at

MIT project—another unusual collaboration, this time between a theater and a group of scientists at the Massachusetts Institute of Technology. To enhance the theatrical experience, and in keeping with my desire to bring together people who may not normally encounter each other, a series of pre- and postperformance discussions were held with guests ranging from climate scientists to environmental policy experts, from physicists to government representatives, and from science historians to activists.

Similarly, another production of *Sila* at Cyrano's Theatre Company (CTC) in Anchorage, Alaska, included postperformance discussions on coastal village relocation and Alaskan Native responses to climate change. CTC also provided opportunities for action: Citizens Climate Lobby left draft letters and a submission box at the theater so audience members could write to their local legislators about concerns and questions regarding the impact of climate change on the Arctic.

These new, slightly unusual partnerships have also happened the other way around, by bringing the play to nontheater audiences in order to expose them to a different way of engaging with a subject they're used to seeing through a specific lens. Excerpts of *Sila* have been presented at a number of conferences, including Warming Arctic: Development, Stewardship & Science at the Fletcher School of Law and Diplomacy at Tufts University in Boston.

EMBRACING CULTURAL DRAMATURGY

At some point in the five years it took to bring *Sila* from idea to full production, I realized that one play wasn't going to be enough. The science was evolving, geopolitics were shifting, and the impacts of climate change were accelerating. How could I fit all of that in one play? The Arctic Council, an intergovernmental forum that promotes cooperation among Arctic communities, is comprised of eight Arctic states: the United States, Canada, Greenland, Iceland, Norway, Sweden, Finland, and Russia. I decided to write a series

of eight plays that would look at the social and environmental changes taking place in those eight states. This became *The Arctic Cycle*.

The *Cycle* appealed to me for several reasons. It provides a lens to look at the entire Arctic region and explore the differences and similarities between countries, something no other playwright has done. Because it unfolds over time—it will take me at least two decades to write all eight plays—it creates a record of our evolving relationship with climate change. And perhaps, most importantly, it stands as witness. The Arctic is warming twice as fast as the rest of the world. We're running the risk of losing incredible riches, both natural and human, before we can fully appreciate them. The *Cycle* captures this moment in time and holds it up to our attention for us to reckon with.

Since *Sila* was very much about the land, for the next play, I turned my attention to the ocean. In 2011, an artist residency gave me the opportunity to sail around Svalbard, an archipelago located halfway between Norway and the North Pole. In preparation for the trip, I read about Norway's long history of polar exploration and came across bad boy Fridtjof Nansen. Nansen lived from 1861 to 1930, and for a few years in the late 1890s, he held the record for getting closest to the North Pole. To this day, he's a revered personality in Norway—an accomplished explorer, scientist, artist, diplomat, and humanitarian who, in the later part of his life, received the Nobel Peace Prize for his work with prisoners of war. Nansen was also ambitious, moody, stubborn, restless, and a little too fond of women—a great character for a play.

Titled after Nansen's ship *Fram*, the Norwegian word for "forward," the second play of the *Cycle*, *Forward*, presents a poetic history of climate change in Norway. It has an unusual structure with one storyline moving backward from 2013 to 1896, and another storyline—the Nansen storyline—moving forward from 1893 to 1896. Nansen's storyline follows his expedition to the Pole from his departure to his return as a national hero three years later. The

Figure 2. *The Antigua* anchored off the coast of Svalbard during an artist residency in 2011. Photo courtesy of Chantal Bilodeau.

modern storyline follows over forty characters whose choices have unintended consequences that ripple through the generations.

This structure allows for a witnessing of decision-making processes and their long-term consequences. When we talk about climate change, we often mention our failure to think about future generations. But how did previous generations think about *their* future generations? What did they imagine for us? Did they make informed, ethical choices? Woven through this history is the passionate love affair between Nansen and the character Ice (representing sea ice).

Canada is where I was born and lived for the first thirty years of my life. I still have family there and visit several times a year, so when I wrote *Sila*, I was familiar with the cultural context. But Norway is foreign. Until 2011, I had never set foot in that country, and I obviously don't speak the language. In order to write a play

with integrity, I had to partner with people who could guide me through the intricacies of Norwegian history and culture. Two years after my visit to Svalbard, I went back to Norway—to the mainland this time—and visited three cities: Oslo, Bergen, and Tromsø. In each city, I met with climate scientists and theater artists to gather information and investigate possible partnerships.

In Tromsø, a gem of a city perched on the coast of the Norwegian Sea above the Arctic Circle, I found wonderful partners. Hålogaland Teater invited me and my US collaborator Jennifer Vellenga—with whom I had been working on the play from the very beginning—to develop *Forward* in a week-long workshop with English-speaking Norwegian actors, a Norwegian singer/songwriter (the character of Ice only expresses herself through song), and a Norwegian dramaturg. We learned later on that this arrangement was unusual. In Norway, foreign plays tend to arrive fully formed and all that's expected from the actors is to perform the parts. But here we were arriving from America with a play in progress, asking actors for their input. It took a full day for everyone to become comfortable, but once they did, we made magic.

An important presence in the play development process is that of the dramaturg. This is a person who is trained to look at plays from an editorial point of view. Depending on the project, the dramaturg may provide research materials to the actors to help them understand their character and the world of the play, point out inconsistencies in the text to the playwright, or put together information so the audience can situate the play within a greater context. With *Forward*, what I needed more than anything was cultural dramaturgy. I needed someone from inside the Norwegian culture to tell me where, as an outsider, I may have missed important clues. Tale Naess, our dramaturg, did that and much more, telling me stories about her family that found their way into the play.

One of my favorite anecdotes from our time in Tromsø, aside from watching the sun rise above the mountains for the first time after the long dark winter, involves a scene where Nansen is telling

Figure 3. Jacob Edelman-Dolan and Sterling Matthew Oliver in the Kansas State University production of *Forward*, directed by Jennifer Vellenga. Photo courtesy of Kansas State University.

his wife Eva how much he loves her—with characteristic American effusiveness. After tiptoeing through that scene a few times in rehearsal, our Norwegian actors gently pointed out that this type of exchange would never be heard in Norway; Norwegians are much more reserved. To illustrate their point, they told us a joke: "How does a Norwegian woman know that her husband loves her? He told her once." This and other similar insights helped me close the gap between my perception of Norwegian culture and what it really is and craft a story that had cultural integrity.

A year later, *Forward* was produced at Kansas State University. Aggie Peterson, our Norwegian singer/songwriter, and Naess joined us in Manhattan, Kansas, for the last week of rehearsals. In addition to their continued work on the play, the two women helped the young student actors understand the cultural context for the play, providing a unique educational experience. Like with the productions of *Sila*, the production of *Forward* included an

array of postperformance conversations with Kansas State University faculty. Represented entities included the Department of Landscape Architecture and Regional & Community Planning, the Department of Agronomy, the Department of Geography, and the Center for Hazardous Substance Research.

My hope is that every play in the *Cycle* will be produced in the United States, where I'm based and in the country where it is set. This is easier said than done, of course, as productions are expensive, complicated affairs. Still, I believe there's tremendous value in modeling this type of cultural dialogue around climate change issues. To that end, *Forward* is being translated into Norwegian and will be shared with potential Norwegian partners.

BUILDING COMMUNITY

With *Sila* and *Forward*, I learned that combining an artistic experience with practical information about climate change, whether scientific, political, environmental, or cultural, can have greater impact than if these things are offered separately. The blend of affective and factual information encourages people to open up and show curiosity rather than straight-out fear. However, no matter how profound the audience's experience, the people most impacted are still the ones who participate directly in the creation of the event—the artists and organizers who must wrestle with the topic for days, weeks, and sometimes months as they plan, rehearse, and perform.

In recent years, as our window of opportunity to reverse the worst impacts of climate change becomes smaller, I have grown acutely aware that as an individual artist, there's only so much I can do—so many plays I can write, places I can visit, people I can talk to. In addition, not all communities are necessarily receptive to my work; since I'm not *of* those communities, I cannot appreciate their specific context and struggles. To get around this problem, there needed to be playwrights from every corner of the world writing

about climate change, and artists invested in presenting these plays in their own community. In 2015, an idea suggested itself to a group of us during a phone conversation. Climate Change Theatre Action (CCTA) was born.

CCTA is a biennial series of worldwide readings and performances of short climate change plays presented in the fall to coincide with the United Nations Conference of the Parties (COP meetings). It uses a model first pioneered by Caridad Svich, founder of NoPassport Theatre Alliance, almost a decade ago. The theater action model works with diverse and accomplished playwrights to create a collection of short plays that are easy to produce and to build a critical mass around timely social questions through a network of participating collaborators.

We piloted CCTA in 2015. Fifty playwrights, representing every inhabited continent, as well as several cultures and indigenous nations, were given a prompt and asked to write a five-minute play about an aspect of climate change. The resulting collection of plays was then made freely available to producing collaborators worldwide. These collaborators were invited to organize and present an event in their community using one or several of the plays from the collection.

To our surprise, we managed to present eighty events in over twenty-five countries—with no resources whatsoever. We brought the project back two years later, and this time one hundred and forty events were presented in twenty-three countries, including Brazil, Canada, Chile, Czechia, Iran, Romania, and the UK. In the United States alone, ninety events were held in forty-one states. We reached twelve thousand people with the plays being presented a combined total of seven hundred and fifty times. Venues included parks, churches, schools, universities, living rooms, libraries, backyards, community centers, yoga studios, cafes, bars, street corners, and the foot of glaciers. Plays were also read on radio, in podcasts, adapted into films, and live streamed. Our producing collaborators ranged from professional theaters and educators to environmental organizations and individual artists.

Figure 4. Megan Oots and Atiya Yanique Taylor in *Brackendale* by Elaine Ávila, directed by Julia Levine, at the New York Launch—the CCTA 2017 kickoff event organized by The Arctic Cycle. Photo by Yadin Goldman Photography.

To emphasize the *Action* part of Climate Change Theatre Action, collaborators are encouraged to think about an action—educational, social, or political/civic—that can be incorporated into their event. We define *action* as something that happens in addition to the theatrical experience, that aims to connect and/or motivate people. It may involve the scientific community, other departments within a university, local environmental organizations, etc. Examples of actions that have been taken include raising money for hurricane relief efforts, donating to a food bank, tabling by social justice and environmental organizations, marching, writing letters to legislators, and sharing tools for sustainability at the local level.

CCTA is highly participatory; while a theatrical production might employ twenty people to reach an audience of one thousand, in 2017 we had two thousand people directly involved in the organization of CCTA events, reaching an audience of ten

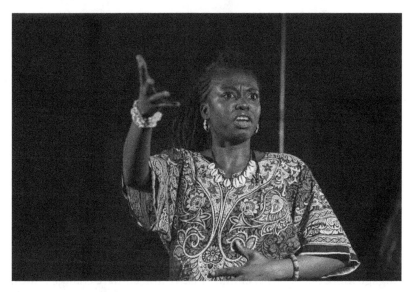

Figure 5. Rebecca Agbolosoo-Mensah in *Gaia* by Hiro Kanagawa at the CCTA 2017 event organized by One World Theatre in Shanghai, China. Photo courtesy of Alejandro Scott.

thousand. This ratio means that a significant number of artists and students dove deeply into the process and spent time researching and/or thinking about the topic. In addition, for the same amount of money it would take to mount a modest production with a fairly limited reach in New York City, we organized a global movement.

Most events are free so there's a low barrier to attendance, and because they are locally organized, events often serve new audiences. Past audiences have included waste water and water treatment workers in Montana; homeless youth in London; refugees in Denmark; kids in New York City, Iran, and Nigeria; faith communities in Washington State; unsuspecting passersby in Brazil, New Zealand, and the United Kingdom; and lots of university students in every corner of the world. Audience members range from young kids to senior citizens, from rural farmers to urban professionals.

CCTA does what I couldn't do on my own: it leverages theater to engage artists and audiences from around the world and

build community around shared concerns. By providing tools (the plays) free of charge, some guidance on how to produce events, marketing support, and a model that encourages leadership and self-determination, we make it easy for everyone to engage with an art form they may not be familiar with, and we empower them to harness their creative potential and put it in service of the greater good. The structure and timeframe of the project allows participants to function as a team and draw inspiration from each other; collaborators sign up because they know other people around the globe will be echoing their efforts. This gives each individual event a greater significance and impact, and it makes theater, for many, an irrelevant art form—alive and vibrant.

As a result of collaborating with us, artists have chosen to engage more deeply with climate justice and climate change issues, sometimes incorporating these themes in their work, sometimes changing the mission of their organizations or the focus of their teaching. University professors have incorporated CCTA plays in their classes—in theater programs to expose students to climate change or in environmental studies programs to look at a familiar issue through a different lens. We often hear from audience members that they have changed their behavior—taking up the challenge of making their institutions more sustainable, giving up single-use plastic, or reconsidering how what they eat impacts the environment—as a result of experiencing our work.

BUT DOES IT REALLY HURT?

I'm not naïve enough to think that a play is going to change the world. Theater audiences are self-selected and represent a small percentage of the population. An even smaller percentage is willing to go see a new play (as opposed to a classic play written by a dead white man), and a smaller percentage still will consider seeing a play about climate change. I'm talking minute numbers here. And most of these people are from a pretty homogeneous demographic group.

I also don't believe that a play is going to turn a climate denier into an activist. Deniers don't go see plays about climate change; why would they? But I do believe that those of us who are already concerned about the climate crisis need to know that we are not alone and sometimes need a nudge. A friend once explained that political campaigns divide voters into categories, creating a chart that separates groups into their political inclinations. The categories go from far left to far right, with a number of variations in between. The goal of the campaign is not to convince voters on the right to vote for the left or vice versa. The goal is to move voters to the adjacent category on the chart. And so it is with my work. I don't aspire to convert anyone but rather to encourage those already concerned to take action or those already active to step up their efforts.

Is it quick? No. Is it lasting? I believe so. Changing a behavior is quick. Changing our beliefs and values so they support a just and sustainable world takes time. We're not hardwired to reset our worldview easily. We usually do it as a last resort, with much kicking and screaming, and often with the help of medication to dull the pain. But change we do and theater is one tool to help us along the way. Through personal storytelling, theater can trigger reflection, generate empathy, and foster new ideas. It can help us imagine different ways of being and relating. It can also, in relation to climate change, make the crisis visible, audible, and felt.

A recent study conducted at University College London's division of psychological and language sciences found that "watching a live theatre performance can synchronize your heartbeat with other people in the audience, regardless of [whether] you know them or not." After monitoring audience members, researchers discovered that in addition to the individuals' emotional responses, hearts were responding in unison, with their pulses speeding up and slowing down at the same rate. As Joe Devlin explains, "This clearly demonstrates that the physiological synchrony observed

during the performance was strong enough to overcome social group differences and engage the audience as a whole."

So it does, in fact, hurt. Maybe not everyone, maybe not every time, but the potential is there. And I'm convinced that the partnerships behind the work—whether those are immediately apparent to audiences or not—contribute to the work's power. I'm convinced that our varied disciplines and backgrounds and outlooks add up to a fuller, more complex picture of where we are and need to go.

I started off as a lone playwright; climate change has turned me into an organizer, constantly herding artists and nonartists alike to harness our collective power. As we enter increasingly uncertain times for the planet and its many species, I continue to write my plays. The next one in the *Cycle*, set in Alaska, is currently in development. We presented a sneak peek performance in September 2018 at the UArctic Congress in Helsinki. Our next CCTA event is happening in the fall of 2019. More partnerships will be developed, and together we'll continue to try to stir our society toward a better future. Whether we succeed or not still remains to be seen, but at the very least, we'll be remembered as those who tried.

WORKS CITED

Bilodeau, Chantal. *Sila*. Vancouver: Talonbooks, 2014.

Bilodeau, Chantal. *Forward*. Vancouver: Talonbooks, 2017.

UCL Psychology and Language Sciences. "Audience Member's Hearts Beat Together at the Theatre." University College London, November 17, 2017. https://www.ucl.ac.uk/pals/news/2017/nov/audience-members-hearts-beat-together-theatre.

BODY OF WATER

Merging Biology and Dance to Reach New Communities

Jodi Enos-Berlage and Jane Hawley

In 2014, Jodi Enos-Berlage, professor of biology at Luther College in Decorah, Iowa, was in the midst of a project investigating water quality in an impaired local stream that drained twenty thousand mostly agricultural acres. She needed to communicate water quality information to landowners and the broader community, as their participation would be key to making improvements, but she questioned whether traditional science communication approaches would be effective.

Meanwhile, Jane Hawley, professor of dance, was also facing challenges. She was searching for ways to broaden her audience and demonstrate that dance could help solve problems. Jane was putting her paradigm-shifting Movement Fundamentals (MF) curriculum into practice—training dancers in concepts rather than steps—to develop a nonstylized movement vocabulary that bodies of all sizes, shapes, ages, and abilities could use to communicate ideas.

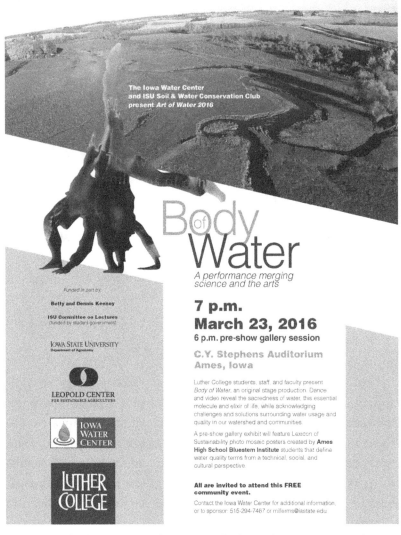

Figure 1. *Body of Water* poster design by Michael Bartels. Courtesy of Luther College.

As Jodi and Jane shared their research one day over lunch, they wondered: Could they partner to help each other? Could dance, usually considered an emotive form, be used to communicate science information? Could science provide an avenue for a broader audience to experience and value dance? Thus, the vision for *Body of Water* was born—a project and performance interweaving art and science.[1] (See Figure 1.)

<p style="text-align:center">*</p>

This case study describes how our paths entwined in a performance, how collaboration instilled trust between our disciplines, how our vulnerability sustained our commitment, and, finally, how *Body of Water* impacted both audience and performers alike, creating connection points for new communities.

PARALLEL STREAMS

Jodi: I grew up on a 320-acre outdoor playground in scenic northwest Illinois, where I would lose myself in the grass and woods, amongst bugs, birds, and the occasional four-legged mystery. My siblings and I helped raise and care for cattle and hogs. However, the biggest draw, in the farm's center, was Lawhorn Valley Creek.

Traversing the creek from one end of the farm to the other, we discovered swimming holes, fish, and dragonflies. We spent hours catching crawdads, slowly lifting rocks to investigate clinging critters, and pursuing the ever-elusive water strider as it jetted with unmatchable speed on the water's surface. In this place, my curiosity and affinity for the natural world was born.

I left home to pursue biology, eventually focusing on the littlest of life's creatures: microbes. Studying these organisms, unseen to the naked eye yet key to the function of all of Earth's ecosystems, fulfilled the curiosity I had experienced as a child.

After obtaining a PhD in bacteriology, I landed at Luther College, where I could study and share the wonder and awe of the

Figure 2. Oneota Flow. View of the Upper Iowa River from Phelps Park, Decorah, Iowa. Courtesy of Sarah Frydenlund.

microbial world with undergraduate students. This residential liberal-arts learning environment in northeast Iowa bore striking similarities to the rural hillsides, bluffs, woodlands, and winding streams of my home.

Jane: My passion for movement began near a stream that ran beneath an old wooden bridge on a dirt road a quarter mile from my farm home in Vail, Iowa. I improvised on the dry dirt floor of this outdoor studio, where the birds, bees, and plowing tractors were my musicians.

Because my mother endured the challenges of rheumatoid arthritis, I grew up helping her bathe, dress, clean, cook, sit, stand, and walk, and witnessed her restricted-yet-moving and mysterious body. Meanwhile, I experienced the capacity of my father's movements while joining him in calving, feeding, baling hay, fencing, bean walking, thistle pulling, and horse riding.

Inspired by the range of movement within the human body, I left home to study physical therapy, with my science teacher's

suggestion to pursue science: "You've got a brain, you might as well use it." Yet, I was not *moved* by lecture halls and textbooks. Dancing, however, awakened my imagination and thinking. How was I not using my brain when I danced? I pursued dance and earned my MFA in performance and choreography. I became curious about renovating dance training to welcome all body types and abilities. The foundation for my research was developing principles and practices for MF, an experimental dance training curriculum at Luther College that focused on practicing embodiment, refining movement, and crafting expression (Hawley).

INTERMOLECULAR ATTRACTION

In fall 2000, we both joined the Luther faculty, in a learning environment where chance interactions between a scientist and an artist were not only possible but likely. Through faculty meetings, students we shared, and occasional encounters with our teaching and research, we became intrigued with each other. In 2010, we applied for and were awarded a dean's office Teaching Partnership, which provided formal time and support for us to learn from each other's teaching and generate ideas for interdisciplinary projects.

TEACHING PARTNERSHIP

Jodi: While taking part in MF classes, I was struck by the atmosphere in the dance studio, an open space with windows overlooking woods rather than the typical wall of mirrors (Figure 3). Students were comfortable and secure with the diversity of their bodies. No one lined up to follow the leader's steps or took direction on how to point their toe or hold their body. In my more structured science classroom, students seemed less comfortable contributing. While the intent of the dancing was not always clear to me, it was thought-provoking; the degree to which students expressed themselves through body *and* words was intriguing.

Figure 3. Luther College, Center for the Arts, Studio One. Courtesy of Jana Lundell.

Jane: Sitting in science lecture hall, I noticed how different this arena was from the collaborative dance studio. Students sat in rows and dutifully took notes from overheads and PowerPoints at the front of the room. A substantial volume of information was covered; however, when Jodi lectured, she included metaphorical prompts and even *movement* to help students learn and absorb the information. Her teaching style enlivened the science lecture, and I recognized a rich potential for using movement to tangibly connect students to science information, awakening their imagination and thought.

ANALYSIS

In each other's classrooms, we discovered an unexpected parallel between our disciplines. As Jodi described the scientific method of

formulating a hypothesis, testing it, then analyzing the results to form a conclusion, dance students remarked, "That's what we do every day developing movements." Jodi had never considered that a dance score could be an experiment, and Jane had never considered that developing movement was like the scientific method.

DUAL DILEMMA

Jodi: As Jane and I were completing our teaching partnership, I received a phone call from Chad Ingels, an Iowa State University Extension watershed specialist. Ingels was helping to organize a group of area landowners to address bacterial pollution in a local stream. The stream contained high levels of fecal bacteria, an indicator of mammalian poop. Ingels asked, "Would you be interested in leading the water monitoring effort?"

Although my expertise was not in water quality, the work intrigued me, as it connected with my backgrounds in agriculture and microbiology. In addition, the small farm that my husband and I owned and operated was located within this watershed. In this case, twenty thousand acres drained into Dry Run Creek, which entered the city of Decorah through a popular campground and emptied into the upper Iowa River next to Luther's campus (Figure 2). Could our farm be contributing to the pollution? I said yes to Chad.

Thus began a multiyear effort in which over fifteen undergraduate students climbed up and down stream banks in rough terrain and through noxious weeds to collect water samples from ten different sites between April and October over a range of conditions, including heavy rains (Figure 4). In the lab, we analyzed these samples for levels of bacteria and chemicals as well as tiny creatures that indicate stream health. We published and presented our work, and I developed several new Dry Run Creek labs and integrated them into my microbiology course.

During this process, we became *intimate* with our watershed.

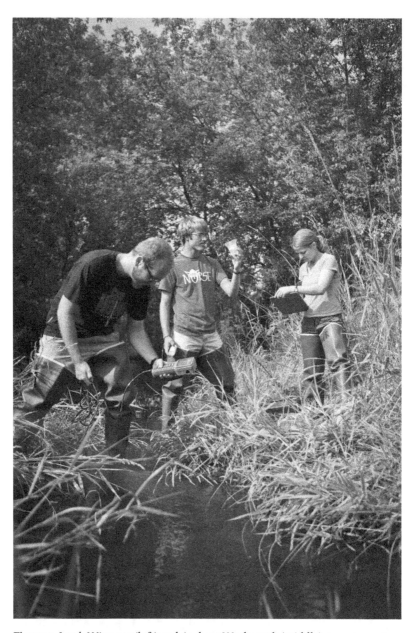

Figure 4. Jacob Wittman (left) and Andrew Weckwerth (middle) measure water-quality parameters in Dry Run Creek, Decorah, Iowa, with biology professor Jodi Enos-Berlage (right). Photo courtesy of Luther College.

We learned to recognize the plant, animal, and topographical uniqueness of each site; where the water ran shallow, deep, smooth, turbulent, clear, or cloudy; where we could walk on rocks or get stuck in the mud; where the riverbed or banks moved in response to a flood; where the beavers built their dams; and where, after exceptionally heavy rains, the water at some sites ran reddish-brown between our fingers and smelled like manure. The vulnerability of this precious resource suddenly became tangible.

The level of concern increased as we became aware of additional data: (1) at least 75 percent of Iowa's surveyed waterways are consistently impaired for at least one of their uses (e.g., recreational contact) and almost 25 percent are impaired for drinking ("Iowa Assessment"); (2) Iowa is one of the top contributors of both nitrogen and phosphorus pollution in the Gulf of Mexico that results in the depletion of oxygen and *all macroscopic life in a five thousand to seven thousand square-mile area*, causing the dead zone, an ecological disaster of epic proportions ("Agricultural"); and (3) the vast majority of nitrogen and phosphorus pollution in Iowa comes from agricultural sources, the primary economic driver in the state ("Iowa Nutrient").

As a scientist, educator, farmer, neighbor, and water monitor, I was anxious for others to see the data and *feel* its impact but also appreciated that water quality is a complex and sensitive topic. Adding further complication is that science communication tends to be highly technical. In the necessary effort to be thorough and precise, the message can become inaccessible.

Jane: As Jodi was researching water quality, I was struggling with pervasive internal queries: Why dance? Why Iowa?

Though I had established the MF curriculum at Luther over fifteen years earlier, a majority of my colleagues, administrators, and prospective students still wondered *what* type of dance we were doing if we did not teach ballet, jazz, tap, and musical theater techniques. Many failed to understand the need to change the paradigm for dance training from a step-based repetition model to

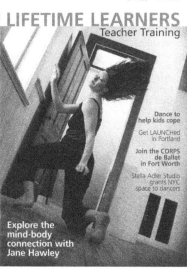

Figure 5. *Dance Magazine* article. Courtesy of Silver Moon Photography.

conceptual-based practice. This shift toward a phenomenological perspective empowered students to become artists, guiding them to imagine and create rather than repeat and do.

The MF curriculum was gaining momentum in the professional dance world, and in 2009, it was highlighted and recognized in *Dance Magazine* as a "groundbreaking dance curriculum culled from somatic and scientific movement studies" ("Radically"). (See Figure 5.)

In 2014, at the Fostering the Future: Higher Education Dance Curricula Development Sessions, an invitation-only conference hosted by New York University's Tisch School of Performing Arts and Movement Research, the MF curriculum was highlighted as one of twelve dance curricula in higher education currently in practice that addressed the needs for the year 2050 ("Dance").

But, despite these national recognitions, how could the potential of dance as a discipline—and, in particular, Movement Fundamentals—be best realized at a rural liberal arts college in Iowa? To

address this question, I found myself searching for a mechanism that could explicitly test how dance could be applied to communicate ideas across disciplines. After all, MF dance courses focused on the *body* as a site for critical socially, culturally, ideologically, biologically, and psychologically embodied discourse through somatic-movement education and artistic expression. MF dance courses established ideal conditions for thinking across disciplines. They also included texts, which supplemented the practice-based studies and framed class investigations by addressing sociocultural perspectives, biological-anatomical understanding, race, gender, sexuality, health-wellness, nature, and the body in contemporary culture.

Further, I wanted to diversify our dance audiences. While performances in Decorah consistently attracted artists and niche members of the community, I felt a need to widen the audience appeal and expand dance sensibility to new attendees and nontraditional arts goers.

As I listened to Jodi share the watershed data from Dry Run Creek and Iowa's contribution to the dead zone, I, at first, felt upset but then inspired as I realized how we could help one another. By merging biology and dance, we could create a performance for both agricultural and urban audiences. We could share her research while emphasizing the emotional connection to water, a universal and necessary resource heavily impacted by human practices. Such a performance presented an opportunity to highlight Jodi's important findings, while at the same time diversifying the dance audience and communicating a vital message across disciplines.

CONNECTING SOURCES

Our lunch meetings generated a flurry of ideas. The more Jodi shared with Jane about the unique molecular characteristics of water and how bacteria devoured the oxygen in the dead zone, the more Jane visualized how movement could demonstrate this

information on an emotional level through the body. The more Jane shared how the science research could be visualized through movement vocabulary, the more Jodi could imagine how the data could move off the page and into the hearts of the audience. We soon focused our conversations on a full evening performance comprised of dance and video. Video would function as a medium to capture local waterscapes and sounds, key data points, and interviews with local water stakeholders, including farmers. Movement would embody human engagement with water, interactions between molecules, and the dramatic impacts of pollution. Our goal was to increase awareness and create an emotional connection to water for an audience that reflected the diversity of water stakeholders.

During the summer of 2014, Jodi teamed up with Ian Carstens, a recent Luther College graduate and videographer, to create the videos for *Body of Water*. After capturing footage of local water bodies, Carstens videoed Jodi narrating in multiple contexts: drawing water molecules on her chalkboard, highlighting data from her stream research sites, and tracing groundwater movement through an underground cave. Carstens then videoed interviews with water stakeholders, including farmers, urban dwellers, city leaders, local authors, artists, scientists, trout fishermen, duck hunters, swimmers, and others.

In their fields and at their kitchen tables, farmers shared their stories. Paul Johnson described Iowa's pollution challenges: "The toughest one and the one we have to deal with most in Iowa is what we call non-point source pollution, and this is the pollution that occurs when that raindrop hits the land."[1]

John Lubke, a longtime organic farmer, spoke of how these challenges have increased in response to climate change: "When I was growing up [more than sixty years ago] it was my job to check the rain gauge after a rain. . . . I can only remember one time of seeing four inches in the gauge in the morning after an overnight rain, otherwise it was—you know—a quarter, half, or inch and a

half or two at the most . . . but now . . . it's 4 or 6 [inches]; all over the country it's that way."[2]

Many farmers spoke of conservation practices aimed to reduce the impact of raindrops. Grain and beef farmer Paul Hunter shared: "We've got some farms that have been no-till for fifteen years—we can get a two-inch rain and not a drop of water runs off."[3] Challenges were also revealed: "I really like the cover crops . . . the challenge is some of the seed you get doesn't take off and grow like it's supposed to . . . and I spent forty-five [dollars an] acre on it. . . . I hope it works, I really do," remarked dairy farmer Dale Humpal.[4]

We also sought voices of women landowners. One elderly widow, who had put her entire farm in a prairie conservation program, consented to an audio recording, one that became a key component in the performance finale: "Because I was a woman . . . I thought it was just ideal for me—I didn't have to worry about renters and what was being done with the land. . . . Now, I would just be concerned about plowing it all up again; I just wouldn't like to see that done [softly giggles] I like it; I like the land."[5]

The video interviews then expanded. Ryan Bishop, a geologist and manager of a local cave, highlighted that our region "has karst topography; you can basically compare the bedrock to swiss cheese—it's full of holes."[6] Carstens traveled to interview Kevin Stier, a Mississippi River boat captain from Dubuque, who spoke of urban pollution: "When I first started on the river, I ran trout lines, and if you didn't pull the trout lines at midnight or one in the morning, they would have so much toilet paper on them they would break—and we ate those fish—and it was just normal."[7] David Faldet, a Luther colleague in English and author of a book about the Upper Iowa River, spoke eloquently: "We are water creatures; I'm 70 percent water, and the water I get all comes from the river basin. It all comes out of the same cool water that feeds the Upper Iowa and feeds local springs. So, whatever's in that water is in me."[8]

During one of the landowner visits, an exciting discovery

emerged: the family's son was a power paraglider. Thus began the development of one of the most memorable film sections in the performance. Through aerial footage, the camera followed drops of rain as they fell on Jodi's farm and moved through the watershed, the city of Decorah, the Upper Iowa River, and into the Mississippi. Carstens felt deeply inspired to follow them all the way down to the Gulf of Mexico, and on a spontaneous weekend whim, he did. His trip set the stage for Jodi's emotional final narration of that footage: When I touch the water flowing off my farm now, . . . I am thinking about all of the connections between those molecules . . . and it makes me realize that I'm touching the ocean.

COLLABORATIVE CONFLUENCE

As the work progressed, the collaborator roles changed and began to cross over typical discipline boundaries. Jodi became an interviewer, narrator, storyteller, and film director. Jane dove into research. She observed water in all its forms; took photos; read books, journals, and poems; and viewed documentaries. Jane also explored how to kinesthetically exemplify human-water interactions, from the mundane to the spiritual. Gestural patterns of brushing teeth, splashing in a puddle, washing windows, swimming in the ocean, experiencing a rainstorm, crying, making coffee, and a baptismal blessing became the artistic fodder for the dancers to create movement phrases. The dancers embodied the use of water and water practices and linked these gestural patterns to form solo dances so that when performed together, they revealed impressions about water not commonly felt or considered.

In the fall, Jodi entered the dance studio to connect with the sixteen college students who would become the cast for the *Body of Water* performance. She shared details of the molecular structure of water, its ground sources, how it moves over surfaces, major pollutants, and Iowa's Nutrient Reduction Strategy, a major state initiative aimed at reducing the amount of nitrogen and phosphorus

The water we drink has passed through millions of other animals and plants.

Figure 6. *Body of Water* performers at the National Mississippi River Museum and Aquarium, Dubuque, Iowa. Courtesy of Luther College Theatre/Dance.

fertilizer being lost down Iowa's waterways. Ironically, it became clear that "nutrients" in this context referred to pollutants.

After Jodi shared her data from Dry Run Creek, everyone packed into vans and Jodi led a tour of the watershed, observing the thousands of acres of streams, woodlands, grasslands, corn, cows, and hog confinements. As the dancers got in the water to test it, they became inspired by doing science. A second field trip to the National Mississippi River Museum and Aquarium in Dubuque (Figure 6) mapped Iowa's land share in the thirty-one-state Mississippi River watershed and illuminated Iowa's disproportionate pollutant contributions. The dancers realized from the displays *Fish on Drugs* and *Frogs with Abnormal Growths* that what humans put into their bodies directly goes into the water and into all water life!

Armed with the science, the dancers developed specific movement vocabulary in response to their knowledge. Taylor Gomez described an example: "Jane would give us a task, like going to a body of water and creating a short phrase with the upper body

about how the water was moving . . . then we came together and tried our phrases in different formations and directions."[9]

Jon Ailabouni, jazz improviser and composer, worked similarly with the musicians, producing complementary and novel moments. Alone and together, the musicians and dancers experimented with how rivers twist and turn, how water ripples and transforms, and how marine life within the Gulf of Mexico experiences the lack of oxygen. Movement phrases were also inspired by water creatures (e.g, the schooling of mackerel or the movement of a blue whale protecting her calf during migration). The dancers kinesthetically portrayed the science findings through images and actions that were sometimes difficult to watch.

For over six months, dancers talked, thought, learned, witnessed, and became water. As they embodied the impacts of pollutants on water and water creatures, this creative process revealed that humans play an abusive, destructive, and ignorant role in their relationship with water. This outcome contrasted with our earlier movement patterns, which emphasized our natural attraction to and daily dependence on this substance (Figure 7). The irony that we damage something so vital to our existence dramatically changed our thinking.

TRANSFORMATION

Suddenly, water was sacred, and dancers felt a new level of empathy (Figure 8).

Daily interactions with water became more meaningful. In the words of Sara Maronde: "Washing my face became a ritualistic act; stepping over a puddle would force me to pause about how the water got where it was and where it was going."[10] Marah Owecke went further: "My daily life shifted to being constantly aware of faucets, showers, sewers, drains, bodies of water, children playing in pools, and how much I depended on water."[11] Dancers also altered their practices, as Michael Ehrecke highlights: "I took to

Figure 7. Marah Owecke, Holly Williams, Taylor Gomez, and dancers wash themselves. Courtesy of Luther College.

turning off the shower as I shampooed and conditioned my hair . . . and instead of leaving the water running while doing dishes, I filled the sink and used only that much for the day's damage."[12]

The experience also promoted a deeper "connectedness." "I have found myself sitting in front of maps and tracing the rivers, streams and deltas . . . the project brought into the forefront of my mind the idea of bodies of water physically connecting millions of people," remarked Travis Nietert.[13] Danica Kafton commented: "I found a vital connection to water through my body . . . I became aware of how water travels through others to us and through us to others."[14] For some, including Jana Lundell, the feeling approached the spiritual: "I became aware that this was a resource that I had been taking for granted most of my life . . . I never had thought of water as a source of true feeling, a vessel that could carry emotion."[15]

Composer/musician Jon Ailabouni reflected: "I was overcome

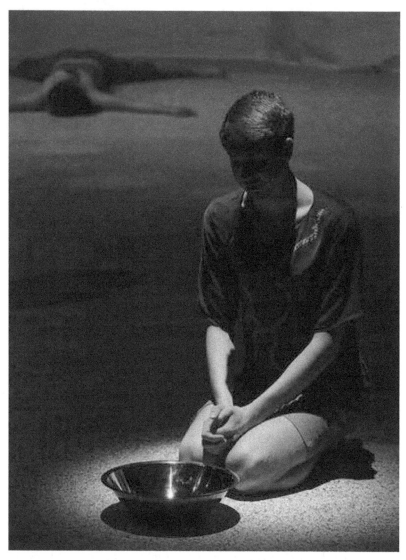

Figure 8. Michael Ehrecke's water mantra. Courtesy of Luther College Theatre/ Dance.

Figure 9. Malanaphy Springs, Decorah, Iowa. Courtesy of Ian Carstens.

by the realization that water is the 'molecule of life'; that all life—in its vast immensity and with all its variety and complexity—is united by this infinitesimal element (Figure 9). This led to an urgent awareness of my responsibility for the water that passes through my domain and flows downstream to all living things."[16] Ian Carsten, videographer, revealed: "The nature of water's interconnectedness has shaped my perspective on understanding conflict, responsibility and action/inaction. . . . I have begun to 'feel' the presence of water . . . I see it in living things and find myself moved to a place of empathy. . . . My sensitivities of body, heart, and mind have been forever changed by this project."[17]

<div align="center">*</div>

As Jodi witnessed these effects during two brief visits to the dance studio in late fall, she could sense that the intimacy she had experienced while monitoring Dry Run Creek had not only been transferred to the performers but powerfully magnified. If only a fraction of this emotional connection could be captured and conveyed to the audience, this project would be a success.

TURBULENCE

In January 2015, after almost a semester of working independently, Jane and the dancers met with Jodi and Carstens to share their work. It was not the climax moment and affirmation that we had envisioned. The dancers watched the final videos with confusion and uncertainty. From their perspective, the ten- to fifteen-minute videos seemed long, static, and motionless. The audience was coming to see a live performance, not a science lecture. Dancers worried that the videos would dominate and not captivate. Where was the dancers' semester of work supposed to fit? The video components, in their current forms, were not yet open to being interwoven with the dancers' material. Complicating this, Jodi and Carstens's time and energy for editing was nearly exhausted.

Jodi sensed a second problem. While she was moved by the choreography, she knew that her appreciation of the movements was in part because she understood the biological inspirations behind the movements. For example, Jodi knew that a mass of moving bodies was inspired by schooling fish; a series of movements cascading down a line of dancers represented a water ripple, and eight synchronous legs in the air portrayed an octopus. Would audience members new to this form of expression—including farmers and scientists—be able to access the choreography, receive the information, *and* understand dance? Scientists cannot use jargon with a lay audience. What does this mean for dance? If the audience left without a sufficient understanding of the science or appreciation of the dance, we would not have achieved our goals. The outcome: *Interdisciplinary collaboration is hard.*

Slowly, with dedication and meticulous effort, the performance came together. Sarah Frydenlund, a performance editor who was impartial to the dance and video components, helped the collaborators compromise. Films were broken into two- to five-minute pieces. Some were limited to audio only. Some sections were dropped entirely. The dancers layered and modified the

Figure 10. Turbulence. Courtesy of Ian Carstens.

choreography in order to help the concepts shared in the videos come to life in interesting, unexpected, and emotional ways. At the same time, having shorter video clips interwoven throughout the performance provided familiar handles to help the audience access and understand the choreography. The videos communicated scientific concepts and data. The movement scores included just enough cues to suggest meaning while protecting the integrity of dance as an art form. Music connected the components and added sensory layers. The process identified the attributes and limitations of each discipline and how they could complement each other.

BODY OF WATER

Muslin-layered "limestone" walls, indicative of Decorah's geology, line the theater and angle up to what could be an altar. The audience waits in silence in what feels like a sanctuary. Steady drops from a one hundred and fifty-pound hanging block of ice accumulate into a pool of water in a large stainless steel bowl.

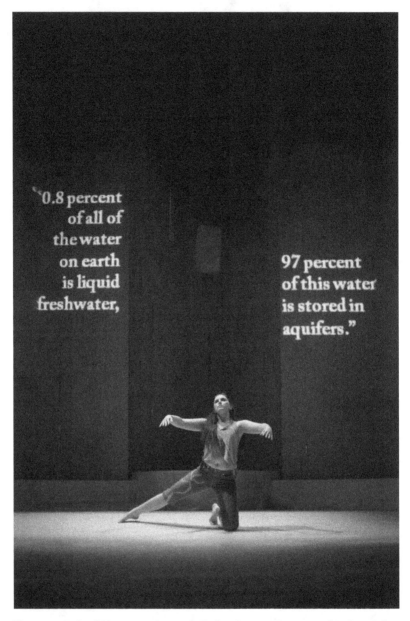

Figure 11. *Body of* Water opening with Taylor Gomez. Courtesy of Luther College Theatre/Dance.

A single body lies splayed and barely lit on the floor (Figure 11). She begins to move, and reverberations from an electric guitar fill the space. The dancer repeats her movements and speaks of being water in all its forms. In a video, wind and water is heard as Jodi sits next to the Upper Iowa River and describes the human biological, innate attraction to water. The audience senses, hears, feels, and even imagines the taste of water. Dancers wash and chant their prayers over steel water-filled bowls, an ancient link to what is both familiar and mysterious about this substance.

Cylinders arranged in the shape of a water molecule elevate dancers in a mirage of the mundane: washing windows, playing in puddles, showering, swimming, canoeing, crying (Figure 12).

Music pulses, lights shift, and dancers submerge into the underwater worlds of an octopus quartet, a deep sea creature duet, and an alluring pair of sirens. Limbs arc and tumble, creating curvilinear patterns. Soaring lifts mix with thrashing turns, head dives, and flying catches.

The rat-a-tat-tat pattern of a drum rim shot sounds. A video shows Jodi at the chalkboard, drawing the hydrogen and oxygen bonds that make up a water molecule. Dancers animate these bonds (Figure 13).

Aerial views of the twenty thousand-acre watershed appear as the raindrop's journey is followed to the ocean. The lighting shifts and the scene is back to land. A pattern of movement ripples through sixteen bodies as a series of videos reveal Iowa's pollutants: from fertilizers to fecal bacteria, soil to street-car residues to lawn pesticides. A dancer now pauses on what looks like a bridge for a smoke (Figure 14). She flicks the butt into the river below.

Other dancers cross and toss a plastic water bottle, a Styrofoam takeout container, oil, paint, vomit; mounds of plastic fill the stage. The bridge breaks and pillar pieces and trash rise and roll over, under, and around the dancers' bodies.

A flood rushes downstage in unpredictable waves. The music builds and crashes to a halt and everything is again silent and still.

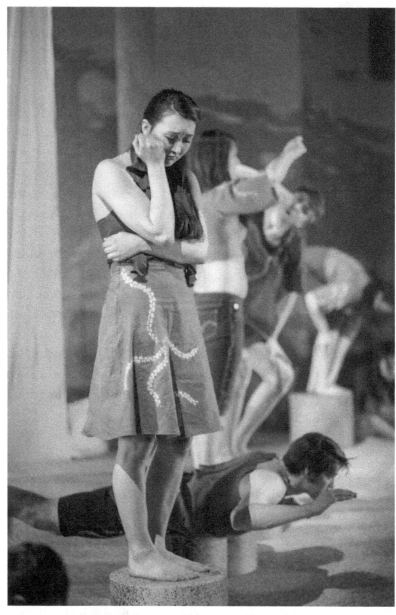

Figure 12. Jana Lundell and Travis Nietert in the "Molecular Mundane." Courtesy of Luther College Theater/Dance.

Figure 13. Interacting water molecules. Courtesy of Luther College.

The sanctuary exhibits bodies as dead organisms are strewn across the space, entangled in trash, nearly touching the audience's feet (Figure 15).

An audio track begins: "Where do we go from here?"

All involved were challenged about how to conclude the *Body of Water* performance in a way that would inspire change in agricultural and urban practices and communal care of water. How could we move from a climax of pollutants and despair to an offering of hope without some feeling targeted? But after listening again to the interviews of the watershed community and reading Native American writings from a key source, we found a solution (McLuhan).

During the performance, an audio track restarts, with the voice of Doug Rossman, a scientist deeply familiar with Native American practices, reciting: "From traditional Cherokee—people who live in the southern Appalachian Mountains—it was a living thing—not just a—you know—a fluid part of the geology, but it was a living thing—and it had the power of healing."[18]

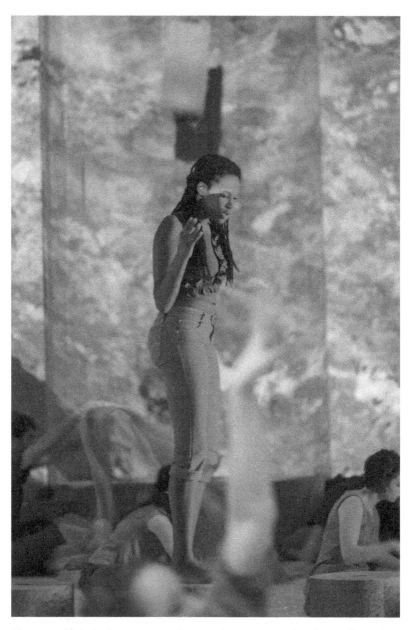

Figure 14. Christie Owens pauses for a smoke. Courtesy of Luther College Theatre/Dance.

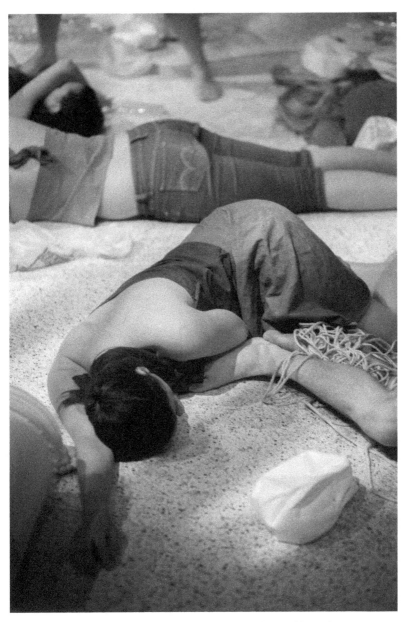

Figure 15. Bodies strewn with trash. Courtesy of Luther College Theatre/Dance.

Figure 16. What is the molecule of Life Worth? Jennifer Schmidt and dancers. Courtesy of Luther College Theatre/Dance

Figure 17. Reflections. Courtesy of Ian Carstens.

A solo dancer returns and takes the silver bowl from the altar and begins to wash herself among the strewn bodies and trash (Figure 16).

The music begins to pulse and drive her baptismal shower. A wild wet dance brings a rain of renewal, and then darkness. In the dark, voices of farmers and naturalists describe their personal attempts to address water quality. Singly, the dancers rise to address the audience and link hands, recognizing that, in the end, humans cannot succeed by attempting to dominate or control but, rather, by harmonizing: seeing themselves as a part of natural systems.

OUTPOURING

Combining two seemingly disparate disciplines and media types, we took a risk making *Body of Water*. But while the project was an experiment with rural neighbors, community, colleagues, and students, the results surpassed expectations.

All five performances of *Body of Water* sold out. As seats ran out, audience members stood in the aisles, on the stairs, and on the catwalks. Farmers came and liked it. Science students were enthralled. Conservationists, urban leaders, city dwellers, outdoor enthusiasts, artists, writers, scientists, educators, and others made up one of the most diverse audiences ever at a Luther visual arts performance. Some people cried. Others exclaimed: "Take it on the road" and "Our Iowa legislators need to see this." The *Des Moines Register* ran a feature article highlighting how the work connected to a major water-pollution lawsuit in the state ("Dirty").

The talkbacks following each performance provided the audience with additional opportunities, as the dancers could share candidly how they developed empathy by *embodying* water molecules, rivers, pollutants, and dead organisms. Several dancers from farm families explained how the project prompted new conversations. As James Mueller indicated, "I began inquiring as to land practices

being used on my family's farm. . . . My mom and I talked about the creek that ran through our property and what a joy it was to be able to cup your hands and drink water bubbling up from the earth. From that conversation began a movement within my family of how the use of our farmland can more closely reflect our love of the land, while also respecting the agricultural and financial needs of our land renter."[19]

After the performance, the codevelopers felt *relieved*. The experiment that had taken the better part of a year had worked. Audience members revealed that they had gained new or enhanced appreciation for the extent of water pollutants, their sources and impacts. Payton Schultz remarked, "After watching the performers 'pollute' the water on stage, I felt a sense of guilt, realizing that I have been that careless person in the past, letting myself pollute waterways in ways that I hadn't realized."[20] Jake Seibert was more specific: "After seeing the performance, I do worry more about field runoff leaching its way into the watershed, culminating into dead zones like in the Gulf of Mexico."[21] Dairy farmers Dale and Mary Humpal reflected on their operation: "I am more aware and think about our water supply and how what happens on our farm could affect people miles and miles away."[22]

Body of Water prompted a new way of thinking about water or water practices, or new plans for action. Schultz said, "I knew that going forward I would be much more conscious of how I use and treat water."[23] Landowner Paul Frana reflected: "I guess I look at the creek running through our farm differently now. We have a group of beavers that have dammed up parts of the stream in the last year, and though it has made some things a lot more difficult for us . . . I know they are helping filter the water running through our land much better than any structure we could have built."[24]

Some attendees' plans for action became very specific. Steve Hopkins, Nonpoint Source (Pollution) coordinator for the Iowa Department of Natural Resources, indicated that, "*Body of Water* helped me to spend a lot of time thinking about the creek closest to

my home in Newton, Iowa. It has the unfortunate name of 'Sewer Creek.'" He went on to describe that due to his prompting, a local high school class had begun "conducting water monitoring of the creek and submitted an application to the US Geological Survey to officially change the name . . . to 'Cardinal Creek' . . . expected to be officially approved this summer."[25]

Finally, additional commentary highlighted the collaborative nature of a project bringing science and the arts together. Chad Ingels, the former Iowa State University Extension watershed specialist who made the initial phone call to Jodi to start the project, shared, "I was moved by the connection of agriculture, water, and the arts. I had never really considered that dance could be used to educate an audience about water and the connections to the land and farmers while entertaining them as well . . . I have been involved in water-quality improvement efforts for a long time, but after seeing *Body of Water*, I find myself being more comfortable using creative means to talk about water and connections to what we do on the land."[26]

Holly Moore, associate professor of philosophy at Luther, shared reflections that went beyond water: "I was really energized by seeing what's possible when people invest in deep and authentic interdisciplinary collaboration. The communal nature of the performance gave me hope."[27] Sara Maronde spoke from her perspective as a dancer: "The biggest and most enduring impact of my participation in *Body of Water* is . . . the integration of two distinct forms of creative research . . . I felt the power of the two women who initiated this project . . . their compromises and adaptation of their own work styles to meld into a single integrated idea and performance."[28]

A RIPPLE EFFECT

Body of Water created a ripple of inspiration, spurring additional performances beyond Luther, a production of a DVD of

the premiere, and a variety of new public outreach mechanisms, including educational workshops and this book chapter.[29] The outcomes of the *Body of Water* project continue to engage local landowners, community members, and college students, in addition to women's groups, retirees, and K–12 students (where science, technology, engineering, and math [STEM] courses are being refocused into science, technology, engineering, arts, and math [STEAM]), as well as broader regional and national audiences through programs such as the Iowa Water Conference and National Water Dance. The codevelopers remain humbled and inspired by the results of this experiment.

REFLECTIONS

Jodi: *Body of Water* was the most substantive and difficult project thus far in my academic career, stretching me beyond my training and experience and cementing a lasting influence: collaborations generate a product more powerful than the sum of their parts. Science is essential but not sufficient. Understanding and motivation are intimately tied to human emotion. I now seek the power of the arts to communicate science, whether in my research laboratory or classroom. Working with artists is invigorating! I am convinced that reaching out to engage with the other is the key to solving our most vexing problems as humans. Let us be inspired to continue.

Jane: Since I can remember, I have loved contemplating Albert Einstein's quote: "The most beautiful thing we can experience is the mysterious. It is the source of all true art and science. He to whom the emotion is a stranger, who can no longer pause and stand wrapped in awe, is as good as dead; his eyes are closed" (Einstein). The creative process and outcome of *Body of Water* confirmed for me the importance of embodied learning. When I *think* through my body and *feel* what I am studying, I learn differently and something mysterious happens. I become immediately aware

of how everything relates and that extraordinary partnerships are possible. My eyes are open.

NOTES

1. Paul Johnson, personal communication to author, June–Sept 2015.
2. John Lubke, personal communication with the author, June–Sept 2015.
3. Paul Hunter, personal communication with the author, June–Sept 2015.
4. Dale Humpal, personal communication with the author, June–Sept 2015.
5. Rose Frana, personal communication with the author, June–Sept 2015.
6. Ryan Bishop, personal communication with the author, January 2016.
7. Kevin Stier, personal communication with the author, June–Sept 2015.
8. David Faldet, personal communication with the author, June–Sept 2015.
9. Taylor Gomez, personal communication with the author, July 18, 2017.
10. Sara Maronde, personal communication with the author, July 18, 2017.
11. Marah Owecke, personal communication with the author, July 18, 2017.
12. Michael Ehrecke, personal communication with the author, July 18, 2017.
13. Travis Nietert, personal communication with the author, July 18, 2017.
14. Danica Kafton, personal communication with the author, July 18, 2017.
15. Jana Lundell, personal communication with the author, July 18, 2017.
16. Jon Ailabouni, personal communication with the author, July 18, 2017.
17. Ian Carsten, personal communication with the author, July 18, 2017.
18. Doug Rossman, *Body of Water* (performance), June–Sept 2015.
19. James Mueller, personal communication with the author, July 18, 2017.
20. Payton Schultz, personal communication with the author, July 18, 2017.
21. Jake Seibert, personal communication with the author, July 18, 2017.
22. Dale and Mary Humpal, personal communication with the author, July 18, 2017.
23. Schultz, personal communication with the author, July 18, 2017.
24. Paul Frana, personal communication with the author, July 18, 2017.
25. Steve Hopkins, personal communication with the author, July 18, 2017.
26. Chad Ingels, personal communication with the author, July 18, 2017.
27. Holly Moore, personal communication with the author, July 18, 2017.
28. Sara Maronde, personal communication with the author, July 18, 2017.
29. Acknowledgments: We thank David Faldet, Bob Larson, Eric Baack, Andy Hageman, and Lise Kildegard for their helpful editorial support and guidance.

WORKS CITED

Department of the Interior. "Agricultural Practices in 9 States Contribute Majority of Excessive Nutrients to the Northern Gulf of Mexico." US Geological Survey. January 29, 2008.

Einstein, Albert. *Living Philosophies*. New York: Simon and Schuster, 1931.

The Free Library. "Radically Somatic: Jane Hawley Transforms Dance at Luther College." *Dance Magazine*, May 1, 2009. https://www.thefreelibrary.com/Radically+somatic%3A+Jane+Hawley+transforms+dance+at+Luther+College.-a0199684095.

Hawley, Jane. "Movement Fundamentals Institute." Movement Fundamentals. Accessed November 9, 2019. http://www.movementfundamentals.org/.

Iowa State University. "Iowa Nutrient Reduction Strategy." http://www.nutrient-strategy.iastate.edu, Accessed July 22, 2017.

Luther College. "Body of Water Project." Accessed August 18, 2017. https://www.luther.edu/body-of-water/.

McLuhan, T. C. *Touch the Earth: A Self-Portrait of Indian Existence*. New York: Outerbridge & Dienstfrey, 1971.

Morain, Michael. "Dirty River Dance: Luther Show Highlights Water." *Des Moines Register*, March 13, 2015.

National Dance Education Organization. "Dance 2050: The Vision of Dance in Higher Education." Accessed June 3, 2018. https://www.ndeo.org/content.aspx?page_id=22&club_id=893257&module_id=172476

US Environmental Protection Agency. "Iowa Assessment Data for 2014." Accessed July 14, 2017.

AFRO-LATIN AMERICA ON STEAM

Doris Sommer with Antonio Copete

Victoria Mena Rodríguez broke down in tears when a warm-up activity left her people cold. Tired teachers, who had been obliged last minute to show up after classes, resented the imposition of yet another training, and they refused to be charmed by theatrical games. Even before a foreign text by Mexican Juan Rulfo could test their tolerance for apparently useless material in Quibdó, the capital city Chocó on Colombia's Pacific coast, the invitation failed to cross cultural barricades built up over decades, if not centuries, of neglect by the rest of the country. The locals candidly refused to submit to an unsolicited workshop by unwanted outsiders. That was when Vicky's unrequited love for the place exploded in sobs, about her deceased father who had graduated from the very school where she expected a warmer welcome, about her local relatives whom she planned to visit during her stay.

The tears took the teachers by surprise. Unscripted emotion managed to break the ice that had stood firm against rehearsed

moves. After that, Vicky became, for Quibdó, more than a teacher of architecture and design in Bogotá's distinguished Tadeo Lozano University. She became family. Had they known her surname, it would have been a clue. Mena is an unmistakably Afro-descendant marker of origins in the department (state) of Chocó. But it was Vicky's vulnerability that brought down boundaries that conventional leadership might have hardened. And though we hadn't yet named this virtue for a future program called Pre-Texts: Literacy, Innovation, Citizenship, vulnerability has since become a recognizable quality of civic and intellectual engagement. It is a signature condition of our shared human frailty, and our workshops inevitably stretch the experience of personal humility, as we facilitate and participate, taking turns to lead, to make mistakes, and sometimes to make magic.

Pre-Texts arrived in Quibdó precisely because it was a stretch for both parties. The capital city of Chocó is a center of cultural effervescence and also—like much of the Afro-Colombian coast—an outlier for national rights and resources. Colombia's arduous process toward peace agreements, between government institutions and rebel forces, has made some efforts to take responsibility for the underserved, and therefore exceedingly affected, areas of armed conflict in the largely Afro-descendant area. That peacemaking project, together with unextinguished resources of local talent and optimism, inspired the national Ministry of Environment and Quibdó's municipal Secretariat of Education to host a training workshop in Pre-Texts during February 2017. The contribution to the peace process would be an approach to social development derived from Paolo Freire's *Pedagogy of the Oppressed* (1969) and would be laced through with local creative practices. Pre-Texts doesn't need to know what those practices are; it simply acknowledges that local arts exist and that participants will identify them to coconstruct the training.

Recycling texts is the core activity, and economically poor areas

are rich in recyclers. As a pedagogy, turning found material into something useful is especially promising now that many countries have adopted skills-based and universal designs for learning. Pre-Texts grounds these good intentions in art-making and popular practices, to engage students at any grade level. With Pre-Texts, even low-resourced schools can promote high-order learning. Intellectual rigor and civic development go hand in hand through the challenges and pleasures of making art.

Collaboration among people and forms of knowing is a Pre-Texts practice that has developed over forty years of trial and error, with lessons learned about reinterpretation and recycling from artists and artisans throughout Latin America. If, for example, children and youth don't want to read, popular tradition has a solution. Read aloud while they do something with their hands. Pre-Texts begins with manual arts while a text is performed by a reader, reviving the practice in cigar-rolling workshops throughout the Spanish Caribbean, including Tampa, Florida, and New York City. If the reading material seems too dense or difficult to understand, the challenge itself becomes an incentive to ask questions, and then to go off on tangents and speculate about answers with fellow "artists" in classrooms-turned-workshops. Artists are not victims but users of the world. This has been a slogan for Pre-Texts and for "Cultural Agents" in general, an initiative to revive the civic mission of the humanities through, among other projects, the Pre-Texts pedagogy.

A metaphor for the method is "stone soup." The concept comes from a folktale about a traveling beggar (the paradoxically more privileged Bogotanos) who arrives hungry in a village with nothing more than a stone picked up on the way: "This magic stone makes the best soup in the world," announces the beggar to the villagers (in Quibdó). "All we need is a pot, a chicken, vegetables, etc."[1] With appetites aroused, people bring what they have and then benefit from the bounty of others. Pre-Texts is this same kind of wry invitation to use local resources to produce new combinations and to

accommodate extraneous material (texts) into something delight-
fully nourishing and largely familiar.

STONE SOUP

With a challenging text as a hard-but-magic ingredient, artistic
interventions achieve remarkably close readings thanks to the
fun of playing with the material, often irreverently. This simple
approach delivers a holistic education that includes high-order
literacy, innovation, and citizenship. Each objective propels the
others like dynamic gears. The movement takes training, because
conventional teachers are protagonists of their classrooms rather
than facilitators for student-centered learning. Pre-Texts decen-
ters attention as students formulate their own questions and then
speculate on answers. They go off on tangents to read broadly along
their own lines of interests in order to publicize their research for
classmates to read. Each participant enriches the experience of
others. The approach adjusts to the tastes and talents of contrib-
utors who explore difficult material through activities they them-
selves propose for turning texts into new works of art (painting,
music, dance, theater, writing, technology, fashion, photography,
cooking, etc.). As artists, students become users of challenging
vocabulary, grammar, and concepts, often exploring their per-
sonal feelings and concerns, indirectly and safely. Original work by
other students awakens admiration among classmates, setting the
ground for good citizenship. When everyone is an artist, bullying
diminishes to the point of disappearing.

Like stone soup, the method has no content but only form: take
a difficult text, read it aloud while people make a book cover, a
costume, a decoration, etc., then ask the text a question, specu-
late on responses through an art activity, and finally ask: What
did we do? Whether we read a scene from *Prometheus Bound*, or a
formula in physics, or a chapter from world history, the procedure
is the same, and the results are astoundingly subtle. Classroom

artists have the right to do as they please with a given text, though classmates will also demand justifications and precise textual references. Empowerment here requires intellectual rigor. The arts that serve as vehicles for learning are the ones that participants enjoy. It matters little if a scene from Aeschylus turns into a rap, or a fashion show, or a cooking recipe as long as the artist can defend a creative decision with reference to the text.

With Pre-Texts, teachers learn to limit their authority and become facilitators, beginning with a training process of basic activities collected in a manual for facilitators. After the first of five sessions, trainees take turns to invent or to adapt activities that they choose to lead, respecting the basic protocol: listen, question, make, and reflect. Taking turns to invent activities, risking mistakes, and getting advice means that all twenty-five new trainees become facilitators during the training week. Once they begin to implement Pre-Texts in classrooms, teachers can invite students to propose their own activities rather than worry about running out of ideas. A slogan for teacher training is "Work less and achieve more." To share leadership with students who take turns facilitating is more than mere relief for fatigued teachers. It is also a model for democratic collaborations.

Basic activities for Pre-Texts are collected in the manual and represent popular practices from Latin America. See, for example, "la cartonera" (making individually decorated books from recycled cardboard, which started in Buenos Aires and spread throughout Latin America); the reader in tobacco factories (someone reads aloud while we make something at tables, as in the Spanish Caribbean); or "literature on the clothesline" (publishing with rope and clothespins, as in the northeast of Brazil). These poor people's arts have now been adopted at Harvard University, through the Bok Center for Teaching and Learning, Harvard Art Museums, and many language courses. Counting on the arts of the manual, and adding those with local flavor, Pre-Texts combines collective pride with high-order engagement of even extraneous materials.

TRANSVERSAL TRAINING ON TWO TERRAINS

Juan Rulfo's short story "They Gave us the Land" (Nos han dado la tierra) from his collection *El llano en llamas* (1953) certainly seemed out of place as the core text for training in Quibdó.[2] On purpose, the cofacilitator for Quibdó's workshop chose an unlikely tragedy about waterless Mexican land for Colombia's Pacific Coast. Margarita Gómez, professor of microbiology at the Universidad de los Andes, Bogotá, took a risk with the Mexican material. It narrates how the postrevolutionary government deceived displaced peasants by granting them plots of land so dry that the concession was useless. Without water, land produces nothing. The legal trick is like Portia's caveat during the trial of *The Merchant of Venice*: you can have flesh, but not blood. "Take then thy bond, take thou thy pound of flesh / But in the cutting it if thou dost shed / One drop of Christian blood, thy lands and goods / Are by the laws of Venice confiscate / Unto the state of Venice."[3]

Mexico's sundried disaster, because nothing happens, seemed very far from Chocó's waterlogged experience of lush vegetation and waves of violence, so the text was irritatingly foreign. Perhaps that was Margarita's point, to demonstrate that any material can be a prompt for local interpretations. When Quibdó's teachers began to pull apart Rulfo's story—inventing, for example, a news program cleverly called *Llanoticias* ("no longer news," as well as "news from the plains")—they discovered that the approach might work to teach practically anything. This included ecology, the declared focus of this particular training workshop, with blessings from the national Ministry of the Environment.

It was a sly decision to start from a literary classic rather than from a scientific text. And then, to disarm her new colleagues even more, Margarita shifted the terrain away from local literature in order to pose general questions. With an alien tale that venerates water and that indirectly underlines an undervalued local resource for Chocó, Margarita led teachers through activities that they now

repeat in their classrooms. Probably the most stunning discovery was that creative literature can lead to scientific inquiry. She also invited them to propose original activities and to continue to cocreate classes with their students. During the Pre-Texts training week, participants who read a story about chronic drought analyzed water samples from various sites, from before and after rainstorms. They identified species of plants and animals that prosper in one environment and another. Each day, trainers and teachers "went off on tangents," as we call the activity of research in Pre-Texts.

As for Vicky, she stretched the terrain of natural science toward art and design, effortlessly, because facilitation doesn't presume expertise on all fronts. Margarita's activities in microbiology were welcome additions to Vicky's experience with Pre-Texts, not necessarily prompts to replicate. No trainer need be an expert in all the interpretive activities we use. Instead, trainers participate in experiments that count on the know-how of others. Vicky is admirably sturdy, apparently invincible, as a capacity builder. Either she wins skeptics through a charm that combines irony and intelligence with affection or, as in the case of Quibdó, she succumbs to a genuine frailty that rallies the concern of others. The connecting thread between verbal agility and occasional speechlessness is her profound dedication to social development and a generous humanity that puts service above ego.

Quite simply, a capacity for love is the knack for disarming resistance that talented facilitators like Vicky and Margarita share, in the spirit that Paolo Freire defended as good teaching. Tragically, he observed, some parents do not love their children. But there are no real teachers who do not love their students.[4] With Vicky's charm, she had, for example, famously cajoled a skeptical indigenous educator to give Aeschylus a chance when he objected that Greek tragedy had nothing to offer to his community's urgent challenges. After two hours, he identified Prometheus' conflict with Zeus as precisely the challenge of unyielding arrogance that they faced.

And then there was the workshop with displaced teachers who had come to Cartagena, practically mute from traumatic violence and displacement. After piecing together fragments of torn paper and cloth, as if piecing together the fabric of torn lives though the literary prompt seemed extraneous, they dared to speak about the text and inevitably about themselves. With the case of Quibdó, we learned that when charm fails, frailty can inaugurate an irrigation of tears to soak some fertile ground.[5]

SUSTAINABLE PEACE

The urgent work of creating sustainable peace in Colombia requires a pedagogy that prepares citizens to live together without resorting to violence. By refreshing an approach to public education, Pre-Texts achieves this civic goal along with significant academic improvements that boost the economy. The refresher course is no novelty but rather a streamlined version of project-based learning that any educator can replicate. Private education has already discovered the good effects of similar practices, while public schools seem reluctant to try them. Do they imagine that poor children learn differently from the rich?

Conventional public classrooms train students to confirm authoritarian structures that undermine democracy and alarmingly drive up dropout rates. With two simple adjustments, one spatial and the other conceptual, we can transform the obligatory hours spent in school into sessions of dynamic civility and academic achievement. An entire community can benefit when students become cofacilitators who engage families and neighbors in making something new from challenging texts. This after-school effect for the community will come from occasional weekend workshops. But first, in-school time must be rescued from the festers of boredom and resentment.

One rescue move is quite concrete. You might call it

architectural. The conventional rows of desks and chairs—where students look at the mute backs of fellow students rather than at their expressive faces—are reorganized in Pre-Texts to form circles in which all are visible and vulnerable to one another. Recognizing each individual as part of the circle generates an anticipation of universal sharing. The sessions that begin with warmups, continue with listening to a live reading of a complex text (any text will do), and follow by posing questions to the text as preparation for creative responses, end with a collective reflection to the prompt: "What did we do?" People who prefer not to speak learn that democratic process includes an obligation to contribute, along with the right to do so. Neighbors encourage neighbors to engage so that the next activity can begin. Pre-Texts doesn't sermonize or bore students with theories about rights and obligations. Instead, it models democracy by staging scenes that, significantly, recover many indigenous traditions of community deliberations in circles.

The other move that Pre-Texts makes is conceptual. We demonstrate that pleasure drives learning forward. It is a motor of development—not a distraction. The pleasure of using difficult texts as raw material for art-making generates passion for one's work. It matters little whether the text had terrified students if the activity enchants them. Fun replaces fear. Students become users and creative agents, making decisions about how to turn one thing into another. Let's get to work! A classical Greek tragedy, or a legal document, or a formula from physics or mathematics becomes mere material to manipulate. Meanwhile, artists investigate the material, the better to use it. They read, dig in, interpret, and gain expertise.

Neuroscience confirms what we had already learned from brilliant educational reformers, including Maria Montessori, John Dewey, and Freire (with background hints from Friedrich Schiller, Sigmund Freud, and Donald Winnicott). Pleasure in work activates cognitive as well as socioemotional development. The neural

connections between academic and emotional growth marks an educational opportunity. But they also mark a fault line in standard pedagogical approaches that distinguish, unproductively, between intellectual and emotional development. Human complexity means that neural paths cross as personal pleasure energizes both academic and civic growth. When Pre-Texts turns a classroom into an art studio to cultivate a variety of interpretations through a range of creative practices, the whole person flourishes to the delight of others.

Pre-Texts trains a taste for different interpretations and develops admiration for the array of creators. It doesn't impose a frequently resented moral obligation to tolerate diversity. Instead, the experience of diversity excites wonder and enjoyment. Students who understand themselves and one another as artists expect more than one answer for most questions, and more than two. Questions can be as unpredictable as the multiple answers, so that participants relish a variety of inquiries that would not have occurred to any one student, even before they begin to play with possible convergent and divergent interpretations. Contemporary societies, challenged with achieving nonauthoritarian stability among conflicts of culture, class, race, gender, and religion, will do well to educate new citizens to enjoy differences, to value divergences along with convergence.

Sustainable peace requires this combination of cognitive, emotional, and civic development. It acknowledges the value of resilient *form* over endlessly changing contents. Any content can serve as a pretext for forging better ways to communicate and to collaborate. Democracy is itself more form than content—more of a time-consuming process than polished product. This is a lesson in civics that is worth refreshing during our impatient times, while parents and principals can become irritated by the demands of dedication to the arts. The good news to share with them is that the time spent is precisely the path to deep learning and to human development in general.

AFRO-LATIN AMERICA ON STEAM

Pre-Texts has been developing since 2007 and caught the attention of Antonio Copete in 2016. He had recently overseen "science clubs" throughout Colombia, with the collaboration of young scientists from renowned institutions in the Boston area. Antonio is a researcher in astrophysics at Harvard and graduate of Harvard's doctoral program in physics. His network of seasoned and also newly minted scientists in a range of fields, from astrophysics and chemistry to agriculture and video gaming, rallied to offer week-long, intensive, hands-on science instruction to groups of economically poor and sometimes geographically isolated youth during a week of activities over the summer months. Distinguished colleagues were invited to offer talks by Skype, if they could not come in person, in order to spike the experience with research by world-class senior colleagues.

The universal enthusiasm generated by the clubs has produced great interest and optimism. But the experience has also taught participating scientists that direct interventions with young people, without taking into account their year-round teachers, has limited long-term effects. After a week of ardent engagement, the youths retain little of what they learn. The experience often becomes a pleasant memory rather than a turning point for future studies and careers. It became clear to Antonio and to his colleagues that lasting effects would depend on incorporating local teachers effectively, integrating their mentorship into accompanying programs such as science clubs. The staying power that teacher training could guarantee made Pre-Texts a promising partner. A decade-long experience could translate into a focus on STEM disciplines. Thanks to Margarita Gómez, and to our inaugural workshop where she used Carl Sagan's *Cosmos* as instructional material, bridges to STEAM were already under construction.

Pre-Texts has become a framework for training science teachers to facilitate hands-on engagement with materials, both natural and

manufactured. Between literary and scientific education, we can take advantage of resources that are as abundant in Latin America as they are undervalued. These are creativity and resourcefulness. While the region may often be challenged with unfavorable economic and political conditions, citizens somehow manage to make do with existing materials and environments. It is art, in its broad definition as a range of techniques to refresh and reinterpret the world, that often rescues desperate situations and also enhances humble conditions. This is a strength that can be overlooked in current practices of Latin American studies that feature problems rather than responses, pathologies rather than public health. The themes of the field tend to favor poverty, corruption, scarcity, and insecurity instead of resourcefulness, collaboration, and aesthetic pleasures.

Practical, almost always technical, responses to the challenges have been too narrow. Therefore, at the beginning of 2017, Antonio and Doris Sommer initiated a collaboration between humanists and scientists called Afro-Latin America on STEAM at Harvard's Afro-Latin American Research Institute.

Quibdó became a welcoming test site.

NOTES

1. Paraphrased from folklore by the author.
2. Juan Rulfo, *El llano en llamas* (México: Fondo de Cultura Económica, 1953).
3. William Shakespeare, *The Merchant of Venice*, 4.2.298–303: "Take then thy bond, take thou thy pound of flesh / But in the cutting it if thou dost shed / One drop of Christian blood, thy lands and goods / Are by the laws of Venice confiscate / Unto the state of Venice."
4. Paolo Freire, *Pedagogy of the Oppressed* (New York: Continuum, 2005), 43, 89, 155. And this fight, because of the purpose given it by the oppressed, will actually constitute an act of love opposing the lovelessness which lies at the heart of the oppressors violence, lovelessness even when clothed in false generosity. (43)

Domination reveals the pathology of love: sadism in the dominator and masochism in the dominated. Because love is an act of courage, not of fear, love is commitment to others. No matter where the oppressed are found, the act of love is commitment to their cause—the cause of liberation. And this commitment, because it is loving, is dialogical. (89)

If children reared in an atmosphere of lovelessness and oppression, children whose potency has been frustrated, do not manage during their youth to take the path of authentic rebellion, they will either drift into total indifference, alienated from reality by the authorities and the myths the latter have used to "shape" them; or they may engage in forms of destructive action. (155)

5. See Pre-Textos in Quibdó, Colombia, at https://www.youtube.com/watch?v=u4bKkYMQxdo.

WORKS CITED

Freire, Paolo. *Pedagogy of the Oppressed.* New York: Continuum, 2005.

Freire, Paolo. *Pedagogy of the Oppressed (Pedagogia do Oprimido).* New York: Seabury Press, 1968.

Rulfo, Juan. *El llano en llamas.* México: Fondo de Cultura Económica, 1953.

Shakespeare, William. *The Merchant of Venice,* 4.1. 298–303.

WHY SCIENCE IS NOT A RECIPE

Expanding Habits of Mind through Art

Madeleine Holzer and Luke Keller

A group of college students in an introductory astronomy class came to the conclusion that, according to the scientific method, astrophysics is not science. A group of fifth graders prepared for a science field trip to a local river with an aesthetic analysis of a one-hundred-year-old painting. Two advanced college research students just encountered the first images from a new NASA telescope by staring at them as if they were in an art gallery, and then by reading poetry.

INTRODUCTION

We, Madeleine (Mady) Holzer, a poet and arts educator, and Luke Keller, an astrophysicist and science educator, describe an approach to teaching and learning science that begins with exploring what artists and scientists *do* rather than what the arts and sciences *are*. We start with action and participation

in order to see, firsthand, how art and a science work. We have explored these ideas in our own areas of teaching—poetry and astronomy—and we suggest that these examples are more broadly applicable to all areas of art and science. Our goal is to prepare students for life as citizens, with a deeper appreciation of both disciplines—as integrated and essential ways of learning and communicating—to develop habits of mind that cultivate informed and confident lifelong learners, as well as confident consumers and creators of information.

When students realize that they are *behaving* like artists while experiencing and creating art, and that they are *behaving* like scientists while learning about and doing science, barriers to learning become porous. We, therefore, have set out to identify habits of mind that are necessary to accomplish this transformation from passive to active learning: we seek to lead our students of science (in the coming examples, K–12 and college undergraduates) to the conclusion that they are both equipped and qualified to understand nature and various types of human descriptions of nature, and that they can master experiencing both poetry and science, subjects many students assume are too difficult for them. By extension, we seek to identify methods of convincing students to use these habits of mind, derived from the arts and sciences, throughout their lives.

Most people are used to thinking about science and art as fundamentally different. John Dewey (1980) clarifies this:

> The difference is the interest in which and purpose for which abstraction takes place in science and art respectively. In science it occurs for the sake of effective statement . . . [for the sake, we would add, of effective description]; in art, for the sake of expressiveness of the object, and the artist's own being and experience determine *what* shall be expressed and therefore the nature and extent of the abstraction that occurs. (94–95)

We, however, started with the idea that both poets and astronomers, as specific types of artists and scientists, are fundamentally similar; they are deliberate and often precise in describing their observations and drawing connections in their descriptions of the natural world. They both tell the story of their experience of the world, but in unique languages and using seemingly different processes. Both invite students to struggle with their understandings of the world and the language they use to describe it; both have their knowledge called into question by experiences and observations that do not appear to fit into their understanding of how nature works. This cognitive dissonance is uncomfortable; it feels dangerous and it can be painful. We find it essential, therefore, to follow an initial experience of new concepts and observations—especially dissonant or counterintuitive ones—with a deliberate and systematic process of transforming new perceptions into communication and action.

SCIENCE AND ART: MORE THAN METHODS

Science, at its pinnacle, is good storytelling: it involves imagination and creativity; it involves clear communication; it inspires action. As with good storytelling in other contexts, the process by which this is done is essential. The scientific process, a way to explore and describe nature, is based on noticing details and identifying the patterns that connect those details through systematic observation. A story emerges from the process of building the details and connections into a narrative—often one that simplifies and condenses the story to its essence—so that any interested person can appreciate the story with confidence. Science, then, is more than a prescribed method, more than a collection of facts, more than a systematic series of observations or measurements, more than a system of logical reasoning, and, therefore, transcends a purely *objective* experience of nature.

As a specific type of art, poetry embraces the kind of expressiveness Dewey describes. It requires precise language; it inspires questions, new ideas, and, often, action. In all its forms, it involves language used to express intense emotions in a condensed, aesthetic way. As with science, poetry involves careful noticing of the world and its patterns, but it also involves sensing—using physical sensations to round out the perception of phenomena. It involves moving beyond what is noticed initially, through connections that are often intuitive, to express something beyond the language itself. Creating or experiencing an artwork focused on natural phenomena, therefore, involves more than spontaneous reactions, more than an emotional response, more than aesthetic connections among experiences, and, therefore, transcends a purely *subjective* experience.

Language, along with its sounds, rhythms, and the way it looks on the page or stage, forms the foundation poets have to describe phenomena and situations in their world that they find compelling. Importantly, poets also have a number of language "tools," like figures of speech or poetic devices, that facilitate their expression of an intense response to a phenomenon or situation. The manner in which poets use these tools allows the reader to experience more than just the words. As such, poets create an artistic/aesthetic artifact that invites readers to use their own intuition and their prior knowledge and experience.

STRATEGIES FOR CREATIVE ACTION

As we thought about these differences and similarities, we realized that our work in the arts and natural sciences fit with parts of a preliminary outline of creative processes Mady had developed, entitled Strategies for Creative Action. The strategies are a collage of many inputs, from the writings of John Dewey and Maxine Greene, to more current work on the imagination (e.g., Liu and Noppe-Brandon), and the development and adoption of design thinking in educational settings (IDEO).

Strategies for Creative Action

(Arrows indicate paths where reflection and assessment occur.)

Imagine
Generate Ideas

- Cultivate stillness
- Understand constraints, yet keep options open
- Ask "What if?" Questions
- Understand the perspectives of others
- Develop metaphors and analogies
- Try out some options through simulations and role play
- Live with ambiguity before a solution is reached
- Propose possible solutions to others for feedback (in writing and/or speech—including visuals)

Perceive
Develop Perceptions

Use all your senses to understand what the challenge is, including:

- Hands-on explorations of resources (text, artwork, invention, natural object)
- Gestures to describe what you see or hear
- Questions about the objects using "How," "Why," "When," and "Where"
- Identifying similarities and differences
- Looking for connections: to what you know from other parts of your life, to other objects, to something you have read, to other people (This reminds me of...)
- Wondering about what you discover
- Discovering patterns
- Discussing your discoveries with others (throughout all of the above)

Act
Create Something Real

Take positive action to solve a problem by:

- Exhibiting a behavior that shows empathy for another person or group of people
- Creating
 - a new construction
 - a presentation (written/verbal/visual)
 - an organization
- Trying again if you fail

© 2012 Madeleine F. Holzer

Figure 1. Strategies for Creative Action. Courtesy of Madeline Holzer.

The strategies consist of three seemingly simple, but deeply complex and interrelated, ideas: perceive, imagine, and act. These can be seen as shorthand for developing perceptions, generating ideas, and making a difference. As a more specific framework for students, they are described in Figure 1.

These strategies are, by definition and of necessity, recursive, with assessment and reflection occurring throughout the process. They require both individual work and collaboration among participants. And they do not exist in a vacuum; they rely on the language, knowledge bases and perspectives of the academic disciplines in order for a solution to make sense.

POETIC SENSIBILITY AND PHYSICAL INTUITION

The process of writing poetry often begins with a struggle to describe what is not easily put down in words but *is* put down

in words by helping to create new and precise forms of language associations in the mind and emotions of the reader. This writing process can be seen as a hybrid of aspects of the perceive/imagine sections of the strategies. Mady calls this hybrid experience the development of a "poetic sensibility" (Holzer). Similar to the strategies, she also posits that a poetic sensibility can more broadly apply to other disciplines, where the foundation and tools might not be based in the same language but rather in the language of that discipline (e.g., dance—space, time and bodily movement—or science—observation, hypothesis development, further observation and measurement, theory development and testing, and action by application).

In parallel, Luke observes that learning the process of science is profoundly enhanced and encouraged by beginning with an investigation or observation that informs and often challenges students' "physical intuition" (Menning and Keller, 30). The process develops knowledge that is based on continuous or repeated experience of the physical, natural world, a world of which we, of course, are part.

Because nature is a system of interconnected systems, organisms, processes, forces, and cycles, learning by observation and experiment requires a capacity for noticing and remembering observable details (perceive), for imagining and describing connections and relationships between these details (imagine), seeking to boil them down to a simple and elegant explanation that has predictive power (a theory), and communicating the experience in words and action to create meaning (act). Our physical intuition, as defined above, necessarily evolves in this process.

Through our exploration of methods of teaching the process of science in the context of astronomy, and of experiencing an artwork in the form of reading poetry, we have reason to suggest that physical intuition and poetic sensibility demonstrate a basis for the ways in which science and the arts are related and mutually informative. Both are human activities that students must participate

in and perform as they learn. In astronomy, we observe and notice the universe, making connections between the details we observe and identifying patterns in those observations and connections. We later describe our observations through hypothesis, systematic study and analysis, development of accurate and predictive theories, and communication of our learning to others. When creating a poem, we notice, make connections, identify patterns, and describe our observations and experiences using precise new forms of language, including metaphor and analogy, that engage the emotions. (See Table 1.)

When teaching at all levels—whether primary school or college, but especially at the introductory level for all age groups—there is no reason to "dumb down" the study of poetry or astronomy if students are invited to identify and use their own intuition—the lifetime of observation and experience that they bring to the classroom—to identify and explore connections, to experience learning authentically.

In the following sections, we provide three examples, from our own experience and practice, of learning that draw on the strategies and the concepts of physical intuition and poetic sensibility: one in elementary school, one in an undergraduate introductory

Table 1

	Astronomy	Poetry
Same	• Observe	• Observe
	• Notice	• Notice
	• Describe	• Describe
	• Make connections	• Make connections
	• Identify patterns	• Identify patterns
Discipline Specific	• Measure	• Develop metaphors and
	• Study and analyze	analogies
	• Develop and test hypotheses and theories	• Communicate through precise new forms of
	• Communicate and describe actions, methods, and conclusions	language that engage the emotions

science course, and the final one in an undergraduate research seminar in a field of natural science (astronomy). The first example integrates visual arts and a science, the second one elaborates on the process of science, and the third integrates learning from the visual arts, the scientific process, and poetic sensibility. In all three examples, students do not create art but rather encounter an artwork, based on John Dewey's idea that in order to fully experience a work of art, the perceiver must, in some way, undergo the process the artist pursued (Dewey). We start with a visual work of art, because Mady discovered through prior teaching experience that it is often the easiest way for students to encounter and eventually learn to apply the overarching strategies.

INTEGRATING ART INTO A FIFTH-GRADE SCIENCE EXPERIENCE

In her work at a charter school in the South Bronx, Mady conducted a lesson with a class of fifth-grade students at the beginning of a year-long multidisciplinary study of water. Mady's goal was to introduce the students to a way of engaging with a visual work of art that would not only enhance their perception of that artwork but also encourage a similar type of perception with in-depth experiences in their science studies on the topic of water. As an extension, she also included similar perceptual skills in social studies and language arts lessons.

This particular lesson served as a review of what the students remembered from their work with Mady on the subject of water in fourth grade as well as preparation for a visit to the Harlem River, a body of water not far from the school, of which the students had little or no knowledge. Activities for developing perception were included throughout. By the end of the lesson, Mady hoped the students would have developed questions about the Harlem River that they could try to answer or think more about on their visit.

The students wrote and thought about the importance of

Figure 2. *Spring Night, Harlem River*, 1913. Painting by Ernest Lawson. Public domain.

water and their unanswered questions from the year before. They did a close viewing of a slide of Ernest Lawson's painting *Spring Night, Harlem River* (see figure 2) and described in detail what they noticed and made connections to prior knowledge they had about themselves, others, and the world.

They discussed how Lawson felt about the Harlem River and gave evidence from his painting to support their position. When they left, they each had at least one question they wanted to take with them on their visit to the Harlem River. Questions ranged from wondering if the Harlem River still looked the same as in the painting (art) to wondering what the pH of the water was (science). The science questions were addressed by a representative of a Harlem River conservation organization who accompanied the students on their river visit.

INTEGRATING DISCUSSIONS ABOUT THE NATURE OF SCIENCE INTO A COLLEGE SCIENCE LESSON

In Luke's college-level introductory science course—designed to give students a first glimpse into what we know about the universe and its evolution *and* how we know these things—a primary learning goal is to develop and demonstrate an appreciation for the scientific process as a human activity.

Through a series of readings and discussions, students in this class learn that in astronomy, unlike other areas of natural science, we cannot directly measure *any* of the physical characteristics that are interesting to us. As such, when observing an astronomical object from Earth, with our eyes or with a telescope, we can *directly* observe only apparent properties: How bright does it look? What color is it? How big does it look? What is its shape? Where does it appear in the sky?

But these directly observable and apparent characteristics are not necessarily what scientists want to know. Their questions focus on other things like: What is it? How far away is it? How did it form? How old is it? What is it made of? Is it moving and, if so, where is it going? A scientist's primary goal is to develop a detailed description of how we proceed from our direct measurements— what we can observe—to learning what we really want to know, the physical nature of the universe. But how do we accomplish this? Students usually quickly suggest using the scientific method, which most can summarize from memory based on their precollege science experience.

Students begin by pondering a few questions: What do astronomers measure? Can astronomical observations be repeated under the same circumstances? Can astronomical experiments be controlled? These lead them to conclude that astronomical measurements are observations of a remote object or phenomenon that *cannot be controlled or manipulated*. In other words, astronomers do not do controlled experiments!

How can astronomers be doing science if they cannot carry out one of the cornerstones of the scientific method? Given a strong intuition that astronomers are doing science when learning about the universe, students arrive at a new conclusion: we need to have a more detailed description and appreciation of how we learn about nature through scientific work and process. So, let's change the name of what we do to the *scientific process*.

As this realization begins to sink in, students read and discuss accounts of how astronomers throughout history have determined the characteristics and processes that resulted in the universe as we now observe it. Based on elements that these accounts have in common, the class then begins to identify several essential elements of what they were now increasingly observing as a scientific process. They include:

- The systematic description or characterization of an object or system
- The formulation of hypotheses and the development of theories to explain what we observe
- Making and testing predictions to exercise and verify our explanations
- Communication to a broader audience to enrich the story of what we have learned and to invite others to participate and collaborate in the process

The students learned that a scientific process incorporates a combination of, and usually multiple iterations of, all of these elements but that it is somewhat out of alignment with the scientific method as traditionally taught. The elements of the scientific process do not necessarily have a particular order and are not necessarily completed by the same person or research group, or even at the same time in history. Science is not a recipe; it is a process motivated by curiosity and inquiry and achieved by human action and interaction.

INTEGRATING ASTRONOMY RESEARCH AND AESTHETIC APPRECIATION

In contrast to his introductory teaching, Luke typically began research projects with advanced students by teaching them skills and methods used to analyze astronomical and interpretive observations, to explore the connection between observations and learning. This involved reading and discussing concepts that are often at a more advanced level than the students have encountered in their physics or astronomy courses. For this reason, Luke led frequent discussions of "the big picture," where their work fits into the scientific process, and how it can enable a more complete understanding of the objects and processes they are observing and analyzing in their research.

But could this unique learning environment (training in professional-level scientific research) be richer and more effective if he and his students took the time to step back, as part of the process, and appreciate their data and methods aesthetically? To find out, Mady and Luke decided to conduct a demonstration of *noticing deeply*. With Luke's undergraduate research students, Matt and Rafael, they used a new data set that neither student had seen before, inviting them to observe with us in the manner that Mady used with her fifth-grade students in their encounter with the river.

RELATING AN EXPERIENCE WITH VISUAL ART TO SCIENTIFIC MEASUREMENTS

To introduce Luke's research students to the first part of the Strategies for Creative Action, Mady took them through a version of the same lesson she had conducted with the fifth-grade students at the charter school. When she showed them the image of the Lawson painting and asked Luke and his students what they saw in the image, Mady immediately noticed that they tended to jump to interpretation, and they did not describe what they actually saw in

the painting. She quickly asked them to identify evidence for their interpretations. They struggled initially but managed to get down to simple description.

Luke admitted that he easily jumps to interpretation, because his goal is to understand the data in the context of his research goals. He wondered what would happen if he and his students slowed down the process and looked very carefully in order to describe what they saw before they attempted to interpret their findings. To achieve this, Mady worked to get them to slow down, take apart what had become a reflexive/intuitive process for them, and say things like, "I see blue, green, and yellow" instead of saying, "I see lights on a bridge." Luke and his students would then look more deeply to describe what they actually saw—lines, colors, and textures that were combined in a way that made them look like lampposts on a bridge. Since this was an important discovery for Mady and Luke, they didn't focus the lesson as much on questions and connections as Mady had with her fifth-grade students.

Did the Strategies for Creative Action look anything like the kind of work they did when they conducted astronomical research? Yes. They concluded quickly that in their research, they also noticed, asked questions, made connections, and found patterns in the data. They had essentially summarized the main strategies for developing perception in the Strategies for Creative Action!

So, what happens when students look at images—recorded data using the Stratospheric Observatory for Infrared Astronomy (SOFIA)—of a star-forming region in the Orion Nebula using the process they used to perceive the Lawson painting?

While looking at a large, false-color infrared image of the nebula on a screen in the physics lab (see figure 3), we took turns describing what we saw in the images—again, not interpretations of what we saw but what we actually saw in as much detail as possible. When we eventually allowed each other to offer interpretations, we reminded ourselves to give observational evidence from what

Figure 3. Infrared images in three "colors" of the Orion Nebula. NASA Stratospheric Observatory for Infrared Astronomy. Public domain.

we actually saw in the image. We did not focus at first on questions or connections.

Again, eventually we allowed ourselves some interpretation.

The interpretation involved descriptions of patterns identified in this process and allowed integration of prior knowledge, including physical intuition, of the Orion star-forming region. We raised these questions: How do the patterns we notice in these new images connect to one another and to the patterns we have noticed in past data sets? Do we see patterns or structures that are new? How do these patterns connect with one another and fit into the big picture we had prior to this new data set? As with any new observations of a familiar physical system, the identification of patterns and connections necessarily developed our physical intuition: our visceral understanding of nature was enriched. We then practiced some more "notice deeply" exercises, with different

kinds of objects the students had brought for the whole group to notice, before we introduced the students to the study of a poem.

RELATING POETRY AND ASTRONOMY

Mady chose the poem *Comet Hyakutake* by Arthur Sze, which we started to study using the same skills we used to look at the painting and the SOFIA images. To do so, we followed with a, by now, somewhat familiar process. We all read the poem to ourselves several times and heard the poem read aloud twice by two different people—to hear two different voices. Mady asked—What do you notice? What jumps out at you? This time, Luke and his students noticed the repeating words and the scientific facts, and they could give specific examples, often leading to someone else saying, "I didn't see that," and then adding something else. When someone said, "I think this means . . ." Mady would ask, "What in the poem makes you think that? What is your evidence?"

Student questions also led to some previously unnoticed findings: "What does ardor mean?" "Why is that long line in the middle? It doesn't seem to fit." "Who is you?" To get students to think about some points they might not have noticed by themselves, she would add: "Why do you think there's a dash at the end of each line? What connection can you make to the content of the poem?" The students quickly replied, "It's like a comet's tail."

But what was the function of the dashes? When there was silence in response to her question, Mady asked them to use their hands to mimic the structure of a comet's tail. Then she asked them the function of the dashes. The response was quick: "They help the poem look like a comet's tail!" After this, a discussion of what we thought the poem meant came easily—each person adding something to the previous one's interpretation. We determined some shared and some subjective meanings, but all were primed and enriched by their prior experiences with visual arts (the Lawson painting) and science (the Orion images). In this moment,

some of the assumed boundaries between science and the arts collapsed. We could begin approaching both using the same habits and techniques.

CONCLUSION

We set out to identify teaching methods that would show students of science the value of *behaving* like artists, as well as scientists, in order to learn about and appreciate nature through science and the scientific process. We posed several related questions: What habits of mind are necessary to accomplish this? What habits of mind must we teach? How can we reinforce learning practices that we want to encourage so that these habits become second nature, especially in times of uncertainty when they can be the most valuable? How can we use our experiences with poetry, visual art, and science to convince science students that they are equipped and qualified to understand nature and human descriptions of nature; that, in order to understand the world, it is essential to include a scientific and a poetic sensibility; that when conundrums and seeming confusion arise they should embrace these as effective tools of learning and understanding?

By exploring these questions in the context of K–12 and undergraduate education, we have identified parallels and relationships between the scientific process, physical intuition, Strategies for Creative Action, and poetic sensibility that are consequential. These relationships show us that successful teaching and learning in the traditionally segregated disciplines of arts and humanities, on the one hand, and science, on the other, involve many of the same aptitudes and strategies. We have identified ways to begin teaching habits of mind through which students realize that they need not distinguish themselves as "a science person" or "an arts person." Rather, to understand and live the full richness of human experience, these ways of appreciating our surroundings must be

seen, and taught, as complementary for all students, regardless of their primary interest or focus.

In both art and science, students begin developing habits of noticing deeply—paying attention to the details of what we can observe directly with our senses and how they may be connected—and of asking clarifying questions using techniques that many would consider to be in the realm of "art appreciation." This enriches the later information processing and analysis that students expect will be the initial, and perhaps only, approach to learning about natural processes. Systematic analysis of observations is an essential component of the scientific process, but getting the most out of such analysis depends upon a full appreciation of the observations, connections, and descriptions that precede the analysis itself.

The key to developing these habits of mind is to invite and encourage students to act as they explore and learn, to behave like artists as well as scientists, as they learn about science. Since some of the fundamental processes and methods used by artists and scientists are similar, indeed almost identical, so, too, should be some of the methods and exercises we use to teach in both areas. Moreover, we have demonstrated and strongly advocate deliberate integration of what C. P. Snow famously called the "Two Cultures" (3) of humanities and sciences as we prepare all of our students for fulfilling, meaningful, and active lives as community members in a complex future.

WORKS CITED

Dewey, John. *Art as Experience*. New York: Perigee Books, 1980.

Greene, Maxine. *Releasing the Imagination*. San Francisco: Jossey Bass, 1995.

Greene, Maxine. *Variations on a Blue Guitar: The Lincoln Center Institute Lectures on Aesthetic Education*. New York: Teachers College Press, 2001.

Holzer, Madeline F. "Poetic Sensibility: What It Is and Why We Need It in Twenty-First Century Education." Poetry.org, February 5, 2017. https://www.poets.org/

poetsorg/text/poetic-sensibility-what-it-and-why-we-need-it-21st-century-education.

IDEO "Design Thinking for Educators Tool Kit." January 2013. http://www.ideo.com/work/toolkit-for-educators.

Keller, Luke, et al. *Narrowband Imaging and Spectroscopic Observations of Hydrocarbon Emission from the Orion Bar* (forthcoming).

Lawson, Ernest. *Spring Night, Harlem River.* 1913. Oil on canvas on panel, 25 1/8 in. x 30 1/8 in. The Phillips Collection. www.phillipscollection.org/research/american_art/artwork/LawsonSpring_Night_Harlem.htm.

Liu, Eric, and Scott Noppe-Brandon. *Imagination First.* San Francisco: Jossey Bass, 2009.

Menning, Nancy, and Luke Keller. "Narrating Science and Religion: Storytelling Strategies in Journey of the Universe." *Diegesis: Interdisciplinary E-Journal for Narrative Research* 5, no. 2 (2016): 21–34.

Snow, C. P. *The Two Cultures.* Cambridge: Cambridge University Press, 2001.

Sze, Arthur. "Comet Hyakutake." Poets.org, 2012. http://www.poets.org/poetsorg/poem/comet-hyakutake.

CHAPTER SEVENTEEN

HUMANIZING SCIENCE

Awakening Scientific Discovery through the Arts and Humanities

Rebecca Kamen

> *To raise new questions, new possibilities, to regard old problems from a new angle, requires creative imagination and marks real advance in science.*
>
> —Albert Einstein, The Evolution of Physics

How do the arts, humanities, and science fit together? For me, it's related to partnerships I am able to establish with a wide variety of people interested in exploring scientific phenomena with me. Our disciplines fit collectively as we try to understand how the beauty of cosmology, history, philosophy, and scientific fields like chemistry, astrophysics, and neuroscience tie into each other. I started my study investigating rare books and manuscripts at the American Philosophical Society, the former Chemical Heritage Foundation, the National Library of Medicine, and the Instituto Cajal in Madrid. In each instance, I stood in awe and wonder as these

manuscripts gave me a glimpse into the past and became the muse into what could be used to inform and inspire my art.

By conducting extensive research, I have realized that before the advent of the camera, scientists were artists. They created beautiful paintings and drawings to represent what they examined. I verified my findings during a discussion with Nobel Laureate Baruch Blumberg. According to Blumberg, science is an illusion— very much like magic. Scientists and artists have intuitions about certain things, which provides the basis for their research. Both disciplines conduct experiments and collect data in a manner that tries to support the illusion, creating a path for making the invisible visible.

I have found that partnering with other artists, dancers, musicians, and poets has enhanced my art practice and provided greater meaning to those who view the work. These artists have insights that complement my own and together we provide new and exciting ways to interpret science. Our projects become multireferential because they create bonds between various scientific fields and historical and cultural references. The project *Divining Nature: An Elemental Garden* provides one example of how we created a multireferential art installation informed by the periodic table that uses sculpture and sound to interpret the electron orbital patterns of elements in the table. It also references sacred geometry of the layout of Buddhist stupas in Southeast Asia.

The following art projects represent my research and its ability to connect various threads of diverse scientific fields of study. My artwork captures and reimagines what the scientists are looking for as they seek out a new light for scientific awareness.

IT STARTED WITH CHEMISTRY

I fell in love with chemistry when I was a little girl. I spent my childhood examining the world of elements with a simple chemistry set. With that set, I was able to create detailed science-fair projects. I

had a voracious appetite and a deep love of learning that helped me create bridges between seemingly disparate disciplines such as astrophysics and neuroscience. Consequently, I have devoted my work to a perceptive investigation of properties that overlap from discipline to discipline.

I remember the inspiration for building my first cardboard telescope and the excitement I felt when I was magically connected to the galaxy. I feel the awe and wonder, still, as I continue to explore matter and meaning. I think that is a gift that all people have. Many lose it as they go through high school and enter adulthood. Part of my art practice is to instill in people that mystery as they learn to explore the possibilities of what could be.

STIFF RIGIDITY BECOMES GRACEFUL ELEGANCE

As mentioned above, my own epiphany occurred when I became aware of a need to create *Divining Nature: An Elemental Garden*. It was 2007 when I became reenergized by the periodic table. My memory of it took me back to eleventh-grade science class. The room held tantalizing smells, test tubes, and Bunsen burners. Magic happened there.

It was also the place where the periodic table cast a pall across the room; its rigid, gridded chart of letters and numbers glared down on us from the wall at the front of the classroom. So many of us were taught science through the drill-and-kill method in the '50s. We were not taught to see how things interrelate. I memorized all the numbers on the periodic table but never understood its significance to me as a person.

As the periodic table flitted through my consciousness, I had a better understanding of life. I looked at it with an artist's eyes. I knew that it would be my first foray into taking something that most people feel is rigid and transforming it into an experience of awe and wonder—through the experience of walking through it, hearing it. I would try to engage audiences through their

encounters as they also remembered sitting in front of a gridded chart of letters and numbers.

I needed to gain an understanding of what the periodic table meant at its core. My initial research started at the Chemical Heritage Museum in Philadelphia. I pored over manuscripts and researched rare alchemy books. Everywhere I went, I became more enlightened in ways I never could have imagined in high school. Powerful relationships started to emerge and became a catalyst for investigating the periodic table as a bridge between art and science.

Travel to India and Bhutan provided additional insight and inspiration for the development of the project. Buddhist mandalas represented a cosmological view of the universe, influencing the layout and the concept for the elemental garden. Because gardens have always served both functionally and metaphorically as a crossing of art and science with nature, they represent metamorphosis. Matter changes from one state into another. How an atom transfigures, changing the number and arrangement of its parts, literally becomes a new element. *Divining Nature: An Elemental Garden* reconstructs chemistry's periodic table of letters and numbers into a garden of sculptural elements based on geometry and atomic number.

While working on this project, I discerned a need for sound, something that would give the installation additional meaning in this unique interpretation of the periodic table. Biomusician Susan Alexjander created a haunting soundscape. The mysterious wave frequencies emitted from the atoms in the elements formed a perfect partnership for my sculptural installation. Susan became a collaborator, and her sound added a mystical quality to the experience of walking though Divining Nature: An Elemental Garden.

This three-dimensional art installation invited people to experience the periodic table in a new, dynamic way. The allure and delicacy of the sculptures simulated by the most ethereal aspect of an element—the orbital pattern. Shapes created by these electrons are

Figure 1. *Divining Nature: An Elemental Garden*, © 2009. Mylar, fiberglass rods, soundscape; 300 in. x 300 in. x 38 in. Sound design by Susan Alexjander. Image courtesy of Rebecca Kamen.

based on the same principles of sacred geometry that has inspired the Fibonacci sequence and is found everywhere in nature.

Divining Nature: An Elemental Garden has been a success in both the artistic and scientific communities. It has sparked rich conversations and has been the catalyst for new chemistry-inspired artwork. And, it allowed me to share this vision with diverse audiences.

MUSE THROUGH MANUSCRIPT

When the digital age came into fruition, most people began thinking that books were becoming obsolete. But as an artist, I have always recognized books as being visionary of time. What secrets did they reveal to inspire form? The books at the American Philosophical Society (APS) Library in Philadelphia were no different, and they inspired me when I was invited to be an artist in residence. Some of my most profound moments researching natural phenomena were documented by the authors' own hands.

My investigation started by encouraging the APS Library staff to contribute some of their favorite books and manuscripts on-site. Viewing these allowed me to see how expansive their special collection was, and I made some introductory judgments on the types of books I wanted to consider further.

I have long been interested in science and its history, so I examined some of Benjamin Franklin's works. Franklin founded the APS in 1743. Some of his scientific curiosity is displayed in papers and drawings, which include electricity, meteorological phenomena, and mathematics.

The books I selected from the APS Library demonstrated the extent of scientific discovery dating back to the seventeenth century and includes such fields as astronomy, biology, geology, and beekeeping. Historic notebooks and journals served as an impetus and inspiration for this project, including diaries of physicist John Archibald Wheeler. The Wheeler notebooks continue to plant seeds, including a recent installation inspired by gravitational wave physics, *Portal*, which is discussed later in this chapter.

It was at APS where I had one of my epiphanies. I was looking at these innate, visceral drawings that captured the details before the advent of the camera. Lewis and Clark's sketchbooks, the incredibly meticulous bug drawings of John LeConte, and John Benbow's sketches in the *Bee Book* left me humbled and inspired. These authors recorded history not only with the written word but also through delicate, executed form. And I realized then how the camera changed the way scientists viewed their work.

While at APS, hydrologist Luna Leopold's beautiful river drawings made me reimagine my own work as an artist. These intricate river maps illustrating the layers of scale and elevation of a specific landscape have had a profound effect on the development of this series of work. The technique of superimposing graphite and acrylic on mylar also depicted the gravity of pages in a book. When observed together, they create an intricate visual narrative and gives context to form.

Figure 2. *Magic Circle of Circles*, © 2008. Acrylic, graphite of mylar; 12 in. x 12 in. x 10 in. Image courtesy of Rebecca Kamen.

A chance to exhibit my work at the APS Library provided an opportunity to showcase how the residency moved me and brought together the rare books and manuscripts with the artwork.

NEUROSCIENCE-BASED ART

My journey took a unique twist in 2011. I presented a lecture at the National Institutes of Health (NIH), which was an initial impetus

for a series of sculptures. The lecture caused an attendee to ask me to examine some drawings of Santiago Ramón y Cajal. I found it fascinating that Cajal, a neuroanatomist, began his early education as an artist. He won the Nobel Prize in 1906 for his discovery of the neuron and is considered the father of modern neuroscience.

The creation of *Illumination*, a sculpture based on awareness of Cajal's investigation of the retina, along with my previous lecture, resulted in the opportunity to become the artist in residence in the neuroscience program at NIH in 2012. This residency offered fertile ground for the conception of a new series of sculptures inspired by Cajal's research, a chance to observe the special collections at the National Library of Medicine, and to be stimulated by the conversations with NIH scientists about their research.

The culmination of my research was an invitation to lecture at the Instituto Cajal in Madrid in early 2013. This afforded an exhilarating opportunity to examine the encyclopedic archives of Cajal. His drawings and research continue to be my "muse" in the advancement of ongoing artwork.

The chance to examine Cajal's research drawings and childhood artwork was enlightening. Superb panoramas and portrait paintings developed as a child unveiled his passion for art and a clear capacity to see and record information so early in life. Cajal appreciated the placement of every line, and his attraction to photography, particularly stereographic photography, also allowed him to establish skills to analyze flattened microscopic substances on histological slides and to decipher and comprehend them dimensionally. Examining his rich archives, it was easy to see how his artistic training as a child improved and provided his capacity as a scientist, to make the invisible visible.

PORTAL

When I think of Einstein, *gedankenexperiment* (or "thought experiment") comes to mind. Imagine being fourteen years old again,

Figure 3. *Illumination*, © 2012. Acrylic on mylar; 36 in. x 36 in. x 10 in. Image courtesy of Rebecca Kamen.

and you have discovered magic! While riding your bike one day, you think about what it would feel like to ride on a wave of light. That was the epiphany Einstein had as a child. At that moment, the seeds for his discovery of general relativity theory came to the forefront of his mind. It sustained him through his whole professional career, won him a Nobel Prize in 1921, and changed history as we know it.

The sculpture and sound installation, *Portal*, emanates from Einstein's theory of gravitational waves, interprets the tracery patterns of the orbits of binary black holes, and the outgoing wave of this astronomical phenomenon. I have included fossils as evidence of similar patterns found within micro and macro scales to construct an observable dialogue between space-time and geological time.

Figure 4. *Portal*, © 2014. Mylar, fossils; 150 in. x 150 in. x 36 in. Sound design by Susan Alexjander. Image courtesy of Rebecca Kamen.

The original impetus for *Portal* was a sequence of intricate wire sculptures that investigated my view of Einstein's exploration of special relativity, exhibited at the American Center for Physics in 2005. Curator Sarah Tanguy describes my work:

> Kamen's wire sculptures honors Aaron Bernstein, who's 19th century writings on popular science kindled the imagination of the young Einstein. . . . With science as her inspiration, Kamen avidly probes the world around her to find a means to describe her research. Rich with associations, her work draws on intuition and the language of abstraction to convey individual ideas and emotions. And, though not literally kinetic, her wire-based sculptures succeed in suggesting motion and change, while instilling an emphatic wonder in the viewer.

As noted earlier, the investigation of rare books and manuscripts at the APS Library contained an opportunity to analyze the

Figure 5. *Doppler Effect*, © 2005. Steel and copper wire; 10 in. x 12 in. x 10 in. Image courtesy of Rebecca Kamen.

notebooks of John Archibald Wheeler. A colleague of Einstein's, Wheeler made compelling advancements to astrophysics and researched gravitation and coined the terms *black hole* and *dark matter*. The notebooks brimming with professional and personal memorabilia and his lecture and research notes designed a portal of possibilities for artistic interpretation of the physics of black holes and relativity.

I have interviewed scientists and science historians at the Massachusetts Institute of Technology and Rochester Institute of Technology. Research at Harvard University's Center for Astrophysics has also provided further revelations for this work, as did inquiry on the Women Computers of the Harvard College Observatory, which developed a system of stellar classification used to interpret the observatory's vast astronomical glass-plate slide collection in the late nineteenth century. Scrutinizing microscopic

specks of light on massive, blackened glass plates in the special collection provided early glimpses of outer space and inspired the name *Portal*.

Susan Alexjander has been instrumental in partnering on the *Portal* project. Her evocative soundscape using an array of vibrations that emanate from outer space, containing sonic frequencies defining a binary pair of orbiting black holes to heighten the viewers understanding of this artistic interpretation of general relativity.

THE ASPIRING SCIENTISTS SUMMER INTERN PROGRAM AT GEORGE MASON UNIVERSITY

When I completed *Divining Nature: An Elemental Garden,* the response that I received was overwhelming. Audiences went through the art installation and it captured the emotions I wanted to share. It changed me. All that I had known about art and science seemed to meld into a different possibility now. This new and innovative way of looking at the periodic table resonated with everyone. Would it be possible for me to go out to teach students this new way of looking at science so they could see it through a different lens?

The Aspiring Scientists Summer Intern Program at George Mason University (GMU) gave me the opportunity to test my hypothesis. I started collaborating with Amy VanMeter, director of the Aspiring Scientists Summer Internship Program (ASSIP) at GMU in 2011. That year, GMU helped forty-eight high school and undergraduate students gain hands-on experience in various science, technology, engineering, and math (STEM) fields. At the end of the program, these students needed to be able to explain their vision to executives, laypeople, and scientists. ASSIP featured creativity and communication that year. This proved to be the perfect position to bring art into the equation.

I presented a lecture describing the intersection between art

and science and then challenged the aspiring scientists to create art depicting the findings of their research projects. The process of creative, artistic, and scientific thought is the same, and this collaboration inspired students to creatively solve complex scientific research problems. At the conclusion of the program, participants presented their art and scientific research projects at a professional poster session. People attending the poster session were in awe of what they saw. The artwork created to interpret their research was very well done even though the students weren't trained as artists. They rose to the occasion when science—the reason they were there—inspired them.

What I taught them was that both scientists and artists use visualization techniques to depict the invisible. The visualization and depiction processes make communication of their findings possible to a wide range of audiences. One of the greatest challenges scientists face, however, is the ability to effectively describe dynamic data sets. All too often, scientists produce static representations of their findings because they have not learned to visualize across multiple dimensions. Specialization further restricts the scientists' discovery process because their work is frequently compartmentalized within a function and a single institution. Because science students and scientists rarely have the opportunity to interact with experts from other fields of study, they miss critical input from people with other viewpoints and thereby constrain their ability to innovate.

Operating within the scope of a single discipline also hinders the development of intuition—a byproduct of a repeated process of trial and success, trial and failure. Yet, intuition is a critical success factor needed by the scientific community to function at its peak. My work creates a new context for modern students and scientists as they learn to visualize how to substantiate their discoveries and capture the essence of what they've learned about the invisible world in a new way. A byproduct of my approach: deeper insight as to what might be possible because students look at their work holistically.

Figure 6. *Spacial Memory,* © 2011. Digital print; size variable. The data collection and artistic rendering were performed in the Physiological and Behavioral Neurosciences in Juveniles Laboratory (the PBNJ Lab; T. C. Dumas, director) at George Mason University by ASSIP participants Himika Rahman, Alexa Corso, and Hua Zhu. Image courtesy of PBNJ Lab, George Mason University.

I am grateful for this experience. The work manifested a different journey than expected. The art component of the ASSIP program revealed to myself, students, and scientists that we could plant a new seed, nurture it, and see what develops. I found that I can take the arts and try to inspire the lives of the people around me, touching them in ways I didn't know was possible.

STRATA

The invitation to "dream big" led to the STRATA project, an artist-residency project exploring art, science, and connections to the land, at an independent girls school in Australia.

Preparing for the project, I did some research and discovered

something magical about the Australian aboriginal culture. A practice, called songlines, used song as a way of describing the direction and the location of the land. In essence, the Aborigines created the first sonic GPS. The aboriginal clan would keep history alive by being the bearer of the songlines for a certain portion of land they inhabited. They gave voice to the sonic direction, or sonic description, of the land in superb detail.

It was fascinating because it took mappings from something that was not only physical but one that is evoked through sound. The richness of what I was uncovering simulated what geologists would do when they were uncovering strata. If you want to understand the age of the land, all you need to do is take a cross-section of the earth or look at rocks or trees, because each one of those layers describes a phenomenon that has taken place in time. It offered art and science in a simple worldview.

STRATA offered an exciting opportunity to show ninth-grade girls how they could create new connections between art, science, and their rich cultural heritage. I used the enthusiasm of my own discovery process in developing the project as a catalyst for inspiring these middle-school girls.

The whole notion behind this project was to:

- Instill a sense of awe and wonder about the land
- Inform students about their natural and cultural heritage
- Disseminate global citizenship to the students

Sally Marks, the printmaking teacher at the school, and I collaborated on STRATA. The final project transformed the intersection of art, science, and aboriginal art and cultural views about the land into powerful, visual expression through a body of prints that the students created. Students experienced firsthand how collaboration and cross-disciplinary investigation have the power to transform research into dynamic, expressive form.

In five weeks, we created nine hundred art prints using the

Figure 7. STRATA project print installation, © 2016. MLC School, Burwood, Australia. Image courtesy of Sally Marks, MLC School.

process of collographic prints to explore and investigate the notion of aboriginal connection with the land. Students created thirty portfolios that included thirty prints each. The money generated from the sale of the portfolios was gifted to an aboriginal charity. This project not only raised awareness of aboriginal culture and the expression of it but it also investigated specific areas of research pertaining to aspects about the earth. Through the medium of printmaking, students engaged with art to transform their insights into visual form.

The STRATA project showcased how the arts and humanities foster collaborative learning and the creative expression of observations, and it showed how the arts served as a catalyst for change, expressed by one of the participating students:

> It's difficult to explain the powerful effect that the Australian landscape can have on you, standing in the red dirt of Broken Hill, outback Australia. The utter remoteness and the fact that you could walk in one direction for a week and not see anyone is completely overwhelming. Your senses are blown out of proportion and it's like a feeling I had never felt before.[1]
>
> Strata, was a project that opened our eyes and minds to culture, art-making and a first-hand experience with an artists practice. For everyone it was a massive eye-opener. This project took us places that we could never have imagined; we went in as year 9 art students and came out budding artists. To have your work in a collection with a world-renowned practicing artist is something many of us could never have dreamed of, yet the majority of prints up on the wall are those of 14 and 15-year-olds.
>
> But of course, our skills did not develop overnight. With this project came hours and hours of research, experimentation and the development of the printmaking process; from the teachers, students and specifically Rebecca. Rebecca had done some printmaking before but was new to the collograph process yet she conducted extensive research into the interconnectedness of science,

art and the aboriginal culture and inspired many of the ideas behind all of our prints.[2]

The STRATA project illustrates the power of the arts and humanities to create a catalyst, for students to have an opportunity to not only transform themselves but to transform the world around them. To me, that has been one of the greatest gifts about this work that I do with art and science.

CONSTELLATION

When you look into the night sky, what do you observe? Being in the outback with these young women at night, and looking up at the night sky, filled me with an incredible sense of awe and wonder. Every world culture looks up at the night sky, not only for navigational direction but to weave stories inspired by these points of light in the sky. It inspired me to look a little deeper when I came home.

Then, I was invited to be an artist in residence at the McColl Center for the Arts in Charlotte, North Carolina. Part of that residency involved working with the Levine Children's Hospital, part of the Carolinas HealthCare System. Because of my research in neuroscience, I was invited to work on a collaborative art installation with a group of young traumatic and nontraumatic brain injury patients.

When one gets a diagnosis of something as difficult as a brain injury, I can't imagine how one could find some light in that darkness. I wanted to be able to use my art practice and my observations about these young patients to honor the bright light of the healing that I observed.

Constellation: Tree of Life celebrates stars. The installation's concept was inspired by the words of neuroscientist Santiago Ramón y Cajal: "As long as our brain is a mystery, the universe, the reflection of the structure of the brain, will also be a mystery."[3]

Figure 8. *Constellation: Tree of Life,* © 2017. The Levine Children's Hospital, Charlotte, North Carolina. Image courtesy of Kathleen Glass LeFever, Carolina HealthCare Foundation, Charlotte, North Carolina.

Similarities in the structure of the brain and the universe are seen in the branching/fractal layout of the installation, inspired by the tree of life logo of the Carolinas HealthCare System. Circular waveform sculptures were created through a process called cymatics, which transforms sound waves into visual patterns. The recording of patient voices for the project was in collaboration with the Levine Children's Hospital's Seacrest Studios. By using sound waves, scientists make the invisible visible.

The residency project empowered these patients and their caregivers to share the bright lights of the healing process. Many of these patients' voices had been altered as a result of their brain injury. On each branch of the installation, a larger cymatic print was created by the patient's voice, and the smaller ones reference the support of family and patient caregivers. Even though these patients' voices might sound different, or altered, the sound-wave

vibration goes out into the universe to create a very beautiful visual pattern. My idea was to inspire them. Even though their voices might have changed due to an accident, beautiful outcomes are possible.

In addition, all the patients and their caregivers did breath paintings. Created by the technique of blowing paint through a straw, the paintings represent the power of breath to communicate and reference the song maps of the Aborigine.

Constellation: Tree of Life continues to ripple out through the sound waves of patients and their caregivers. It is a symbol of the extraordinary patients and caregivers at the Levine Children's Hospital and honors the bright light of their healing process that shines on all of us. The installation symbolizes the human spirit and its ability to connect and weave stories of healing and transformation, inspiring us all.

I am in awe of how a person can come up with just an idea. That idea grows, and suddenly you can hold the light for others in ways you can't even imagine. People you touch become the change agents in the world. The gift goes on.

CONCLUSION

It seems that as the world is becoming more polarized and insular, the thought of collaborating with professionals outside of your field of expertise is generally not always encouraged by superiors and peers. Yet, when you take the time to converse with these people one-on-one, you can hear the excitement in their voices as they describe the intricacies of their work. That excitement grows when you add value and share insight they haven't conceived upon because it's not in their lexicon. It's really a matter of perspective, and that's where the arts and humanities can play a pivotal role.

I believe that cross-pollination between the arts, humanities, and sciences needs to continue. When we open the dialogue across a wide variety of seemingly inconsistent fields, it uncovers that

these disciplines are, in fact, linked. The networking partnerships that form act as a vortex. Scientists, artists, and researchers link because of the possibilities of what we can discover together. Of course, we don't know what the possibilities truly are, and yet linked together, our thoughts expand our boundaries exponentially.

NOTES

1. Student A, spoken directly to the author, 2016.
2. Jane E., email communication with author, April 23, 2017.
3. Paraphrased by the author.

WORKS CITED

Rebecca Kamen. *Divining Nature: An Elemental Garden*. Greater Reston Art Center, Reston, VA, 2009. http://rebeccakamen.com/gallery/divining-nature/divining-nature-an-elemental-garden/#2.

CHAPTER EIGHTEEN

WHEN AN ENGINEER TELLS A STORY . . .

Ari W. Epstein, Elise Chambers, Emily Davidson, Jessica Fujimori, Anisha Gururaj, Emily Moberg, and Brandon Wang

College students in the science, technology, engineering, and mathematics (STEM) fields generally get rigorous training in problem-solving, but often that training focuses primarily on the technical aspects of problems, ignoring or minimizing the human context in which those problems arise and the impacts on people who will be affected by the solutions. Terrascope, a learning community for first-year undergraduates at the Massachusetts Institute of Technology (MIT), works to engage students in a more holistic process of identifying and addressing problems. This essay is about one component of the Terrascope program: Terrascope Radio, a class in which science and engineering students change gears from technical problem-solving to storytelling. In the process, they acquire a richer and broader understanding of the context and implications of their own, more technical work.

In this chapter, we tell the story of Terrascope Radio itself: how the class is structured, the work involved, and the class's outcomes for students. Inspired by the chapter in this volume by Jodi Enos-Berlage and Jane Hawley, we present this as a conversation between one of us—Ari Epstein, who teaches the class—and the others, who are all former students in the class.[1] We also briefly describe Terrascope as a whole, in order to give a sense of the context in which the students encounter the radio class; more detailed descriptions of Terrascope itself can be found elsewhere.[2]

Most Terrascope students enter the program in the fall semester, taking a class called Solving Complex Problems. In this class, the instructors present the students with a single large problem, or "mission." The problem is always a real one that must be dealt with but for which there is no perfect solution—one for which trade-offs are always necessary. The problem always has something to do with sustainability, and it is always one that cannot be solved using science and technology alone; in order to address it, one must understand and reckon with social, political, ethical, historical, and other factors. This problem then becomes a theme for the rest of the year's Terrascope classes.[3]

The students' deliverables are a website presenting their solution in full technical detail and a presentation and defense of their solution to a panel of global experts brought to MIT for the purpose. Beyond those deliverables (and their associated due dates), the students are given very little direct structure or guidance. Faculty, staff, undergraduate teaching fellows (upperclassmen who were in the program as first-year students), librarians, and alumni mentors are all available to give support, but the project is fully in the students' hands.

These deliverables are aimed at audiences that are already interested in (and readily able to understand) the technical details of the problem. But what about the great majority of people who are not technically minded and who might not think they are interested in whatever problem the students have been studying? That is where

Terrascope Radio comes in. In this class, offered in the spring, the students' final project is to create a radio program of interest to general audiences and related in some way to the year's problem.

As students come to realize, in order to grab and hold the interest of general audiences, they need to take a different, more specific and personal, view of the issues.[4] Jessica Fujimori, who took the class in the spring of 2011, describes this change of perspective and approach.

JESSICA FUJIMORI, TERRASCOPE RADIO, 2011

Topic: Addressing global hunger; field trip: Sirsi, India[5]

In the fall semester of Terrascope, the world grew large. As we talked and debated and read about global food insecurity, I felt my brain swimming with the vastness of it. This was not one problem; this was a complex system of problems that differed depending on geography and politics. In multivariable calculus, we were learning to integrate in three dimensions. In Terrascope, there were too many dimensions to count. Hunger, poverty, corruption, inequality—in my mind, I tried to trace the thread of effects backwards to the true, ultimate root cause to no avail. We read books and articles debating theories of economic development. Many of us developed pet projects—hydroponics or GMOs or public-private partnerships or farmer education. As we became overwhelmed with the immenseness of it all, we each gravitated toward subjects we were interested in or comfortable with (e.g., I wrote a tome about primary education).

In Terrascope Radio, the world came into focus. We began to learn to listen. We explored Sirsi, India, with our headphones on and our microphones at the ready. We interviewed farmers about their agricultural practices. We talked to merchants selling fruits and vegetables at a market. We captured the sounds of villagers' hoes biting the earth as they laboriously chunked out the terrace farms we had dutifully researched, typed up, and posted to our class website months earlier.

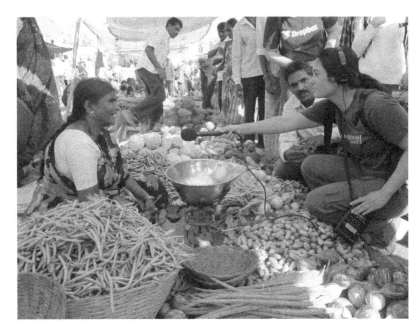

Figure 1. Jessica Fujimori interviews a vendor in a vegetable market in Sirsi, located in Karnataka State, India. Photo courtesy of Ari W. Epstein.

This was the soil on which they would grow the food that would sustain them and their children. How would our lists of agricultural technologies and government policies and school programs fit into these people's lives?

It can be easy for scientists or engineers or policy makers to design from afar, diving deep into scientific literature and technical specifications, optimizing in a lab and, to some degree, for ourselves. Terrascope Radio was about communication and our presence in the world. Pay attention to what's around you. Ask the right questions and really listen to the answers. Allow some silence. Linger for a little while after a conversation, and then the real conversation will start. Remind yourself why you're doing what you're doing. Get out into the world and just listen.

<div align="center">❋</div>

To prepare students for these tasks, during the first half of the semester, the class concentrates on two general areas: acquainting students with storytelling processes and techniques and giving them experience using equipment and software for gathering, editing, and mixing sound. About half of the classes are given over to listening sessions in which we listen together to a wide variety of existing audio stories and students discuss them, identifying aspects of each piece that worked (or didn't work) for them, and gradually building their toolboxes of techniques and approaches. These classes serve another purpose as well: they begin to make the classroom a safe space for critique and for diversity of opinion, so that when students begin creating their final project, they will already be accustomed to listening analytically, understanding one another's tastes and perspectives, and providing informed feedback. This makes the task of critiquing one another's work less fraught and more productive.

Students become familiar with audio equipment and software through a variety of small projects, including a short story about some person and a place that is special to that person (produced individually) and an audio postcard of MIT (produced in teams, in order to introduce students to team audio-production process). Through listening to and critiquing these pieces, students learn ways to improve their technique (e.g., holding the microphone close enough to the subject and in the right position, adjusting recording levels, finding audio-friendly places to record) and ways to start using some of the conceptual tools they are acquiring during listening sessions.

Then, during spring break, Terrascopers go on a field trip to a place or region that is relevant to the year's topic. The field trip is open to all first-year students in Terrascope, not just those taking Terrascope Radio, and the itinerary is developed with multiple purposes in mind, but the trip provides a fantastic opportunity for students to conduct interviews and gather ambient sound. They must be somewhat purposeful as they do so, or else they will end

up with a large collection of unrelated recordings; at the same time, however, they must remain open to discovering new stories and angles. In the evening, the radio students gather to listen to and "log" their sound (i.e., create rough transcripts), play one another highlights of the day, and develop their evolving sound-gathering strategy, asking questions such as: What kind of interviews are we missing? What new questions should we start asking? And Are we using the equipment properly? They also start to formulate possible stories in their minds. (Not all radio students choose to go on the trip, and integrating the students who did not come along into the collective process is an interesting and important thing for the students to do.) Emily Moberg, who took the class in 2008, describes some of her experiences on her Terrascope trip, and also some of her experiences with classroom process.

EMILY MOBERG, TERRASCOPE RADIO, 2008

Topic: Restoring and protecting global fisheries; field trip: Iceland[6]

When we received the email informing us the Icelandic Minister of Fisheries had agreed to meet with and be interviewed by our radio-production class, equal parts excitement and dread filled me. His agreement launched our radio project from a potentially cobbled together, bumbling class project to a real journalistic endeavor in my mind. I believe it was the radical combination of that responsibility with a creative medium that made Terrascope Radio so impactful. We were given the freedom and encouragement to brainstorm, sketch, and plan a piece as wild and as inventive as we pleased, but the opportunities— both for recording and for broadcasting—made me want to produce an excellent piece as well.

Our final radio production was the clear culmination of the class, which made the intermediate assignments relevant and engaging. Intermediate projects (such as interviewing a dorm mate) allowed us to explore the tools (e.g., the recorder, the editing software), and

Figure 2. A former whaler, now the captain of a tourist-excursion vessel in Iceland, tells Emily Moberg about the condition of the local fishery. Photo courtesy of Ari W. Epstein.

feedback was immediately usable in our next iteration. As we built our skills, we were also planning our final piece—its content, our interviews, its music.

On our trip, we balanced the responsibility for collecting high-quality sound with the exuberance of teenagers. We recorded the sounds of our footsteps on every surface we walked on. We recorded each other snoring when we fell asleep working. We recorded our classmates' reactions when we joked that the ice cream was made of whale's milk. In retrospect, this wanton exploration was incredibly useful: we quickly developed more recording skills and, more importantly, learned that the "crazy" idea for a recording is sometimes actually a great, usable one!

The variability and unexpected nature of interviews and recording were both exhilarating and frustrating. We could craft questions, but

over-adherence to those questions might have led us to miss or not fully explore the direction our speaker hinted at. We had putative stories in our heads, narratives we hoped our experience and our audio could be shoehorned into; letting go of those strict confines while not slipping into the trap of recording fragmented pieces that wouldn't fit into a cohesive story later was difficult. An unexpected answer could quickly render the rest of our questions moot, so thinking quickly on our feet was critical. There were infinite possibilities for what to record—each person we talked to, each question we asked, each auxiliary sound we chose to track down. We had to collaboratively and spontaneously make decisions about where our limited microphones would go. I learned through this process that my initial impressions were often wrong. One classmate was incredibly excited about interviewing a fisherman who had participated in Iceland's cod wars, which I thought was a boring waste of time; the audio he collected was fantastic and told a compelling, fascinating story.

Our microphones were thrust into many faces, bins, shorelines, and fish-processing machines. I recall at one point jokingly interviewing a dead fish. We interviewed a tour-boat captain who had previously worked on a whaling vessel and lamented how changing cultural norms meant his favorite foods (seal and puffin meat) were less available, and a shopkeeper who told us about elves. We talked to an engineer at a geothermal plant, fishermen at the docks, museum curators, tour guides, college students, and, of course, the much-awaited Minister of Fisheries.

The interview with the minister began with a ride in an ornate elevator that seemed straight out of Willy Wonka's chocolate factory. Our recording team had divvied up who would ask questions and who would record and had decided which questions we needed to ask. I had landed the honor of holding the microphone and operating our recorder, and I was deeply terrified I would fail to record anything (or get the sound levels wrong, or tap my fingers on the microphone and ruin our sound quality) in our critical interview. The interview itself passed in a blur; we went through our list of questions, but I mostly

remember staring at the little row of lights that indicated we were recording sound correctly. The minister was sharp, polite, and very businesslike. I felt official and validated having conducted a task that felt like something a real journalist would do.

That evening, as we did each evening, we painstakingly loaded our audio onto computers and started transcribing what we had collected. For me, this part weighed most heavily; I was so nervous I would discover I hadn't hit Record or had my settings adjusted such that the sound I had collected for our team was useless. Each file was incredibly precious and wasn't safe until it was backed up on as many hard drives as our USB cables would load it to. Transcribing our audio, on the other hand, felt like an immense chore. Surely we'd remember what each clip contained? Later, however, I rued each clip we hadn't transcribed as we sifted through hundreds of files, trying to piece together the clips of audio into a coherent, compelling story.

Crafting a story around the sound we collected was another challenge, as the initial plans we'd made did not mesh with the material we had actually collected. I found it difficult to decide whether to be guided by particular compelling pieces of sound or by the content that would drive a narrative. In the end, we produced a series of short vignettes that were loosely connected by having been collected in the same place. We spliced, edited, wrote, rewrote, gave feedback, disagreed with feedback, recorded, and rerecorded the requisite pieces to weave together our full program barely in time for it to air on our campus radio station.

The class took us through an entire creative journey, from conception to airing it to the public. Along the way, I think I learned as many concrete skills about audio editing and production as I did about time management, teamwork, and the process of completing a complicated task from beginning to end. Several of my classmates and I were so inspired by our experience in this class that we started our own environmental talk-radio show, which we hosted and produced for several years, and I have continued to seek outreach opportunities within my academic research career.

Additional Comments about Process Learning

In class, we listened to curated radio pieces that illustrated creative approaches to telling stories, fortuitously encountered but expertly captured pieces of audio, and evocative uses of sound. These pieces effectively illustrated the possibilities that this new medium afforded us, while also training us to really listen more closely than I was accustomed to doing. Did that voice sound like it was in a boxy room? A stairwell? Did that implied space alter the story or the mood of the piece? We were encouraged to comment on the pieces—both positively and negatively. I found this skill particularly useful later, as I think it is particularly easy either to find complete fault in something while nitpicking (and gloss over what was done well) or to glibly praise it (while missing critical failures).

Our radio pieces were also produced in groups, which was a unique crash course in creative teamwork. Teamwork in other classes typically involves a more dispassionate division of labor and feedback; in radio production, feedback to teammates reflected on their unique ideas and their execution, which felt so much more personal and subjective. We had to balance deadlines and our own conflicting visions for the project, figure out how to incorporate different workflows, and interact effectively with each other.

One of the most valuable skills I learned in this class was assertiveness and the possibilities that just asking could produce. We walked into a church service in Reykjavik as it was starting, asked if we could record the singing, and got a tepid yes; other times, we got a firm no. We were able to interview the Icelandic Minister of Fisheries and an executive at a whaling company. I learned that the worst outcome of an ask was a polite no, and the best outcome was an opportunity I had previously never imagined being possible.

＊

One fundamental outcome of the class is that students develop new respect for the importance of communication in scientific and

engineering practice. It's not enough to have the brilliant ideas and invent the new technology—you have to be able to explain what you are doing and why it matters. For Elise Chambers, who took the class in 2009, and Emily Davidson, who took the class in 2007, those lessons continue to be important.

ELISE CHAMBERS, TERRASCOPE RADIO, 2009

Topic: Access to fresh water in western North America; field trip: Arizona[7]

Terrascope Radio was that class that I never knew I needed. I still maintain that it was the best class I took at MIT. The reasons for this are varied and include an instructor who actually cared about how I was doing, listening sessions where I got closer to my classmates, and the chance to create something of a kind I never even knew existed. Terrascope Radio changed how I did everything else in my career after that. After the class, I couldn't help but think about how technical subjects were being communicated. I already had some pretty extreme pet peeves about how terrible PowerPoint presentations are, but after Terrascope Radio, I developed even higher standards for how we should share our technical knowledge with the world. I am a visual and kinesthetic learner, and so communications that use only sound often would go in one ear and out the other. Through Terrascope Radio, I not only developed how I absorbed audio information but also used my own auditory "weakness" to challenge my teammates to make our pieces more digestible and easier to understand.

After college, I worked in environmental consulting for several years. During that time, I saw that more than half the battle of doing a project "right" is communicating it well to your stakeholders and especially to your client. Terrascope Radio was a launching-off point for me in thinking about how we as scientists and engineers communicate our knowledge, our work, our successes, and our failures to those for whom it is important. What if all we had was audio? What would you say then? How could you help someone understand something

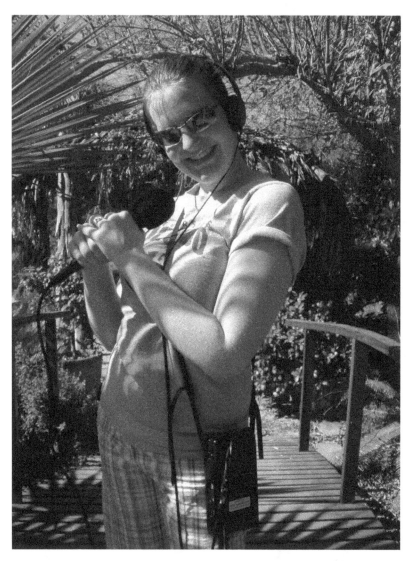

Figure 3. Elise Chambers preparing to conduct some of her first interviews in Arizona, at an arboretum specializing in desert plants. Photo courtesy of Elise Chambers.

they've never studied? These questions become all too real for me in our current age of tweets before facts and "fake news" versus science. How could this conversation change if we all knew more about how we communicate ideas? And what might happen if we were all forced to listen to each other for a little while, as in a Terrascope listening party?

EMILY DAVIDSON, TERRASCOPE RADIO, 2007

Topic: Rebuilding New Orleans after Hurricane Katrina; field trip: New Orleans[8]

Terrascope Radio is a remarkable course at MIT, and I am deeply grateful that they offered it when I was an undergraduate. It enables students to momentarily step away from their theory and equations, to gain a deep experiential view of how science, technology, and engineering interact with individuals—policy makers, politicians, farmers, fishermen, nurses—to create the world as it is.

I took the course over ten years ago, and while I loved it as a student, I am also thankful for it ten years later. As a student, I was initially drawn to Terrascope Radio as an opportunity to travel, to directly interview people I wouldn't have an opportunity to speak to otherwise, and to work in a medium I was unfamiliar with. Once in the program, I particularly enjoyed how working with radio developed my ability to listen, to carry on conversations with anyone, and to create story arcs.

Today, I am a postdoctoral researcher in materials science (and previously a high school teacher with Teach for America). I have seen too many conference talks where nobody in the audience understood what the presenter's point was and outreach talks to middle school students that try to use unreasonably technical language. I've seen promising projects and scientific collaborations fall apart because scientists couldn't directly and succinctly tell the story of their work in a way that was correct for their audience (often advisors and other scientists from outside their field).

The further I get from MIT, the clearer it becomes that excellent communication is essential to a successful career in science and

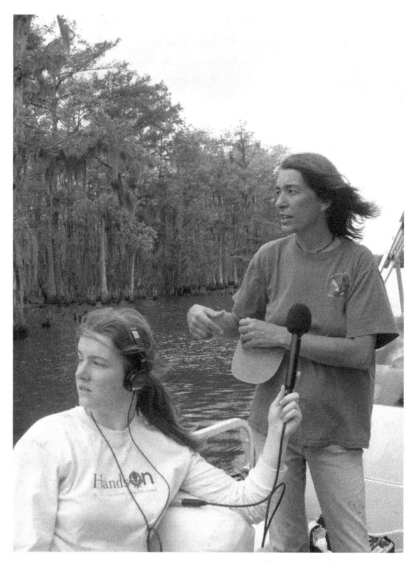

Figure 4. Captain Ginger describes the history and ecology of the bayous south of New Orleans as Emily Davidson records. Photo courtesy of Ari W. Epstein.

engineering. Recently, I was told that I have a gift for articulating the most complicated of scientific concepts. While I strongly appreciated the compliment, I think this was partially misattributed. I don't have an innate gift; I am a reasonably good scientific communicator because I have practiced and have been trained. Terrascope Radio was, for me, one of my most important and rigorous early experiences in learning to communicate complex ideas tailored to a wide range of people.

<p align="center">*</p>

In addition to highlighting the importance of communication, Terrascope Radio, by focusing on stories and storytelling, helps students get an even greater appreciation for the human context in which all of the technical problems they have been thinking about occur. It helps them refocus their efforts on the people being served by their solutions, not just the solutions themselves, and make serving those people a priority. Brandon Wang, who took the class in 2016, directly relates the act of storytelling to the ability to understand multiple human perspectives.

BRANDON WANG, TERRASCOPE RADIO, 2016

Topic: Food insecurity and climate change; field trip: New Mexico and the Navajo Nation[9]

The spoken word is powerful. It's complex, rich, and full of meaning. It's also slippery and unpredictable. In editing our piece for Terrascope Radio, I've listened to pieces of interview tape over and over—looking for the rhythm in a conversation, just the right lilt in an answer, a meaningful pause taken. Your voice is personal stuff. When we talked with people in New Mexico, it was usually off-the-cuff, informal conversations with people who had agreed to talk to us. Sure, they knew they were being recorded, but they felt comfortable speaking their minds, and we got to engage in authentic conversations.

In class, we talked about the ethics and gray areas of audio editing. One can easily splice together sentences, cut out words, and change

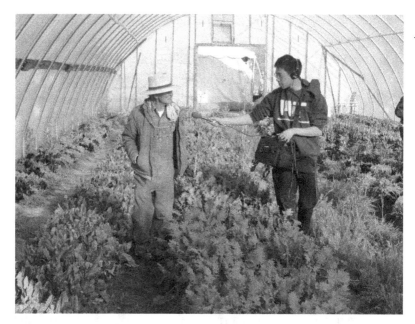

Figure 5. Brandon Wang learns about near-urban organic farming from Lorenzo Candelaria, at the Cornelio Candelaria family farm just outside Albuquerque, New Mexico. Photo courtesy of Ari W. Epstein.

the message of someone's speaking. We often cut pauses and entire phrases to make a point more quickly or more crisply for a piece—this is an integral part of making an audio story. But there is always tension between the interests of the producers (us) and of those being interviewed. We tried our best to ensure that our piece accurately conveyed their thoughts and that we simply acted as a medium for them to tell their stories.

But that's not guaranteed, and with the tape sitting in our hard drives, we had the power and the responsibility. Looking back now, our study of such a human experience (talking) and a personal medium (the voice) helped me realize the importance of individuals and the personal when understanding the world. In engineering and as a student studying computer science, I'm often aware of engineering solutions that are conceived, created, and foisted on the world without much

thought to the individuals and communities they impact. It's really easy for engineers, software engineers, technologists to become isolated from the ultimate question driving our work: Does it benefit the people? Terrascope Radio taught me that it's not an easy question, and that we cannot expect easy answers. Asking these questions isn't a box to be checked off; it should be a conversation, and Radio taught me that while it's impossible to get perfect, it's always worth it to try.

<div align="center">*</div>

And beyond even these outcomes, for some students, such as Anisha Gururaj who took the class in 2012, the process of finding and telling stories has shaped their work and lives in deeper ways, affecting how they see and interact with others, how they develop ideas, and how they choose what to work on.

ANISHA GURURAJ, TERRASCOPE RADIO, 2012

Topic: Preserving global biodiversity; field trip: Costa Rica[10]

The first time I truly understood what it took to be someone who cared about working to create social impact, I was standing in front of an old, worn-down gate in front of the porch of a tiny house with a vegetable garden in Santiago, Costa Rica. An older couple sat on their rocking chairs, their expressions lined with skepticism as they eyed the three of us, college-aged kids with audio recorders and microphones in their hands, only one of whom spoke Spanish. It was one of our last days left on the Terrascope trip to Costa Rica, where we'd hoped to better understand how the global biodiversity crisis actually manifested itself in a particular social, environmental, and geographical context.

Having spent the week trudging through rainforests, inspecting caterpillars, and talking to scientists, employees of ecotourism businesses, and nature guides, the three of us had ventured out on a bit of a whim, to see whom we might bump into. At first, the couple seemed unwilling, providing monosyllabic answers. Slowly, we moved closer to the porch

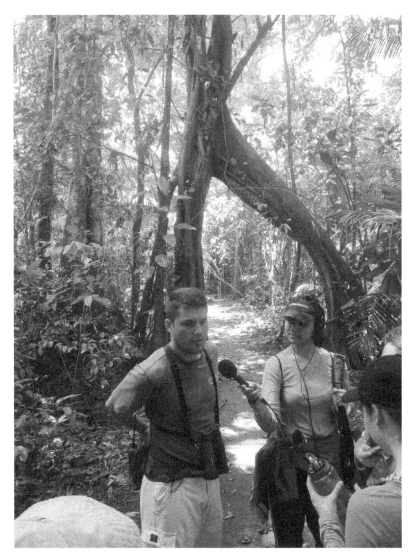

Figure 6. Anisha Gururaj interviews a guide to the rainforests of Costa Rica. Photo courtesy of Ari W. Epstein.

as they began to tell us about the husband's work on a cacao plantation before it shut down, which we'd heard about from some other people we'd talked to. Instead of the effects on the area's biodiversity, he was telling us about what life as a plantation worker had meant for him and his family. We pushed gently, but deeper, with our questions. Before we knew it, the gate opened and we had been invited into the house— the husband pulling us into the garden to show us what a cacao plant looked like and gifting us one to take back, and the wife showing us around her home, telling us about her difficult childhood, her family members, even breaking down in tears at one point. The three of us were in tears too, moved not only by her emotion but by the power of this unlikely, unexpected moment in which we were invited into the intimacy of a stranger's life.

People often say that they use very little of what they studied in college in their real life, but it's difficult to overstate how many times in my life I've reached back to Terrascope Radio, that completely anomalous class from my freshman year, one that I think about more often than even my technical classes at MIT. The stories that we heard and learned how to tell through the medium of radio were unlike the ones we often tell in science or engineering, which tend to be linear, causal, analytical, and rational. But for all of us who believed that we could make technology and innovation weave its way into impacting real lives, this was an early glimpse into the real world, where we learned that the most relevant stories are complex and to collect all the parts into a coherent whole. Having come back with external hard drives full of sound, there were twelve of us who had already started composing different versions of this story in our heads. Self-organizing and working across these divisions was something we had already experienced in the first part of the Terrascope program, but that was a science project, not a piece of art. Terrascope Radio helped to blur the lines between those increasingly irrelevant divisions. By spending time listening to and creating stories through sound, I began to appreciate and break down the mechanics involved in the inspiring, at times infuriating, art and science of telling stories that are multidimensional, winding, and complex.

Perhaps the most important thing I learned was a skill that I never really thought mattered for anyone other than journalists: interviewing. That day on the front porch of the couple's house in Costa Rica, and so many other days on that trip, I unknowingly began to figure out the nuances of interviewing that cut to the core of interpersonal interactions themselves—what piques an interviewee's interest, the power of silences, how to build someone's trust in less than a minute, and what can completely turn someone off. There was also the adrenaline rush when you did it right and suddenly realized you had stumbled upon the pot of gold (i.e., some authentic, central core beyond the naked eye). It's a set of muscles that I've come back to again and again, from interviewing trauma surgeons for a piece I wrote on the Boston Marathon bombings to designing my qualitative research in grad school (studies that would inform the design of a low-cost ultrasound device for rural Indian primary health centers) to serving as an emotional support volunteer at a sexual abuse and rape crisis center. As my professional life centers around designing the most appropriate solutions to addressing access to high-quality health care around the world, I only continue to gain appreciation for the ability to approach people and worlds, even ones that I am familiar with, with a genuine curiosity, a desire for depth, and a willingness to suspend any assumptions. Whether interviewing one of my closest friends about the sounds that take her back to her childhood, approaching a set of strangers in Costa Rica, or designing the best medical device for a low-resource setting, I don't know what I don't know.

Terrascope Radio gave me another thing as well: an understanding of the sheer responsibility that comes with representing others' stories in your work, the power they are putting in your hands to hold and share that with gentleness, compassion, and deep respect, whether you share that through words on paper, voices on the radio, or products on the market.

NOTES

1. We are grateful to the volume's editor, Christine Henseler, for suggesting that we read that chapter and take it as inspiration.
2. See, for example, S. A. Bowring, A. W. Epstein, and C. F. Harvey, "Engaging First-Year Students in Team-Oriented Research: The Terrascope Learning Community," in *Geoscience Research and Education: Teaching at Universities, Innovations in Science Education and Technology*, ed. V.C.H. Tong, 223–36 (Netherlands: Springer, 2014), doi:10.1007/978-94-007-6946-5_17 and references contained therein.
3. Examples of Terrascope problems and students' solutions can be found at https://terrascope.mit.edu/missions/.
4. Most students in Terrascope Radio have taken the fall class, but some have not; in addition, Terrascope also offers a hands-on design class in the spring, but that is beyond the scope of this chapter.
5. Link to program at https://terrascope.mit.edu/radio/food-for-thought.
6. Link to program at https://terrascope.mit.edu/radio/iceland-volcanoes-geysers-and-fish-oh-my/.
7. Link to program at https://terrascope.mit.edu/radio/just-add-water-life-in-arizona.
8. Link to program at https://terrascope.mit.edu/radio/nerds-in-new-orleans-no-were-not-here-for-mardi-gras.
9. Link to program at https://terrascope.mit.edu/radio/journey-through-new-mexican-agriculture.
10. Link to program at https://terrascope.mit.edu/radio/pura-vida-costa-ricas-culture-of-conservation.

WORKS CITED

Bowring, S. A., A. W. Epstein, and C. F. Harvey. "Engaging First-Year Students in Team-Oriented Research: The Terrascope Learning Community." In *Geoscience Research and Education: Teaching at Universities, Innovations in Science Education and Technology*, edited by Vincent C. H. Tong, 223–36 (Netherlands: Springer, 2014). doi: 10.1007/978-94-007-6946-5_17.

Terrascope. "Food for Thought." Massachusetts Institute of Technology. May 11, 2011. https://terrascope.mit.edu/radio/food-for-thought.

Terrascope. "Iceland: Volcanoes, Geysers and Fish, Oh My!" Massachusetts Institute of Technology. May 8, 2008. https://terrascope.mit.edu/radio/iceland-volcanoes-geysers-and-fish-oh-my.

Terrascope. "Just Add Water: Life in Arizona." Massachusetts Institute of Technology. May 9, 2009. https://terrascope.mit.edu/radio/just-add-water-life-in-arizona.

Terrascope. "Pura Vida: Costa Rica's Culture of Conservation." May 12, 2012. https://terrascope.mit.edu/radio/pura-vida-costa-ricas-culture-of-conservation.

Terrascope. "Nerds in New Orleans: No, We're Not Here for Mardi Gras." May 7, 2007. https://terrascope.mit.edu/radio/nerds-in-new-orleans-no-were-not-here-for-mardi-gras.

Terrascope. "Rebeldes: A Journey through New Mexican Agriculture." May 11, 2016. https://terrascope.mit.edu/radio/journey-through-new-mexican-agriculture.

Terrascope. "Terrascope Academic Year." Massachusetts Institute of Technology, October 23, 2019. https://terrascope.mit.edu/missions/.

CHAPTER NINETEEN

UNLIKELY PARTNERSHIPS

On Sociology and Art

Gemma Mangione

I am a sociologist of art. I study how social systems (organizations, policies, practices) impact people's experience of art and how people's experience of art can, in turn, shape those systems. Sociologist of art is not a readily recognizable job title, nor a particularly desired one (as my father likes to intone, deadpan, when chatting with new acquaintances about his only daughter: "Hers is a field in which jobs abound"). It also strikes many as oxymoronic. As the French sociologist Pierre Bourdieu once (in)famously wrote, "Sociology and art do not make good bedfellows."[1] He mostly blamed art enthusiasts for this, bemoaning their conviction that art is an irreducibly special field of inspired creation that somehow exists apart from the world of social relations and rules that govern the rest of us. From the perspective of said enthusiasts, of course, sociologists are party poopers. Sociologists study art not for its own sake but instead to explain how society works. The approach

often yields arguments suggesting art is not much different than, say, wine or envelopes or socks or scrapple, a suggestion few happily accept. In this tension between the general and particular, sociologists of art make their home.

What role does a sociological approach play in art worlds more broadly and for professionals in the arts and culture sectors specifically? Reflecting on this edited volume, I ultimately find myself thinking about the unlikely partnership of bad bedfellows that structures what I do as an academic and museum evaluation consultant. Fortunately, my current work has taught me that the contemporary disconnect between sociology and art may be more practical than philosophical and, thus, that any presumed impasse is worth revisiting.

To be sure, while the kinds of numbers and patterns that organize social scientific analysis make the messy world we live in easier to understand, squishing that world into neatly ordered categories inevitably reduces detail and depth. And this is particularly challenging for those who find themselves in what the French sociologists Luc Boltanski and Laurent Thévenot have described as "inspired worlds" like art, which often privilege "feelings and passions" that are hard to measure.[2] Nevertheless, reconciling these challenges is now a matter of necessity. No longer insulated from the pressures of the market, cultural institutions must compete for limited funds in a crowded recreational marketplace, while continually tasked with providing impact-based measures of their social value.

Perhaps as a result of these exigencies, both my students training for arts careers—and my clients building them—are generally on board with the idea that they have to think systematically about art's role in a broader social ecology. But these professionals' interest in defining the worth and impact of art is not merely instrumental; it also reflects their efforts to align deep passion with reflective, data-driven intention.[3] In what follows, I discuss how sociological thinking may serve as a useful tool toward this goal.

Specifically, I reflect on how it may foster, for arts professionals, a "philosophy of practice": a way of thinking and talking about not just *how* to do their work but *why* to do it and why it matters.

PORTRAIT OF THE SOCIOLOGIST AS A YOUNG WOMAN

Some part of this story is personal, for while I can now clearly see the disconnect between bedfellows, it was not always easy for me to do so. Even before I could give a name to it, sociological thinking helped me explain and mediate some of the challenges I observed in the art worlds I had loved since childhood. I took a class on postmodernism, for instance, as an art history major in college. As the daughter of two immigrants from Italy—who had taught me early to distinguish a Michelangelo from a Modigliani and, in general, to consider art museums home—I found myself exposed to *weird* art for the first time through this class. Like urinals, signed "R. Mutt." Women, coated in impossibly vibrant blue paint, who threw their bodies against walls. Feminist artists who appropriated (duplicated and retitled) the work of male grand masters.

To me, the work was fascinating and delightfully bizarre. But to many of my peers, it engendered frustration. In a typical rejoinder to lecture, a sophomore once asked: "If we don't have you here to explain the theoretical stuff, how are we supposed to get anything out of this on our own?" The professor was sympathetic; no doubt she had heard some version of this before (the most common being: "Why is this art?" followed by its indignant cousin: "My kid could make that!"). She left the question open, though, and it sat with me uncomfortably, long after class. It was only years later, while pursuing my PhD in sociology (and reading Pierre Bourdieu), that I learned how the love of art that aficionados so often take for granted as natural and given is instead a learned privilege, afforded through upbringing and education.[4]

Sociological thinking also guided me beyond the classroom.

I began my career in art museum education, coordinating tours, artmaking workshops, and slide talks for older adults attending community centers across Manhattan, Queens, and the Bronx. Many of these programs—despite engaged and informed teachers, thoughtful program design, and a vibrant collection—had low attendance. The job thus challenged me to check my assumptions about the "best" way to teach art and first think about the barriers stratifying cultural participation. I invested time in site visits with program participants and center staff to learn more about what they wanted and needed. During these visits, I found it most useful to write up a list of questions that could guide our conversations, and I thought it was important to keep the questions the same so I could compare feedback across centers. I did not know then that I was undertaking my first experiment with the qualitative data collection I now regularly use and teach. At the time, it just made sense to me to look for patterns that could inform my broad understanding of a particular problem.

SOCIOLOGICAL THINKING IN ART: TWO CHALLENGES

This is my story: I fell into sociology by accident, but it felt natural to be there. (Following, of course, a year or so of soul-searching agony lamenting that "I [didn't] want to be an art historian anymore!" before I applied to sociology programs. As a professor, I have come to understand this is the kind of panic typical of twenty-two-year-olds who are unaware they will change their minds about work again and again and again throughout their lives.) Nevertheless, it is clear to me that a sociological orientation to problem solving does often come less naturally to the art and museum professionals with whom I collaborate. The explanation for this is twofold, and the first issue concerns expertise.

At Teachers College, Columbia University (TCCU), I teach an elective course on arts evaluation focused on social scientific research methods. To explain his motivation for taking my seminar

in spring 2018, one student volunteered brightly: "I want to learn how to do what you [as an evaluator] do, so I can do it myself!" The comment underscored how acutely young arts professionals understand the need to produce data-driven research. Nevertheless, for both emerging and established professionals, a single workshop or even a fifteen-week course is insufficient to fill gaps in training. Such short exposures cannot substitute for the expertise afforded by an advanced degree or the decades of work experience external consultants typically hold (in the same way that such consultants, after taking one introductory semester of art history, could not curate an exhibition or lead public tours of it).

So-called capacity building—typically in the form of episodic professional development opportunities—thus often leaves arts administrators both dependent on those consultants and feeling as though they are on the fringes of important conversations about their work. As Vu Le, a nonprofit executive who maintains the Nonprofit AF blog, has further noted, the trouble is exacerbated by a lack of infrastructure (staffing, time, finances) to sustain capacity building over time.[5] In analogizing nonprofit professionals to carpenters—skilled in building solid, beautiful things—he notes that with the "teach a man to fish" metaphor:

> We are forcing [these professionals] to spend most of their time learning to fish, and catching fish, and not allowing them to do carpentry. We have brilliant leaders or organizations in our [nonprofit] sector. They are good at getting people to vote, getting kids to study, helping parents understand the school system, delivering hot meals to seniors, helping individuals with mental illness, supporting victims of domestic violence, advocating, saving the environment, etc. But we force them to use 50% of their time trying, and struggling, to do capacity building. It often doesn't work, and the more time and energy these orgs spend trying to build capacity, the less they can actually do the stuff they're good at and passionate about, and that we need them to do.

The first impediment to finding a place for sociological thinking in art worlds concerns the boundaries of expertise. The second is what I call the *And then what?* problem. In a now-famous lecture entitled "Science as a Vocation," Max Weber—one of the most influential sociological thinkers—reflected on the purpose of science and scientists (which, according to Weber, included social scientists like sociologists).[6] In it, he concedes that science does not give counsel, advice, or otherwise lay out what goals are or are not worth pursuing. Fair enough, but often deeply unsatisfying.

For instance: Whether they have read Bourdieu or not, every museum educator I have ever met is well aware that the understanding and appreciation of high culture is a learned ability, stratified by socioeconomic status. It is perhaps useful for them to know that this ability is called "cultural capital," that demonstrating it is a way (intentionally or not) to signal one is elite, that people without it feel unwelcome and uncomfortable in art worlds, and that this all explains why policy studies of arts audiences consistently reveal they have a high level of education relative to the general population. It is useful, but only to a point. Beyond making arts administrators feel defeated about their work, deconstructing the origins of the problems they face democratizing art worlds ultimately does not tell them how to move forward. It leaves open the question: And then what?

TOWARD A PHILOSOPHY OF PRACTICE

After spending much of his lecture belaboring what science *cannot* do, however, Weber then helpfully offers some reflections on what it makes possible. Science furnishes practically useful information; for example, it can help develop critical thinking. But beyond this—and here he places greatest emphasis—science can promote clarity about choices by helping people account for the effects of their actions. This may sound unnecessarily abstract, but it doesn't

have to be. In art worlds, I argue, sociological thinking is most useful for cultivating a theory that governs effective decision-making and ways to understand its impact. In short, it can promote a philosophy of practice.

The idea of cultivating a philosophy of practice infuses my work in various ways, including my teaching and curriculum design. I am presently on faculty in a program that confers graduate degrees I describe as MBAs for arts professionals. As a field, arts administration has been rapidly growing since the mid-1960s, largely due to that period's increase in government support of arts organizations that required those organizations hire and train staff to meet the regulatory requirements of grants.[7] We are thus a long way from the "impresario" style of management that was characteristic of Luigi Palma di Cesnola, whose fifteen-year tenure as the first director of the Metropolitan Museum of Art, New York, was conferred largely due to his gender, good breeding, and social connections (and distinguished by his metal-bottomed shoes and surveillance of staff from a glass-walled balcony office). A century later, a master's degree is often a prerequisite for entering arts careers, not to mention advancing in them.

Accordingly, TCCU's program is guided by the belief that arts administrators need rational management principles. Along with faculty member Jennifer C. Lena, also trained as a sociologist, I teach students how to balance a budget, develop outreach programs for underserved audiences, and fundraise using social media. But we are also keenly aware that they will develop many of these skills on the job, and that a not-inconsequential segment of our students with substantial prior work experience will have honed them even before entering our classrooms. We thus compliment this practical emphasis on the *how* with core and elective courses rooted in the *why*. In the words of one alumna, Emily, we aim to ensure for our students that "when it comes to decision-making, [they] as arts administrators will be able to answer not only how

to make something happen but also to persuade others *why* we are doing this."[8] We thus explore such questions as: Why did the American arts sector develop the way that it did? Why are some things categorized as art and others not (and with what consequences for artistic careers)? "Why" (in the words of the great Linda Nochlin) "have there been no great women artists?"[9] And—most importantly—why does this matter for the work arts professionals do now and in the future?

Our curriculum furnishes answers to these questions through TCCU classes—from Cultural Policy to Access and the Arts to Art and Pop—that marry current policy reports and professional case studies with sociological theory and research. Most saliently, first-year students—many of whom come from humanities (art history, musicology) or practitioner (actor, musician) backgrounds—take a required seminar called Arts in Context, which offers an introduction to social-scientific perspectives on the arts. When I teach the class, each week I ask two students to present an article discussing a phenomenon in the contemporary art world that effectively illustrates that session's course themes. In this part of class, we discuss everything from the flexibility and precariousness of the gig economy to the likability of Celine Dion's music to the politics of removing Confederate statues.[10] The goal is not to reach consensus on these issues (admittedly highly charged, even with Celine), but instead for students to reflect upon ideas that can inform their future administrative decision-making. For example, sociological research highlights how artworks have more than one meaning: different social groups receive them differently based on the cultural presuppositions they bring to the aesthetic encounter. And some groups have more power to advance their interpretation than others. Grappling with this idea aids students in articulating the different understandings of art at stake in censorship and cultural appropriation, whose understandings they would foreground when facing these issues in their work, and, of course, *why*.

CONSULTING: OR, SOCIOLOGICAL THINKING IN THE FIELD

If I rely on sociology as a teacher to cultivate a philosophy of practice, I do so in equal parts as a consultant. This essay has moved somewhat casually between the sociology of art and arts evaluation. This is deliberate on my part, because I see them as more similar than different. I have worked for five years now as a consulting analyst for RK&A—a planning, research, and evaluation firm serving museums—and early in my tenure with them, I wrote a blog post about the relationship between sociology and evaluation that first explored some of the ideas I develop at length here.[11] As I noted in the post, the foundational difference between the fields regards the role of theory. Sociologists study an arts organization to understand something broader about the world, whereas evaluators work to help specific organizations with specific problems and may even make formal recommendations. Regardless, as I wrote:

> High quality evaluations present museum staff with systematic research in efforts to help them make more informed choices about what they do, how they do it, and with what impact. This objective, I've come to understand, is central to how RK&A understands the role of evaluation in museum settings, and what we here call "intentional" practice.

The "case for holistic intentionality" made by the firm's founder, Randi Korn, guides RK&A's work and is elaborated in an article bearing that name.[12] It charges museums to "carefully write intentions that reflect and describe the essence of the museum and its unique value and potential impact."[13] Here, evaluation (defined as understanding how well people have achieved their goals) is positioned as only one piece of intentional practice.[14] And before evaluation can even happen, defining what administrators *want*

to achieve is critical.[15] One would be surprised how many (over-worked, underpaid) arts professionals lose sight of—or at least find themselves with less time to reflect upon—the passion that led them to their careers and spurred their ambitions for impact. In a visit to my assessment class, for example, RK&A's director Steph-anie Downey introduced my students to an exercise intended to lead organizations interested in articulating an impact statement, wherein RK&A staff ask museum professionals to reflect upon the following question: What about your work with your organization is most important to you? Following this, staff ask: Why is that important? And then: Why is *that* important? And then: Why is *THAT* important? As Downey explained, this exercise often makes professionals in the culture and museum sectors quite emotion-al—a statement that made my students nod, knowingly.

Case studies from Korn's latest book underscore the transfor-mative potential of this impact-driven work.[16] One such case study details how education professionals at the Philadelphia Museum of Art took Sherlock, their curriculum for first-year medical stu-dents, and adapted it for fifth- and sixth-grade students. Redefin-ing impact and revising their outcomes for an established program in light of a new audience allowed them to preserve Sherlock's effectiveness while also evolving it to serve a broader public. Con-sider also the core group of professionals on staff at History Rel-evance, who work to support the visibility and value of museums and historic houses. In collaboration with RK&A, they revisited their ambitious intentions detailed in an earlier impact frame-work. This revision work helped them understand that they had taken on more than was possible and allowed them to adjust their goals to better reflect the relationship between aspiration and achievement. Their making the "deliberate decision to do less" reflects how defining intention through evaluation work is an ongoing commitment.[17] The process functions as a reflexive way of *thinking*—again, a practice—rather than merely a set of meth-odological tools arts administrators typically do not have the time

nor interest to master and that they implement hastily only at the end of a grant cycle.

ON UNLIKELY BEDFELLOWS

I fell in love with art because it rendered for me humanity's diversity of ideas and passions. I initially came to sociology because it helped me imagine more inclusive, equitable, and accessible art worlds by illuminating what hinders them. Marrying sociology with art has served me well in arts administration, and I thus work to resolve tensions between these ostensibly bad bedfellows. In particular, for those who wonder how sociological thinking can aid them in the arts-and-culture sector, I frame sociology as a tool for promoting a philosophy of practice rather than an abstruse set of skills or defeatist conclusions that leave one wondering: And then what? This approach dovetails with a view of evaluation in the cultural sector that seeks to portray the work as reflexive, ongoing, intention-driven, and, ultimately, transformative.

As all partnerships are symbiotic, it is also an equally worthy project to think about the role humanistic thinking and values should play in the social sciences. My essay has only briefly acknowledged how our current political climate promotes a focus on the instrumental outcomes of arts participation; these often eclipse the intrinsic benefits of art, that people otherwise report as most important.[18] Notably, sociologists themselves have written about this issue (not for nothing that my assessment elective is titled The Politics and Practice of Arts Evaluation). With my students and my clients, I see a determination to develop new ways to talk about such benefits, to defend them, and to establish why they are important. The very idea of evaluation work sparked by RK&A's "passion exercise" reflects a sensitivity to explicating the particularity of "inspired worlds" in an evaluative climate that otherwise treats all organizations the same.

I am a sociologist of art. It is an unlikely partnership, but an extraordinary one.

NOTES

1. Pierre Bourdieu, *Sociology in Question*, trans. R. Nice (London: Sage, 1993), 139.
2. Luc Boltanski and Laurent Thévenot, *On Justification: Economies of Worth*, trans. Catherine Porter (Princeton, NJ: Princeton University Press, 2006), 159.
3. See Randi Korn, "The Case for Holistic Intentionality," *Curator: The Museum Journal* 50, no. 2 (2007): 255–64.
4. In particular, Pierre Bourdieu, *Distinction*, trans. R. Nice (Oxford: Polity Press, 1984).
5. Vu Le, "Capacity Building 9.1: Give Someone a Fish, Let Them Focus on Carpentry," Nonprofit AF, 2016, accessed May 14, 2018, nonprofitaf.com/2016/10/capacitybuildinggivesomeoneafish/.
6. Max Weber, "Science as Vocation," in *From Max Weber*, ed. and trans. H. H. Gerth and C. Wright Mills (Oxford: Oxford University Press, 1946), 129–56.
7. Richard Peterson, "From Impresario to Arts Administrator: Formal Accountability in Nonprofit Cultural Organizations," in *Nonprofit Enterprise in the Arts: Studies in Mission and Constraint*, ed. Paul DiMaggio (New York: Oxford University Press, 1986), 161–83.
8. Vimeo, "Emily—ARAD program," May 9, 2018, https://vimeo.com/268812619.
9. Linda Nochlin, "Why Have There Been No Great Women Artists?" in *Women, Art, and Power* (New York: Harper and Row, 1988), 145–78.]
10. Highly recommended re: Celine: Carl Wilson, *Let's Talk about Love: A Journey to the End of Taste* (New York: Continuum Books, 2011).
11. Gemma Mangione, "Thinking Intentionally about Sociology and Evaluation," Intentional Museum (blog), June 24, 2015, https://rka-learnwithus.com/blog/2015/06/24/thinking-intentionally-about-sociology-and-evaluation/.
12. Korn, "The Case for."
13. Korn, "The Case for," 255.
14. Following planning and evaluation, museums must practice reflection (i.e., what have we learned from our evaluation, and how can we do better?) and, finally, alignment: How do we align our actions to achieve impact?
15. Along similar lines, my assessment elective in ARAD spends a significant amount of time on goal clarification, though I don't call it that. As Michael Quinn Patton has noted, the "goals clarification game" is a "boring game"

that clients "typically hate" because "they have played the game hundreds of times . . . [and] when playing the game with an evaluator, the evaluator almost always wins." Michael Quinn Patton, *Utilization-Focused Evaluation*, 4th ed. (Thousand Oaks, CA: Sage, 2008), 234.

16. Randi Korn, *Intentional Practice for Museums: A Guide for Maximizing Impact* (Lanham, MD: Rowman & Littlefield, 2018), 125–68.

17. Korn, *Intentional Practice*, 126.

18. This paradox has been addressed at great length in cultural policy and arts evaluation. See, for example, Kevin McCarthy et al., *Gifts of the Muse: Reframing the Debate About the Benefits of the Arts* (Santa Monica, CA: Rand Corporation, 2004) and Alan Brown, "An Architecture of Value," *Grantmakers in the Arts Reader* 17, no. 1 (2006): 18–25.

WORKS CITED

Brown, Alan. "An Architecture of Value." *Grantmakers in the Arts Reader* 17, no. 1 (2006): 18–25.

Boltanski, Luc, and Laurent Thévenot. *On Justification: Economies of Worth.* Translated by Catherine Porter, 159. Princeton, NJ: Princeton University Press, 2006.

Bourdieu, Pierre. *Distinction*. Translated by R. Nice. Oxford: Polity Press, 1984.

Bourdieu, Pierre. *Sociology in Question*. Translated by R. Nice. London: Sage, 1993.

Korn, Randi. "The Case for Holistic Intentionality." *Curator: The Museum Journal* 50, no. 2 (2007): 255–64.

Korn, Randi. *Intentional Practice for Museums: A Guide for Maximizing Impact*. Lanham, MD: Rowman & Littlefield, 2018.

Le, Vu. 2016. "Capacity Building 9.1: Give Someone a Fish, Let Them Focus on Carpentry." Nonprofit AF, 2016. Accessed May 14, 2018. http://nonprofitaf.com/2016/10/capacitybuildinggivesomeoneafish/.

Mangione, Gemma. "Thinking Intentionally about Sociology and Evaluation." Intentional Museum (blog), June 24, 2015. https://rka-learnwithus.com/blog/2015/06/24/thinking-intentionally-about-sociology-and-evaluation/.

McCarthy, Kevin F. et al. *Gifts of the Muse: Reframing the Debate About the Benefits of the Arts*. Santa Monica, CA: Rand Corporation, 2004.

Nochlin, Linda. "Why Have There Been No Great Women Artists?" In *Women, Art, and Power*. New York: Harper and Row, 1988.

Patton, Michael Quinn. *Utilization-Focused Evaluation*. 4th ed. Thousand Oaks, CA: Sage Publications,

Inc., 2008.

Peterson, Richard A. "From Impresario to Arts Administrator: Formal Account-
ability in Nonprofit Cultural Organizations." In *Nonprofit Enterprise in the
Arts: Studies in Mission and Constraint*, edited by Paul DiMaggio, 161–83. New
York: Oxford University Press, 1986.

Vimeo. "Emily—ARAD program." May 9, 2018. https://vimeo.com/268812619.

Wilson, Carl. *Let's Talk about Love: A Journey to the End of Taste*. New York: Con-
tinuum Books, 2011.

.

EPILOGUE

TWO BIRDS WITH THE PHILOSOPHER'S STONE

How the Humanities Will Redefine and Reinvigorate the Future of Work for Millennials

Julia Hotz

As Becky rides the 7:21 a.m. express train to Penn Station, she keeps a mental countdown of the hours until 5:00 p.m. Her eyes—inseparable from the dark, fatigue-swollen pockets underneath them—look tired and bored, yet they find the energy to roll in frustration as she reads her supervisor's email: a condemnation of her use of Helvetica font on the company newsletter.

As has become routine for Becky, she closes her Gmail app and opens her LinkedIn, Indeed, and Glassdoor apps, furiously browsing them for other administrative assistant job openings. In doing so, she personifies the two-thirds of polled millennial employees who intend to leave their current organization within four years ("Millennials"). But perhaps more alarmingly, Becky represents the whopping 71 percent of millennials who claim they're "not

engaged" with, or even "actively disengaged" from, their work (Brandon and Nelson).

Across the aisle sits Brad, a victim to a different sort of worker disengagement. Adorned with the same dark and puffy pockets, Brad's eyes are strained from overexertion, as he's stayed up all night studying for his next installment of accounting exams. Yet Brad's eyes nearly gauge out of their sockets as he reads his boss's email, which announces that half of his organization's employees will be laid off in the upcoming weeks. The reason, though unstated in the email, is that the company has acquired new financial software, estimated to perform the tasks human laborers would perform at a fraction of the time and cost. Here again, Brad's fate is an all-too common one, shared by nearly 50 percent of Americans whose jobs face the high likelihood of becoming automated before 2033 (Frey and Osborne).

Even so, Becky and Brad are considered the "lucky" ones of their generation, for at least they're employed in any capacity.. But despite their relative fortune, both of them can't help but feel something's not right. They begin to doubt that their near two decades of schooling should culminate in careers they find tedious, mechanical, and boring or that their contributions within the labor market should be tasks that a powerful computer could just as easily and more reliably perform. Above all, they doubt that their existence as workers, an activity to which they devote nearly one-half of their waking lives, should be so strikingly separate from their existence as human beings. And so, they, like many other millennials, begin to wonder: What is the purpose of work?

Their stories are not unusual. And they point to much-needed reevaluation and reinvigoration of a partnership that is absolutely essential to the building of a holistic future that embraces our human potential: that between the everyday purpose of work and the study of the humanities.

BAKERS, TAILORS, AND BLACKSMITHS

Merriam-Webster's dictionary defines "work" as an "activity involving mental or physical effort done in order to achieve a purpose or result." But what happens when the worker renders such "a purpose or result" irrelevant (like Becky) or has their "mental or physical effort" deemed replicable by a computer (like Brad)? While today's challenges of disengagement and automation complicate the traditional confines of "work," this primitive definition had been valid for hundreds and hundreds of years, before globalization took its course; it accurately described a time when we created jobs to meet our needs, rather than needs to *sustain* our jobs.

In fact, the earliest "economy" was conceived on this very notion of work as a means to a tangible, overtly meaningful end; derived from the Greek word oikos (household) and nomeia (management), such a network, indeed, functioned like a well-managed household—a domain in which "chores" were performed for the greater good of the community. Each "economy" had its so-called chore doers—its baker, its tailor, its blacksmith—whose labor required true mental or physical effort, whose function had community meaning, and whose product inspired active feedback. If you, the carpenter, created a sturdy and beautiful table, everyone in the community knew to praise you for the table's successes. But if your creation was flimsy or ugly, everyone knew to criticize you for its inadequacies. Since this feedback on your work was essentially feedback on your character, your work became part of your identity within the community. Perhaps this work-as-identity dynamic explains why many of the earliest vocations double as common surnames—Baker, Taylor, Smith, Cook, and Carpenter, to name a few ("Common").

Yet, as the population grew larger and the economy expanded, such a dynamic weakened; as more of these "chore-doing communities" emerged around the globe, the incentive to trade among

them grew, while the incentive to work exclusively within them diminished. Demand steadily grew from a local phenomenon to a global phenomenon, and as demand itself expanded, so did the labor forces designed to meet it; technology developed, corporations formed, capitalism intensified. As such, the quality of the carpenter's table was no longer evaluated by members of the self-sufficient community but by tradesmen of the global economy who now had to consider factors such as the table's practicality, aesthetic appeal, distinction from its competitors, ability to be shipped, and propensity to be mass-produced.

Today, consistent with the size and demands of the global population, such forces of technology, industry, and capitalism are at an all-time high, especially within typical millennial career circles. For the most part, decreasing are the local economy's carpenters and increasing are the global economy's construction-site analysts; decreasing are the individual shoemakers and increasing are the corporate-fashion retail sellers; decreasing are the jobs designed to directly serve the community and increasing are the jobs designed to serve the people who serve the people who serve the global economy, which, only transitively, serve the local community.

Countless studies have shown the ramifications of severing this natural, long-standing tie between the individual workers and the community for which they work. For starters, as explained by Chicago psychologist John Cacioppo, feelings of loneliness or isolation from a group can have extraordinarily damaging effects on our mental and physical health. In explaining our fundamental human need for social connection down to the microlevel, Cacioppo demonstrates how loneliness correlates with increased blood pressure, dulled cognition, a deteriorated immune system, accelerated aging, and an increased presence of stress hormones (qtd. in Hawkley and Thisted). Such consequences are only exacerbated in the workplace, according to Hakan Ozcelik and Sigal Barsade, whose study on work loneliness and employee performance indicates an inverse relationship between the two; neither does

"feeling lonely and disconnected . . . make [an employee's] work experience less psychologically rewarding" but it also decreases the employee's "affective commitment" or emotional attachment to and involvement with his or her organization. This, in turn, weakens his or her performance.

Conversely, employees with greater emotional attachment to, identification with, and involvement in their organization have both a more rewarding work experience and better work performance. A separate Stanford University study from Priyanka B. Carr and Gregory M. Walton reaffirms this relationship between connectedness and work performance, explaining how feelings of belongingness to a group or a connected team can bolster motivation:

> Our research found that social cues which conveyed simply that other people treat you as though you are working together on a task—rather than that you are just working on the same task but separately—could have striking effects on motivation. (qtd. in Parker)

Perhaps this is why the most fulfilling and desired jobs appear to be the ones which most resemble the early "economy" paradigm— both facilitating collaboration with other humans and fostering opportunities to make a tangible impact on them. Teachers and nurses, for instance, consistently rank as both highly fulfilling and popularly sought-out professions, reportedly because they minimize isolation, maximize human impact, and continually facilitate community collaboration (Ferguson).

These desires are particularly strong for millennials who crave tangible human impact like no other generation that's preceded them. As Mark Zuckerberg noted of millennials in his 2017 Harvard commencement speech: "[They] are already one of the most charitable generations in history. In one year, three out of four US millennials made a donation, and seven out of ten raised money for charity."

In fact, in the majority of cases, this reward of tangible impact and workplace engagement outweighs the traditional reward of monetary compensation. According to a 2013 Intelligence Group study, 64 percent of the millennials surveyed claimed they would "rather make $40,000/year at a job they love than $100,000/year at a job they think is boring" ("Millennial Generation").

To address this shortcoming of loneliness, boredom, and disengagement from humanity, many corporations are attempting to highlight human contact through a variety of solutions. A *Harvard Business Review* article entitled "Workspaces That Move People" showcases how companies such as Facebook, Yahoo, and Samsung have strategically designed their offices in order to minimize cubicle-induced separation and maximize communal spaces and "face-to-face" interaction, which they've deemed "the most important activity in an office, by far" (Waber and Magnolfi et al.). Freelancers, technologists, and programmers have recognized this benefit as well by actively seeking out "coworking spaces" in which they can work side-by-side in a common space rather than at home in isolation. A recent *Deskmag* survey suggested the overwhelming benefits of coworking, with 75 percent reporting increased productivity and 80 percent reporting an increased business network ("First Results").

Employers are also looking inward to increase their workers' engagement with humanity. In recognizing how unappreciated and unnoticed digital work can feel for a worker, many corporations have begun to actively build close relationships with their employees and provide tangible feedback—a measure that's had a significant positive effect on worker morale (Harrison and Ahmad et al.). Corporations have similarly taken note of millennials' altruistic tendencies, with the UN Global Compact engaging eight thousand companies in more than 145 countries on social issues, ranging from preventing human rights violations to pushing environmentally friendly practices, in response to demands for more corporate social responsibility and engagement with humanity (Kell).

WORK AS THE EXERCISE OF INTELLECTUAL VIRTUE

While these top-down measures to reconnect with humanity might help with the issue of workplace disengagement, they serve only as the Band-Aid on a much deeper wound. It's true that we tend to prefer work that feels meaningful in the community and facilitates tangible human interaction, but we'd be remiss to think these are the *only* two necessary components of workplace engagement and satisfaction. Think, for instance, of a supermarket cashier: though we might concede that her work has a clearly defined community meaning and enables frequent human contact, such a profession, we'd likely agree, probably doesn't *challenge* the cashier to the extent that other careers do. Indeed, we're unlikely to consider this work "engaging" for its failure to cultivate the cashier's most distinctly human passions and talents (it's doubtful that the cashier's previous education and life experiences have directed her to scan barcodes for eight hours a day). The same, though less obviously so, can be said for certain jobs in the corporate workspace; even if Becky and Brad were reminded every day that their work is meaningful in the community, directly appreciated by fellow humans, and impactful in the world outside of work, they still may face a sort of existential longing to further apply their intellect and their passions.

Luckily, this intellectual longing comes at a perfect time; for the first time in human history, there is an additional incentive to pick a mentally stimulating profession. Indeed, not only might millennials, like Becky and Brad, *desire* to perform work that reflects their unique human capabilities, but they also might be *required* to choose such creativity-sparking, intellectually challenging, distinctly human vocations based on the risk that (cheaper and more reliable) automation technology will overtake their nondistinctly human tasks. As worded by prominent data scientist and Kaggle CEO Anthony Goldbloom in his TED Talk:

We have no chance at competing against machines on frequent, high volume tasks. But there are things we can do far better than machines, like handling novel tasks. . . . Humans have the ability to connect seemingly disparate threads to tackle problems we've never seen before.

Two Oxford researchers, Carl Benedikt Frey and Michael A. Osborne, confirm this theory in their groundbreaking 2013 study "The Future of Employment: How Susceptible Are Jobs to Computerization?" While they estimate 86 percent of "highly creative professions" face "low to no risk of automation," the future is less optimistic across the board, where they estimate that 47 percent of current job categories, including typically high-collar professions such as accountancy, legal work, and technical writing, are at high risk of automation. For more anecdotal proof, look no further than the disengaged supermarket cashier, whose work is already in the process of being replaced by self-checkout machines.

Fortunately, the study of this distinctly human potential, and how to best cultivate it, has existed for many centuries. It likely dates back twenty-four hundred years to Ancient Greek philosopher and taxonomist Aristotle who, like Becky and Brad and most millennials today, expressed dissatisfaction with the idea that our lives consist of the mere execution of tasks; instead, Aristotle argued that humans are "[taxonomically] above" such a daily routine. In a unique field he coined "teleology," or "the study of the ends [of things]," he observed: "How can it be that a carpenter and a shoemaker have a proper function, but that a human being as such doesn't have one? Or how can the eye, the hand, the foot each have their proper functions, but the individual as a whole does not?"

Through this analogy, Aristotle suggests that humans are more than the sum of their parts; while we might have the *ability* to perform practical functions—scan barcodes, draft emails, input data into Microsoft Excel—these do not collectively encompass

our *holistic* function, nor do they represent our distinctly human potential. Rather, Aristotle wrote, our most distinctly human ambitions involve the exercise of our most uniquely human capability: "intellectual virtue." He added that the exercise of this virtue marked the "contemplative life" (*bios theoretikos*), the most godlike way of living and thus an end to which all people should strive.

To achieve this end, Aristotle suggested we cultivate and exercise three subvirtues of intellect: practical skills (*phronesis*), intelligence (*synesis*), and wisdom (*sophia*). By "practical skills," Aristotle meant common sense and prudence—the sort of "knowledge" we access when we travel to a foreign country or walk down a dark alley. To be "intelligent," on the contrary, is to be logical, analytical, and quick-witted—more like the situational performances that IQ tests attempt to measure. Yet it is "wisdom," Aristotle's third tenet, that he considered the most important ingredient of intellect. Incidentally, it is also the most difficult to define, with some translating wisdom as "the supreme mode of discovering truth" ("The Idea"), and others classifying it as a remarkable combination of insight, imagination, and creativity.

As proof of Aristotle's unprecedented insight into today's workforce, we might notice how many of the most satisfying and popular careers are ones that actively exercise human intellect. In addition to teachers and nurses, another profession consistently ranked as highly desirable is engineering—says an article in the *Guardian*—purportedly for the engineer's ability to "come up with new designs that offer solutions to industry problems, a lot of freedom when testing ideas, and learn new skills on a daily basis" (Ferguson). Marketing specialists recently topped a separate list in a Forbes article, claiming to enjoy the way a worker can "exercise creativity and problem solving in their task of building out a company's market strategies" (Strauss).

Yet, perhaps the most popular "career" through which millennials most actively practice their intellect and creativity are the ones *they've* created—spaces they've "self-started" for an entrepreneurial

end. Within these nontraditional spaces—YouTube channels; Soundcloud pages; mobile applications; online brands for fashion or furniture; blogs for comedy, fitness, or cooking; to name a few—millennials are writing their own rulebooks, for no previous generation has pioneered such a medium in the way millennials have.

Indeed, entrepreneurship is "in"; while only 13 percent of millennial respondents in a recent *Forbes* survey said their career goal involves climbing the corporate ladder to become a CEO or president, more than two-thirds (67 percent) said their goal involves starting their own business (Asghar). Such popularity confirms millennials' collective desire to make a tangible human impact, create a product, curate it to particular audience, and promote it through effective communication channels, and thus utilize their distinctly human intellect.

CREATION OVER AUTOMATION

Pablo Picasso, the esteemed early twentieth-century artist, supposedly once lamented to his friend Gertrude Stein about the absence of creativity in adult life: "All children are artists," he is believed to have said. "The problem is how to remain an artist once he grows up."

But if Picasso were to witness the way in which millennials are beginning to disrupt the traditional conception of work—prioritizing explosive passion and tangible human impact over job titles and salary benefits, choosing intellectual exercise and creative freedom over job security and corporate advancement—he might understand how creativity is becoming an essential skill in the twenty-first-century workplace.

More importantly, though, is how he would see today's simultaneous automation and innovation revolution as an opportune moment to cultivate this talent, from K–12 classrooms to community art workshops, in college departments and in marketing

departments. Not only is this investment in creativity culturally relevant but also economically savvy, as is anecdotally explained by MIT scientist David Autor, who theorized in a TED talk why human bank tellers exist despite the invention of automated teller machines (ATMs):

> ATMs could do certain cash-handling tasks faster and better than tellers, but that didn't make human tellers superfluous. Instead, it increased the importance of their problem-solving skills and their relationships with customers. The same principle applies if we're building a building, if we're diagnosing and caring for a patient, or if we're teaching a roomful of high schoolers. As our tools improve, technology magnifies our leverage and increases the importance of our expertise, judgment and creativity.

Given this ongoing economic phenomenon, it would be wise for governments to invest in the discipline that best cultivates such "judgment and creativity," or our most "human" abilities: the humanities. Defined by classics professor Josiah Ober as "the study of how people process and document the human experience," the humanities touch upon disciplines such as philosophy, literature, religion, art, music, history, and language (Ober). In relating this field to workplace gains, Katie Cottle, chair of humanities at Wilmington University, explains in a TED talk that the students who make the greatest gains in critical thinking are those who "read over 50 pages a week and write over 20 pages over the course of a semester." Like Autor, she reasons that "critical thinking is essential in the workplace—almost every technical skill you could learn now in college is probably going to be obsolete in the next five years. But those literacy skills and critical thinking skills are going to last the rest of your life."

Despite educators' and economists' shared consensus on the importance of cultivating critical thinking to prepare for the

twenty-first-century workplace, president Donald Trump has recently proposed to eliminate two of the largest channels that encourage literacy, creativity, and critical thought: the National Endowment for the Arts and the National Endowment for the Humanities. While some supporters of this budget proposal argue that investments in arts programs and humanities education initiatives could be better spent on technology in the classroom, the Organization for Economic Co-operation and Development (OECD) proves otherwise, as they find "education systems that have invested heavily in computers have seen 'no noticeable improvement' in their results for reading, maths and science in the Programme for International Student Assessment (PISA) tests" ("New Approach").

But perhaps more important than the actual skills such humanities programs cultivate in the classroom are the attitudes they instill: curiosity, exhilaration, life-long learning, and engagement with the world and the humans in it. This attitude shift, more than any top-down workplace initiative or dialogue, is what will ultimately re-engage workers like Brad and Becky. After all, as Mark Zuckerberg noted in his 2017 Harvard Commencement Speech, millennials predominantly view their identity as "citizens of the world." Therefore, policymakers, curriculum designers, and educators at all ends of the spectrum must act in response to millennials' preferred identity by treating the humanities for what they are: a means to promote both career success and work engagement for life.

Indeed, what history, philosophy, and, yes, everyday life teaches us, above all, is that the most extraordinary partnerships we can build for the future of work are the ones that enhance our human impact and engagement. We can be more than the sum of our parts if we continue to support and encourage the deep and broad study of the humanities in our educational institutions and our everyday lives.

WORKS CITED

Aristotle. *The Nicomachean Ethics*. 1st ed. Trans. Robert C. Bartlett and Susan D. Collins. University of Chicago Press, 2011.

Asghar, Rob. "Study: Millennials Are the True Entrepreneur Generation." *Forbes*, November 11, 2014. http://www.forbes.com/sites/robasghar/2014/11/11/study-millennials-are-the-true-entrepreneur-generation/#24781dfe73dc.

Autor, David. "Will Automation Take Away All of Our Jobs?" Ideas.TED.com, March 29, 2017. https://ideas.ted.com/will-automation-take-away-all-our-jobs/.

Frey, Carl Benedikt, and Michael A. Osborne. "The Future of Employment: How Susceptible are Jobs to Computerisation?" Oxford Martin, September 17, 2013. http://www.oxfordmartin.ox.ac.uk/downloads/academic/The_Future_of_Employment.pdf.

Cottle, Kate. "Oh the Humanities!" YouTube, TEDxWilmingtonUniversity, May 15, 2015. http://www.youtube.com/watch?v=ZovidIWkymo.

Deloitte. "Millennials Have One Foot Out the Door: The Deloitte Millennial Survey 2016." https://www2.deloitte.com/content/dam/Deloitte/global/Documents/About-Deloitte/gx-millenial-survey-2016-exec-summary.pdf.

Hawkley, Louise C., and Ronald A. Thisted et al. "Loneliness Predicts Increased Blood Pressure: Five-Year Cross-Lagged Analyses in Middle-Aged and Older Adults." *Psychol Aging* 25, no. 1:132–41. http://www.ncbi.nlm.nih.gov/pmc/articles/PMC2841310/.

Ferguson, Donna. "The World's Happiest Jobs." Guardian, April 8, 2015. http://www.theguardian.com/money/2015/apr/07/going-to-work-with-a-smile-on-your-face.

Foertsch, Carsten. "First Results of Global Coworking Survey." Firstmag, November 3, 2011. http://www.deskmag.com/en/first-results-of-global-coworking-survey-171.

Generation Opportunity. "Millennial Unemployment Rate Stagnant at 12.8 Percent." March 4, 2016.

Goldbloom, Anthony. "The Jobs We'll Lose to Machines and the Ones We Won't." TED Talk, February 2016. https://www.ted.com/talks/anthony_goldbloom_the_jobs_we_ll_lose_to_machines_and_the_ones_we_won_t?language=en.

Griffith-Greene, Megan. "Self-Checkouts: Who Really Benefits from the Technology?" Marketplace. CBC News, January 28, 2016. http://www.cbc.ca/news/business/marketplace-are-you-being-served-1.3422736.

Kell, George. "Five Trends That Show Corporate Responsibility Is Here to Stay." Guardian, August 13, 2014. http://www.theguardian.com/sustainable-business/blog/five-trends-corporate-social-responsbility-global-movement.

Lutins, Allen. "Common English Surnames Derived from Professions." Lutins. December 2, 2015. http://www.lutins.org/lists/surnames.html.

McKnight, D. Harrison, Sohel Ahmad, and Roger G. Schroeder. "When Do Feedback, Incentive Control, and Autonomy Improve Morale? The Importance of Employee-Management Relationship Closeness." *Journal of Managerial Issues* 13, no. 4 (Winter 2001): 466–82. https://bit.ly/3byIKdE.

"Millennial Generation Eager to Work, 'But on Their Terms.'" Columbus Dispatch, March 30, 2014. www.dispatch.com/content/stories/business/2014/03/30/eager-to-work-but-on-their-terms.html.

Ober, Josiah. "What Is Democracy?" Stanford Humanities Center. Accessed November 12, 2019. http://shc.stanford.edu/what-are-the-humanities.

OECD. "New Approach Needed to Deliver on Technology's Potential in Schools." September 15, 2015. http://www.oecd.org/education/new-approach-needed-to-deliver-on-technologys-potential-in-schools.htm.

Ozcelik, Hakan, and Sigal Barsade. "Work Loneliness and Employee Performance." Wharton Faculty Platform. Accessed November 12, 2019. https://faculty.wharton.upenn.edu/wp-content/uploads/2012/05/Work_Loneliness_Performance_Study.pdf.

Parker, Clifton B. "Stanford Research Shows That Working Together Boosts Motivation." Stanford News, September 15, 2014. https://news.stanford.edu/news/2014/september/motivation-walton-carr-091514.html.

Rigoni, Brandon, and Bailey Nelson. "Few Millennials Are Engaged at Work" Gallup: Business Journal, August 30, 2016. https://news.gallup.com/businessjournal/195209/few-millennials-engaged-work.aspx.

Strauss, Karsten. "The Happiest Jobs of 2017." *Forbes*, March 13, 2017. www.forbes.com/sites/karstenstrauss/2017/03/13/the-happiest-jobs-of-2017/#5a4611954996.

Waber, Ben, Jennifer Magnolfi, and Greg Lindsay. "Workspaces That Move People." *Harvard Business Review*, October 2014. https://hbr.org/2014/10/workspaces-that-move-people.

The Xavier Zubiri Foundation of North America. "The Idea of Philosophy in Aristotle." Accessed November 12, 2019. http://www.zubiri.org/works/englishworks/nhg/ideaofphilosophy.htm.

work, n. Merriam-Webster, 2011. Accessed November 12, 2019. https://www.merriam-webster.com/dictionary/work.

Zuckerberg, Mark. "Mark Zuckerberg's Commencement Address at Harvard." *Harvard Gazette*, May 25, 2017. https://news.harvard.edu/gazette/story/2017/05/mark-zuckerbergs-speech-as-written-for-harvards-class-of-2017.

Contributors

In 2000, **Betsy Andersen** became founding director of Museo Eduardo Carrillo, an online museum devoted to the art and impact of the pioneering artist Eduardo Carrillo. Museo fulfills its responsibility as a museum by exhibiting under-represented artists and developing free educational resources based on contemporary Latinx art. Based on these programs, Museo was given the Rydell Award. Andersen developed the California Central Coast Chicano/a Legacy program to capture their untold stories.

She has been a radio host on NPR-affiliate KUSP, providing weekly in-depth interviews with visual artists, developed intimate documentaries on artists, and was the first curator for the Santa Cruz Art League. She worked as an art teacher for kindergarteners up to university students.

Amar C. Bakshi is a multidisciplinary artist whose work focuses on connecting people who likely would not otherwise meet. In particular, he creates novel digital-physical environments to redefine public space, helping generate sites where members of diverse communities can interact and create their own meanings.

In December 2014, he launched the global public art initiative called Portals. Portals are gold-colored shipping containers

equipped with immersive audiovisual technology and spread out in public sites around the world. When individuals enter a Portal, they feel as though they are sharing the same space as someone in an identical Portal somewhere else on Earth. As many participants have put it, they feel like they are breathing the same air. Since launch, Portals have connected hundreds of thousands of people around the world in intimate dialogues, classes, performances, and events. Community partners have built more than forty permanent Portals in twenty countries around the world in diverse locations, including refugee camps, American inner cities, universities, technology hubs, museums, and public parks.

Amar's work utilizes law, policy, and institutional formations of sites of artistic exploration. While a student at Yale Law School, he organized The Legal Medium: New Encounters of Art and Law to study how contemporary artists use law as material. Amar has an AB from Harvard University, an MA from the Johns Hopkins School of Advanced International Studies, and a JD from Yale Law School.

Charles Batson is professor of French and Francophone studies at Union College in Schenectady, New York, where he also won the Stillman Award for Excellence in Teaching. He is the author of *Dance, Desire, and Anxiety in Early Twentieth-Century French Theatre* (Ashgate, 2005), coeditor of a 2012 special double issue of *Contemporary French Civilization*, and coeditor of three recent issues devoted to a Queer Québec (appearing in *Québec Studies* and in *Contemporary French Civilization*). A member of Montreal's Working Group on Circus Research, he has published work on French and Francophone cultural production and performance in such journals as *SITES, Québec Studies, Gradiva, Dance Chronicle, Nottingham French Studies, Contemporary French Civilization*, and *French Politics, Culture, and Society*. He coedited, with Louis Patrick Leroux, a compendium of essays on Québec's contemporary

circus called *Cirque Global: Quebec's Expanding Circus Boundaries* (McGill-Queens University Press, 2016), and he is coleading a series of research encounters in the new field of inquiry referred to as Circus and Its Others, with international conferences held in Montreal and Prague.

Chantal Bilodeau is a playwright, translator, and research artist whose work focuses on the intersection of science, policy, culture, and climate change. She is the artistic director of The Arctic Cycle—an organization created to support the writing, development, and production of eight plays that look at the social and environmental changes taking place in the eight countries of the Arctic—and the founder of the blog and international network Artists & Climate Change. She was a co-organizer of the Climate Change Theatre Action, which presented over a hundred events worldwide in support of the United Nations 2015 Paris Climate Conference.

Jennifer Burkhart is a recent graduate of the University of Alaska Anchorage (UAA) PhD program in clinical-community psychology. She conducted her dissertation research with the actors involved in the *Stalking the Bogeyman* project, completing interviews about their experiences and ways in which they maintained their overall health and wellbeing. Her professional interests include program development and evaluation, the integration of clinical and community psychology perspectives, individual and community wellness and resilience, community-based and mixed-methods research, indigenous ways of knowing and healing, and the use of technology to support efforts in all of these domains. She is currently employed as a senior research associate with Strategic Prevention Solutions, a research and evaluation firm that aims to address and prevent social and health problems on community, state, and national levels.

Elise Chambers is the community coordinator for the Terrascope program at the Massachusetts Institute of Technology (MIT). Terrascope is a learning community for first-year undergraduates that focuses on team-oriented, project-based learning on complex, sustainability-related problems. Elise holds a BS in environmental engineering and science from MIT. During her time as an undergraduate, she participated in the Terrascope program as a student and a teaching fellow. Elise spent several years in environmental consulting working on a variety of environmental assessment, remediation, toxicologic and epidemiologic, litigation, stormwater, and industrial hygiene projects. As a member of the Terrascope Program staff, Elise is passionate about growing leadership capacity in the students who will become her fellow alumni.

Julia Chiapella worked as an art director before becoming a freelance journalist covering the arts for the San Francisco Bay Area. She earned her MA in education in 2005 and taught at the elementary level as both a classroom teacher and a writing specialist. She has led the Young Writers Program since 2012, producing over thirty-five titles of student written work. A project of the Santa Cruz County Office of Education, the Young Writers Program opened an after-school writing lab and adjacent gallery—The Word Lab and the Chamber of Heart & Mystery—at the Santa Cruz Museum of Art & History in 2016, earning Chiapella a Gail Rich Award in 2017 for community service in the arts.

Kim Cook generates collaborative opportunities and participates in projects that advance the role that aesthetics and kinetics play in human experience, through creative interventions in space, interdisciplinary performance, and connected communities. Cook joined Burning Man in a newly created role as the director of art and civic engagement in 2015, managing the teams that deliver civic arts initiatives and community events, including Burners Without

Borders, the Global Regional Network, and Art to the Playa, which also included honoraria and Global Arts Grants. Cook also serves as the lead on the "Man" for aesthetics and activation. Previously, Cook served as the president and CEO for the Arts Council New Orleans, working at the intersection of arts, culture, and civic life. While in New Orleans, she was the creative director and founder of LUNA Fête, a projection mapping and light festival, and created Youth Solutions, a trauma-intervention and design-education placemaking project that garnered National Endowment for the Arts and Artplace America funding.

Cook has a history of being at the center of change and the forefront of innovation. With an MA in arts and consciousness, a BA in performing arts, and as a Kennedy Center fellow, Cook has worked in strategic collaboration, cross-sector partnerships, and creative placemaking. She acted as a member of the Zero One San Jose Biennial launch team in 2006, a national consultant for the Nonprofit Finance Fund between 2008 to 2013, and as the instigator behind the Leveraging a Network for Equity initiative for the National Performance Network/Visual Arts Network, funded by the Mellon Foundation. Cook has a diverse skill set and dynamic ability to connect and catalyze projects across multiple platforms and stakeholders. Cook also has a certificate in circus dramaturgy from the French and Belgian National Circus Schools and serves on the South by SouthWest (SXSW) Advisory Board for the Arts.

Cook Inlet Tribal Council, Inc. (CITC), is a tribal nonprofit organization in Anchorage offering opportunities for Alaska Native and American Indian people residing in the Cook Inlet region of south-central Alaska. CITC is an innovative leader in the social services arena, helping program participants pursue opportunities to develop their personal potential and self-reliance through four core service areas, ranging from education and workforce development to recovery services and support for children and families.

Antonio Copete is a postdoctoral researcher at the Harvard-Smithsonian Center for Astrophysics in Cambridge, Massachusetts. He has a PhD and MA in physics from Harvard University and an SB in physics from the Massachusetts Institute of Technology (MIT). His area of research is high-energy astrophysics, in which he works making observations with the Burst Alert Telescope (BAT) on board NASA's Swift Gamma-Ray Burst Observatory mission. Antonio has also been involved in advancing numerous science and technology initiatives in Latin America and Colombia in particular, most recently the Clubes de Ciencia (science clubs) program, in which professional scientists from institutions around the world were brought to the region to work in developing research competencies in high school and university students.

Emily Davidson is currently a postdoctoral research fellow at Harvard University where she develops reversibly shape-changing polymers for 3-D printing of complex actuators in the research group of professor Jennifer Lewis. She received her PhD from the University of California, Berkeley, where she developed and studied the physics of mesostructured block copolymers. She is fascinated by designing materials from the molecular through the macroscale to integrate function and structure, inspired by the hierarchical assembly that drives function in nature and biology. Emily was a 2010 to 2012 Teach for America corps member, through which she taught high school chemistry and physics in Richmond, California, and she spent several summers teaching high school computer science to Israeli and Palestinian high school students in Jerusalem through the MIT-MEET program (Middle East Entrepreneurs of Tomorrow). She received her SB in chemical engineering from MIT, where she participated in the MIT Terrascope program, and also served as an undergraduate mentor for the Terrascope program, Terrascope Radio, and Terrascope Youth Radio.

Ella Maria Diaz is an associate professor of English and Latina/o studies at Cornell University. Her book *Flying Under the Radar with the Royal Chicano Air Force: Mapping a Chicano/a Art History* (University of Texas Press, 2017) explores the art, poetry, performance, and political activism of a vanguard Chicano/a art collective founded in Sacramento, California, during the US civil rights era. For this work, Diaz won the 2019 Book Award for the National Association for Chicana and Chicano Studies Association (NACCS). Diaz has published in several anthologies as well as articles in *Aztlán: A Journal of Chicano Studies, Chicana-Latina Studies Journal*, and *ASAP/Journal.*

Jodi Enos-Berlage is professor of biology at Luther College in Decorah, Iowa, where she teaches biology, microbiology, and immunology and leads an active undergraduate research program. She has written or cowritten a range of successful grant proposals to support this work. Jodi has served as chair of the mathematics, science, and physical education division and is currently the associate dean for integrated academic and career development. She is a passionate advocate for the sciences, arts, and environment.

Together with undergraduate students, Enos-Berlage performs water-quality research in local streams, springs, rivers, and wells, publishing and presenting this work in a variety of journals and professional conferences. Her agricultural upbringing and current small-farming operation in an impaired watershed have contributed inspiration for this research. Spurred by her longstanding collaboration with Luther Dance professor Jane Hawley, and their interest in merging art and science for more powerful outcomes, Enos-Berlage and Hawley launched the *Body of Water* performance and project in 2014. Performances, workshops, and educational sessions have since been conducted at a wide range of venues. Enos-Berlage holds a BS in microbiology from the University of Illinois at Urbana/Champaign and a PhD in bacteriology from the University of Wisconsin-Madison.

Ari W. Epstein is a lecturer in the Terrascope program at the Massachusetts Institute of Technology (MIT). Terrascope is a learning community for first-year undergraduates that focuses on team-oriented, project-based learning on complex, sustainability-related problems. Epstein's scientific background is in oceanography, particularly interactions between physics and biology in the coastal ocean. He also has extensive experience in outreach and public education, including directing Terrascope Youth Radio, a program funded by the National Science Foundation (NSF) in which local urban teens created radio programming on environmental topics; assembling and leading exhibit-development teams at the New England Aquarium; developing video workshops for K–8 teachers at the Science Media Group of the Harvard-Smithsonian Center for Astrophysics; and serving as Editor of Scientific American Explorations, a hands-on science magazine for families. Epstein holds an AB in history and science from Harvard College and a PhD in oceanography from the MIT/Woods Hole Oceanographic Institution joint program. He is particularly interested in developing ways to integrate free-choice learning (the kind of learning promoted by museums, community-based organizations, media, and other outlets) into the academic curriculum, integrating formal and informal educational strategies.

Brittany Freitas-Murrell is a doctoral candidate in the University of Alaska Anchorage (UAA) PhD program in clinical-community psychology and is a member of the Community Psychology Research Collaborative. Freitas-Murrell is passionate about research, lecturing, and building community partnerships. In both clinical practice and research, Freitas-Murrell pursues utilizing the strengths and diversity within integrated, multidisciplinary, or transdisciplinary collaborations to inform and enhance interventions. As an instructor, she encourages students to conduct research and disseminate it in creative and engaging ways that bridge the gap between academia and broader communities. Freitas-Murrell conducted her

dissertation research on the *Stalking the Bogeyman* project. Specifically, she conducted a longitudinal study documenting the effects of the play on audience member's attitudes about child sexual abuse and theater as a modality for social change.

Susan M. Frost founded Frost Marketing Communications, Inc., a marketing, advertising, and public relations firm in 1984. The company designs and manages marketing programs for a variety clients. Much of the company's creative work is based on the applied humanities, a fundamental approach to her company's unique branding philosophy. Frost has a BA from the University of Wisconsin–Green Bay with a triple area of emphasis in communications, business, and the humanities and an MA in English/modern studies from the University of Wisconsin–Milwaukee. She is an associated lecturer in the humanistic studies department of the University of Wisconsin–Green Bay. Over the past decade, she has developed and taught Intro to the Humanities: Baroque to the Modern and currently teaches an online course in the applied humanities, Humanities, Business, & Critical Thinking. In 2020, she will be teaching in the university's new Impact MBA program. Active in the continuing education of public servants, business professionals, and health-care workers, her workshops and dialogues in the applied humanities are growing in popularity. She is involved in her community's theater, symphony, and historical venues, where she has served on many boards of directors, and she led the University of Wisconsin Founder's Association as president. She and her husband, Max, have two grown children. They reside in De Pere, Wisconsin.

Jessica Fujimori is an alumna of Terrascope's Mission 2014, focused on global food security. Projects that grew out of her work in Terrascope led her to spend two summers in Tanzania, working to help improve and empower the local communities. She holds a BS in earth, atmospheric, and planetary sciences and a BS in

science writing from the Massachusetts Institute of Technology (MIT). She is currently working as a freelance communications professional and volunteers with Boston Court Appointed Special Advocates (CASA) to help ensure safe and permanent homes for court-involved children.

Margaret Graham is the University Director of Academic Affairs for the office of the provost at the University of Rochester, New York, where she leads initiatives related to faculty policies. She has spent over twenty years as an adjunct instructor and academic affairs administrator at a variety of colleges and universities in the United States. She is a proud first-generation college graduate who holds a BS in physics with a concentration in fine arts from Clarkson University in Potsdam, New York, an MS in astrophysics from the New Mexico Institute of Mining and Technology, and an EdD in higher education leadership from Walden University in Minneapolis, Minnesota. Outside of her professional life, she leads and organizes social-justice efforts in her community.

Anisha Gururaj is a global health fellow at the Bill & Melinda Gates Foundation. At the foundation, she leads projects spanning across several initiatives that bridge technology development and health-systems innovation, including developing tools that draw on artificial intelligence and other data-science approaches to maternal, newborn child health (MNCH), applying human-centered design approaches to contraceptive technology innovation and designing the foundation's investments in next-generation rapid diagnostic platforms. Prior to joining the foundation, Gururaj was conducting research for her MA thesis, applying her interdisciplinary backgrounds in engineering and global-health governance to taking a user-centered, systems-based approach to analyze obstetric ultrasound technology design, development, and implementation in two rural Indian districts. Her past experience has spanned product and program innovation across a wide variety of organizations

and sectors, ranging from the Baltimore City Health Department, where she served as special assistant to the commissioner. She also designed and implemented the first Baltimore city civic health innovation program geared toward large manufacturing and engineering companies like P&G and Boeing to small medical device start-ups developing diabetic foot ulcer detection and cardiovascular surgical devices. Gururaj is a Rhodes Scholar and holds dual MSc degrees in global governance and diplomacy, and the medical sciences, obstetrics, and gynecology from the University of Oxford. She received her BS in chemical-biological engineering from the Massachusetts Institute of Technology (MIT). Outside of global health, she is an avid traveler, photographer, and Indian classical singer and dancer.

Madeleine Fuchs Holzer is the educator in residence at the Academy of American Poets. In that capacity, she has written over one hundred and sixty lessons for Teach this Poem, a free weekly interdisciplinary resource for teachers. Previously, she served for over twelve years as the educational development director and program development director at the Lincoln Center Institute for the Arts in Education, where she wrote the Institute's "Capacities for Imaginative Learning" and other conceptual documents. At the same time, she was responsible for the Institute's education programs for K–12 and teacher education collaborations in the New York City metropolitan area. She was also part of the initial development of the High School for Arts, Imagination and Inquiry and partnered with New Visions for Public Schools on two new charter high schools. She was also a fellow at the MacDowell Colony. Her poetry and essays have been published in *Education Week*, *Black Fly Review*, *Footwork: Paterson Literary Review*, and *Pearl*, among others. Holzer has taught in a number of K–12 educational institutions in addition to serving in administrative and teaching positions at Cornell and New York University.

Christine Henseler is an arts and humanities advocate and professor of Spanish and Hispanic studies at Union College, New York. A German immigrant, she earned her BA, BSJ, and MA degrees in journalism/advertising and romance studies from the University of Kansas and her PhD from Cornell University. She has been at Union College since 2001, where she has served as the chair of the Department of Modern Languages & Literatures, as the Director of Faculty Development, and the director of Latin American and Caribbean studies, among other administrative positions.

Henseler is actively engaged in advocacy of the arts and humanities on national and international fronts. At Union College, she served as the principal investigator for an Andrew W. Mellon planning grant called Our Shared Humanities. She coleads 4Humanities, a a digital platform concerned with concerned with the role and perception of the humanities in public, and she continues to build a website called The Arts & Humanities in the 21st Century Workplace. She was a blogger for HuffPost and she actively publishes public opinion pieces in Inside Higher Ed and other outlets, often in collaboration with colleagues from different fields and professions outside of academia.

Henseler has published widely. Her books and articles focus on contemporary Spanish literature and digital culture and on Generation X, youth culture, millennials, and social change. She is currently working on several projects about the arts and humanities, including an advice guidebook for and by students and young professionals called *Arts and Humanities: Don't Leave College without Them*.

Amy K. Hamlin is associate professor of art history at St. Catherine University in St. Paul, Minnesota. From 2016 to 2019, she was the Alberta Huber, CSJ, endowed chair in the liberal arts and director of the Evaleen Neufeld Initiative in the liberal arts. An educator in art history and an advocate for the liberal arts, she is informed by intersectional feminist pedagogies and believes that

close encounters with the humanities, arts, and sciences cultivates self-awareness and ethical participation in a democratic society. Together with Karen J. Leader, Hamlin is a cofounder of Art History That (AHT), a multiplatform project that aims to curate, crowdsource, and collaborate on the future of art history.

Hamlin holds an MA in art history from the Williams College graduate program in art history in Williamstown, Massachusetts, and a PhD in art history from the Institute of Fine Arts at New York University. She has presented and published on the art of Paul Cézanne, Max Beckmann, William H. Johnson, Jasper Johns, and Kara Walker. She is interested in reception theory and critical historiographies that aim to reveal and interrogate received ideas about art and art history. She is presently working on a project that explores the discourses of mourning, allegory, and eschatology in modern and contemporary art.

Jane Hawley has been the professor of dance in the visual and performing arts department at Luther College in Decorah, Iowa, since 2000. Her research emphasizes understanding how the body is the realization of self through the continuous experimentation, practice, and development of Movement Fundamentals: Liberating Practices for Dance Artists. Hawley has presented Movement Fundamentals at the National Dance Educators Organization; Motus Humanus: Laban Institute of Movement Analysis; American College Dance Association; the International Association for Dance, Medicine, and Science; and at Fostering the Future Dance Curricular Development Sessions sponsored by New York University's Tisch School of the Arts and Movement Research where Movement Fundamentals was recognized as one of twelve dance curricula across the nation, currently in practice for the year 2050.

Dance Magazine featured Hawley and the dance program of Luther College in the article "Radically Somatic" in the 2009 May issue of *Lifetime Learners*, a supplement to *Dance Magazine* and *Dance Teacher*. Hawley continues to conduct Movement

Fundamentals residencies internationally and nationally and hosts certification programs through the Movement Fundamentals Institute, collectively disseminating the Movement Fundamentals paradigm with alumni and artists through various disciplines and lifestyles, continuing the experiment while developing new research and praxis.

Julia Hotz is a journalist, educator, and co-host of Google Tell Me Something Good. She comes to the Solutions Journalism Network from the University of Cambridge, where she received her Masters in Sociology and founded LokPal—a local community workshop initiative to increase offline social activity. While teaching literature and history as a Fulbright Fellow in Greece, she published essays and chapters on Epicurean wellbeing, the future of work, and loneliness. Her work has appeared in the *New York Times, Fast Company, VICE, Next City,* and more. She's also a proud member of the World Economic Forum's Global Shaper community, and is the daughter of the alleged inventor of cheese fries.

Rebecca Kamen is a sculptor and lecturer on the intersections of art and science, seeking "the truth" through observation. Her artwork is informed by wide-ranging research into cosmology, history, and philosophy, and by connecting common threads that flow across various scientific fields to capture and reimagine what scientists see. She has investigated rare scientific books and manuscripts at the libraries of the American Philosophical Society, the Chemical Heritage Foundation, and the Cajal Institute in Madrid, utilizing these significant scientific collections as a catalyst in the creation of her work. Kamen has researched collaborative projects at the Center for Astrophysics at Harvard University, the Kavli Institute at the Massachusetts Institute of Technology (MIT), the Rochester Institute of Technology, and at the National Institutes of Health where she was artist in residence in 2012.

Exhibiting and lecturing both nationally and internationally,

Kamen has been the recipient of many awards and fellowships. Selected as a Salzburg Global Seminar fellow in 2015, she was invited to Austria to participate and present her work as part of a seminar titled "The Neuroscience of Art: What Are the Sources of Creativity and Innovation." As professor emeritus of art at Northern Virginia Community College, Kamen continues to investigate how the arts and creativity can enhance innovation and our understanding of science. Currently, Kamen is serving as artist in residence in the Computational Neuroscience Initiative and in the Department of Physics and Astronomy at the University of Pennsylvania.

Luke Keller is the Charles A. Dana professor in the natural sciences at Ithaca College, New York. He and his students in the Department of Physics and Astronomy study the formation of stars and planetary systems using observations of gas and dusty material orbiting young stars. Keller is a member of a team using data from the Infrared Spectrometer on the Spitzer Space Telescope to study young solar systems. He also develops instruments for astronomical telescopes, most recently on a team that built an infrared camera and spectrograph for NASA's airborne Stratospheric Observatory for Infrared Astronomy. He has worked for over a decade on implementing new methods of teaching large-enrollment introductory science courses to nonmajors, focusing on the nature of science, how science really works as a human activity, and the intersections of science and the arts and humanities. Keller holds PhD and MA degrees in astronomy from the University of Texas at Austin and a BS in physics from the University of Arizona.

Claudia Lampman is vice provost for student success and professor of psychology at the University of Alaska Anchorage, where she has been on the faculty since 1992. She received her BA degree in psychology from Boston University and both her MA and PhD in applied social psychology from Loyola University of Chicago.

In her twenty-five+ years in academia, she has taught thousands of students in courses ranging from the introductory to doctoral level. Lampman's area of specialization is in the study of sexuality and gender in the workplace, including the study of sexual harassment and attitudes about pregnancy, childbirth, and childlessness. She has published more than forty journal articles and book chapters. Her recent research focuses on the experience of contrapower harassment in academia. She has conducted several studies (including a national survey) on faculty members' experience with student incivility, bullying, aggression, and sexual harassment. Her research has been published in such journals as *Sex Roles, Sexuality and Culture, Basic and Applied Social Psychology, American Psychologist, Birth, Journal of Applied Social Psychology,* and the *Journal of HIV/AIDS Prevention & Education for Children & Adolescents.*

Christina Lanzl is the director of the Urban Culture Institute and has been teaching in the Department of Architecture at the Wentworth Institute of Technology in Boston, Massachusetts, since 2015. She is a public art and placemaking consultant with more than twenty years of experience, working with public- and private-sector clients, cultural institutions, communities, and professionals in the creative sector. The Massachusetts Bay Transportation Authority, the Boston Children's Hospital, and the cities of Boston and Worcester have been major clients. She has managed the public art programs of the city of Memphis, Tennessee, and of the Urban Arts Institute at the Massachusetts College of Art and Design, administering over one hundred permanent and temporary initiatives ranging from local to international in scope. Given her professional background and expertise, Lanzl is particularly versed in public art facilitation and cultural planning, public engagement, research, and education. Committed to design excellence and placemaking, she has published extensively on the correlation of the arts, architecture, and public places. Among other

organizations, the Public Art Network of Americans for the Arts, the Massachusetts College of Art and Design, and the Brookline Arts Center have honored Lanzl's work. Trained in the United States and in Germany, she holds degrees in art history, with a PhD concentration in public art from the University of Munich and an MA from Boston University, and information management, with a diploma from Stuttgart Media University, Stuttgart, Germany.

Gemma Mangione is a lecturer in the arts administration program at Teachers College, Columbia University, and is a consulting analyst with RK&A, a planning, research, and evaluation firm serving museums. She previously worked as a member of the Whitney Museum of American Art's education department, coordinating a community outreach initiative for older adults. Her current research examines therapeutic programs for visitors with disabilities in art museums and botanical gardens. In recognition of this project, she received a 2015 to 2016 American fellowship from the American Association of University Women. Portions of this work have also appeared in *Poetics*, *Museum & Society*, and the *Sociology of Health & Illness*. As part of Mangione's sustained commitment to coupling arts management theory and practice, she has twice presented at the Leadership Exchange in Arts and Disability (LEAD) Conference organized by the Kennedy Center; she also participated in a National Art Education Association roundtable on museums and wellness. She writes on the intersection of sociology and evaluation for RK&A's blog The Intentional Museum. Gemma holds BA degrees in journalism and art history and an MA and PhD in sociology, all from Northwestern University.

Emily Moberg is a scientist at the World Wildlife Fund. She specializes in theoretical ecology and bioeconomics, with an emphasis on modeling and optimization. She researches problems at the interface of natural resources and human dynamics. Moberg holds an SB in environmental engineering from the Massachusetts Institute

of Technology (MIT) and a PhD in biological oceanography from MIT/Woods Hole Oceanographic Institution joint program. She has published on the bioeconomics of fisheries, climate change, and the history of science, and has a coauthored a textbook on decision analysis in environmental problems. She also serves on the executive board of the National Network for Ocean and Climate Change Interpretation (NNOCCI). NNOCCI connects and trains climate scientists and informal science educators on how to alter the national conversation around climate change. In this organization, she has worked on curriculum development and building a community of practice among scientists.

Bailey Reutzel is a long-time financial technology reporter focused primarily on cryptocurrency and blockchain since 2012. She is currently the multimedia editor at CoinDesk, the leading cryptocurrency publication, where she explores transmedia storytelling. In the second half of 2015, in the run-up to the Trump election, she took her 2008 Escape through the contiguous forty-eight US states, asking people about politics and money and trying to figure out both America and herself. Always gonzo and a bit navel gazing, Reutzel's work pushes the boundaries of the day-to-day journalist.

Doris Sommer is the founder of the NGO Cultural Agents, and is the Ira and Jewell Williams professor of romance languages and literatures and African and African American studies. Her academic and outreach work promotes development literacy, innovation, and citizenship specifically through "Pre-Texts" with partners in science, medicine, and other arts in Boston Public Schools, throughout Latin America, and beyond. Pre-Texts is an arts-based training program that invites teachers to become facilitators of art-making projects based on challenging texts. Among her books are *Foundational Fictions: The National Romances of Latin America* (1991) about novels that helped to consolidate new republics; *Proceed with Caution When Engaged by Minority Literature* (1999) on

the rhetoric of particularism; *Bilingual Aesthetics: A New Sentimental Education* (2004); and *The Work of Art in the World: Civic Agency and Public Humanities* (2014). Sommer has enjoyed and is dedicated to good public-school education. She has a BA from New Jersey's Douglass College for Women and a PhD from Rutgers, the State University, in New Jersey.

Rebecca Volino Robinson is an assistant professor of psychology at the University of Alaska Anchorage (UAA) and a licensed psychologist in Alaska. Robinson leads the Community Psychology Research Collaborative (CPRC) at UAA, a research learning community funded by the National Institute of Health's BUILD EXITO program. CPRC brings together students, academic researchers, practitioners, and community partners who are dedicated to improving the health and wellbeing of vulnerable populations living in the United States. Robinson was recipient of the 2014 UAA Selkregg Community Engagement and Service Learning Award and is a three-time recipient of the UAA Innovate Award in 2014, 2016, and 2017. Robinson served on the steering committee for the *Stalking the Bogeyman* project at UAA; she led the clinical support team on the project, collaborated on community outreach efforts, and supervised student research.

Brandon Wang is a computer science major in the class of 2019 at the Massachusetts Institute of Technology (MIT). As a first-year student, he participated in Terrascope's fall class, which focused on issues surrounding global food security. He went on to take Terrascope Radio the following spring and worked as a Terrascope undergraduate teaching fellow during his sophomore and senior years. During his undergraduate career, Wang has interned at a software company and NASA's Jet Propulsion Laboratory, and he worked with an urban planning research lab at MIT. Brandon's current interests lie in applying computer science to transportation and the environment.

Amanda Zold recently completed her PhD in clinical-community psychology at the University of Alaska. Zold is passionate about reducing stigma toward mental health treatment and disorders and views advocacy for underserved populations as crucial to her role as a psychologist. Clinically, she enjoys working with individuals who experience chronic, severe mental illness in both inpatient and outpatient settings. She gained specialty training in treating individuals with psychosis during her doctoral internship at the University of Arizona and will soon begin her postdoctoral residency at the Institute of Living in Connecticut in the Schizophrenia Rehabilitation Program. Her research focuses on stigma, program implementation, and evaluation. Zold conducted an in-depth process and outcome evaluation of the *Stalking the Bogeyman* project.

Index

Art+Feminism, 120–122
 purpose and origin, 120–122
 Wikipedia Edit-a-thons, 15, 120–127
Art+Feminism Wikipedia Edit-a-thon,
 15, 120–127
 demographic diversity within,
 132–133
 fourth international, 130–131
 in higher education, 119–120,
 122–128
 purpose and origin, 120–122,
 130–133
 student ambivalence regarding,
 128–130
art history, 124–126, 143
 See also Art+Feminism Wikipedia
 Edit-a-thon
Art in America, 119
Artists and Climate Change (blog), 18
ARTnews, 125
arts administration, 349–350
Arts Council New Orleans, 12
arts funding, 211–212, 370
Arts in Context class, 350
Ashe Cultural Center, 43
astronomy, 287–288, 290–291,
 309–310
 poetry and, 295–296
 scientific process and, 291
 visual arts and, 292–294
automation, 366
Autor, David, 369
Aztecs, 142, 144

Bakshi, Amar C., 5–6, 9, 11–12, 25–36,
 47, 373–374
 chapter by, 25–36
Barraza, Jesus, 167
Barsade, Sigal, 362–363
Bartels, Michael, 235

Bartlick, Silke, 77
Bateman, Sidney Iking, 81–82
Batson, Charles, 9, 374–375
 chapter by, 73–88
Bebelle, Carol, 43–44
Bedoya, Roberto, 44
Belfiore, Eleonora, 7–8
Benbow, John, 304
Berlin, Germany, 56–57, 73
Bernstein, Aaron, 308
Bilodeau, Chantal, 17–18, 375
 chapter by, 215–232
Bishop, Ryan, 245
Bitcoin, 210
Black Mirror (Netflix show), 212
Black Rock City, Nevada, 45–46
Body of Water (performance), 18, 235–
 236, 246–265
 effect of on performers, 248–251
 interviews for, 243–244
 natural inspiration for, 246–248
 performance of, 253–261
 photos of, 254, 256–257260
 poster, 235
 reaction to, 261–264
 reworking of, 252–253
Books (Please!) In All Branches of
 Knowledge (Rodchenko), 130
Boston, Massachusetts, 54–56, 59–61
Boston Society of Architects (BSA),
 52
Bourdieu, Pierre, 344
Brik, Lilya, 130
British Academy of Film and
 Television Arts (BAFTA), 112–113
Brody, Paul, 58
Burkhart, Jennifer, 14, 375
 chapter by, 89–102
Burners Without Borders, 45
Burning Man, 9, 12, 45